S0-ARY-355

AMERICAN
INDIAN ART

AMERICAN INDIAN ART

Norman Feder

75-715 TITLE II

HARRY N. ABRAMS, INC·PUBLISHERS·NEW YORK

CONCORD HIGH SCHOOL MEDIA CENTER
59117 SCHOOL DRIVE
ELKHART, INDIANA 46514

Frontispiece.
Headdress. Tlingit or Haida. 7 x 5 3/4″.
Denver Art Museum (Cat. No. QBC–2).
Collected by Ed Malin from the Kwakiutl,
but not of Kwakiutl manufacture.

Consulting Editor

DOUGLAS NEWTON

Curator, The Museum of Primitive Art, New York

Milton S. Fox *Editor-in-chief*

Book design Ben Feder

Standard Book Number: 8109–0014–9

Library of Congress Catalogue Card Number: 69–12484
All rights reserved. No part of the contents of this book may be
reproduced without the written permission of the publishers,
Harry N. Abrams, Incorporated, New York.
Printed and bound in Japan

Acknowledgments

So many people helped in the preparation of this book, and in so many different ways, that it is difficult to single out just a few for special mention. My main debt is certainly to the many museums and private collectors, who not only had the forethought to amass and preserve their invaluable collections, but who also made their holdings available to me for study. I am deeply grateful to the staff members of these various institutions for their time, courtesy, and patience. In addition to locating specific treasures in their storerooms, they also searched through records for additional data, and in many cases even supervised photography. To all, my very sincere thanks.

Special acknowledgment must be given to Mr. Milford G. Chandler, certainly one of the most thorough collectors of all time, who unselfishly shared his deep insights of both Indian life and art, and who guided my appreciation of many little-known aspects of material culture.

I am indebted to Mr. Bill Holm of the Washington State Museum for reading the section pertaining to the Northwest Coast, and for making several very helpful suggestions.

Unfortunately most photographers remain anonymous, but I must single out Mr. Lloyd Rule of Denver who worked long hours taking nearly all the photographs of specimens in the Denver Art Museum. Special thanks also to Mr. Carmelo Guadagno of the Museum of the American Indian who supplied all of the photos from that institution.

And to the staff of the Denver Art Museum and particularly its director, Dr. Otto Karl Bach, for constant encouragement and inspiration, I express my deep gratitude.

The following private collectors and museum personnel have been particularly helpful:

Mr. L. Drew Bax, Mr. Larry Frank, Dr. William L. Gannon, Mr. John Hauberg, Dr. James Howard, Mr. Dennis Lessard, Mr. Richard Pohrt, and Mr. Roy H. Robinson.

Dr. Stanley A. Freed, American Museum of Natural History, New York
Mrs. Jane Powell Rosenthal, Brooklyn Museum, New York
Mr. Donald J. Metzger and Mr. Don W. Dragoo, Carnegie Museum, Pittsburgh
Mr. William Marshall and Mrs. Sally Roedeck, Colorado State Historical
 Society, Denver
Dr. Warren L. Wittry, Cranbrook Institute of Science, Bloomfield Hills, Michigan
Dr. Donald Collier, Dr. Philip H. Lewis, and Dr. Leon Siroto, Field
 Museum of Natural History, Chicago
Mr. Robert Hart and Mr. Myles Libhart, Indian Arts and Crafts Board,
 Washington, D.C.
Dr. Thomas A. Witty, Kansas State Museum, Topeka
Dr. Robert Ritzenthaler, Milwaukee Public Museum, Wisconsin
Dr. Alan R. Woolworth, Minnesota Historical Society, St. Paul
Dr. Frederick J. Dockstader and Mr. William F. Stiles, Museum of the
 American Indian, New York
Mr. Douglas Newton and Mr. Allan Chapman, Museum of Primitive Art, New York
Dr. Dave Damas, National Museum of Canada, Ottawa
Mr. Marvin F. Kivett, Nebraska Historical Society, Lincoln
Dr. William N. Fenton and Mr. Charles E. Gillette, New York State Museum, Albany
Mrs. Mahala E. Mueller, Northern Plains Indian Crafts Association,
 Billings, Montana
Dr. Ernest S. Dodge, Peabody Museum, Salem, Massachusetts
Mr. Charles F. Hayes III, Rochester Museum of Arts and Science, New York
Dr. Edward S. Rogers and Mr. Harold Burnham, Royal Ontario Museum, Toronto
Mr. Roy E. Coy, St. Joseph Museum, Missouri
Mr. Charles R. DeBusk and Miss Lillian R. Smith, Sioux City Public Museum, Iowa
Mr. Carl Dentzel and Mr. Bruce Brian, Southwest Museum, Los Angeles
Dr. Saul H. Riesenberg, Dr. William Sturtevant, Mrs. Margaret Blaker,
 and Mr. Robert Elder, United States National Museum, Smithsonian
 Institution, Washington, D.C.
Miss Frances Eyman and Mr. David Crownover, University Museum, Philadelphia
Dr. Joan Freeman, State Historical Society of Wisconsin, Madison

N. F.

Denver, 1965

Contents

List of Plates

Whenever possible, museum catalogue numbers have been included in the plate captions.

Frontispiece. *Headdress, Tlingit or Haida*

10

THE SOUTHWEST

13

CALIFORNIA

THE GREAT BASIN AND THE PACIFIC PLATEAU

THE PACIFIC NORTHWEST COAST

THE ARCTIC COAST

THE WOODLANDS

INTRODUCTION

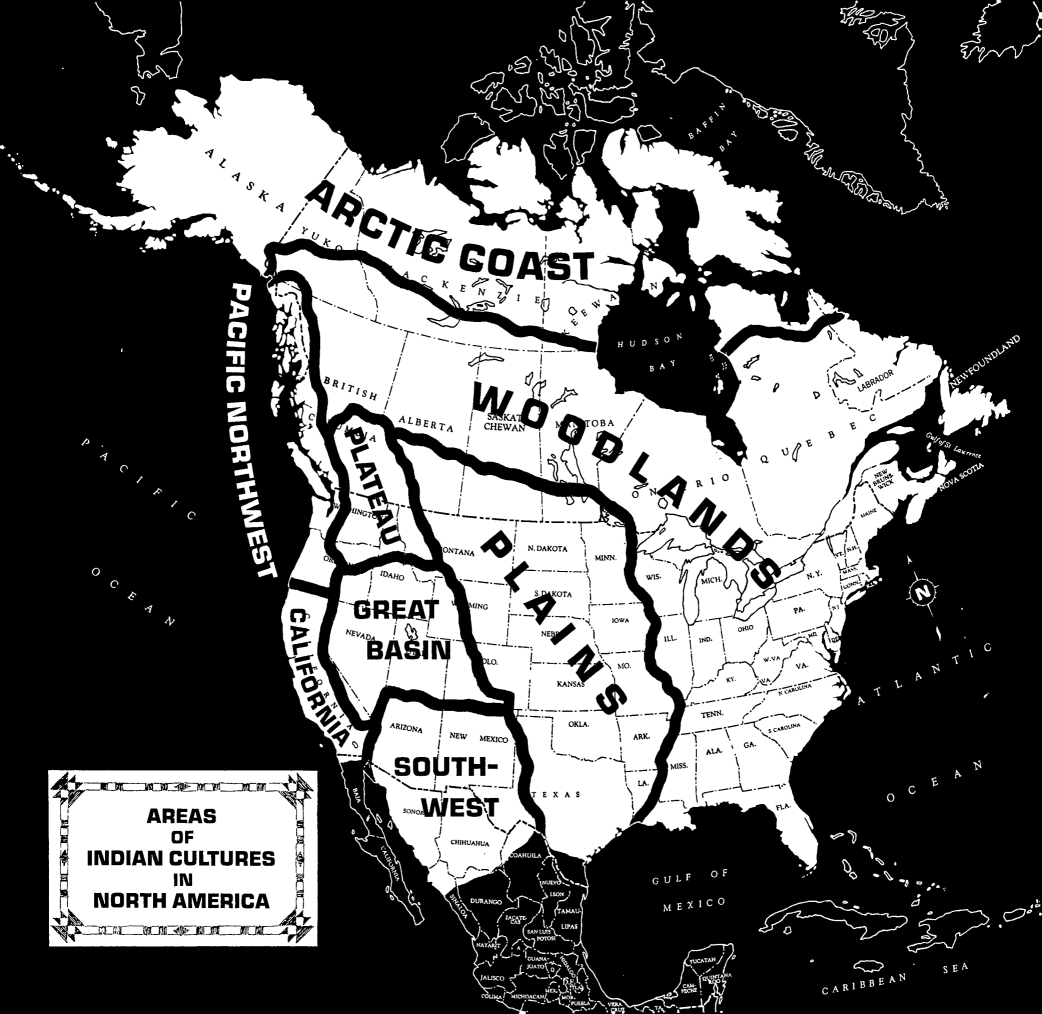

The past decade has seen an increasing awareness of American Indian art develop among the American people. A short twenty-five years ago, the only place where primitive art could be seen was in the usual culturally oriented exhibits of the major natural history museums. Today, such museums have begun to display specimens with an emphasis on their artistic qualities, and art museums are forming new departments of primitive art. In addition, certain types of American Indian materials are in demand by discriminating collectors as well as by museums.

It is somewhat difficult to explain this sudden interest in American Indian art, but it is probably due to at least two major factors. First of all, the general increased awareness of the arts of Africa and Oceania, owing in part to the enthusiasm of modern artists in Europe, has tended to draw attention to the arts of America. In other words, American Indian art is riding on the popularity bandwagon of a widespread interest in primitive art from all regions of the world.

Another factor is that the American Indians are gradually being assimilated into American society. This is partly due to government programs of termination and relocation, and partly to an inevitable process of acculturation which began with the Indians' first contact with Europeans, and has been going on ever since. At this point we can look into the future and foresee the final stage of this process: almost complete acculturation will have taken place, resulting, of course, in the complete disappearance of the native arts.

Interest in, and collection of, American Indian art has gone through a series of phases. During the first hundred years of the discovery of this art, examples of Indian handicraft were eagerly sought as souvenirs, and were taken or sent back to Europe as specimens of the strange and wonderful things being produced by the American natives. This interest lasted into the second half of the nineteenth century in some areas of the Plains.

With further contact, the early sense of novelty wore off; on the one hand, Indians were usually hated or ignored by those who lived in proximity to them, while on the other, people remote from the Indians developed overly romantic notions about them based on the novels of James Fenimore Cooper and Karl May. This latter group continued to collect as the opportunity afforded itself.

21

The final phase is the present one. Collecting is again feverish, a last effort to obtain whatever is left of the old culture before it completely disappears.

In spite of the fact that Indian exhibits have been on view in American museums at least since 1800, and at present there is an interest in collecting artifacts, even today only a small portion of the vast variety of Indian production is deemed worthy of display. The implication is that only a modest segment of this production has any artistic merit. The usual display of American Indian art found in an American museum tends to rely heavily on prehistoric material, an emphasis which is carried over into the few books on the subject. Typically, these exhibits include several examples of Northwest Coast wood carving, a painted shield and buffalo robe from the Plains, and perhaps a fetish and *kachina* from the Southwest. Nevertheless, the art of the historic American Indians has a great deal more to offer than the few examples currently valued by collectors. One of the main reasons why more Indian material is not displayed is sheer lack of knowledge of the variety of Indian production.

The acceptance of Indian art by the general public is directly related to efforts to popularize it by exhibits and publications. These efforts started in 1931 with the Exposition of Indian Tribal Arts, advertised as "the first exhibition of American Indian art selected entirely with consideration of aesthetic value."[1] This was followed in 1939 by a major show at the San Francisco World's Fair organized by Frederic H. Douglas and René d'Harnoncourt, who later created a similar exhibit at the Museum of Modern Art in New York in 1941. The book *Indian Art of the United States*, a collaboration between Douglas and d'Harnoncourt and based on the New York exhibition, has become a classic on the subject. In 1949 and in 1950 two important books[2] devoted solely to the art of the Northwest Coast area assured recognition for this art form. Subsequent exhibits and publications on specific aspects of Indian art—sculpture, paintings, ceramics—have all made their contribution to the popularization of the subject. In all probability, if there were a major exhibition focusing on some special aspect of Indian art such as Woodland wooden dolls or Plains sculptured catlinite pipes, these artifacts would come to enjoy the same popularity as those which are already well known, such as Northwest Coast art.

SCOPE OF THE BOOK

No one writer can hope to describe all North American Indian art exhaustively. The scope of this book has therefore been confined to historic or "postcontact" art from the land mass north of Mexico, taken area by area. It is further limited by an emphasis on art rather than craft so as to show the very best of American Indian production. Admittedly, the differences between arts and crafts are nowhere clearly defined and a stress in one direction inevitably leads to certain inequalities, so that the production in some subareas is scantily represented while in others it is relatively fully illustrated. However, an effort has been made to include at least one example of each type of production and at least one example from each area. To accomplish this, several specimens have been illustrated which, while not of the highest artistic merit, still represent the best, or indeed, the only, art produced in the areas from which they come.

Some authors have stated that American Indian art must be viewed through Indian eyes to be appreciated properly, a feat no one brought up in a non-Indian culture can hope to perform successfully. Indian art can and should be appreciated on its own merits, and the finest Indian art can certainly be judged and appreciated by the highest Western standards. But one should realize that the more knowledge one has concerning the world from which a given work comes, the richer will be one's appreciation of it. Familiarity with both the techniques and the cultures will enhance this appreciation.

In attempting to present only the best of Indian art, I have included little production of a strictly decorative nature, although most of the crafts produced by American Indians are purely decorative. We can admire the fine workmanship of a basket made by a California Indian, the countless hours involved in making a solidly beaded Sioux dress, the fine, even lines painted on a Pueblo pot; but their technical excellence does not necessarily mean artistic excellence. Certainly most American Indians prided themselves

on their skill and were able to produce amazingly fine craftwork, often with primitive tools. Although we can appreciate this skill and admire its results, it is only those works which have an emotional impact on the viewer that are included here. Sometimes they are crudely made, sometimes finely finished; and usually, but not always, they were intended for use in some religious capacity.

INDIAN ART

The area of America which lies north of Mexico is vast, and the people native to each of the sections of this territory differ notably from each other physically, linguistically, and culturally. Yet, by popular usage, all are called Indians, or Eskimos in the far northern sections. This has led to the fairly widespread misconception that all Indians are alike, and generalizations concerning Indian art are common. In reality, it is almost impossible to make generalizations which genuinely apply to this whole vast region.

Each tribal group—in some instances even each division of a tribal group—should be considered as a separate entity. However, since there are no less than over three hundred different tribes, anthropologists have been forced to utilize the concept of "culture areas" as a convenient tool for discussions of groups which are culturally similar. This concept is adopted here for its practical value.

Tribal styles within any one culture area may vary, and are usually quite distinct; culture areas and artistic areas, in fact, do not necessarily correspond. For instance, even the least trained eye will notice that the colors, designs, and techniques of application are completely different in Crow and Cheyenne decorative beadwork although both tribes are located in the Plains culture area. Some of these tribal differences will be discussed in the section on culture areas.

CONCORD HIGH SCHOOL MEDIA CENTER
59117 SCHOOL DRIVE
ELKHART, INDIANA 46514

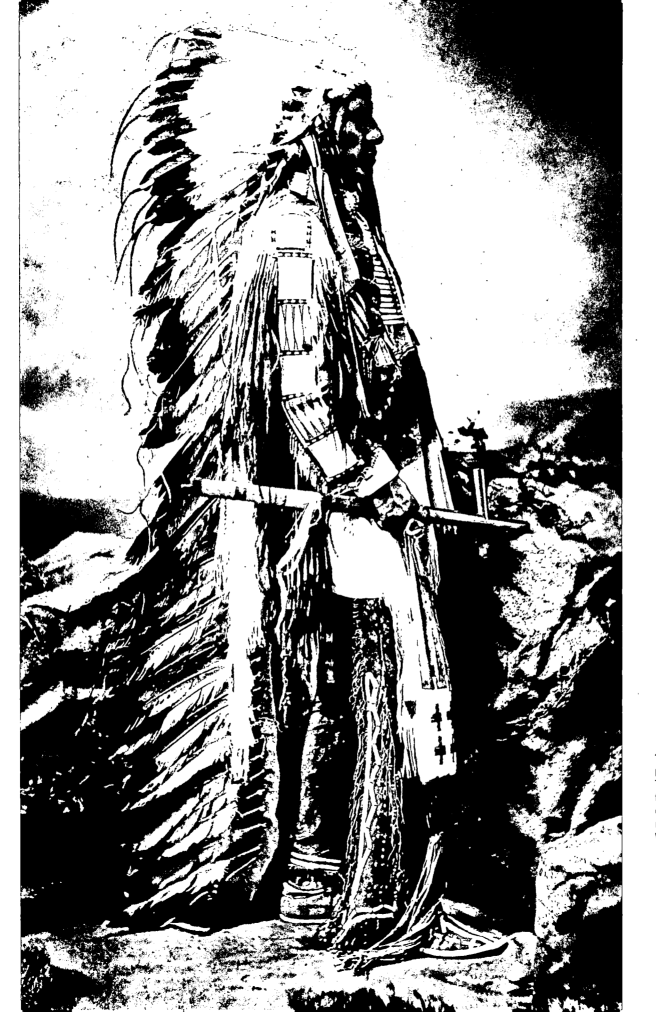

1. American Horse, an Oglala Sioux, photographed by Jackson about 1877. The buckskin shirt and leggings and the feather bonnet exemplify the popular image of "the typical Indian." The fine shirt is now in the Adolf Spohr Collection at the Whitney Gallery, Cody, Wyoming.

ORIGINS OF INDIAN ART

The origins of most Indian arts are hopelessly lost in prehistory. We can now only guess how or when or where a particular style developed. Archaeologists, of course, give us some clues gained from material recovered from prehistoric sites, so that we know, for example, that basketry preceded pottery in the Southwest. However, the only materials recovered from archaeological sites are usually of a non-perishable nature such as stone, bone, or ceramic.

Certain techniques developed during the historic period with the introduction of European trade materials; the origins of these techniques are clouded due to the scarcity of early, well-documented specimens. While it is interesting to speculate about the possibilities that beadwork developed from the older technique of decorating with porcupine quills, or that ribbon appliqué developed from a previous use of cut-and-dyed buckskin appliqué, these are strictly conjectures. It is, however, demonstrable that certain materials that were introduced were readily accepted and spread over almost the whole country within a brief period. Glass beads, silk ribbon, and sheet metal were eagerly sought after almost everywhere for use in decoration; but in adopting them, each group developed its own range of tribal styles, and even techniques. These styles and techniques were sometimes borrowed from neighboring tribes along with the materials themselves, but were as often adaptations of existing ones.

A couple of instances will illustrate this latter process. The lazy-stitch beadwork made with imported beads by the Sioux and Cheyenne was stylistically similar to their quillwork in its use of straight lines; thus, the geometric designs used in quillwork were accommodated to the beadwork (at least in early phases). On the other hand, the Eastern tribes could not duplicate their original curvilinear and floral designs in lazy-stitch, so they had to develop an overlay sewing technique for their beadwork. (In spite of the popularity of beads in other areas, the Pueblo groups never used them for decoration to any appreciable degree. Why they did not remains inexplicable.)

DIFFICULTY OF IDENTIFYING TRIBAL STYLES

Although many tribes have art styles that are distinctly their own, there is still considerable confusion in the identification of some items. This is due largely to the inadequacy of documentation which besets our collections, including those of museums. Objects bought from dealers are often unaccompanied by collection data because a dealer may refuse to disclose his source. Field collectors are sometimes negligent in questioning the seller of each piece as to when it was made, who made it, or its function. Sometimes museums themselves are at fault in not recording the information available from the field collector. Occasionally records are lost through fire, negligence, or improper cataloguing procedures. The most common museum fault is making an attribution without recording it as inferential. Future researchers are then led to accept guesswork as fact, and may very possibly perpetuate mistakes. Other sources of confusion include private collectors who do not catalogue their collections at all, although in many cases they can remember the complete history of each piece. Should the collection change hands, all information concerning it is irrevocably lost. Also, the souvenir hunter will often collect a few pieces of Indian material which may pass through several generations of owners before coming to a museum, at which time these pieces may be very old and rare but lack documentation beyond such a statement as "Grandma purchased them years ago from a cute little Indian girl out West."

Uncertainty about the real origin of Indian objects can also be due to actual tribal custom. Most Indian groups engaged in exchanges of gifts with other groups during informal visits or peacemaking. When such exchanges continued over a long period, they contributed to a blending of tribal styles. A basic similarity of style then emerged for the participating tribes. The beadwork style of the Crow and Nez Percé tribes is due to this kind of reciprocal influence.

Still more significant is the fact that most tribes preferred to part with

gifts other than their own work. Consequently, much of the material collected from any one tribe as their production may in reality consist of gifts from quite another tribe. An outstanding example of the confusion which this phenomenon can cause is shown in the book *Crow Indian Art*[3] in which of some thirty-one beadwork specimens illustrated as Crow and collected from this tribe, only eleven are actually of Crow manufacture. This phenomenon is still prevalent today: Nez Percé corn husk bags can be purchased more easily and less expensively from the Crow than from the Nez Percé. Conversely, Crow painted *parfleches* can be more easily obtained from Plateau groups than from the Crow themselves.

Further complicating factors were intertribal marriage and the spoils of war. Almost one hundred forty years ago, George Catlin commented: "There is, certainly, a reigning and striking similarity of costume amongst most of the Northwestern tribes, and I cannot say that the dress of the Mandans is decidedly distinct from that of the Crows or the Blackfeet, the Assiniboins, or the Sioux; yet there are modes of stitching or embroidering in every tribe which may at once enable the traveler who is familiar with their modes to detect or distinguish the dress of any tribe. These differences consist generally in the fashions of constructing the headdress, or of garnishing their dresses with the porcupine quills, which they use in great profusion.

"Amongst so many different and distinct nations, always at war with each other, and knowing nothing at all of each other's languages, and amongst whom fashions in dress seldom if ever change, it may seem somewhat strange that we should find these people so nearly following or imitating each other in the forms and modes of their dress and ornaments. This must, however, be admitted, and I think may be accounted for in a manner without raising the least argument in favor of the theory of their having all sprung from one stock or family; for in their continual warfare, when chiefs or warriors fall, their clothes and weapons usually fall into the possession of the victors, who wear them, and the rest of the tribe would naturally more or less often copy from or imitate them; and so also, in their repeated councils or treaties of peace, such articles of dress and other manufactures are customarily exchanged, which are equally adopted by the other tribe, and consequently lead to the similarity which we find amongst the modes of dress, etc., of the different tribes."[4]

Some utensils and articles of clothing had a wide distribution because

they were copies or adaptations of European styles. For instance, the full skirts used by Navaho and Apache women in the Southwest were copied from those of early European pioneers. The blouses of most Woodland Indian women are also patterned after European prototypes; in precontact times, Woodland women wore no blouses. Much Indian silverwork imitated earlier pieces made for trade by non-Indians. In addition, many Indian prototypes were modified. Thus, the shape of the Indian knife case was changed so as to fit commercially introduced knives.

Certain items usually varied considerably from tribe to tribe, making it an easy matter to trace their origins. Moccasins are a case in point. A distinctive type of one piece soft-sole moccasin, with a seam running the full length of the sole, was characteristic only of Osage and Quapaw, two very closely related tribes. However, there is probably not an Osage alive who would recognize this type of moccasin, because of the changes in the style. Most Osage now wear moccasins of the Cheyenne type. Even some women, who are generally more conservative than the men, wear a hard-sole adaptation of the older soft-sole style. The Omaha and Ponca at one time used a one piece soft-sole moccasin which only a few old Omaha remember today, and which is unknown among the Ponca. A field collector, ethnologist, or museum curator could, then, easily be misled into believing that there is no distinct style of moccasin among these tribes unless he had access to older documented collections.

In summary, while there are many distinct tribal styles of certain objects, and many area styles, there is still a serious problem of identification of many items of Indian manufacture.

2. Beaded storage bag. Arapaho. c. 1890. \longrightarrow
15 x 22 1/2″. Denver Art Museum (Cat. No. BAr–28). Collected by Charles Wiegel. A copy in beadwork of a pictographic painting style.

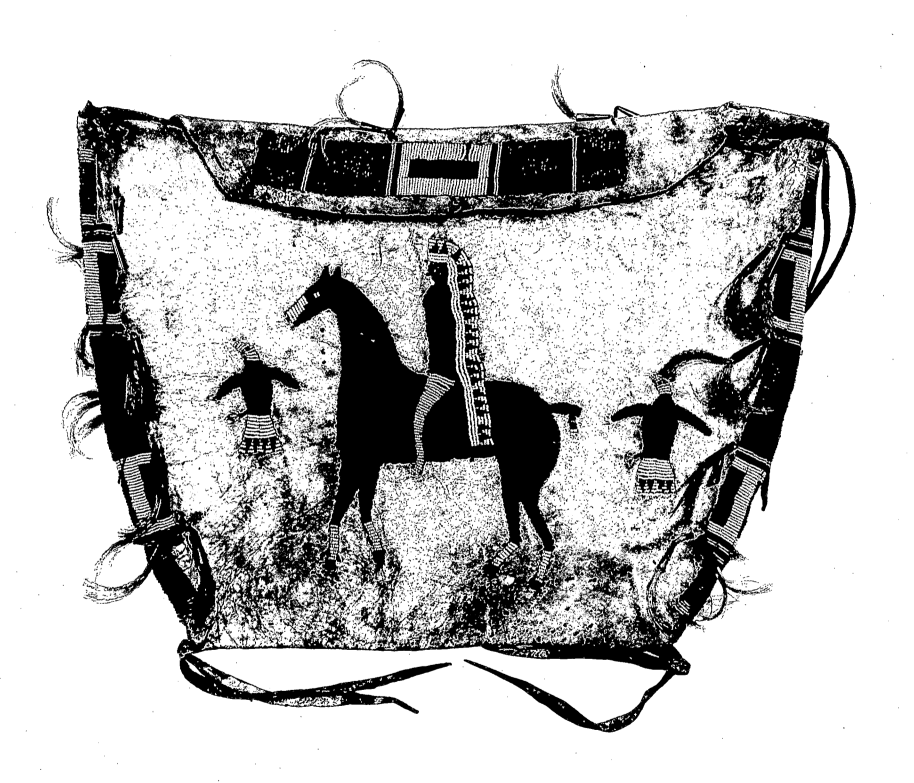

CONCORD HIGH SCHOOL MEDIA CENTER
59117 SCHOOL DRIVE
ELKHART, INDIANA 46514

3. Large pottery bowl. Zuñi. Diameter 28″.
Denver Art Museum (Cat. No.
X–Zu–46–P). The deer with heart lines
are a common Zuñi motif.

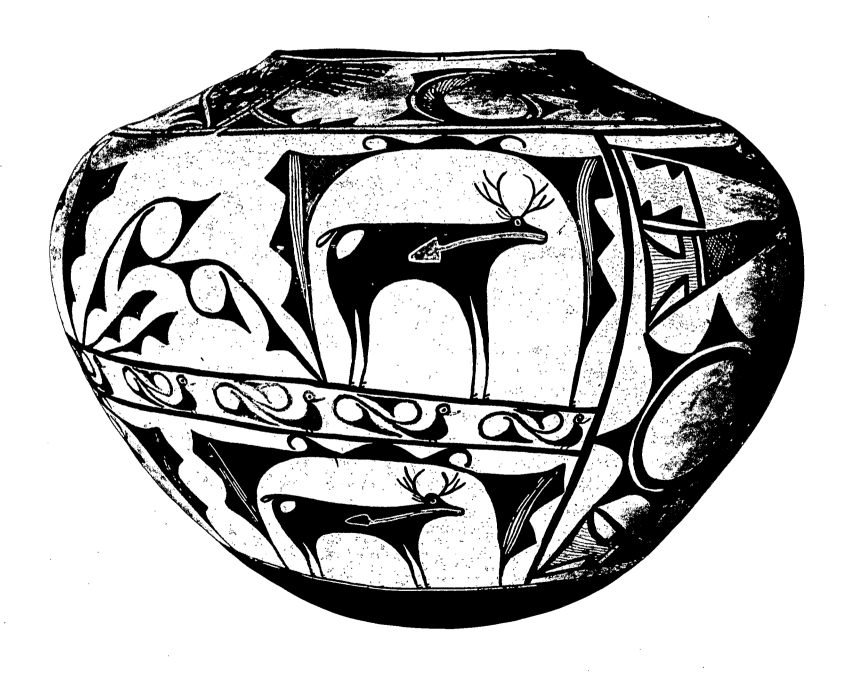

USE OF MATERIALS AND TECHNIQUES

As a rule, the Indian artist generally used whatever material was most readily available: wood and wood products were the dominant materials in the Northwest Coast and Woodland areas, buffalo hides on the Plains, and clay in the Southwest. However, almost everywhere the rare material was eagerly sought because of the prestige its ownership brought. The intertribal trade in finished products was paralleled by the trade in raw materials, and long journeys were undertaken to obtain them. Seashells from the Pacific were traded as far east as the upper Missouri River area, and were common in the Southwest. Parrot feathers, metal bells, and seashells were traded into the Southwest from central Mexico. Catlinite for pipe bowls was traded from a center at Pipestone, Minnesota throughout all the Plains area as far as the state of Washington. Skins, horns, bowwoods, and pigments were also commonly traded.

The use of any given material, then, is not necessarily indicative of its place of origin. Furthermore, the distribution of some materials has changed with time, particularly in the case of animal sources. The bison, for example, once widespread over the Plains and parts of the Woodland area as well, are now confined to national parks. Other creatures—the Plains grizzly, the ivory-billed woodpecker, and the Carolina parakeet—at one time fairly plentiful over a wide area, are now all but extinct.

The wide variety of materials introduced by Europeans in some instances had a radical effect, being readily accepted by the Indians as more colorful than native equivalents, or better suited to their purposes. Originally they were supplied as gifts to win Indian friendship and alliance. This was particularly true in the days when Europeans were a minority, but also during the days when England, France, Spain, Sweden, and Holland were all vying with one another for control of territory. The custom of gift-giving lasted well through the period of the American Revolution and was gradually replaced by the trade in furs. (Some individuals, like John Jacob Astor of

the American Fur Company, controlled large portions of the fur trade and became the first American self-made millionaires.) An extensive industry was developed to supply goods which would entice the Indians to deal with a specific merchant. Many silversmiths, at first in England, and later in New York, Philadelphia, Detroit, and Montreal were kept busy producing ornaments for Indians instead of table services for Europeans.

European manufacturers even duplicated Indian crafts on a mass production basis. If the Indian valued such things as wampum beads laboriously handmade of clam shells, Europeans would and did manufacture them in quantity for Indian trade. Others, finding the wampum industry too difficult or costly, had special imitation wampum made of glass beads. Likewise dentalium shells were supplied by traders throughout the Plains, and abalone shells were traded into the Southwest.

Indian trading posts are still a common feature of the American economy but, of course, they are small businesses compared to the Astor era. Modern traders supply glass beads, shells, wool cloths, brass bells, dyed feathers, and a host of other raw materials used by present-day Indians in their craftwork. The romantic purist today bemoans the fact that traders stock brightly colored—often garish—materials, but neglects the fact that these items please Indian taste. The older, softer, pastel shades produced with native dyes were eagerly replaced with aniline dyes. Improved methods of coloring glass also had a profound effect on Indian arts, usually one which was less pleasing to non-Indian taste. A very few traders, in the interest of modern commercial production, have persuaded Indians to use again the older native dyes (as in the case of some Navaho rugs), or have specially ordered glass beads in the older, subdued colors. However, in general, Indians will not employ either for their own use.

ECOLOGY VERSUS ART

As a very general rule, the quantity of artistic production is directly related to problems of securing a livelihood. Where food is abundant and easy to obtain, a good deal of leisure time is available for artistic production. Needless to say, the reverse is also true: little art is produced in areas where all the hours between sunrise and sunset are consumed in just finding enough to eat. We should then expect to find an abundance of art in the Pacific Northwest area because of the plentiful supply of fish and other easily available foods, and in fact we do. Likewise we find very little artistic production in the desert areas of Nevada.

However, other factors are involved in addition to the food supply. For example, the Indians of the Great Plains region generally had an adequate supply of food in the form of bison, but their very dependence upon this animal forced the people into nomadism. Since they were continually on the move following the herds, a problem of portability developed. Leisure time was often, if not always, available for artistic production, but weight, size, and ease of packing were important factors to be considered in the design of even the simplest everyday utensil. Items of manufacture, to be worth transporting, had to be of some importance within the framework of Plains culture. Such items usually were related to religion, as in the case of pipes and pipe stems, or were connected with warfare, such as shields and weapons. We would certainly not expect to find any great development of monumental wood or stone sculpture in a nomadic society no matter how much time was available.

In the Southwest we find a group practicing agriculture in an arid, difficult region. In good years, when the harvest was bountiful, the Pueblo people had much leisure. But more often the crops were in danger from day to day either because of an inadequate water supply or insect pests, or, in the past, from the threat of raiding Navaho or Apache. These people then developed a complex religious life centered on insuring successful har-

vests. Almost all their hundreds of gods were literally responsible for bringing rain, insuring fertility, and in general, preventing crop failure. Most artistic production was in some way connected with this intense religious activity. Fetish figures were carved of wood, stone, or shell; elaborate costumes were made to be used by dancers imitating the gods, or *kachinas;* and miniature gods (*kachina* dolls) were carved in wood for gifts to children.

In sharp contrast to the Pueblo agriculturalists are the farmers of the Eastern Prairies and Woodland areas. There, although a limited amount of agriculture-centered ceremonialism was developed, it was never as dominant as in the Pueblo area, largely because of the lack of major threat to the crops.

Colorplate **1**. Beaded moccasins. Iowa. c. 1860. Length 10 3/4″. Collection Milford G. Chandler, Detroit. A fine example of the colorful abstract style which developed near the Kansas–Nebraska border.

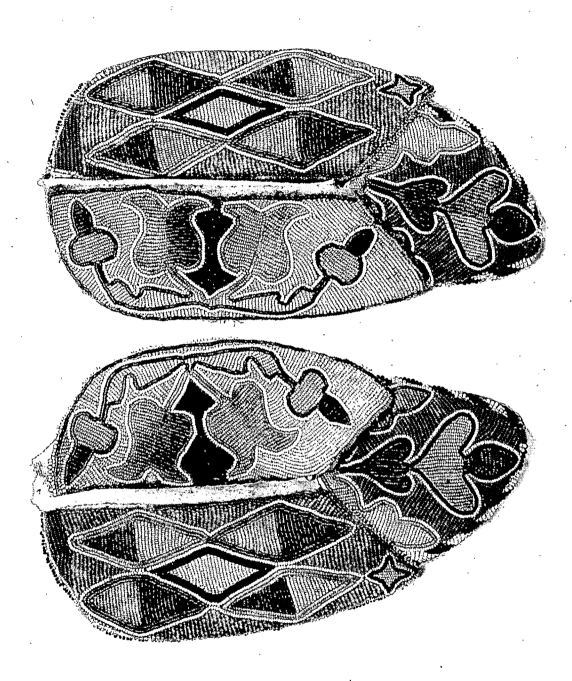

WHY ARTISTIC PRODUCTION?

Two basic facts seem to be in opposition to one another. One is that in a comfortable environment, man tends to become indolent; and the other is that he almost universally wants to decorate everything he uses. What form of motivation would prompt a lazy man to make the extra effort of carving an anthropomorphic figure on the lip of his wooden bowl when it would certainly be easier and simpler to carve a plain round bowl? Or what would prompt a Sioux woman to spend the countless hours necessary to completely bead her leather dress, when the dress without the beadwork would be just as functional and a good deal more comfortable? It seems always to be a matter of motivation which varies from one society to another.

As stated earlier of the Pueblo people, a common form of motivation stems from religious activity. Almost everywhere in North American cultures an article used in prayer or ritual is made with extra special attention to detail and is decorated more lavishly than a similar article intended for everyday use. There is a marked contrast, for example, between the plain smoking pipes made and used for everyday pleasure and the elaborately decorated ones produced to be included in a sacred bundle. Of course, many of the finest pieces of American Indian production were made strictly for sacred use, and had no counterpart in secular activities. This is true of all of the masks and fetishes produced by the Pueblos, the wooden dolls of the Woodland area, the sand painting of the Navaho, the masks of the Apache, Delaware, and Iroquois, and the spirit figures carved by the people around Puget Sound. The painted shields of the Plains Indians, which offered protection more magical than real, were inspired by dreams obtained during a religious quest for visions. Similarly the masks and rattles used by *shamans* among the Tlingit and Tsimshian are generally more forceful in their emotional impact than similar items designed for *potlatch* use.

Vanity and prestige are quite common forms of motivation for artistic excellence. Pueblo potters will sometimes vie with one another to see who

can produce the thinnest, best-shaped, and the finest painted pottery. Likewise basket makers, bead workers, and silver workers will all take competitive pride in their ability to do fine work. Craft workers are sometimes also conscious of the volume of their production and will often brag about the quantity of baskets they have woven or the number of hides they have quilled.

Among some Plains groups, such as the Sioux, vanity takes the form of trying to outdo others. If a man wishes to compete with a neighbor who owns a pair of fully beaded moccasins, he can have his wife bead his moccasins on the soles as well as the tops. A woman can bead her dress all the way to the bottom edge instead of only on the yoke. This aspect of being dressed in garments more lavishly decorated, and decorated with more expensive or rarer materials than those of others is very similar to the same phenomenon in our own society where platinum and mink are status symbols.

Decoration for prestige is also a common element of Northwest Coast culture. Here families vied with one another to gain family heraldic crests, and adorned everything they owned, from their homes to their eating utensils and clothing, with crest animals. Likewise, on the Northwest Coast the people labored to accumulate wealth in the form of carvings, blankets, food, and other valuable material in order to obtain prestige by giving them all away in the famous *potlatch* ceremonies. Here the importance of gift-giving coupled with a great deal of leisure time combined to create a highly productive society.

Often the motivation for artistic production comes from various aspects of society that have special significance for the individual. In the Plains area, where hunting and warfare were such an important part of everyday living, tools were often made with more than ordinary attention to detail. There also existed in the Plains a series of secular men's societies with special ritual costumes and equipment which were often elaborately decorated.

Another fact, almost universal among American Indians, is the desire to show their love for children. Relatives went to great lengths to lavishly decorate a child's first cradle board.

Some forms of artistic production seem to be made with no thought in mind other than having a beautifully decorated item rather than a plain one. This category includes painted Pueblo pottery, decorated baskets, reed mats, and yarn bags from the Woodland area, and in general, secular util-

itarian articles such as awls, heddle frames, and Cowichan-type spindles and weaving frames.

The pictographic painting on skins, so common on the Plains, is a form of bragging in that it usually depicted the war exploits of the artist. These exploits were often painted on robes and on the outside and inner linings of tents. Generally the tents and linings were painted by more than one individual so that, in essence, the artist got a free billboard and the tent owner got a free mural. Needless to say, each warrior was more than eager to accept an invitation to help paint a new lodge or lining.

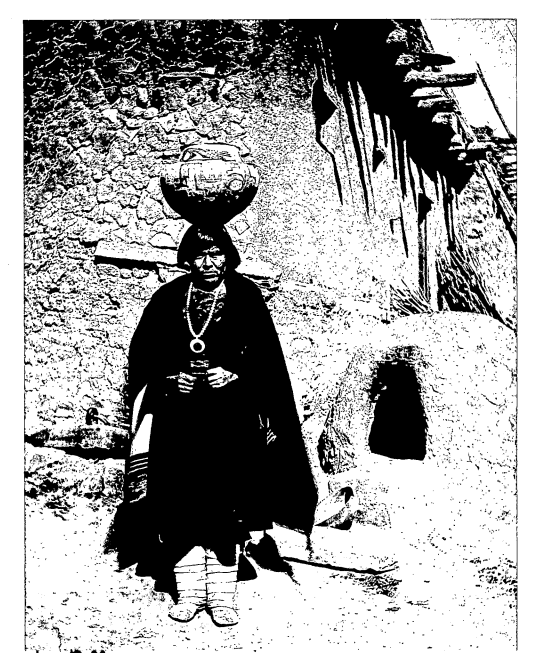

4. Zuñi woman water carrier in buckskin boots and native manufactured textiles. Note the adobe bake oven to the right.

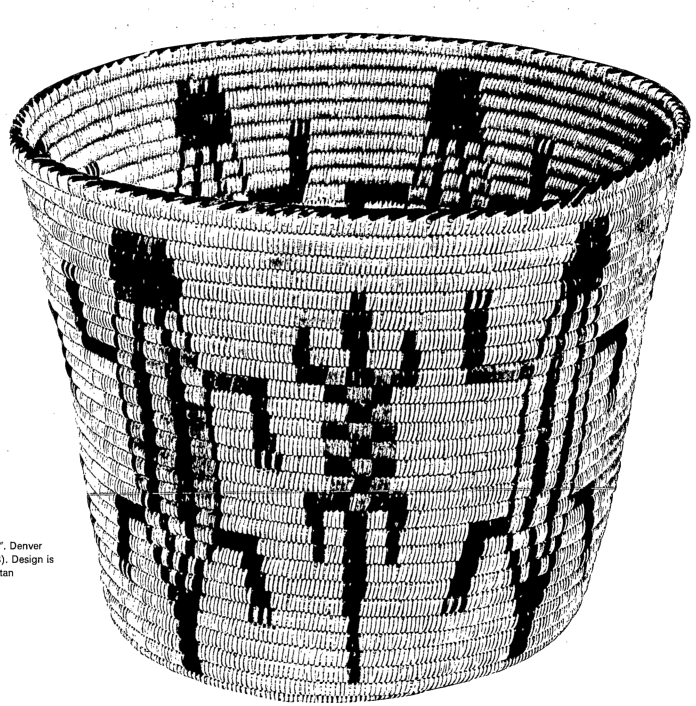

5. Basket. Pima. Diameter 11″. Denver Art Museum (Cat. No. YP–78). Design is in red and black on a natural tan background.

CHANGE VERSUS STABILITY

Almost everywhere, American Indians were firmly confined within the conventional artistic limits imposed by their particular society. The individual artist was usually allowed very little freedom of expression, though the degree varied from tribe to tribe. Objects connected with religion were usually more conventionalized than secular items, so that various examples of the Hemis *kachina* mask made by the Hopi look very much the same regardless of who made them. A few minor changes resulted from the introduction of new, better, or more colorful materials. However, while a newer paint pigment might be substituted for an older, native one, the painted area and design usually remained the same.[5] Major changes in style or material were infrequent and often the result of more or less accidental influences. Examples of such innovations were the black pottery developed by Maria Martinez at San Ildefonso, or the Haida carvings in argillite. But these were unusual developments.[6]

Several of the different factors which caused a gradual series of changes in American Indian art have already been discussed. They include the role of intertribal trade as a factor in spreading tribal art styles (definitely one of the major causes of radical changes), the introduction of new materials, and the adaptation of European patterns and designs into Indian crafts. Such adaptations as silver brooches, hair plates, and earrings were introduced first as gifts and were later copied by the Indians themselves. Probably at first the Indians copied these non-Indian examples in as minute detail as their tools would allow, but a gradual process of experimentation with new forms, and new techniques for applying designs ultimately developed to the point where each tribe had formed some unique stylistic formula. The "chip carving-like" effect produced by filing with a metal file, used by the Winnebago on their metal bracelets, is an outstanding example of technique and design style of Indian invention applied to a basically non-Indian product.

There is still controversy among students of Indian material culture

CONCORD HIGH SCHOOL MEDIA CENTER
59117 SCHOOL DRIVE
ELKHART, INDIANA 46514

about the origin of such traits as, for example, the floral designs used in much Woodland beadwork. Are these copies of embroideries taught in French mission schools, or did the Indian receive his inspiration for floral designs from seeing European garments so decorated? To state it another way, it is possible that entire design concepts were introduced by Europeans and readily accepted by Indians over a wide area. Also, the origin of the shape of the Indian crooked knives is a debatable point, and so is the question of whether the technique for making finger-woven yarn sashes in a multiple braiding is aboriginal or introduced. Some of these problems will never be resolved, but it is certain that introduced materials and designs had a tremendous impact on aboriginal crafts.

One common cause of radical change occurs with the development of a new religion. Among American Indian groups a new religion usually started with an individual having a dream-revelation in which he received full instructions concerning ritual and the religious equipment necessary to it. The ritual and equipment might often be based on some older form, but were frequently complete innovations. Such new religions have created objects like the Ghost Dance painted shirts, the specific form of decoration on Dream Dance drums, the Tree Dweller dolls of the Eastern Sioux, and the distinctive form of Kickapoo prayer sticks.

Often a dream-revelation was an individual experience which dictated the design a man painted on his shield, the ornaments he chose to wear in his hair, or the way in which he painted his face. Sometimes these designs were perpetuated by gift or purchase, especially if their magical power proved effective. However, they were as frequently discarded upon the death of the originator.

We have mentioned that, in general, items connected with religion became the most standardized and least subject to change within the originating tribe. However, when a given piece of religious equipment passed from one tribe to another it almost always suffered a series of changes which were often radical. In fact, an object which was sacred in the originating tribe was often secularized within the borrowing tribe. One example which will make this clear is the spread of *tablita* dances from the Rio Grande Pueblos to the Hopi. Among Rio Grande groups, during a dance variously called the Corn or the Harvest Dance, the women wear very simple and small *tablitas* (small board headdresses), the form and shape of which have

probably not changed materially for at least a hundred years. However, when a similar dance was introduced to the Hopi as the Butterfly Dance, they began an elaboration of the basic *tablita* form into large and involved shapes with ample painting in polychrome. These are still being produced in elaborate forms, and individual makers have a tremendous amount of freedom in design. This presents a marked contrast to the rigid conventions followed by the Hopi in making their sacred *kachina* masks, or among Rio Grande *tablita* makers. Needless to say, among the Hopi the Butterfly Dance is considered more secular than sacred.

Change also occurs quite frequently with the breakdown of old established religions and military societies. Suddenly items which were once sacred become secular, and their forms become more subject to alteration. Dream Dance drums, which are considered highly sacred by tribal groups practicing the Drum religion, are used as powwow drums or even coffee tables by groups which no longer practice this religion. Standardized ritual equipment and costumes of a particular military society are altered and used indiscriminately by anyone after the society breaks down. This occurred frequently throughout the Plains after the Indians were placed on reservations, and the opportunity for warfare was no longer present. As the military societies became obsolete, their ritual equipment was stored away in old trunks. Years later, with the reintroduction of the Grass Dance and the popularity of the intertribal powwow, youngsters wanting to dance would rummage through grandfather's trunk for anything which they might wear as a dancing costume. Of course, they found old society regalia and, not knowing the significance of these items, wore them for their Grass dancing. Others seeing these old items being worn, copied them in slightly altered form, and as a result, new styles were developed.

In the Oklahoma area and elsewhere, a special phenomenon known as Pan-Indianism[7] has developed. Here many different tribes were placed on reservations in proximity to one another, and a blending and borrowing of tribal styles evolved to the point where most groups completely lost their individuality. Today in Oklahoma, instead of distinct Ponca, Oto, Osage, Pawnee, Cheyenne, and Kiowa styles, there is one common Oklahoma style with only occasional tribal differences still visible. This blending is particularly evident among the male population. American Indian women are almost universally more conservative than the men, and it is still possible,

even in Oklahoma, to identify a woman's tribe by some distinctive article of her dress. Often the women continue to wear a particular tribal style of moccasins, or the cut of their blouses remains unchanged. Some women seem to take a certain amount of pride in their conservatism of dress, but some styles of women's clothing are worn for their prestige value in preference to the older tribal styles. In Oklahoma, for example, women of any tribe will wear the buckskin beaded dresses in Cheyenne style if they can possibly obtain them. This dress has become the standard Pan-Indian powwow style because it is made of Indian tanned buckskin which is hard to obtain, and because it has a considerable amount of beaded decoration which makes it comparatively expensive. Rarity and high cost have made this dress a symbol of prestige.

To sum up, it is fairly safe to state that change is a continual but slow process interrupted only very rarely by a radical innovation. For example, in comparing Sioux Indian pipe bags manufactured in 1850 with pipe bags made in 1900 and 1950 respectively, one can see considerable variations in decorative designs, techniques, and materials. However, the basic form of the bag remains much the same throughout all of this hundred-year period. A comparison of Sioux pipe bags manufactured over a segment of this period—say in 1900, 1905, and 1910—would show hardly any major alterations whatever, although some slight variations would probably be present.

Colorplate **2.** Painted stone fetish. Zia ⟶
Pueblo. 7 7/8 x 3 1/2″. Denver Art
Museum (Cat. No. QZ–1)

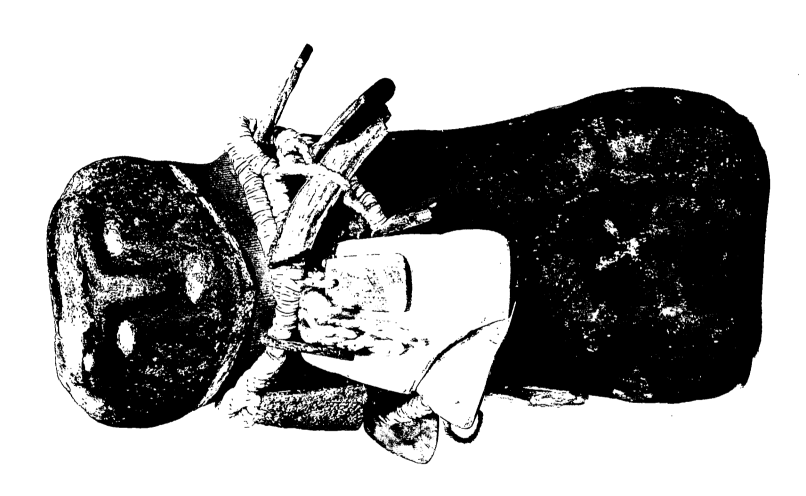

THE INDIAN ARTIST

Among American Indians, specialization of labor was the exception rather than the rule, and each family was generally a self-sufficient unit. At times, particular large-scale undertakings, such as the Plains Indian buffalo drives, or the Pueblo cleaning of the irrigation ditches, called for community effort. But if isolated from the rest of their community, a husband and wife team could produce for themselves almost everything necessary for their survival. The outstanding exception was the specialization of some select individuals in the healing arts; however, even these doctors, *shamans*, or medicine men still had to be self-sufficient since the fees for their services were rarely enough to support them adequately.

There was usually a division of craftwork by sex. In areas where hunting constituted a major part of the economy, the males concentrated on producing equipment for the hunt, and a major portion of their time was spent in the chase. In these groups, most of the other necessary household crafts fell to the females. For example, in most of the Plains area, the men made bows and arrows, some horse gear, shields, and charms connected with warfare, and a limited amount of religious equipment. At the same time, the women made the domestic equipment, clothing, utensils (such as *parfleche* containers), and carried out all the beading and quilling for decoration on garments and ceremonial items.

Among the Pueblo groups which depended on agriculture, the men were the farmers. Hunting was still men's work, but it was such a secondary part of the economy that it occupied little of their time. The men, therefore, also practiced such crafts as weaving which was often the work of women in other societies. The women in Pueblo groups made pottery, basketwork, and carried out general domestic chores.

The upper Missouri earth-lodge people, and most Woodland groups, had an economy about equally divided between agriculture and the hunt, and among them the women were the farmers and the men the hunters. In

a few areas some forms of specialization did occur. Perhaps the most notable was in the Northwest Coast where certain individuals were famous for their skill as wood-carvers and were commissioned to make important carvings.

While it is generally true that all Pueblo women could and did make pottery, or that all Plains men could make bows and arrows, or that all Sioux women could decorate a pair of moccasins with beadwork, it was also an accepted fact that—without being actual specialists—certain individuals were known for their exceptional ability in a specific craft. Thus some men, noted for their skill in chipping arrowpoints, would often produce more points than they needed for their own use, and would then barter their surplus to a ready market. Almost everywhere fine craftsmanship was recognized by the population at large, and skilled artisans gained prestige through their labors. This was perhaps carried to an extreme among the Cheyenne where a special women's society was organized solely to produce sacred items. This Guild of Southern Cheyenne Women[8] had an organization in many respects parallel to that of men's military societies. The women recognized as the best bead workers within the tribe would meet together to make tepees, tepee linings, pillows, and bed sheets all in a standard form. Various members of the guild would proudly recount the number of linings they had beaded, much in the way a man would recount his war exploits.

Specialization was also connected with non-essential crafts. Only a few individuals within each tribe became proficient in the production of silver ornaments, and they were easily able to produce enough to satisfy the demands of their entire tribe. This same sort of specialization is common today, but with items, once essential, which have since been replaced with articles of non-Indian manufacture. While it was once important for every woman to be able to make moccasins for her family, her family now wears commercially manufactured shoes for normal wear. Traditional Indian moccasins are still worn to a limited extent during some religious observances and at intertribal powwows but, on a day-to-day basis, the demand is not on the great scale of the past. Therefore, only a few women, recognized as experts, still manufacture moccasins to supply the limited demand. The same can be said for most items of traditional Indian craft which are still in limited use; only a comparatively few women have the knowledge and willingness to tan hides, to decorate with porcupine quillwork, to make a *parfleche*, or to weave a basket.

COMMERCIALIZATION VERSUS DECADENCE

Almost from the time of first European contact, it was the habit of travelers visiting Indian groups to collect souvenirs as mementos of their trips. The Indians were quick to realize the commercial potentialities of this tourist trade and very soon started making articles specifically for this purpose. Initially there was little difference in the quality or materials of these pieces, since they were made following old traditions. Most Indians, however, soon realized that the travelers were willing to accept inferior materials, and that they often preferred novelties which could be simply and inexpensively produced.

If decadence is involved in commercialization, it is largely induced by the taste of the customer. This decadence soon set in, and is still going on today. There are, for example, several very capable bead workers among the Prairie Potawatomi tribe in Kansas, women who are perfectly capable of producing duplicates of the finest shirts and moccasins of a bygone era. In practice they insist upon making little gewgaw earrings, dolls, and lapel pins because they have found from experience that these will sell to tourists as shirts and moccasins in the traditional form will not. The same can be said of the Pueblo craftsmen who still sit on the streets in front of the Palace of Governors in Santa Fé, and who formerly waited at the train stations to sell pottery and jewelry to tourists. At first the artifacts they sold were identical with those made for their own use; but they also found that tourists preferred tiny pieces of pottery which they could transport more easily, and did not care if the jewelry was inferior so long as it was less expensive. The very same craftsmen who produce "junk" pottery and jewelry for tourists are usually fully capable of producing fine work; and they do so on occasion for their own use, or when making gifts for friends or relatives. It is extremely rare today to find a craftsman who, whatever his skill, retains the old pride of craftsmanship to the extent that he refuses to turn out an inferior piece even for sale to tourists.

On the Pine Ridge and Rosebud reservations in South Dakota a few exceptional women continue to make fine beaded and quilled items. Their pipe bags have beading sewn with sinew beads on Indian tanned buckskins, and their quilled fringes are done in the same technique that was popular one hundred fifty years ago. However, when one of them makes a pipe bag for her husband or a relative it will be decorated in an elaborated design with the brightest colored beads available, and the quills will be dyed with modern aniline dyes. The resultant product will not be very pleasing to someone familiar with older work, but in the maker's eyes it will be far superior to the older style with its dull colors and simple designs. To the Indian this is progress, and it would be as foolish to expect an Indian woman to continue making items in the style of fifty years ago as it would be to ask a non-Indian woman to wear clothing patterned after her grandmother's.

Private collectors of Indian material have always prided themselves on acquiring only "old" material manufactured by Indians. This sense of antiquity has led to some curious anomalies. Many persons will not buy an item that is not sewn with sinew, but few realize that in parts of the East, commercial threads were used at least as early as 1750. Today, in American museums there are very few examples of cloth apparel from the pre-1850 period made by Eastern Indians, even though this apparel was common in that era. This lacuna is largely due to the fact that the collectors in the mid-nineteenth century were only interested in obtaining older, "more aboriginal" examples of clothing rather than contemporary production. This short-sighted attitude persists. Today few collectors or even museums are making a conscientious effort to collect modern crafts. Most despise the brightly colored fluff feathers used on dance bustles, and the gaudy sequin-covered capes and aprons. However, these same collectors would readily add to their collections pre-1850 cloth apparel which was considered gaudy, and which was all but ignored by the collector of that period. In the same vein, collectors of the 1850 period would not acquire pipe tomahawks because these were manufactured by non-Indians for Indian use. Today, of course, these same tomahawks are highly valued.

Still other collectors pride themselves on assembling only items made by Indians for their own use, rather than souvenir or tourist material. However, they will gladly purchase any example of Haida carving in argillite even though every known piece was made for the tourist trade. In all prob-

ability, the pipestone novelties sold in the 1830s at the Falls of St. Anthony (near the present-day city of Minneapolis, Minnesota) were considered decadent at the time, but these same novelties are today considered fine works of art, worthy of any collection.

In short, then, there is still little understanding, or concensus of opinion as to what constitutes good Indian art, or good Indian taste, or even what is or is not decadent.

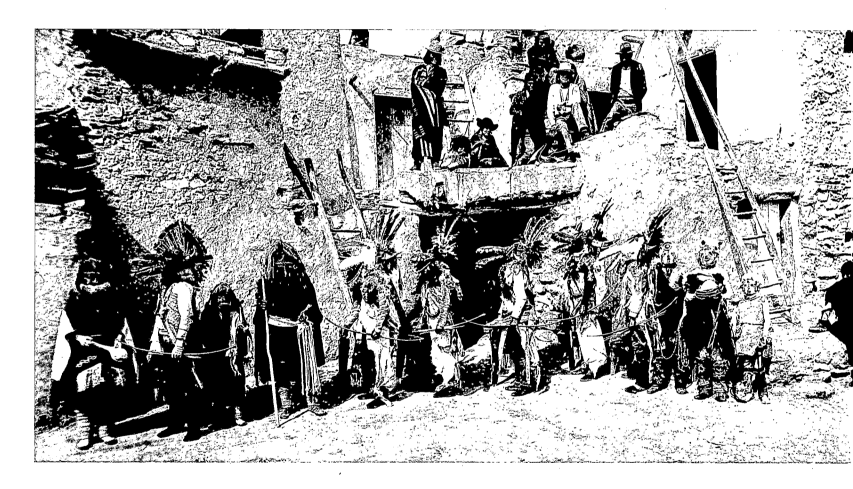

6. Hopi Natashka *kachina* dancers.
Photographed at Walpi by James Mooney
in 1893.

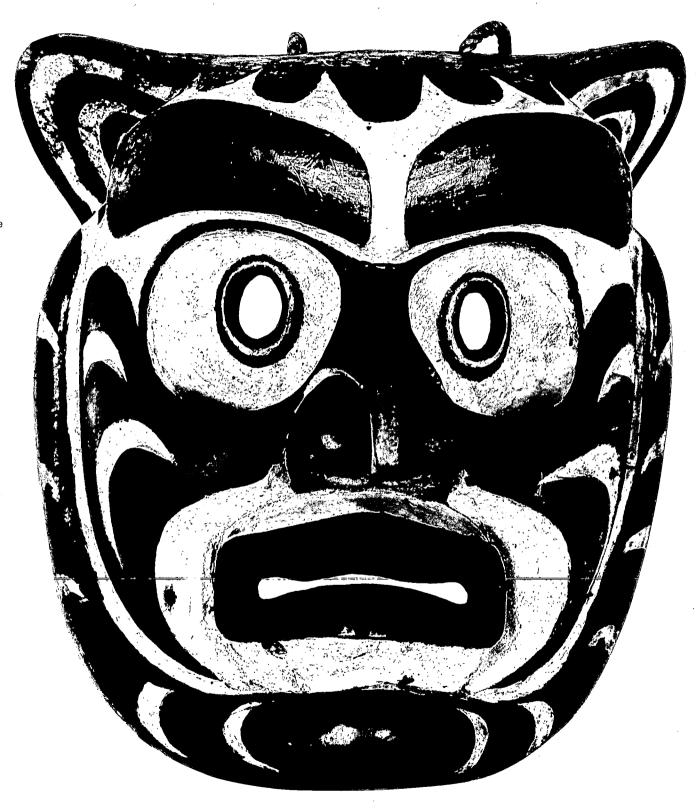

7. Face mask. Bella Bella. National Museum of Canada, Ottawa (Cat. No. VII–EE–33). Represents the Wild Man of the Woods.

FUTURE PROSPECTS

It is somewhat surprising to find that today, nearly five hundred years after the arrival of Columbus, there is still a considerable amount of Indian artistic activity. Of course, some old forms are now extinct. Not a single northern California Indian remembers the technique of making spoons out of elk antlers, and nowhere is buckskin dyed black for clothing. In general, the skills which have survived are those which have had some important use within Indian culture. Costumes are still being made and worn by many Plains Indians at powwows, and sometimes for religious observances; Pueblo peoples still make pottery and weave dresses, kilts, and sashes for *kachina* costumes; Iroquois still carve their wooden "false face" masks, and members of the Native American Church still produce their Peyote fans, staffs, and rattles. But many of these arts are themselves in decline.

Today, fewer and fewer Indians participate in the Pan-Indian, tribal or intertribal powwow, and the old religions (with the possible exception of the Native American Church) are slowly losing members. It is only a matter of time before the need for many of the existing arts disappears, and of course without the need the arts too will vanish. However, as often as old forms disappear, new forms develop to take their place. The objects produced for use in the Peyote religion are an example of an artistic revival following a religious revival. A certain amount of new production will continue to supply the tourist trade as long as a demand exists. The silver jewelry produced in the Southwest will undoubtedly be made for a long time to come.

The independent Indian trader is an important stimulus toward continued production. Here is an individual whose livelihood depends upon Indians making marketable work. The trader has done an amazing job in encouraging Indians to maintain standards of excellence. Traders have publicized Indian art, and created a market for it. Had it not been for these men, it is likely that many types of work would by now have completely disappeared or would exist only in a badly deteriorated form. As it is, traders

have helped certain styles to survive; for instance, among the Southern Cheyenne, Mr. Reese Kincaid of the Mohonk Lodge insisted that the workers use only sinew for sewing and only traditional Cheyenne designs. Even more, the effect of the traders' efforts has been efficacious in the Southwest, with the marketing of Navaho textiles and jewelry.

The Indian Arts and Crafts Board, a branch of the Department of the Interior, has also assisted Indians who were so inclined to supplement their incomes with craft production. The Board maintains museums and sales stores in several localities, and continually strives to promote better work and better markets.

Nevertheless, in spite of all these efforts, traditional Indian art seems doomed eventually to disappear. Perhaps the process can best be explained by contemplating the history of one particular object, the Plains Indian shield. Elaborately painted and decorated shields were made by most Plains Indians as an important part of their war regalia in the period before they were relocated on reservations. As stated earlier, the design was often dream-inspired, or purchased from a warrior of proven ability. The shield itself was usually made of heavy raw bison skin, and protected with one or more buckskin covers. The covers were then painted, and feathers or other charms chosen for their magical significance were attached. The power of these shields was always more magical than real: although some would stop an arrow, none would stop a bullet.

Shields became a popular item with collectors and almost all of the old decorated shields were soon sold by the Indians, who no longer had any need for them. But—to phrase what happened as a case history—the Indian on the reservation who had sold his shield continued to be bothered by collectors wanting to buy a shield. Remembering how his old one was made, he attempted to make a copy. However, usually he had to substitute a steer hide for bison hide and the pigments available to him were considerably different from those used on his original shield. Nevertheless, this second shield, when completed, was made according to the old techniques and bore a traditional design. Still later, the Indian discovered that a collector was mainly interested in the painted outer cover. In making a further replica, he eliminated the heavy rawhide inner shield; the third version, then, consisted of a buckskin cover nicely painted, but stretched on a wooden hoop. At a further stage still, the fourth shield was a copy of the third, but of canvas instead of buck-

skin because Indian tanned skins had by this time become a rare and costly commodity. The final version of the shield was simply a round disc cut out of masonite and painted with commercial house paints. This was quite a change from the original form, but all of the forms mentioned above can be commonly found in dealers' stores, and were often made by Indians.

Of course, the change from the bison rawhide shield to a masonite disc took a period of several generations to complete. The modern Indian making a masonite shield may often try to copy the old styles, but without much knowledge of just what the old styles were. He no longer has examples on the reservation for reference, and rarely does he visit the local museums to do adequate research. However, even if he were to take the time to examine several specimens in museums, the old materials would not be available, the old techniques have been forgotten, and in any case his taste is considerably different from his grandfather's.

The point is that when a craft worker tries only to copy old forms the result is rarely equal to the original specimen. The future of the Indian arts lies not in a slavish copying of old forms, but rather in developing new forms based on old traditions. In this development of new traditions we are far behind countries—such as Nigeria—where artists are producing exciting contemporary work without losing sight of indigenous older traditions. Some efforts have been made among American Indians, such as the inception of watercolor painting about 1930, but here again there has been little subsequent development.

The romanticist's and the purist's views have always led to a deploring of the fact that American Indian art has been undergoing a slow process of change; and very often change is simply equated with decadence. It should be understood that, even in precontact times, Indians were continually striving for new materials and new techniques, particularly for producing clothing and ornaments which would be more showy. Hence, there was a ready acceptance of European materials as being far superior to Indian materials. This acceptance has gradually led to the development of new forms and, of course, as new forms develop the older forms disappear.

The unrealistic romanticist would love to see American Indians living today much as they were one hundred or two hundred years ago. He would love to preserve the picture of the American Indian as "a noble child of nature." However, whenever two culturally different types of people are

57

forced to live in proximity, an eventual blending of the two cultures occurs. This produces a distinct new culture which often embodies the best facets of both of the original cultures. In the almost five hundred years since first white contact, the pattern toward assimilation has been firmly molded: it may take a long period, but complete assimilation will occur. Indian culture has contributed much to white culture ultimately in the form of foods, local place names, and art. We will never forget the place of the American Indian in the history of the development of the United States; we will continue to have books written on Indian subjects; and Indian art treasures will always be on display in American museums.

Colorplate **3**. Bear mask. Haida(?). Carnegie Museum, Pittsburgh. Fred Harvey Collection (Cat. No. 3178/28)

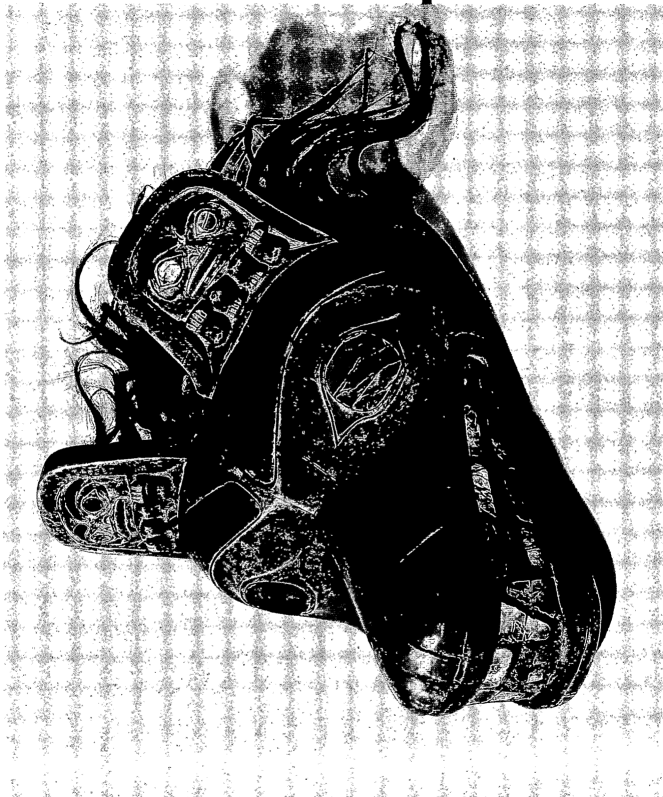

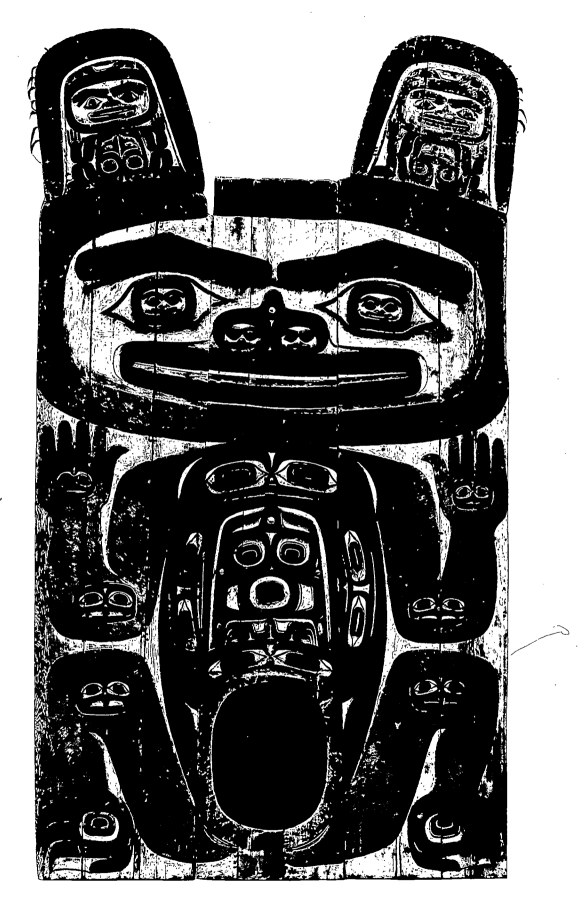

8. House partition screen. Tlingit. Height 15'. Denver Art Museum (Cat. No. QTI–41). The famous bear screen, once the property of Chief Shakes of Wrangell, Alaska.

The Plains

THE PLAINS

The Plains comprises the territory from the Rocky Mountains to the Mississippi Valley and from Texas and Oklahoma north into Canada. The inhabitants depended mainly upon the bison for food, clothing, shelter, and other necessities of life, though in parts of the Plains some agriculture was practiced and bison hunting became a seasonal activity. These Plains people are the ones most commonly thought of as being "typically Indian" in that they were the warriors who fought Custer, wore feather bonnets, and lived in skin tepees (plate 1). Elaborately decorated skin clothing was common but, in general, material possessions were few because of the nomadic existence necessitated by following the bison herds.

The Plains culture pattern was dependent upon the horse for its development. Prior to the introduction of this animal, the Plains area was only sparsely settled by semi-sedentary groups that practiced some agriculture in addition to sporadic hunting. Horses, of course, were introduced by Europeans, most probably the early Spanish explorers in the Southwest. The horse gave the Indian in this area the mobility needed to hunt the bison successfully, and to transport his tent and personal belongings. The other salient features of Plains culture are the importance of warfare, which was the accepted method of gaining prestige, and the annual religious ceremony known as the Sun Dance.

From an artistic standpoint the Plains is not a homogeneous area. Certain traits are common throughout the entire region, but even these are generally stylistically distinguishable. For example, most Plains tribes produce skin garments and horse trappings elaborately decorated with bead or porcupine quill embroidery, but each tribe that does so uses distinct designs and techniques. Likewise most Plains groups produce the painted rawhide containers known as *parfleches*, painted shields, painted tepees, robes, and tepee linings with pictographic designs, carved stone pipes, feather bonnets, and some metalwork. Certain other crafts such as ribbon appliqué for dec-

oration, carved wooden bowls and war clubs, and yarn bags and belts are only found in parts of the area.

During the first half of the nineteenth century, most of the Plains area was uninhabited by Europeans, and as a result very little pre-1850 Plains material is now extant. Hence little is known about early Plains styles. The earliest collectors in the Plains area included Prince Maximilian and George Catlin, both in the 1830s. Other small collections were made by military expeditions such as those of Lewis and Clark, and Nathan Sturges Jarvis at Fort Snelling. These people all collected mainly on the eastern fringes of the Plains area, and used the Mississippi or the Missouri rivers as the main routes for their travel. Catlin actually made a trip into the Southern Plains area, but unfortunately was ill most of the while. As a result we have almost no documented early material from the Southern Plains, and very little from the Central Plains.

The early Plains material which has survived seems to indicate that even in the pre-1850 period Plains people were prone to elaborate decoration of garments with beads or quills, with a considerable use of split bird quills instead of the more usual porcupine quills. Bird quillwork is not adequately described in the literature, and just what species was utilized is not known. A limited amount of work in bird quills was still being produced in the Fort Berthold area as late as 1900, but this now seems obsolete in the Plains. Only a few Northern Athabascans in Canada and some Eskimo continue to use a limited amount of bird quills for decoration.

Another characteristic of early Plains quillwork is the substitution of the stems of the maidenhair fern (*Adiantum*) for porcupine quill whenever black was desired. Evidently Indians west of the Mississippi did not know the secret of how to dye quills black until after contact with the white man, although Eastern Indians used black dyed quills in place of maidenhair fern stems. It is, therefore, fairly easy to determine if a piece of pre-1850 quillwork is from the Plains or the Woodland area. In general, Plains people used only the natural white, yellow, orange red, and dark brown maidenhair fern stems in their quillwork, while Eastern Indians were able to obtain bright reds and blacks (plate 9).

Early in the nineteenth century, the fur traders introduced wool cloth, called "stroud," in both red and blue, and these colors were often transferred to quills by boiling the quills and pieces of cloth together. Occasionally a

64

purple could be made by combining the red and blue, and sometimes a weak green was obtained by combining the blue cloth dye with a natural yellow usually obtained from bloodroot (*Sanguinaria canadensis*). Whenever green is found in early Plains quillwork it is safe to presume that the quill is probably bird and not porcupine; the pithy inside of the bird quill was usually left intact in splitting the quill for use and this substance took a dye more readily than the hard surfaced porcupine quill. A Cheyenne specialty, right up to the modern period, was the substitution of various grasses and, later, of corn husk for porcupine quills. Very little documented early porcupine quillwork came from the Northern Plains, and I do not know of a single early documented specimen from the Southern Plains. Porcupine quillwork decoration on buckskin, then, seems to have been confined to the groups along the upper Missouri and into the Central Plains area and may very well be the westward extension of an Eastern craft.

In the early part of the nineteenth century, beads were introduced into the Plains, and—although some quillwork has continued up to the present— beadwork soon began gradually to replace the older tradition. Early beads were fairly large, of a type known as "pony beads," and were mostly white, black, and blue, so that early Plains beadwork is characterized by bold designs in blue and white or black and white (plate 11). A major reason for the great use of these three colors is their relative cheapness to produce which therefore afforded a greater margin of profit to the traders who carried them. Right up to the present day, with our improved methods of coloring glass, it is still more costly to produce beads in reds and yellows, while black and white remain the least expensive of all.

The smaller glass beads known as "seed beads" were in use in the Western Plains as early as 1830, and probably by that date the Western Plains Indians were in a position to obtain any of the usual trade items available to Eastern Indians of the period. When Astor withdrew from the fur trade in 1834, a host of independent traders entered the field and established a chain of trading posts all along the eastern foot of the Rockies. Keen competition must have forced these independent traders to stock a wide variety of goods.

When we consider the period after 1850, we are on much surer ground because of the vast bulk of artifacts collected and still in existence. Warfare between Indians and United States troops was at its peak during this period;

CONCORD HIGH SCHOOL MEDIA CENTER
59117 SCHOOL DRIVE
ELKHART, INDIANA 46514

soldiers often took souvenirs of battles, many of which are now on deposit with the United States National Museum (Smithsonian Institution) in Washington, D.C. By the late 1860s most of the Plains Indians were placed on reservations—a course which, while altering their way of life—also made Plains material plentiful for the collector. A careful analysis of this material reveals distinct styles and influences in many directions, both into and out of the Plains area.

The groups of the Central Plains, Sioux, Cheyenne, and Arapaho are considered most typical of the Plains area. They all produce quantities of beaded articles. The beads are sewn in the lazy-stitch and geometric designs.

The Sioux living in North and South Dakota are particularly fond of covering large areas with bead or quillwork, usually in not more than four or five different colors. The designs are often developed by combining triangles and straight lines. In contrast, the Crow of southern Montana use an overlay sewing technique. Their designs are very similar to, and perhaps derived from, those painted on their *parfleches*. These people are fond of using as many colors as possible—up to twenty or so—on a single item, and of having them all blend into a pleasing design. Still another characteristic of Crow beadwork is the technique of outlining a central design motif in white beads running in a different direction from the rows of background beadwork (colorplate 7). This style is not found among the Blackfeet, the northern neighbors of the Crow, or among the Sioux to the south; however, it has a wide distribution to the west and southwest from the Crow center. The Nez Percé in Idaho seem to have copied the Crow style with the greatest fidelity, and much Nez Percé beadwork is indistinguishable from that of the Crow (colorplate 8). Other typical Plateau groups such as the Yakima, Umatilla, and Walla Walla seem to have borrowed the style from the Nez Percé. From the Southwest come occasional examples of beadwork produced by the Shoshone and Ute (plate 13), which bear a strong resemblance to the Crow style and were undoubtedly derived from it.

The Northern Plains, comprised of portions of northern North Dakota, Montana, and parts of southern Canada, evolved still another distinct substyle. Here the beadwork is in bold geometric designs with the beads applied in an overlay stitch in straight lines. There is a tendency to develop all the lines by using small solid rectangles joined from corner to corner. Most of the Northern Plains work is limited to four or five colors. The Blackfeet

66

tribe is probably the center of this style today, but it may have originated, at some time in the past, through influences from the upper Missouri River tribes. The style extends among the Assiniboin and Montana Gros Ventre, the Yanktonai, and in slightly modified form, among the Sarcee and Plains Cree.

It might be well to mention here that another different and distinct style is also popular in the same area, in the form of an overlay beadwork in a floral motif. This style, introduced sometime before 1900, was widely distributed all across the Northern Plains, even reaching the Sioux and Crow. It certainly had its origin in the eastern area, and probably spread west across the Northern Plains with Plains Cree and Plains Ojibwa peoples. These two numerous tribes were great travelers, and probably carried the style clear up into the interior Athabascan tribes of Alaska. In Montana a group of these people settled on the Rocky Boy reservation near Havre, where they continue to influence neighboring tribes.

Another style is found in the Southern Plains area among the Kiowa, Comanche, and Southern Cheyenne tribes. Here bead decoration takes the form of light, delicate bead trim in contrast to the large bead-covered areas employed in the north. Shirts and leggings from this region usually lack the fully beaded strips on sleeves, shoulders, and down each legging. Women's dresses generally have only a simple band across the shoulders; the Cheyenne add an additional band on the front and back. These designs are normally simple geometric units done with only one row of the lazy-stitch on men's garments and with few colors—much like an overly simplified Sioux style. Moccasins, however, are normally fully beaded by the Cheyenne and sometimes by the Kiowa as well (plate 14). As a replacement for the elaborate beading, buckskin is often painted in yellow, blue, and green by the Kiowa and Comanche, and in red and yellow by the Cheyenne. In addition, Kiowa and Comanche often cut long, and sometimes twisted, fine skin fringes.

The Kiowa are also noted for two other distinct forms of bead decoration. One is the use of an abstract floral type element. It is difficult to define, but distinct from floral styles found elsewhere, and is usually carried out in an overlay bead sewing technique (plate 15). The other distinct form is a peculiar bead sewing stitch which is actually a form of bead netting. Formerly it was used by the Kiowa and Comanche to decorate moccasins, baby carriers, and beaded pouches. It is now known as the "gourd" stitch or the "peyote"

stitch because at present it is used by Indians everywhere to decorate the fans, staffs, and gourd rattles used in the Peyote ceremonies of the Native American Church (plate 16). These two styles may have been introduced to the Kiowa by displaced Delaware Indians from the East Coast. Delaware and some Shawnee had an abstract floral style much like that of the Kiowa, and both tribes used the gourd stitch in making garters and other ornaments. In addition, the Delaware were in the Texas area as early as 1820, when they came into contact with Kiowa as they still do today.

In the southwestern Plains live the Ute and Jicarilla Apache. The Ute were basically a mountain tribe which mainly lived by hunting deer and elk, and only seasonally ventured into the Plains proper in search of the bison. During the latter half of the nineteenth century, both tribes were pushed to the west side of the mountains by the pressure of Kiowa and Comanche raiding. They received some influence on their art from the Cheyenne who hunted in the same area, but much more must have come down through the mountains from the north, from the Crow through the intermediary, the Shoshone.

The Ute and Jicarilla both decorated their moccasins using typical Cheyenne designs; however, the Jicarilla cut their patterns in a unique way, with pointed toes and a slit down the instep. Some beading on pouches and horse trappings is very similar to the Crow style in having white-outlined overlay geometric designs in a variety of colors. In addition, these tribes developed a style that, while distinctively their own, is yet reminiscent of pre-1850 work from the Central Plains area. Working with the smaller seed beads, from about 1850 on, they produced leggings, shirt strips, and bands for women's dresses with massive triangular designs in two or three colors. Usually blue and white or black and white, the beadwork thus seems to be a continuation of the early widespread Plains style in pony beads (plate 18). A somewhat similar survival of this old massive, basic color style was found on parts of the Plateau as late as the early part of this century.

The Ute and Jicarilla, unlike most other Plains tribes, produced a type of coiled basketry very similar to that of some Paiute, Navaho, and Pueblo groups at Jemez. In short, these two tribes incorporated in their art elements from each of the many tribes with which they came into contact.

On the eastern fringes of the Plains are several other distinct groups. The upper Missouri River area is the home of the Mandan, Hidatsa, and

Arikara, three separate tribes which now reside on the Fort Berthold reservation in North Dakota. These tribes were semi-sedentary; they lived in earth-lodges for the major portion of each year, and hunted bison only seasonally. Living along the Missouri River, these people utilized simple round skin-covered boats called "bull boats." Generally they were farmers. Their combination of farming and earth-lodge dwelling was evidently the common pattern over most of the Plains in the prehorse period. They made a little basketry and pottery. They produced the usual beaded and quilled buckskin garments in the style of the Northern Plains people (plate 19). The designs used most closely resemble those of the neighboring Northern Plains groups to the west; however, a mixed style developed due to influences from related tribes. For example, the Hidatsa and Crow were at one time a single tribe which split up sometime before the historic period. They speak closely related languages, and frequently visit and intermarry. Partly as a result, the Hidatsa have adopted many Crow design motifs. Likewise, the Arikara and Pawnee at one time belonged to a single tribe, and even today they share much in common.

The so-called Prairie tribes, to the south of the upper Missouri, form still another distinct artistic area. These groups, however, are also not very homogeneous and they could easily be broken into smaller art areas. Basically they differ from other Plains tribes in the larger number of Woodland traits which they have adopted. They make twined yarn bags and finger-woven sashes in the Woodland style, utilize cloth apparel decorated with ribbon appliqué or beadwork in an abstract floral style, and wear soft-soled moccasins in contrast to the usual Plains hard-sole types.

These groups tend to replace the Sun Dance with the Grand Medicine Society of the Great Lakes area. The Pawnee tribe living in Nebraska seems to have developed a most complex religious organization which had a profound influence on all their neighbors. However, the Pawnee apparently did not contribute much in the way of artistic styles.

It is difficult at this late date to try to reconstruct the locations of style centers and to trace the diffusion of any particular style from its center. However, I believe that a style center developed in the early reservation period around the southeastern portion of Nebraska and northeastern part of Kansas. Here the Iowa and Sauk-and-Fox of the Nemaha reservation, combined with the neighboring Oto and Missouri, seem to have developed

a very rich form of decoration using the abstract floral beaded designs (plates 20, 21; colorplate 1). The Oto-Missouri were probably responsible for spreading this style to the Osage and Kaw as well as to the Omaha and Ponca. This same basic style was common among the Nebraska Winnebago and the Prairie Potawatomi in Kansas. Either or both could have played a large part in developing it. Certainly the basic idea of abstracting floral designs developed along the eastern part of the Kansas–Nebraska line, and the impetus must have come from an older floral style in the Great Lakes area. In all probability the Winnebago, Potawatomi, and Sauk-and-Fox brought a basic floral tradition with them when they moved to Kansas and Nebraska, and this changed upon contact with the Iowa and Oto-Missouri.

Painting, on a variety of objects, occupies a prominent place among Plains techniques. In precontact times, the Indians had only a limited range of natural pigments, including red and yellow ochers, a brown lignite, and perhaps a very limited amount of native blues and greens. Some of the oldest surviving painted buffalo hides seem to be done in brown only, with colorless glue sizing. The glue sizing lines did not show up at first on a freshly painted hide, but appeared white after the hide became dirty. At a very early date, a mercury vermilion from China was introduced by trade; consequently, hides from the first half of the nineteenth century were often painted in red, brown, and white (plate 23). Still later, with the introduction of other commercial pigments, hides were also painted in green, blue, and yellow.

There seems to be little difference between hides from the Central Plains and the upper Missouri areas. The standard designs were a sunburst of concentric circles made up of feather-like elements (often called the "black bonnet" design), and a box-and-border design (colorplates 12, 13). The sunburst type seems to have been worn by men, while the box-and-border was worn by women; however, both styles were painted only by women. The many variations on these two basic patterns probably indicate local styles (plate 24). Southern Plains peoples, Kiowa and Comanche, painted a design of an hourglass with border. Blackfeet often painted hides with simple horizontal stripes.[10] Very early hides show the use of a border with a complex design in the center, but unfortunately the tribes they came from have not been identified.

Painted shields are not easily assigned to areas because they vary considerably even within a single tribe. This of course was due to the fact that

the shield type and design had been dictated by a vision. Generally the form of a shield was cut from the thick skin on the neck of a bison and shrunk so as to become convex. Sometimes it was painted, but more often a soft buckskin painted cover was fitted over the rawhide. Occasionally, still a third layer was added: an undecorated cover to protect the painted one. The Crow Indians in particular seem to have produced large numbers of shields. These are usually about twenty-two inches in diameter, have a double covering, and the designs tend to show a single animal in profile, with rows of zigzags representing bullets (plate 28).[11] The Arapaho often painted a turtle on the shield cover (colorplate 16). Recognizing the difficulty of killing turtles, the Arapaho believed that they themselves would be similarly difficult to kill if they carried the turtle's image. A special type of Cheyenne shield has simple crosshatched lacing taking the place of the heavy rawhide; needless to say it would not stop any arrows, but was considered a form of magical protection. Kiowa and Comanche, along with some Pueblo tribes, made their shields by lacing together two layers of rawhide for double thicknesses and, supposedly, for double protection.

The Plains Indians practiced painting their war exploits in a simplified pictographic style. This was a male art, in contrast to the geometric painting done by women. Buffalo robes, tepees, and tepee linings were all often painted with such war chronicles (plates 29–32). Here again stylistic differences between tribes exist, but since this was an individualistic art, the artists in any one tribe might vary more from one another than from artists in neighboring tribes. In general, the older hides show both human and animal figures as "stick figures," with straight lines for limbs, and dashes or hooks for feet and hooves. Later, a more naturalistic style was formed. In general, Northern Plains examples tend to use solidly colored silhouette forms without internal detail while Central Plains examples tend toward simple outline drawings with considerable detail. Some recent examples from the Kiowa have even moved toward the use of perspective and the inclusion of minute detail.

After the reservation areas were set up, and Indians moved to them, much pictographic painting was made in European notebooks and ledgers (plate 33). These were drawn with trade-colored inks and pencils, but were usually made by Indians for Indian use. However, a commercial development of pictographic painting took place. Paintings on small deer hides or elkskins,

and miniature tepee covers were made for sale (colorplate 17). At least one Shoshone man, about 1885, mass-produced painted hides which resembled each other so closely that there is a possibility that they were done with the aid of stencils.[12]

Finally, there is a type of painted object which is common all over the Plains, the *parfleche*, which is a rawhide container (plate 34; colorplate 18). It varies from tribe to tribe in details of painting and techniques for lacing. The designs are almost always simple and geometric, being laid out on the flat stretched hide with the aid of willow stick rulers—a method which, of course, determined the geometric character of the pattern. Some tribes will occasionally use curved elements; rarely, a naturalistic design is included on a *parfleche* intended to contain religious equipment (plates 35–37).[13] Raw, or untanned hide was also used for sunshades, rattles, burden straps, and lacing thongs.

The most significant form of sculpture from the Plains takes the form of carved stone pipes (plates 38–42). The usual material is red pipestone (catlinite), found in several localities in Minnesota and Wisconsin. Where this was not available, Indians used shales, soapstones, calcite, chlorite, and limestone. The practice of carving anthropomorphic forms on pipe bowls originated in prehistoric times. In the historic period of the Plains area, the Iowa and Oto-Missouri produced some of the finest effigy pipes. (The Sioux and Chippewa, living near the Minnesota pipestone quarries, still produce well-carved pipes; though they are for sale to tourists and collectors, they closely resemble those made in the 1830s. A standard modern version has a T-shaped bowl and a carved bison standing on the stem.) Pipe stems carved of Green ash wood were also often elaborately decorated (plates 43–45). Any important visitor to the upper Mississippi River region could be assured of receiving a finely carved and decorated pipe as a ceremonial gift. The stems were usually wrapped with a form of quill plaiting and decorated with woodpecker beaks, mallard duck necks, horsehair, ribbons, and feathers. Some stems lack this added trim, but are decorated with animal forms carved into the wood portion. The Teton Sioux specialize in shallow relief carvings of deer, turtles, sheep, elk, and dragonflies. Santee Sioux and some Woodland groups carve the wood stems into spiral forms.

The typical visual image of the American Indian wearing a flowing feather war bonnet is due in part to the fact that featherwork was an im-

portant craft among most Plains tribes (plate 46). Feathers were used in making a variety of head ornaments, but also served as decorations on shields, pipe stems, shirts, leggings, coup sticks, and banners. In addition, feathers were used in a type of dance ornament known as a bustle or "crow belt" (plate 47). Generally, featherwork can be classed as a decorative craft, but some exceptional specimens have considerable aesthetic quality. Some Cheyenne and Arapaho bustles fit this category, with their refined use of cut leather, painted designs, and added trim in the form of bead or quillwork, metal bells, fringes, dyed feathers, and ribbons.

A limited amount of wood carving was done in parts of the Plains area, but was of very minor importance in comparison to the quantity of work produced in the Woodlands. "Love flutes" were often made with carved top blocks (plate 48); Grass Dance whistles were sometimes carved in bird forms (plate 49); some bowls were made in the Eastern Plains and various ornaments such as mirror frames and Horse Dance sticks were carved for use in certain dances (plates 50, 51). Some Eastern Plains groups often added carved decoration to their cradle boards (plates 53, 54). Such boards were a specialty of the Osage and Pawnee, but carving also occurs on some Eastern Sioux boards. Wooden doll-like fetishes are found in many parts of the Plains. In the Eastern area such types as the Santee Tree Dweller dolls (plate 55) and Prairie Potawatomi love dolls were due to an extension of a Woodland tradition. However, dolls are also found in Crow Indian medicine bundles and examples have been noted for the Arapaho. The Eastern Plains area also produced some finely carved wooden war clubs—again probably owing to Woodland influence (plates 56, 57). A type with a wide distribution, but especially favored by the Oto, shows an otter carved in the round, with its head facing the ball of the club. Elk antler was carved much like wood for some specialized uses such as for quirt handles, awl handles, and roach spreaders (plates 58, 59).

The Plains Indians produced only a limited amount of metalwork, mainly for the decoration of horse headstalls, breast ornaments (plate 60), finger rings, bracelets, earrings, and arm bands.

Other arts practiced on the Eastern Plains as a result of Woodland influence include ribbon appliqué (colorplate 19), loom beadwork (plate 61), and the making of yarn bags and sashes. Pottery and basketry are extremely rare, and nowhere in the area was true weaving practiced.

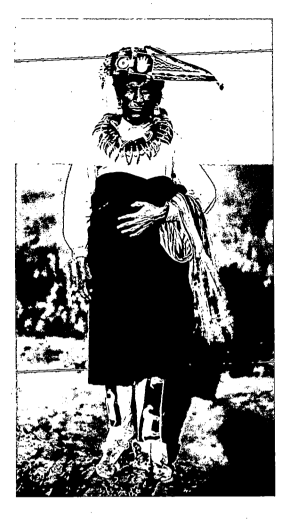

10. Gi-He-Ga, an Omaha chief. Note the beaded horses on the leggings, and the ribbon appliqué designs on the otter fur turban.

9. Cradle board. Eastern Sioux. c. 1830. 34 x 15". Peabody Museum, Salem, Mass. (Cat. No. E27, 984). Porcupine quillwork in orange, white, and brown quills. The wooden backboard is a reconstruction.

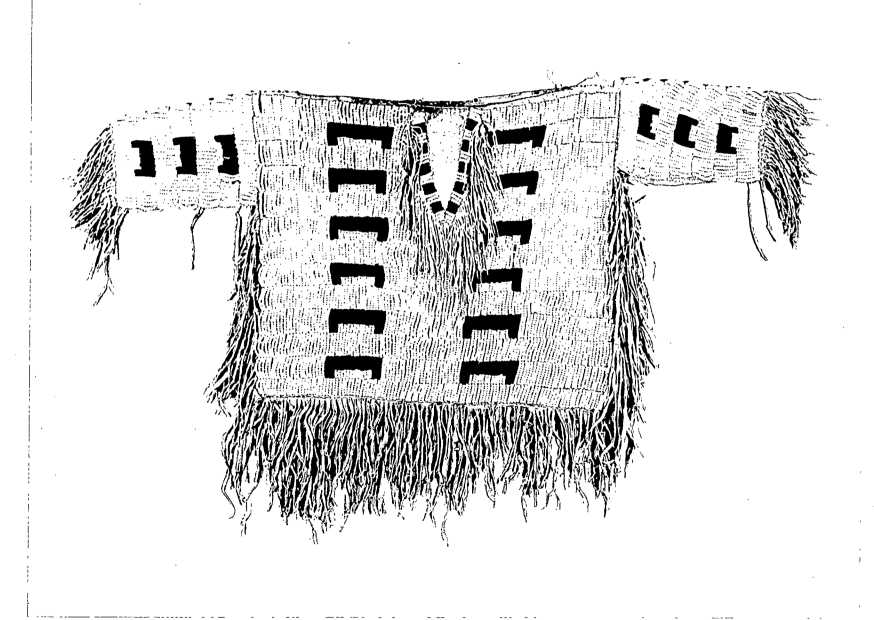

11. Boy's shirt. Jicarilla Apache(?).
c. 1850. Front panel 11 x 14″. Colorado
State Museum, Denver (Cat. No. E–1957.2).
Pony trader beads in black and white
only. The solid beadwork is unique for
such an early specimen.

Colorplate **4**. Beaded pipe bag. Cheyenne. ⟶
c. 1900. 39 x 6 1/2". Denver Art Museum •
(Cat. No. BChy—56). Made with small
faceted seed beads in the pictographic
painting style.

12. Beaded pipe bag. Cheyenne. c. 1880.
19" (less fringe) x 6 1/2". Denver Art
Museum (Cat. No. BS—155). The reverse
side of this bag has two hands in place of
the two stylized heads. The large beads
woven into the fringe are an old
Cheyenne—Arapaho characteristic.

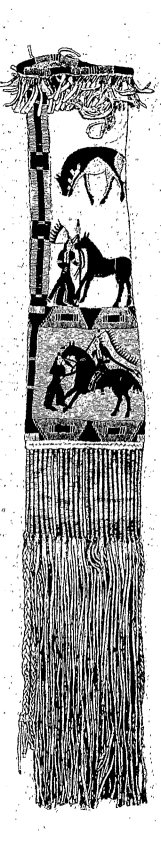

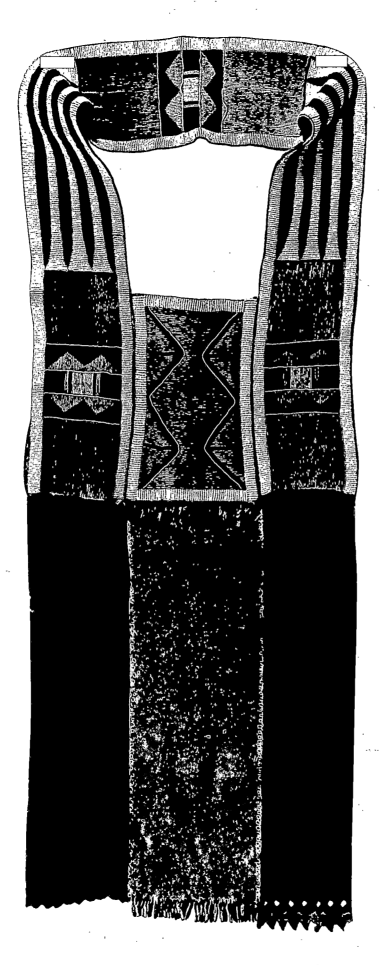

13. Beaded bandoleer. Ute. c. 1880.
52 1/2 x 18″. Denver Art Museum (Cat.
No. BU–66). Collected by General
U. S. Hollister. Beaded on skin with
red and yellow stroud cloth trim. This
illustrates a carry-over among the Ute
of a Crow beadwork style. Although
used as a bandoleer by the Ute, similar
ornaments were used by the Crow as
horse breast ornaments.

14. Beaded moccasins. Kiowa. c. 1880.
Royal Ontario Museum, University of
Toronto, Canada (Cat. No. 963.210).
An old example of fully beaded Kiowa
moccasins, which during this period are
unique in that the uppers are not sewn to
the rawhide soles inside out, as are other
Plains hard-soled moccasins.

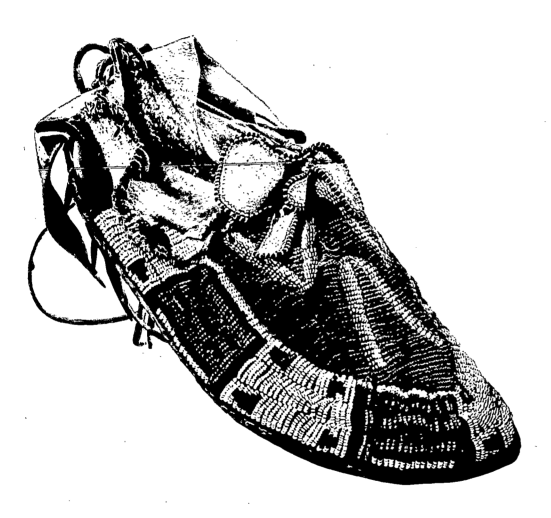

15. Kiowa woman carrying a child in a cradle. Photo by James Mooney in 1893. Note the fully beaded cradle board with overlay beadwork in an abstract floral design.

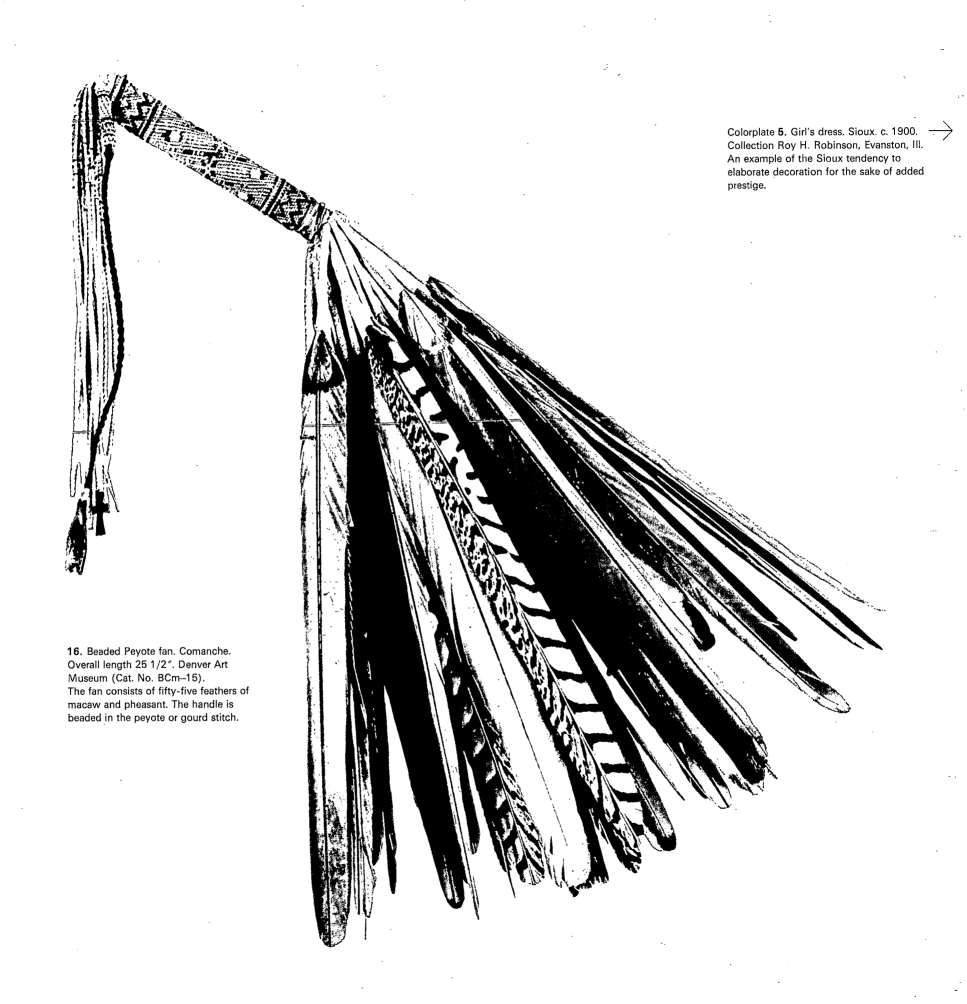

Colorplate **5**. Girl's dress. Sioux. c. 1900.
Collection Roy H. Robinson, Evanston, Ill.
An example of the Sioux tendency to
elaborate decoration for the sake of added
prestige. →

16. Beaded Peyote fan. Comanche.
Overall length 25 1/2″. Denver Art
Museum (Cat. No. BCm–15).
The fan consists of fifty-five feathers of
macaw and pheasant. The handle is
beaded in the peyote or gourd stitch.

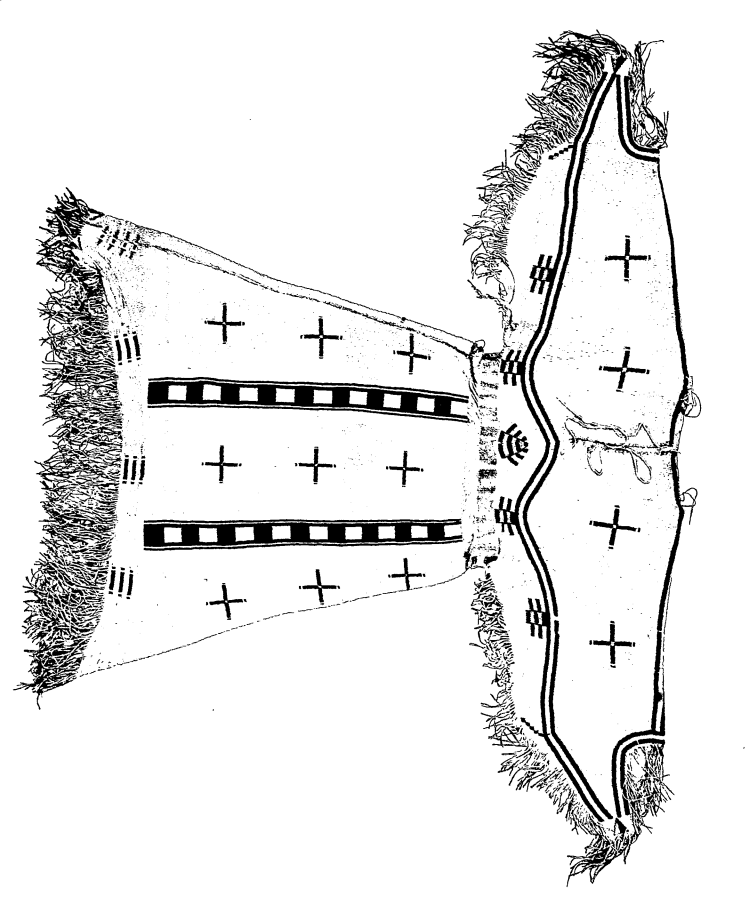

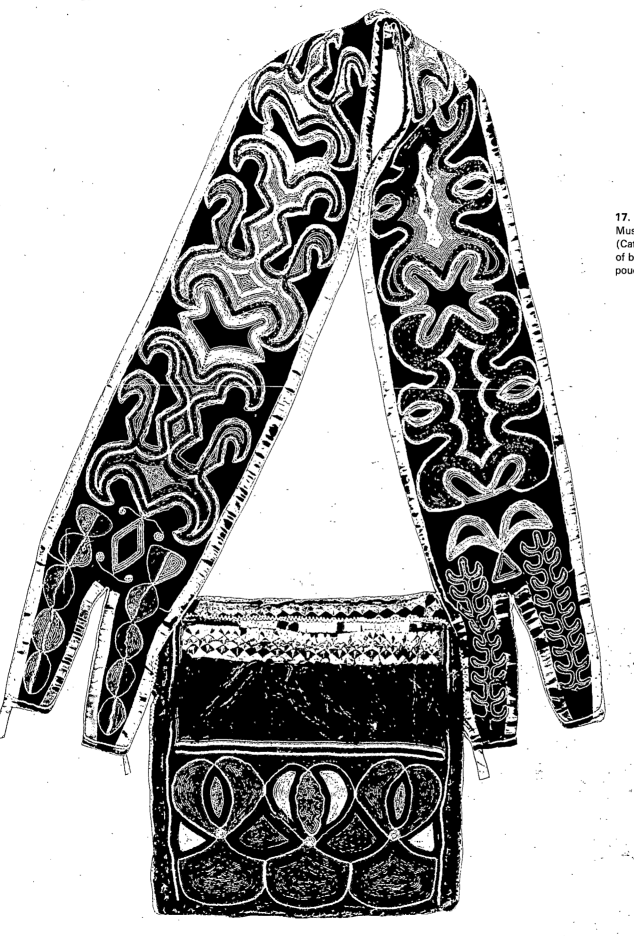

17. Bandoleer bag. Delaware. National Museum of Ethnology, Leiden, Holland (Cat. No. 360–9961). An older form of bandoleer bag than Colorplate 11. The pouch portion is on black dyed buckskin.

18. Man's shirt. Jicarilla Apache. c. 1880.
Length across sleeves 65″. Denver Art
Museum (Cat. No. BAJ–21)

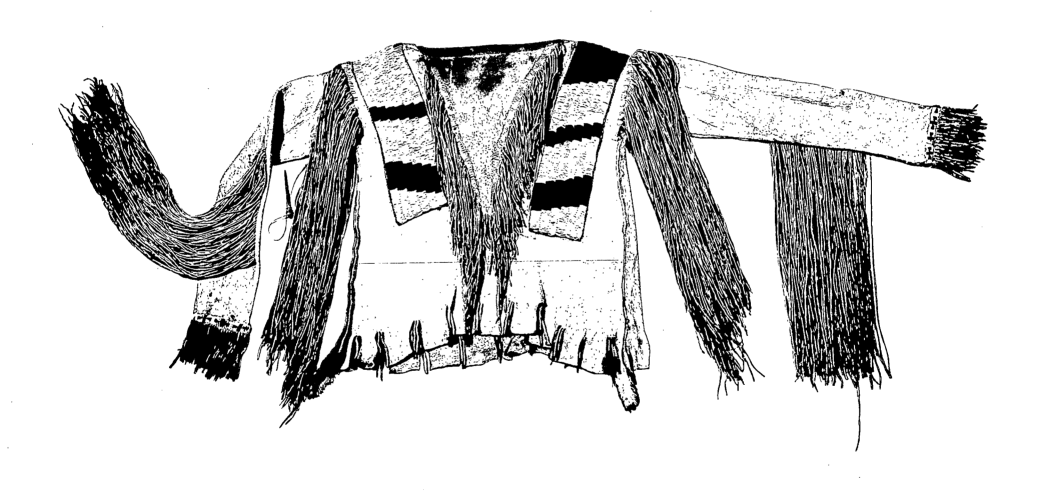

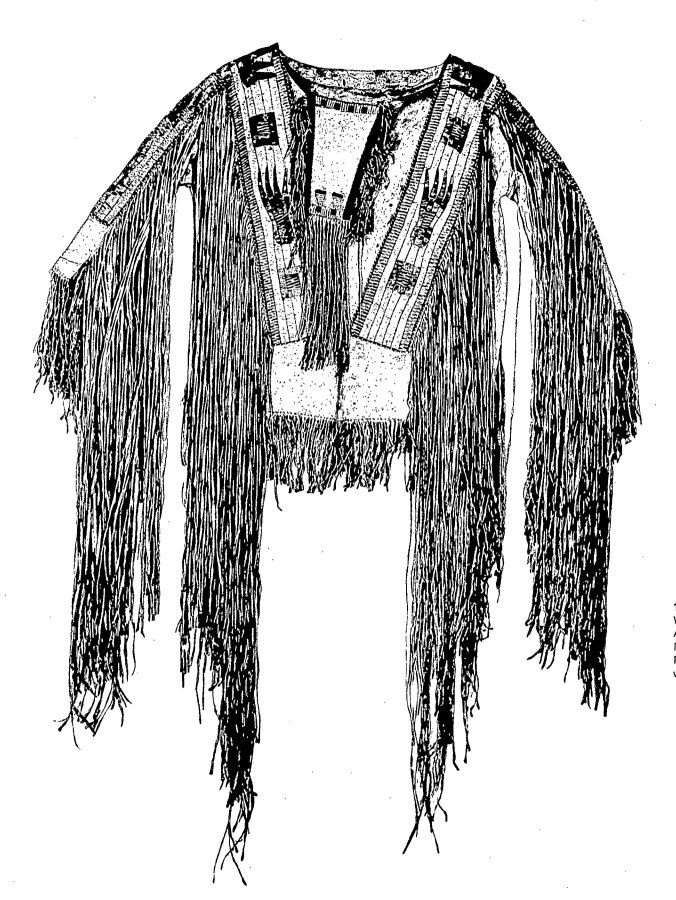

19. Man's shirt. Mandan(?). c. 1860.
Width at shoulders 17″. Museum of the
American Indian, Heye Foundation,
New York City (Cat. No. 20/1473).
Porcupine quillwork and pony trader beads
with designs representing bear paws.

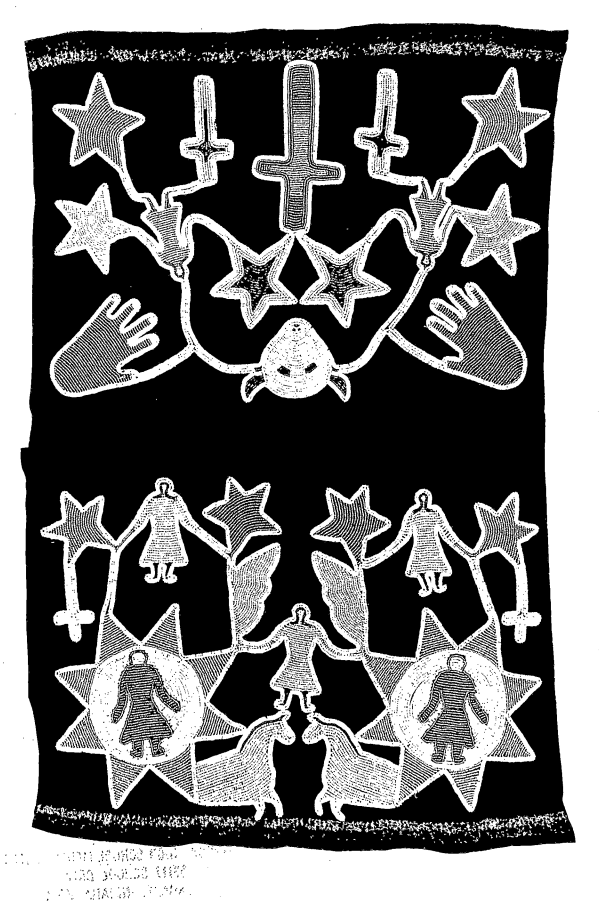

Colorplate **6**. Lance case, incised buffalo →
skin, and beads. Crow. Carnegie Museum,
Pittsburgh. Fred Harvey Collection (Cat.
No. 2418/109)

20. Breechclout. Winnebago, Nebraska.
55 x 18″. State Historical Society of
Wisconsin, Madison (Cat. No. 50.6415).
Collected by T. R. Roddy before 1908.
Beaded on list cloth. Although collected
from the Winnebago in Nebraska, it is very
unlike Winnebago work and may have
been made by the Oto or a related tribe.

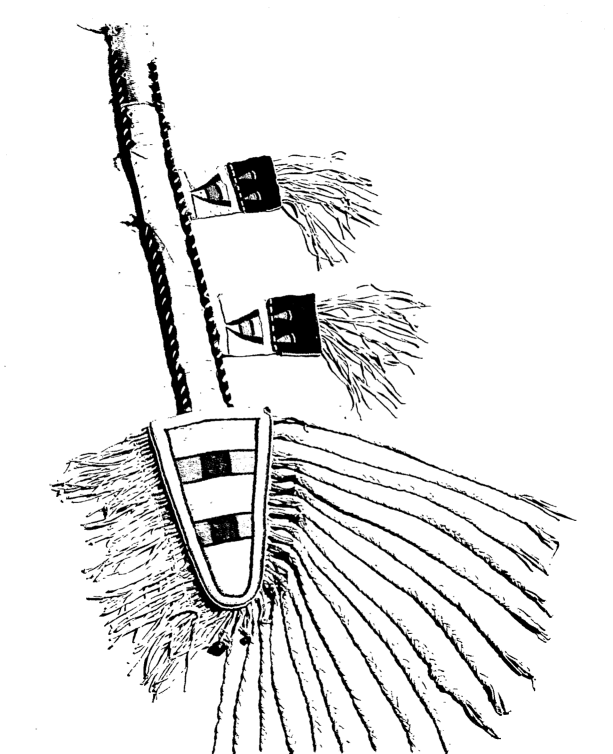

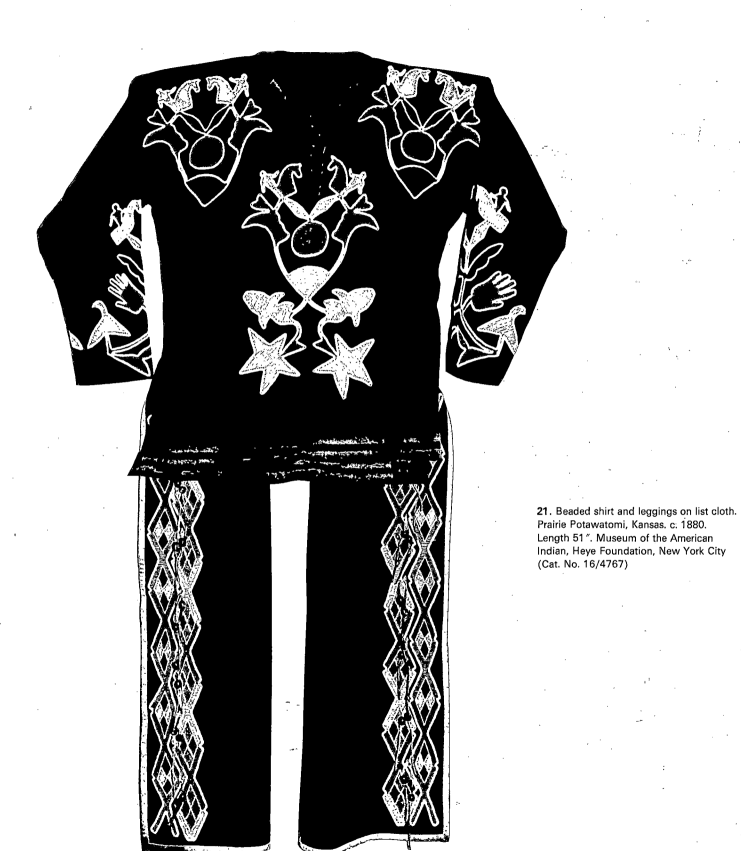

21. Beaded shirt and leggings on list cloth.
Prairie Potawatomi, Kansas. c. 1880.
Length 51″. Museum of the American
Indian, Heye Foundation, New York City
(Cat. No. 16/4767)

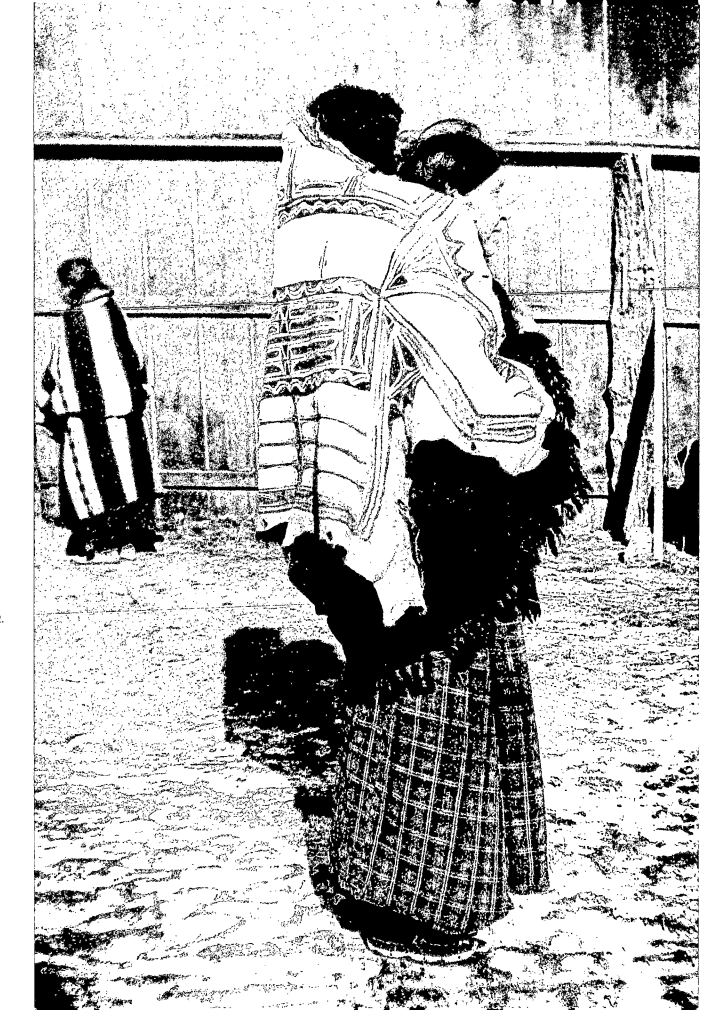

22. Brule Sioux woman using a painted box-and-border calfskin as a baby carrier. Photo by Arthur E. McFatridge about 1902.

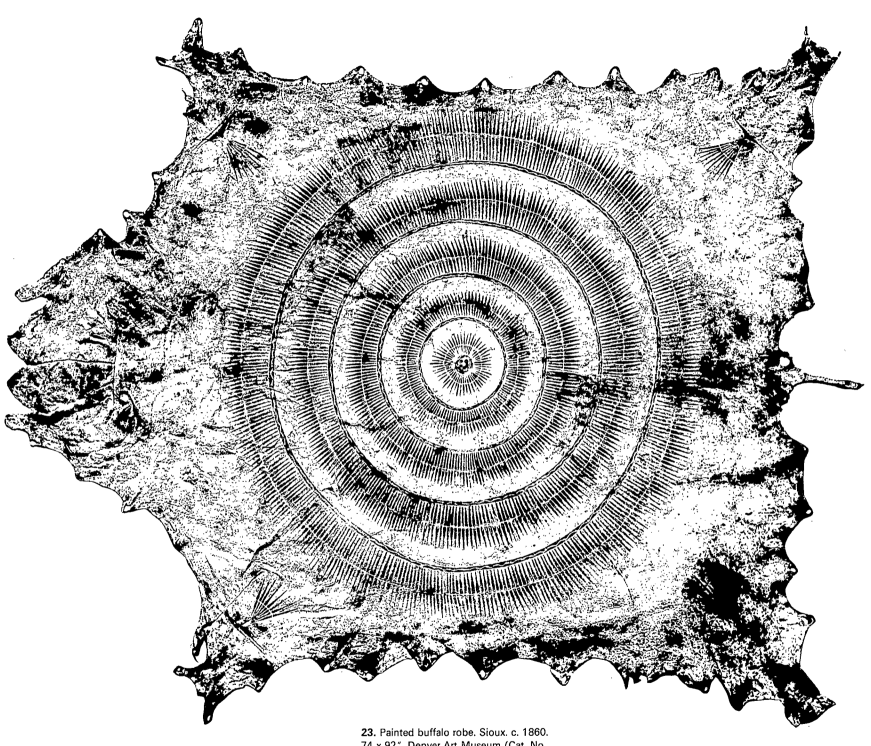

23. Painted buffalo robe. Sioux. c. 1860.
74 x 92″. Denver Art Museum (Cat. No.
PS–39). An extra large size robe with a
standard sunburst design.

Colorplate **7**. Cradle board. Crow. c. 1900. →
40 1/2 x 11″. Denver Art Museum
(Cat. No. BCr–40)

24. Painted robe. Hidatsa. American
Museum of Natural History, New York City
(Cat. No. 50.1/6021). A pair of stylized
calumet pipes are shown in the center.
Note the birdlike designs on the border at
top and bottom.

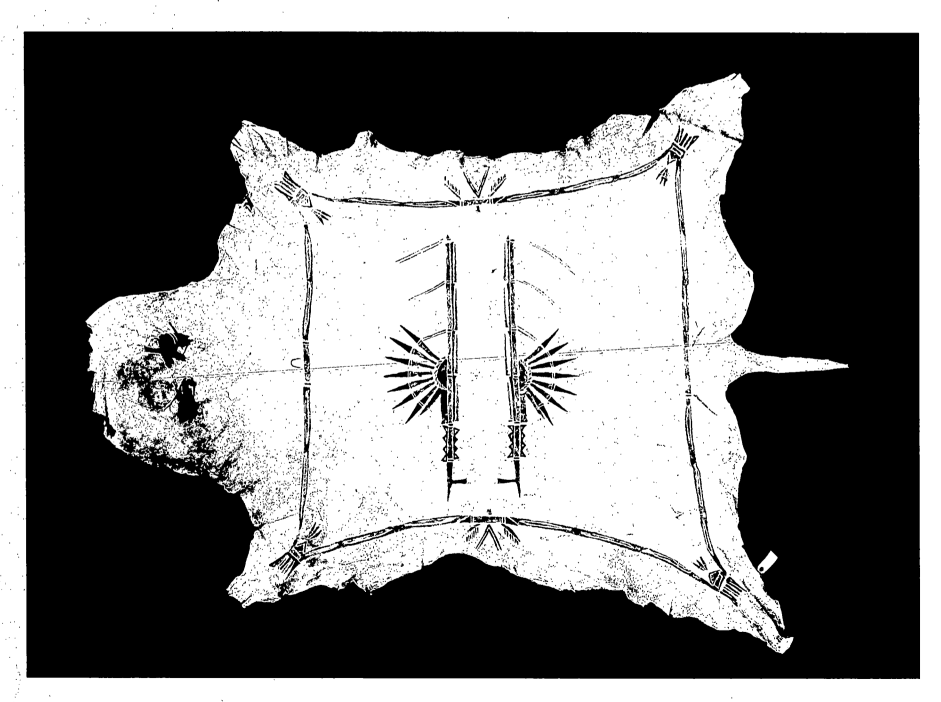

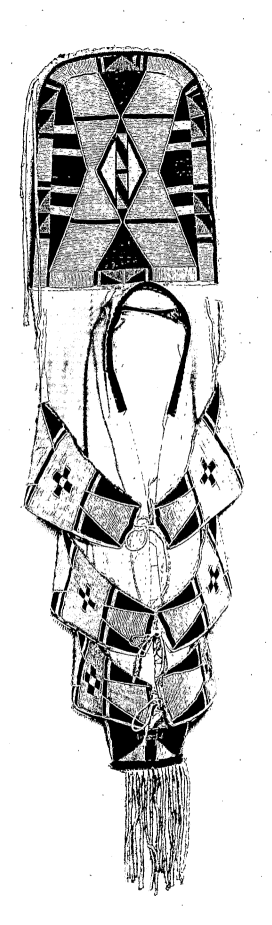

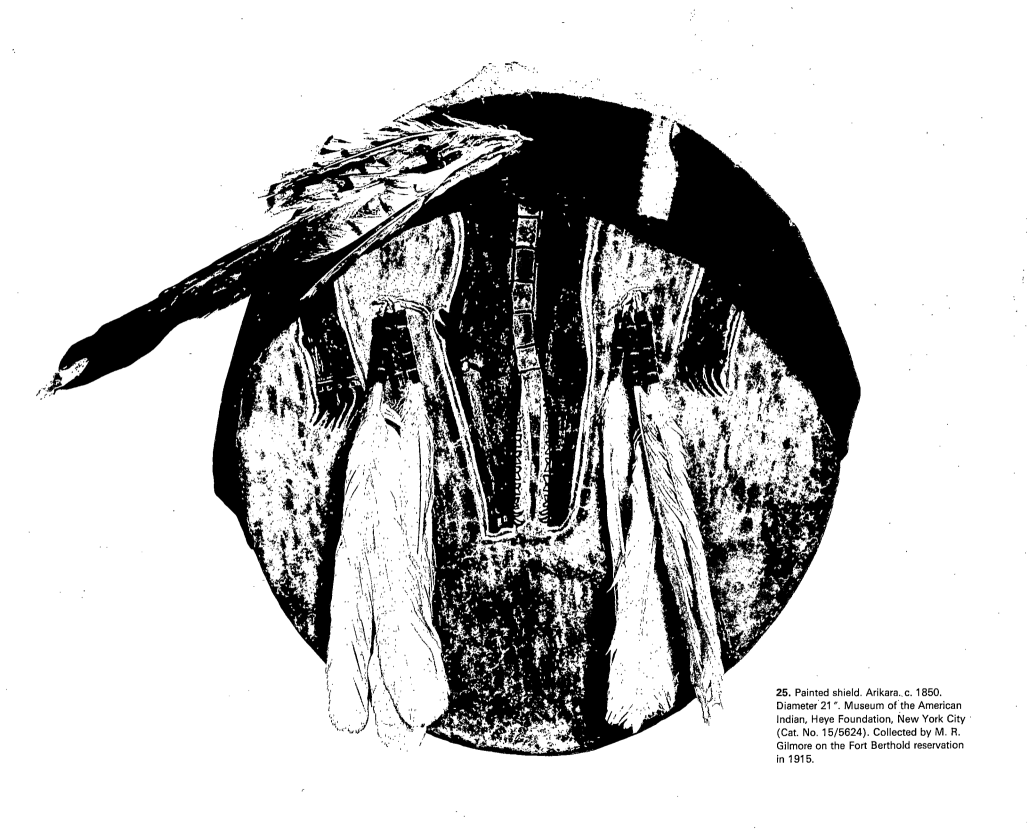

25. Painted shield. Arikara, c. 1850.
Diameter 21″. Museum of the American
Indian, Heye Foundation, New York City
(Cat. No. 15/5624). Collected by M. R.
Gilmore on the Fort Berthold reservation
in 1915.

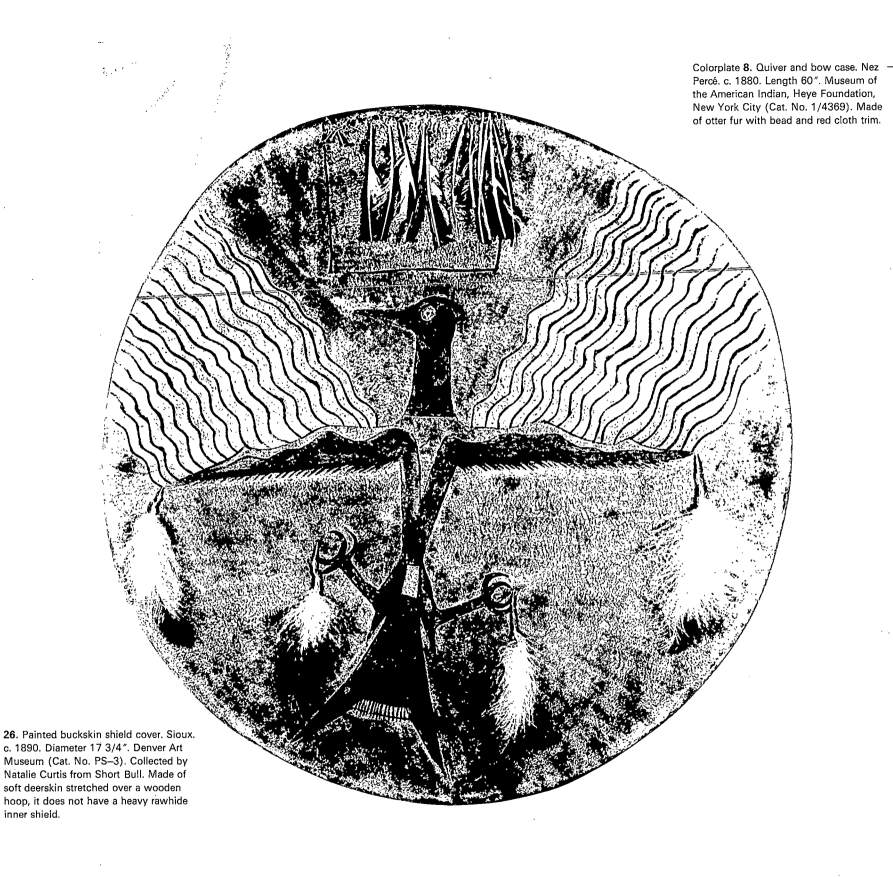

Colorplate **8**. Quiver and bow case. Nez →
Percé. c. 1880. Length 60″. Museum of
the American Indian, Heye Foundation,
New York City (Cat. No. 1/4369). Made
of otter fur with bead and red cloth trim.

26. Painted buckskin shield cover. Sioux.
c. 1890. Diameter 17 3/4″. Denver Art
Museum (Cat. No. PS–3). Collected by
Natalie Curtis from Short Bull. Made of
soft deerskin stretched over a wooden
hoop, it does not have a heavy rawhide
inner shield.

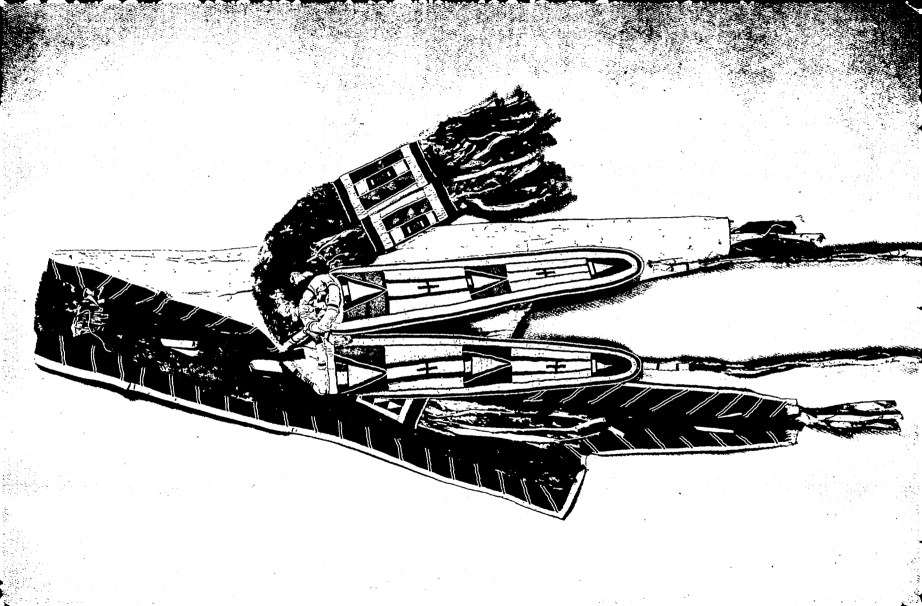

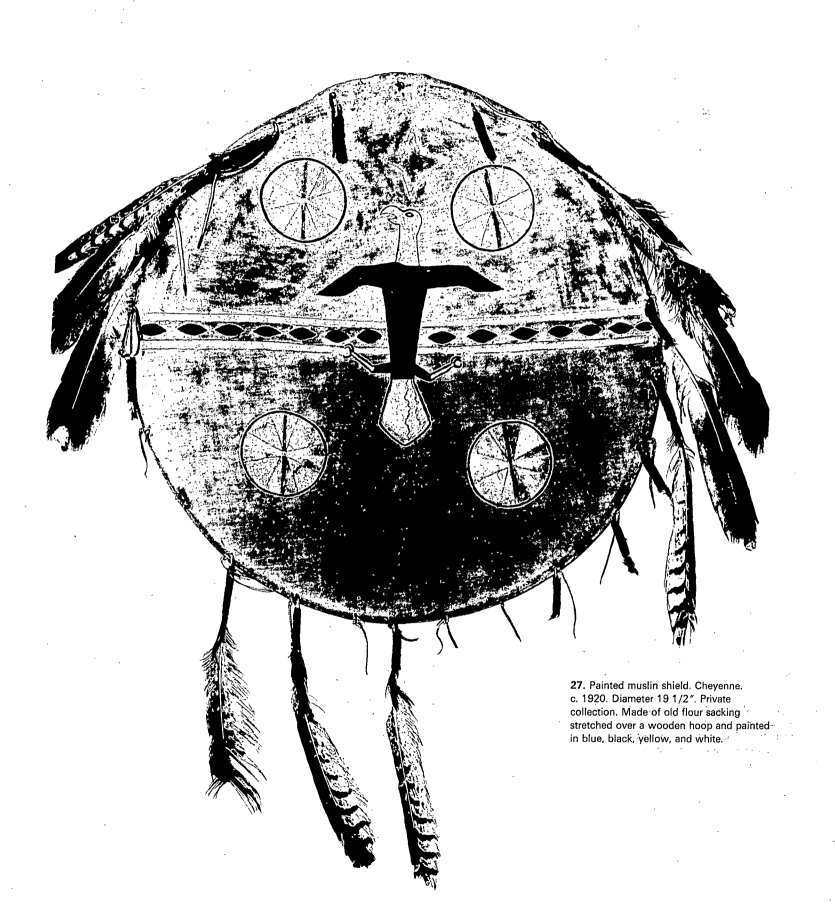

27. Painted muslin shield. Cheyenne.
c. 1920. Diameter 19 1/2". Private
collection. Made of old flour sacking
stretched over a wooden hoop and painted
in blue, black, yellow, and white.

Colorplate **9.** Painted and perforated man's →
shirt. Blackfeet. c. 1900. Length across
sleeves 63″. Denver Art Museum (Cat. No.
LBI–1)

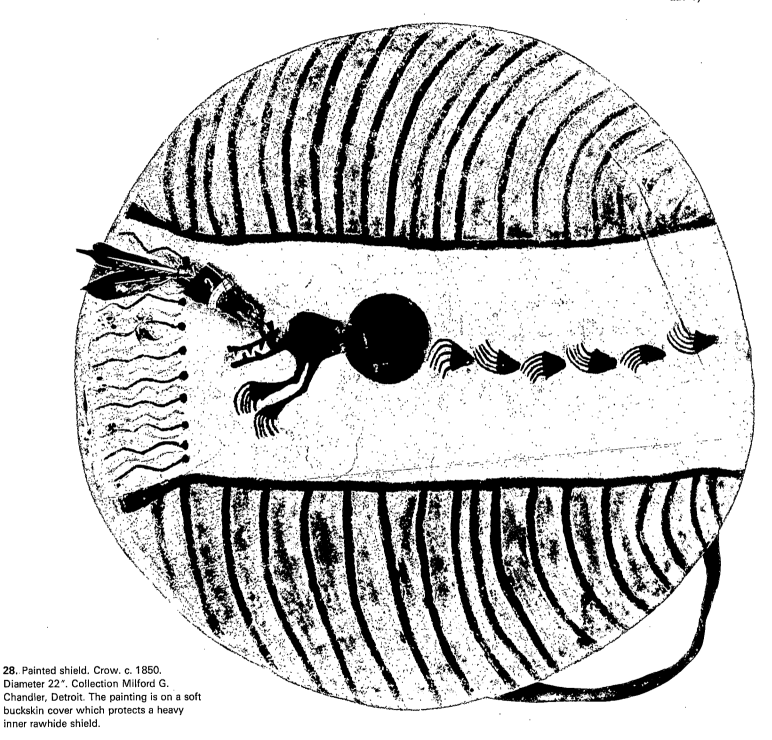

28. Painted shield. Crow. c. 1850.
Diameter 22″. Collection Milford G.
Chandler, Detroit. The painting is on a soft
buckskin cover which protects a heavy
inner rawhide shield.

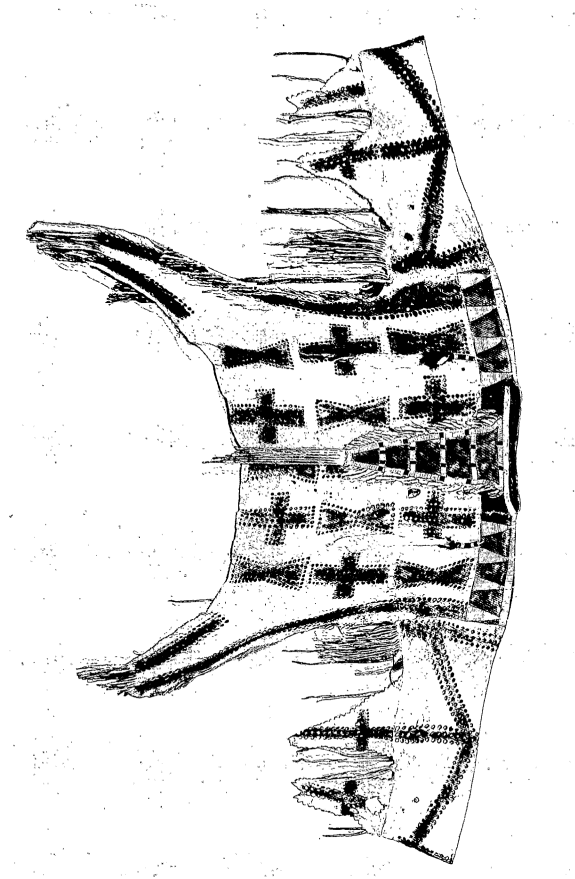

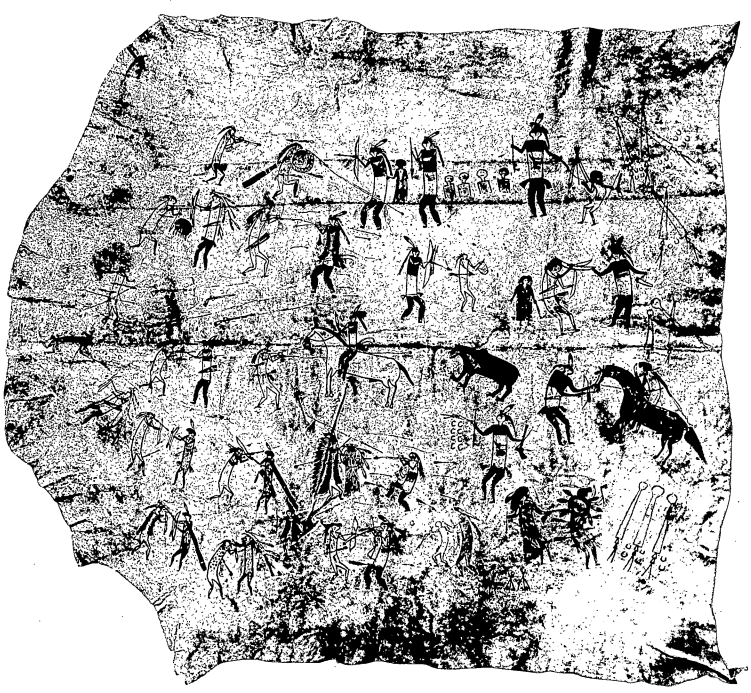

29. Painted buffalo robe. Tribe unknown. c. 1830.
62 x 68". Smithsonian Institution, Museum of
Natural History, Washington, D.C.
(Cat. No. 2130). A good example of the older
style of simplified pictographic painting.

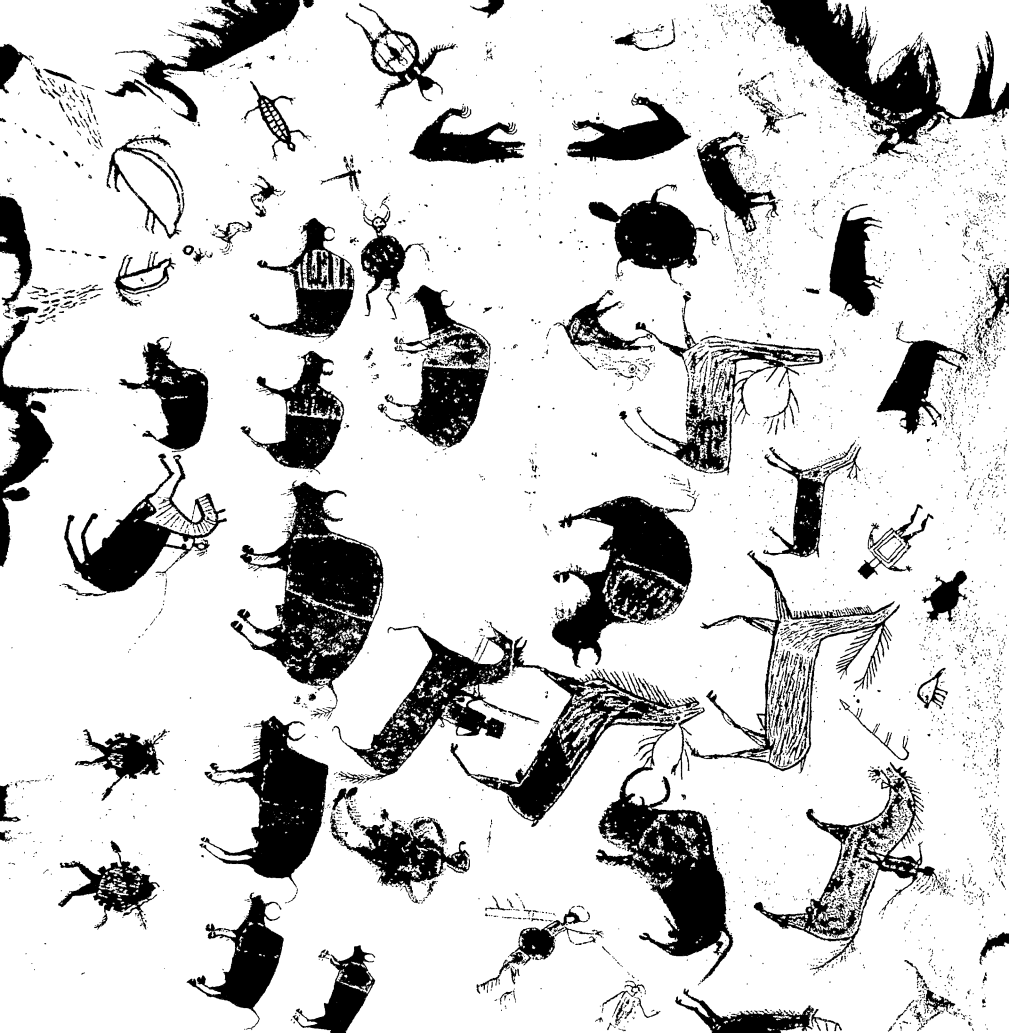

30. Painted pictographic buffalo robe.
Sioux(?). Museum für Völkerkunde,
Berlin (Cat. No. IVB 208). Collected by
Kohler, 1846.

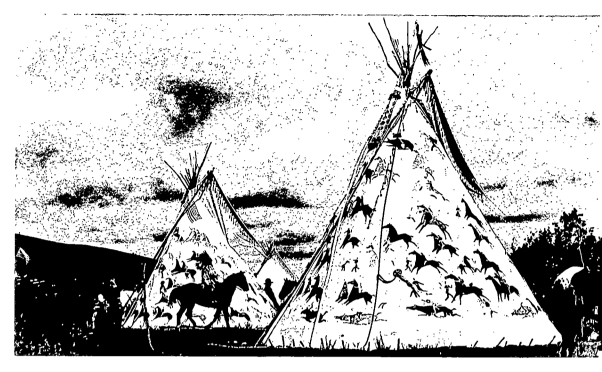

31. Old Bull's tepee. Sioux. Photo taken
by Fiske at Fort Yates.

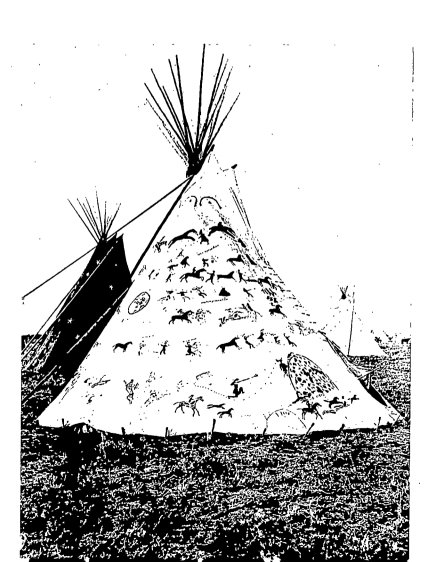

32. Painted tepee. Assiniboin. Painted all
over with pictographic designs.

Colorplate **10**. Pony bead cradle.
Comanche. c. 1880. Peabody Museum,
Salem, Mass. (Cat. No. E38858). Solidly
beaded in gourd stitch. →

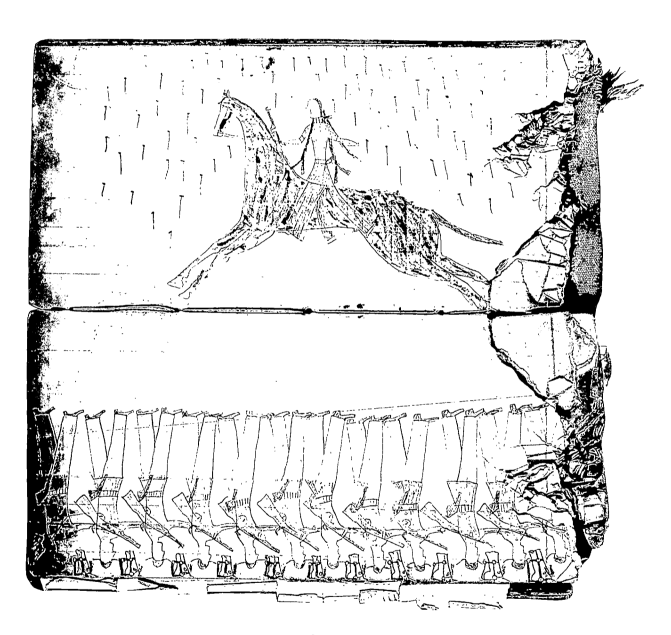

33. Pictographic drawing. Northern
Cheyenne. American Museum of Natural
History, New York City. An example of the
later style of pictographic drawings done
in paper ledger books.

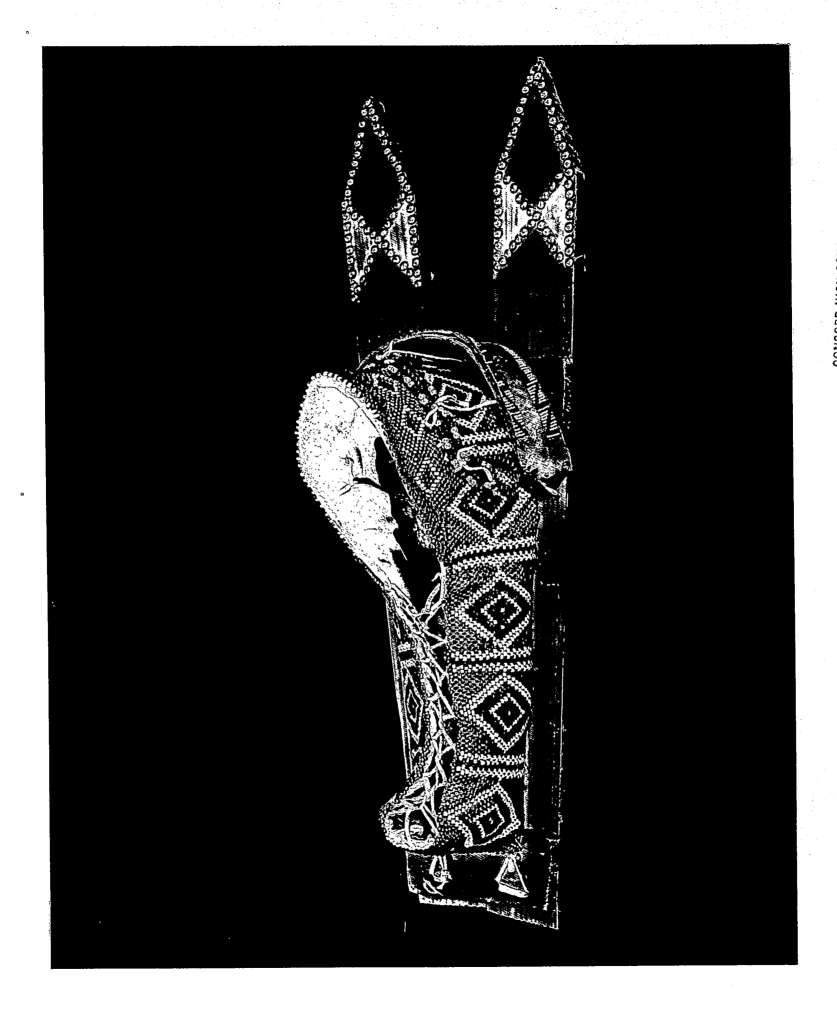

CONCORD HIGH SCHOOL MEDIA CENTER
59117 SCHOOL DRIVE
ELKHART, INDIANA 46514

34. Painted rawhide container. Tribe unknown. Peabody Museum, Harvard University, Cambridge, Mass. (Cat. No. 99.12.10/53004). Collected before 1899 by David Kimball. The painted bear paw designs in the center are unusual; most rawhide painting is geometric in character.

35. Incised buffalo rawhide sunshade (detail of front only). Northern Cheyenne. Complete shade 13 x 17″. Collection Richard Pohrt, Flint, Mich. Collected at Fort C. F. Smith in the 1860s. The horses are incised into the leather by scraping away the epidermis.

Colorplate **11.** Bandoleer bag. Delaware. Museum of the American Indian, Heye Foundation, New York City (Cat. No. 21/3358). Beaded buckskin bag with beaded cloth strap. \longrightarrow

36. Rawhide cutouts. Oglala Sioux. Man,
height 13″; Buffalo, height 8 1/2″.
Peabody Museum, Harvard University,
Cambridge, Mass. (Cat. Nos. 27498 and
27497). Collected in 1880 by Alice
C. Fletcher. These cutouts were suspended
from the top of a Sun Dance pole during
the annual Sun Dance ceremony.

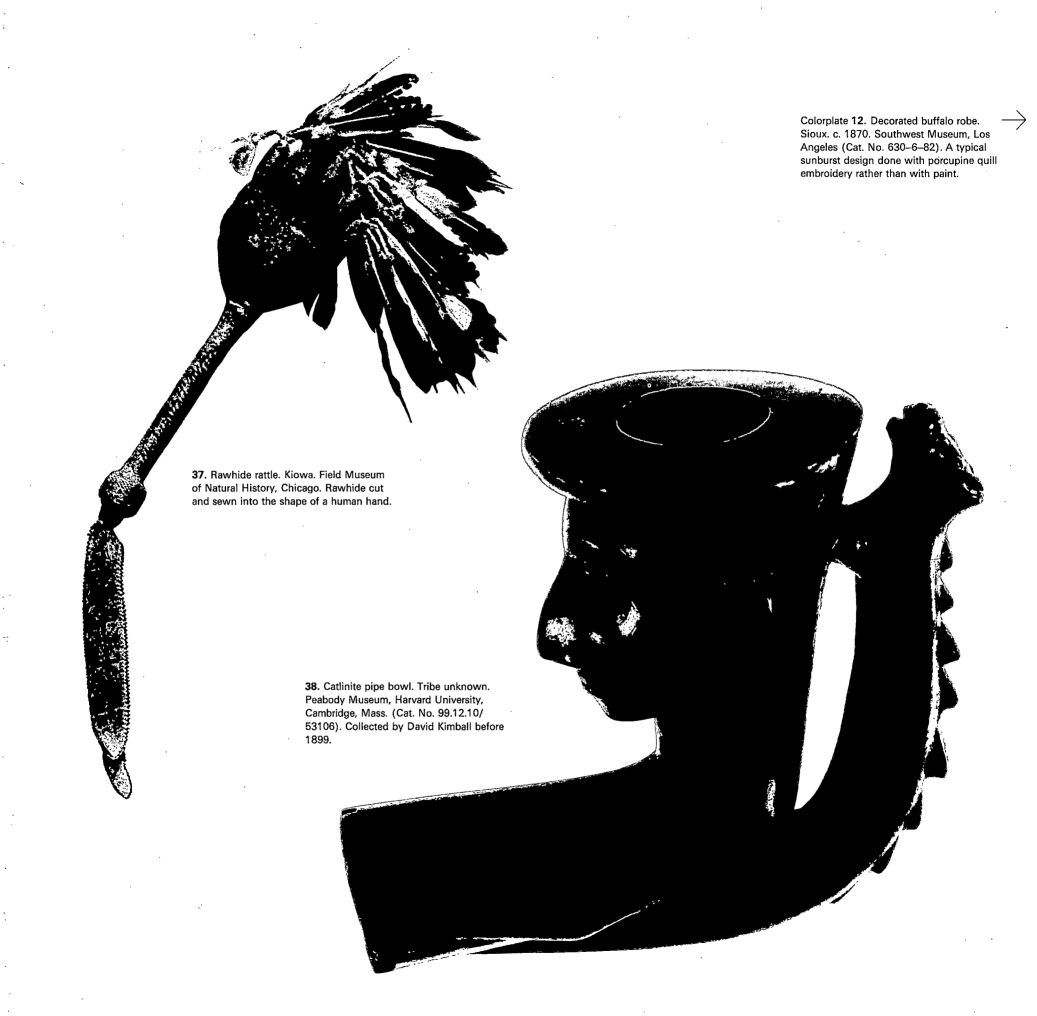

Colorplate **12**. Decorated buffalo robe. Sioux. c. 1870. Southwest Museum, Los Angeles (Cat. No. 630–6–82). A typical sunburst design done with porcupine quill embroidery rather than with paint.

37. Rawhide rattle. Kiowa. Field Museum of Natural History, Chicago. Rawhide cut and sewn into the shape of a human hand.

38. Catlinite pipe bowl. Tribe unknown. Peabody Museum, Harvard University, Cambridge, Mass. (Cat. No. 99.12.10/ 53106). Collected by David Kimball before 1899.

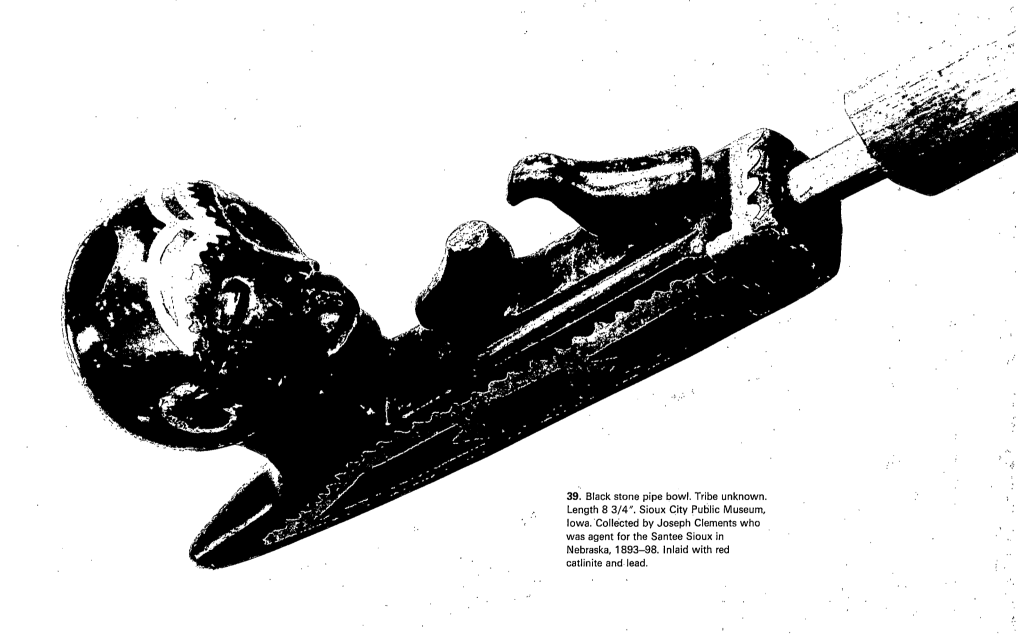

39. Black stone pipe bowl. Tribe unknown. Length 8 3/4″. Sioux City Public Museum, Iowa. Collected by Joseph Clements who was agent for the Santee Sioux in Nebraska, 1893–98. Inlaid with red catlinite and lead.

Colorplate **13**. Beaded buffalo robe. →
Sioux. c. 1870. 71 1/2 x 92". Denver Art
Museum (Cat. No. BS–141). Typical
box-and-border design for a woman's
robe, but unusual for having beadwork
rather than a painted design.

40. Catlinite pipe bowl. Sioux. Length
4 1/8". Smithsonian Institution, Museum
of Natural History, Washington, D.C.
(Cat. No. 42669). Collected by G. L.
Febiger in 1881.

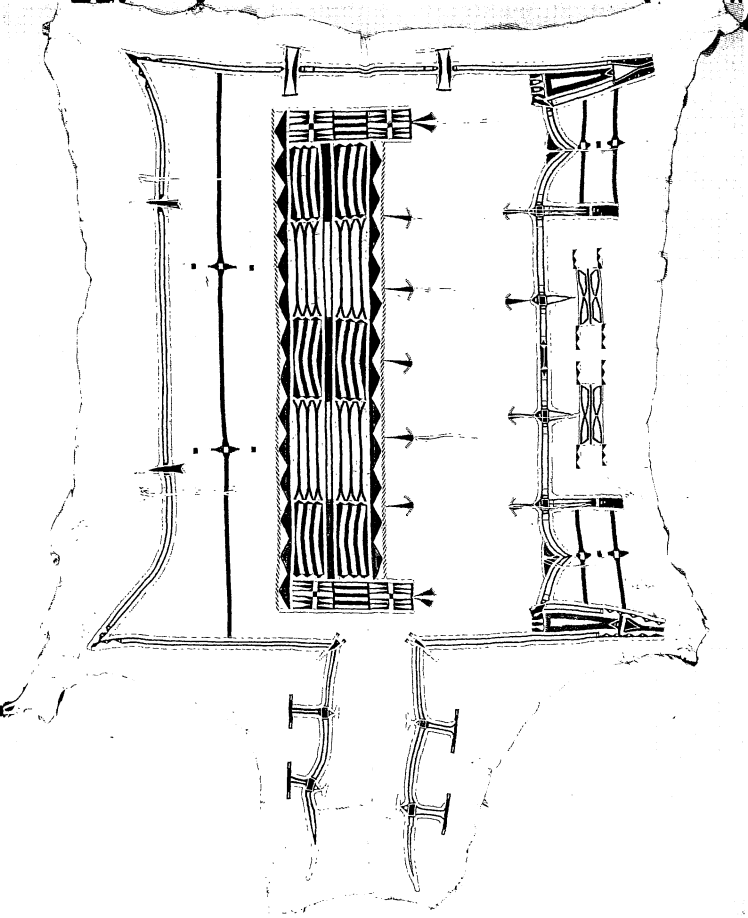

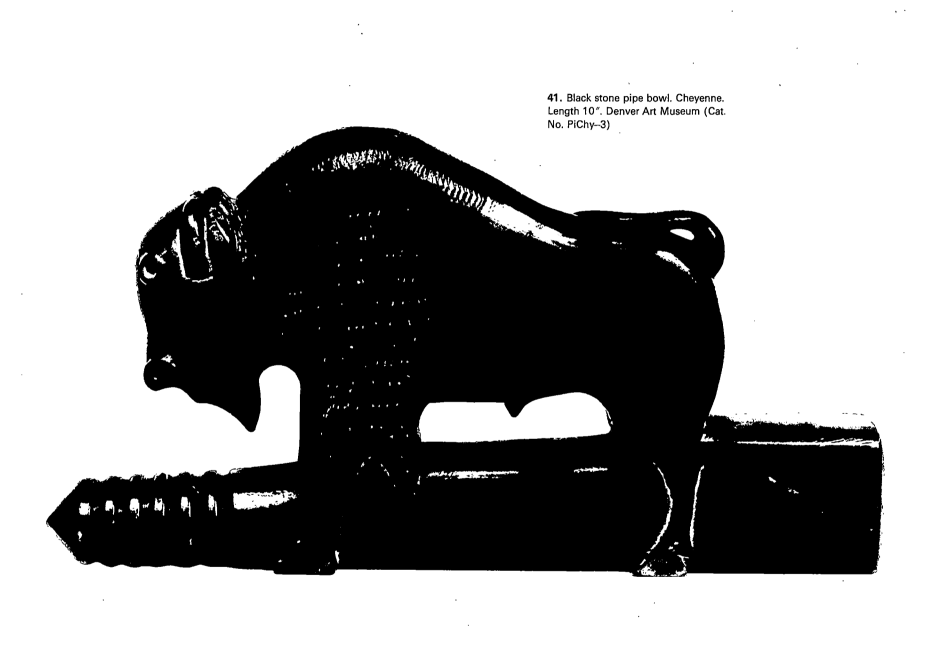

41. Black stone pipe bowl. Cheyenne. Length 10″. Denver Art Museum (Cat. No. PiChy–3)

Colorplate **14**. Painted shield. Sioux.
c. 1850. Diameter 20 1/2". Minnesota
Historical Society, St. Paul (Cat. No.
E110). Heavy buffalo rawhide shield with
deerskin cover painted in typical Sioux
design. →

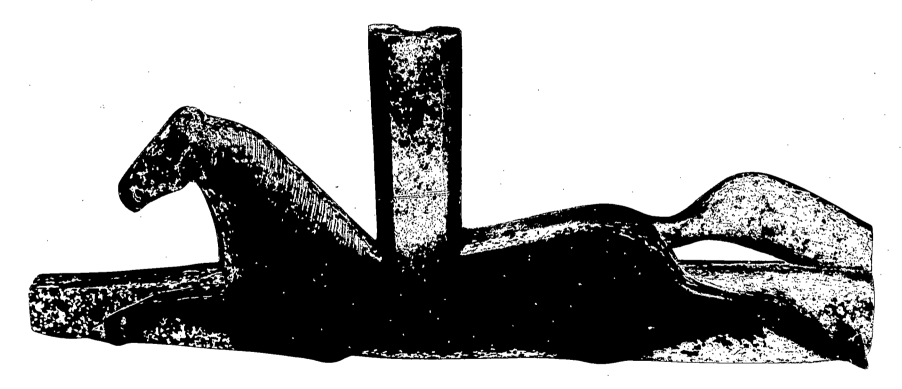

42. Catlinite pipe bowl. Sioux. Length
10 1/2". Denver Art Museum (Cat. No.
PiS–31). The artist took advantage of the
natural variation in the coloring of the stone.

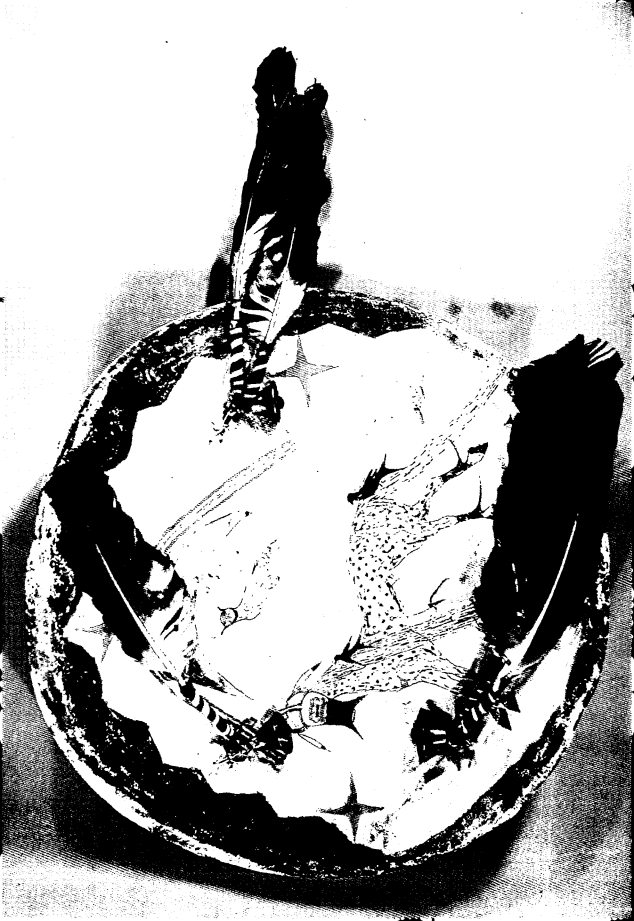

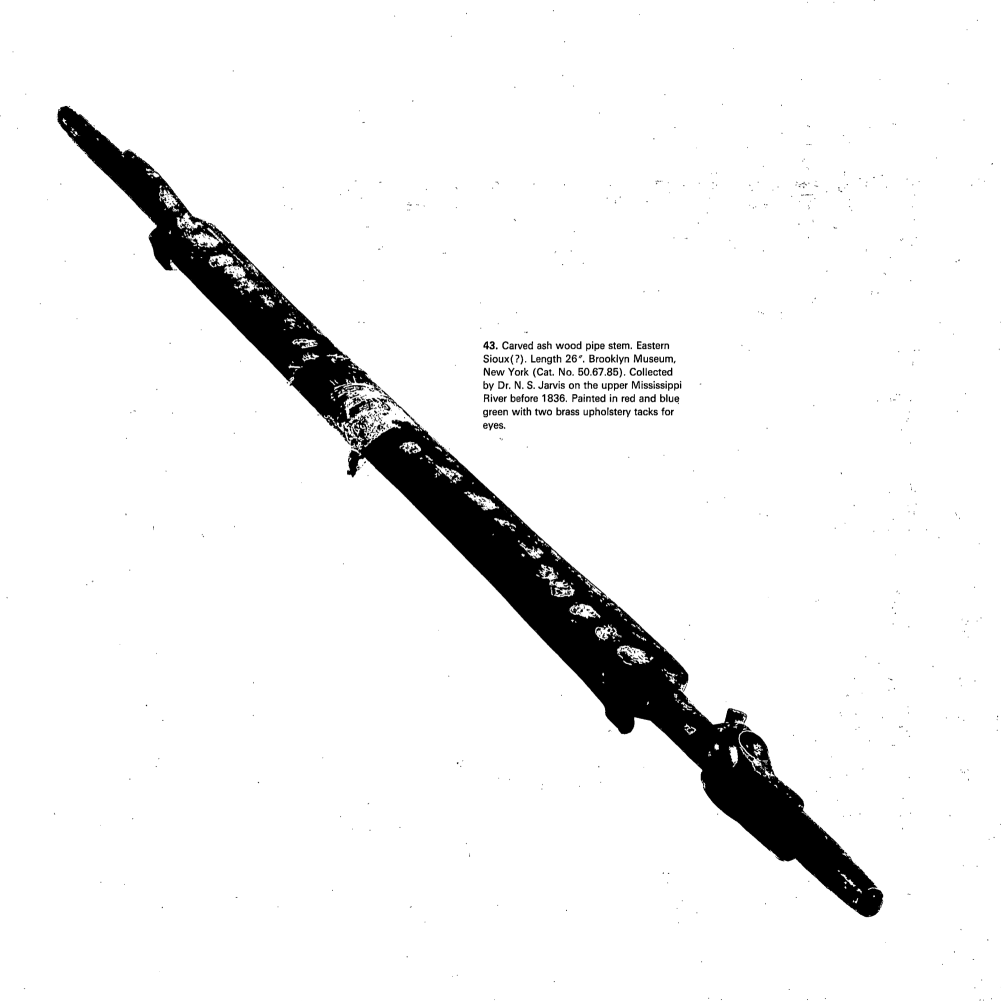

43. Carved ash wood pipe stem. Eastern Sioux(?). Length 26″. Brooklyn Museum, New York (Cat. No. 50.67.85). Collected by Dr. N. S. Jarvis on the upper Mississippi River before 1836. Painted in red and blue green with two brass upholstery tacks for eyes.

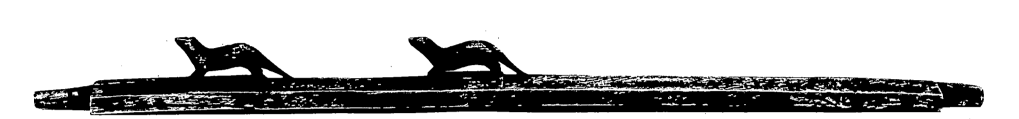

44. Carved ash wood pipe stem. Tribe
unknown. Length 24 1/2". Denver Art
Museum (Cat. No. Pi–1). Two otters are
carved in high relief.

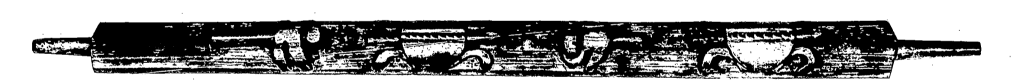

45. Carved wood pipe stem. Sioux. Length
24 7/8". Denver Art Museum (Cat. No. PiS–25).
Collected in 1900, this is a typical form
of Sioux pipe stem.

Colorplate **15.** Painted shield. Crow.
Carnegie Museum, Pittsburgh. Fred
Harvey Collection (Cat. No. 2418/116).
Design of a man within a star.

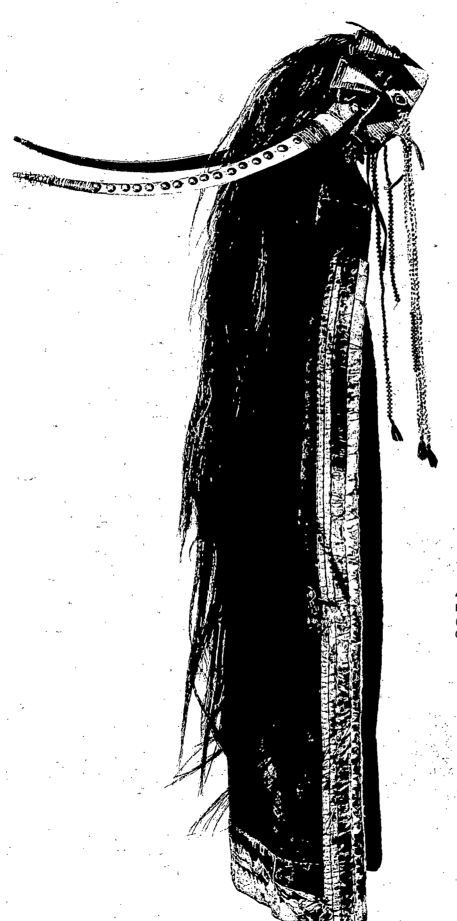

46. Feather bonnet. Osage. c. 1870.
Field Museum of Natural History, Chicago
(Cat. No. 57513). Collected by General
C. C. Augur, 1870–80.

CONCORD HIGH SCHOOL MEDIA CENTER
59117 SCHOOL DRIVE
ELKHART, INDIANA 46514

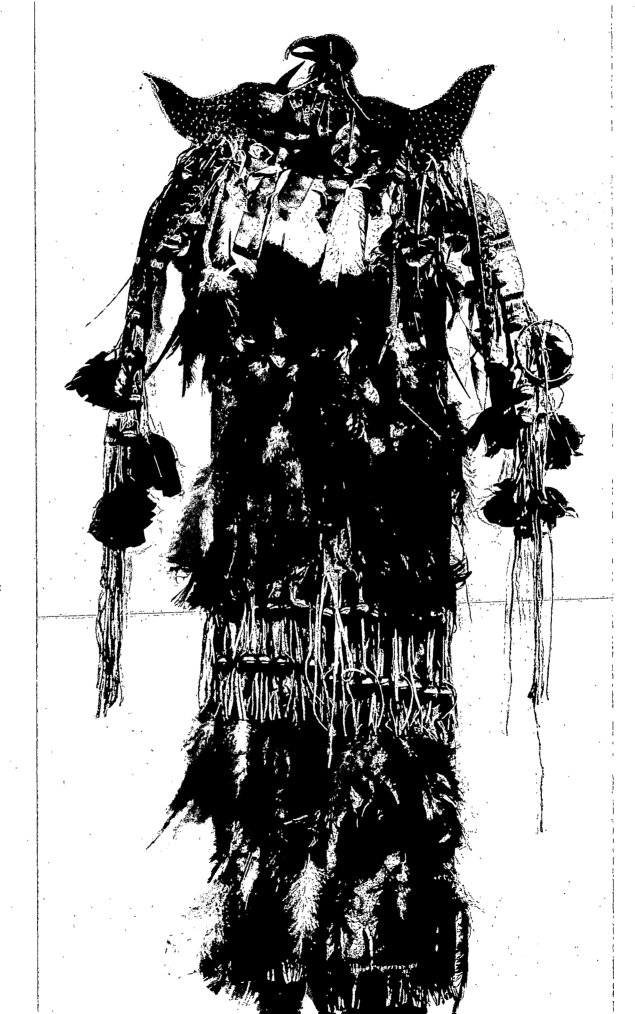

47. Feather bustle. Arapaho. American Museum of Natural History, New York City (Cat. No. 50/301). Collected by A. L. Kroeber in 1899. Feather bustles, often called crow belts, are used as an ornament in the dance. This example is unusual in having a rawhide cutout in the form of a bird.

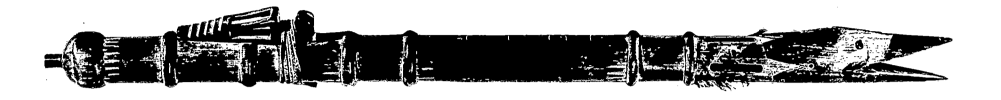

48. Love flute. Oglala Sioux. c. 1900.
American Museum of Natural History,
New York City (Cat. No. 50/2914)

49. Grass Dance whistle. Sioux. Length
19″. Denver Art Museum (Cat. No.
MS–12). Carved of sumac wood with a
bird's head at one end and a buffalo head
carved in low relief.

Colorplate **16**. Painted shield. Arapaho. →
c. 1850. Diameter 19″. Museum of the
American Indian, Heye Foundation, New
York City (Cat. No. 22/8539). Heavy
buffalo hide shield with deerskin cover
painted in a turtle design.

50. Decorated mirror frame. Iowa.
13 1/4 x 6″. Museum of the American
Indian, Heye Foundation, New York City
(Cat. No. 14/805). Collected by Milford
G. Chandler. Carved of walnut with lead
inlay and brass tacks as trim. Such mirrors
were carried by dancers in the Grass
Dance.

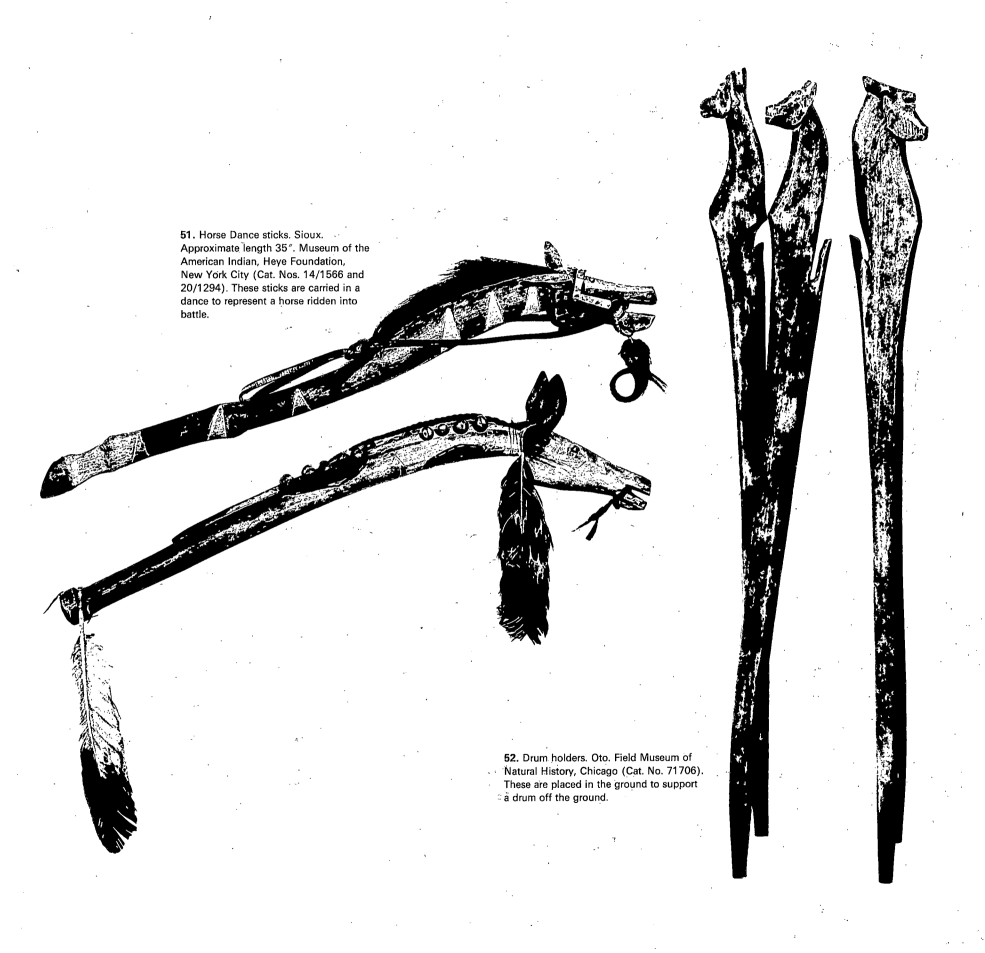

51. Horse Dance sticks. Sioux. Approximate length 35″. Museum of the American Indian, Heye Foundation, New York City (Cat. Nos. 14/1566 and 20/1294). These sticks are carried in a dance to represent a horse ridden into battle.

52. Drum holders. Oto. Field Museum of Natural History, Chicago (Cat. No. 71706). These are placed in the ground to support a drum off the ground.

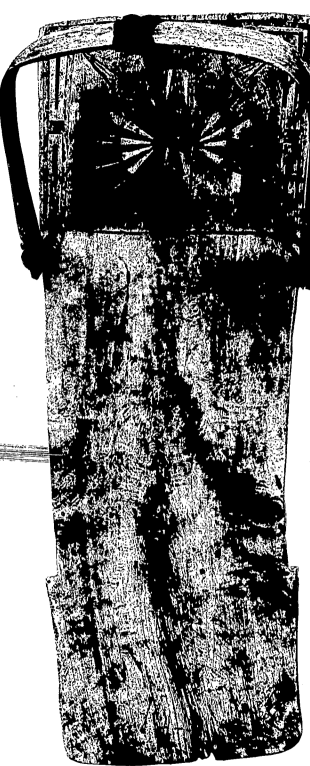

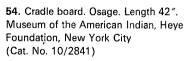

53. Cradle board. Pawnee. Field Museum of
Natural History, Chicago (Cat. No. 59381).
A full size cradle board carved from
cottonwood.

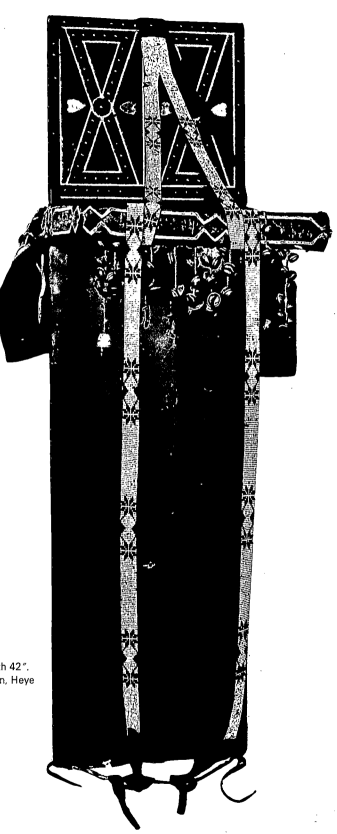

54. Cradle board. Osage. Length 42".
Museum of the American Indian, Heye
Foundation, New York City
(Cat. No. 10/2841)

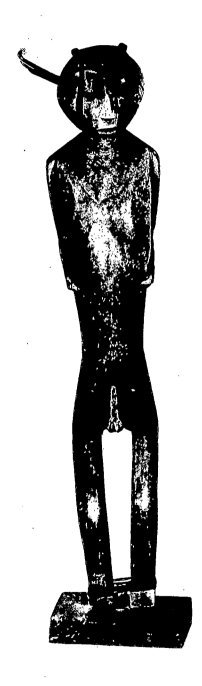

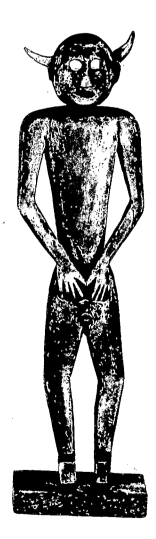

55. Tree Dweller dolls and container. Eastern Sioux. Dolls, heights 6 1/2 x 8 3/8″; container, height 10 3/8″. Colorado State Museum, Denver (Cat. No. 500). Collected by A. D. Osborne in Nebraska before 1908. These dolls are used in an Eastern Sioux variant of the Grand Medicine Lodge ceremonies.

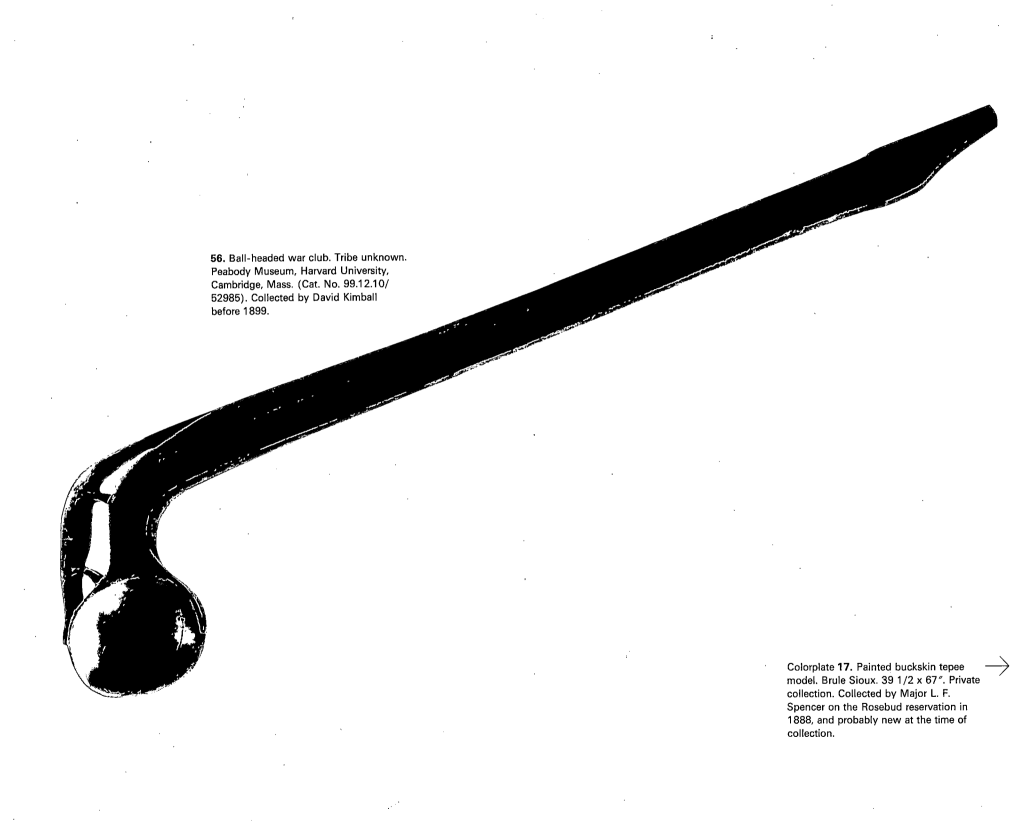

56. Ball-headed war club. Tribe unknown. Peabody Museum, Harvard University, Cambridge, Mass. (Cat. No. 99.12.10/ 52985). Collected by David Kimball before 1899.

Colorplate **17.** Painted buckskin tepee model. Brule Sioux. 39 1/2 x 67″. Private collection. Collected by Major L. F. Spencer on the Rosebud reservation in 1888, and probably new at the time of collection. →

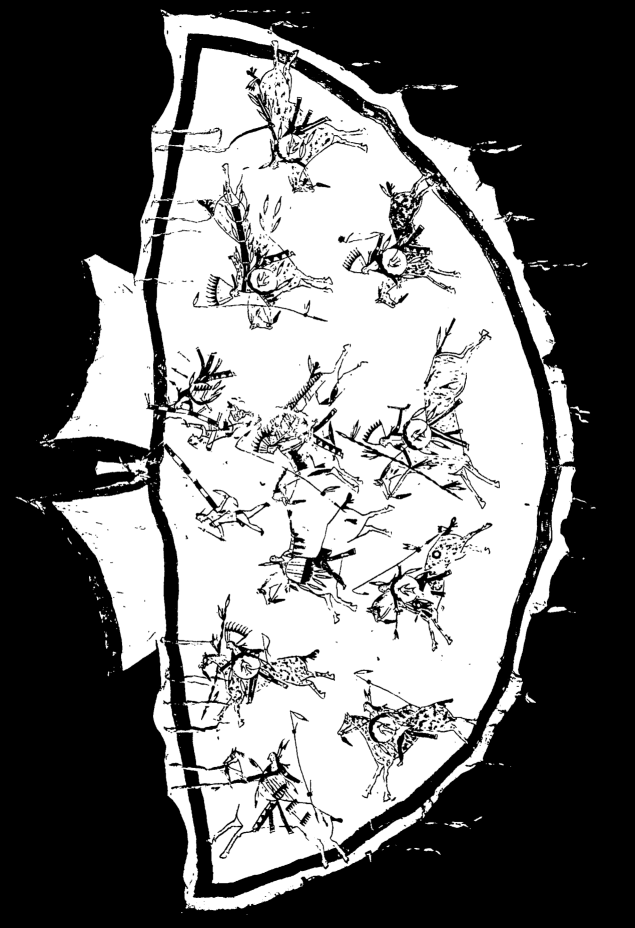

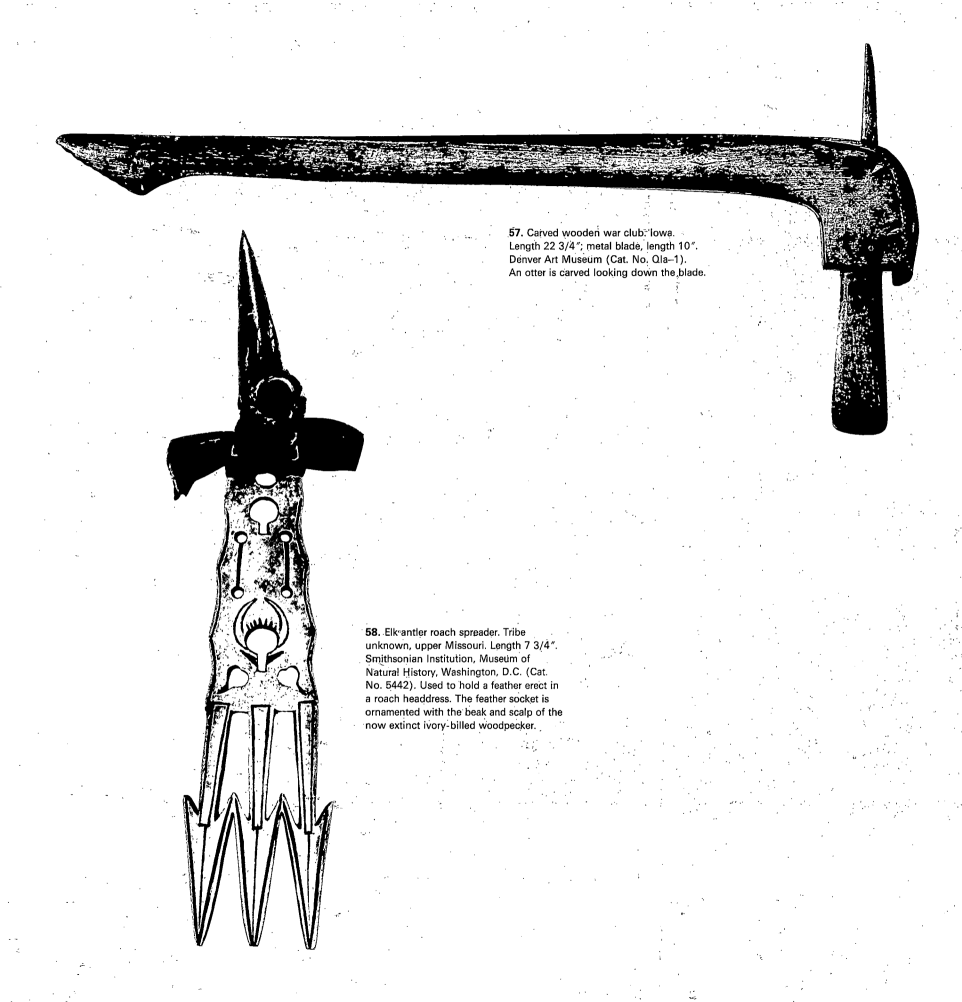

57. Carved wooden war club. Iowa.
Length 22 3/4"; metal blade, length 10".
Denver Art Museum (Cat. No. QIa–1).
An otter is carved looking down the blade.

58. Elk antler roach spreader. Tribe
unknown, upper Missouri. Length 7 3/4".
Smithsonian Institution, Museum of
Natural History, Washington, D.C. (Cat.
No. 5442). Used to hold a feather erect in
a roach headdress. The feather socket is
ornamented with the beak and scalp of the
now extinct ivory-billed woodpecker.

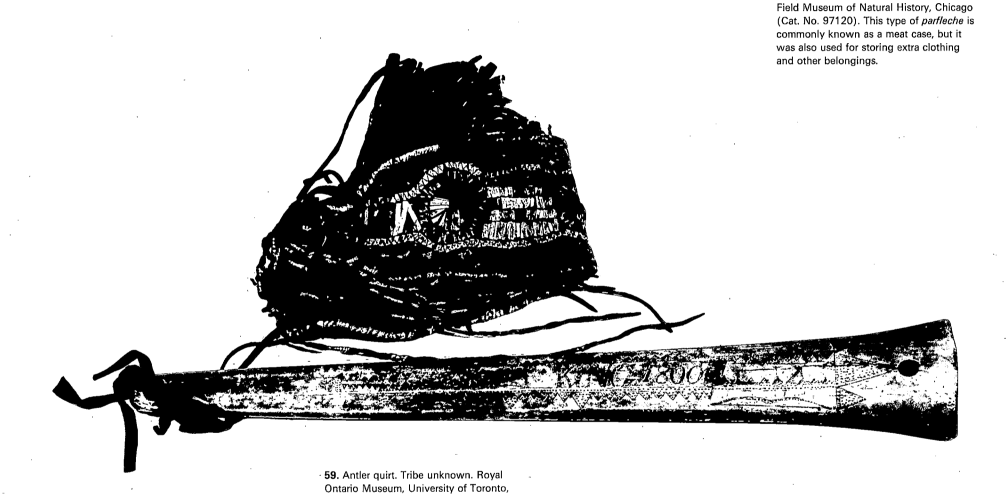

Colorplate **18**. Painted *parfleche*. →
Cheyenne. c. 1875–1900. 18 x 42".
Field Museum of Natural History, Chicago
(Cat. No. 97120). This type of *parfleche* is
commonly known as a meat case, but it
was also used for storing extra clothing
and other belongings.

59. Antler quirt. Tribe unknown. Royal
Ontario Museum, University of Toronto,
Canada (Cat. No. HK 1301). The strap is
decorated with porcupine quillwork. The
quirt is finely incised and marked "King
1800."

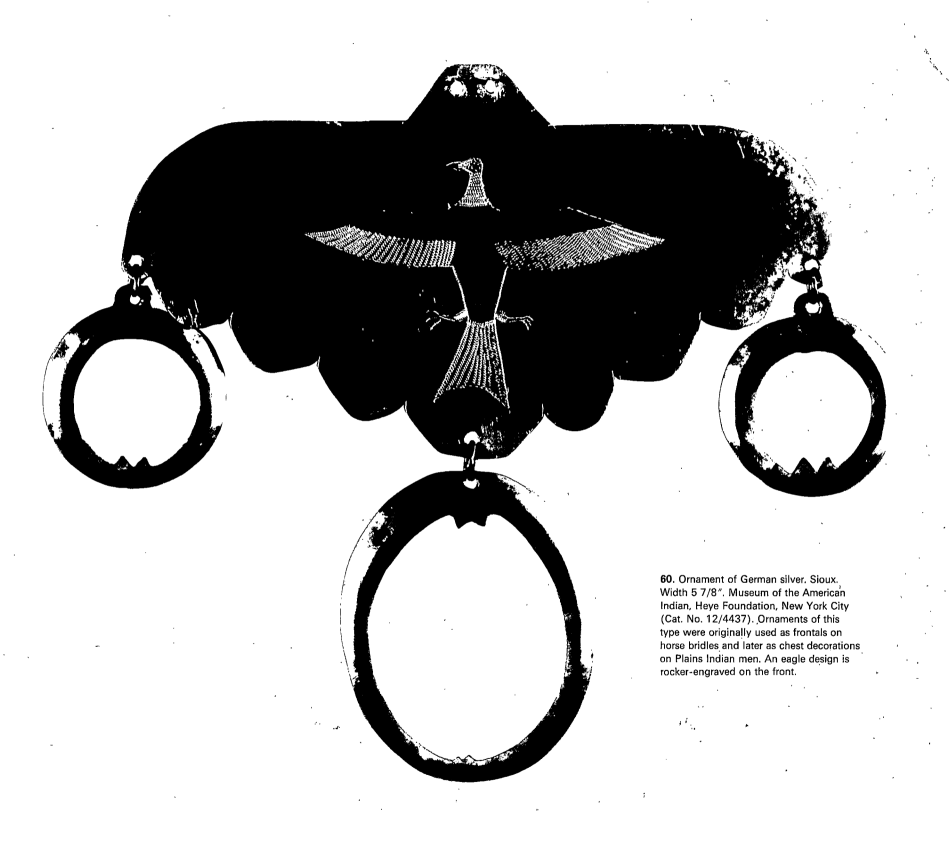

60. Ornament of German silver. Sioux.
Width 5 7/8″. Museum of the American
Indian, Heye Foundation, New York City
(Cat. No. 12/4437). Ornaments of this
type were originally used as frontals on
horse bridles and later as chest decorations
on Plains Indian men. An eagle design is
rocker-engraved on the front.

Colorplate **19**. Ribbon appliqué shawl. →
Osage. 55 1/2 x 67 1/2". Denver Art
Museum (Cat. No. AOs–13). A typical
example of an Osage woman's blanket on
list cloth.

61. Garters. Osage. Length with fringe 33".
Denver Art Museum (Cat. No. B–101).
Tied below the knee to hold up women's
leggings. The hand design is common
among the Osage. Compare with
Colorplate 19.

THE SOUTHWEST

The Southwest area is comprised of the states of New Mexico and Arizona. The land varies considerably from north to south and from east to west. In parts of the area, there are high mountains with piñon pine and juniper blending into arid desert with cactus and sparse vegetation. Its inhabitants comprise three distinct types of culture, with of course the usual variations within each of the three major divisions. The Pueblo peoples have developed a sophisticated agricultural town dwelling society; Navaho and Apache are nomadic hunters; and Papago, Pima, and Yuma had a primitive farming and gathering existence. The land is diverse, the people are diverse, and the culture area is not clearly defined.

The Pueblo farmers live in permanent villages along the Rio Grande in New Mexico, from Taos in the north (plate 62), down to Isleta, just south of Albuquerque; west to Acoma and Laguna and Zuñi, and north to the Hopi villages in Arizona. The Pueblo peoples have occupied the area continuously for well over one thousand years; indeed, some of the present-day villages have been occupied in the same location since before the first Spaniards arrived in 1539. Thanks to the preservative qualities of the dry climate, a good deal is known about the prehistory of the region. The Pueblo peoples are the most conservative and perhaps the most resistant to change of any Indian group in the United States in spite of almost continuous and intensive white contact for over four centuries. They were certainly influenced by the early Spanish settlers, but have also managed to retain their aboriginal culture to a surprising degree. Most groups continue to farm with the same primitive tools that their ancestors used, and they continue to plant the same crops of corn, beans, and squash. Corn remains the staple food even though, of course, many villages now have irrigation and a wide variety of newly introduced crops.

Because of their dependence on agriculture in an arid region where agriculture is difficult, the people have developed a complex religious life

centered around rainmaking and crop fertility. The rituals are so lengthy that it has been estimated that the average Hopi man spends almost half his time participating in dances or ceremonies. A good deal of energy is spent in making ceremonial clothing and fetishes and learning songs in preparation for the actual performance of the dances. This is men's work, so it is the men in Pueblo villages who make the masks, prayer sticks, and *kachina* dolls.

There are cultural differences between the eastern and western Pueblos, and stylistic differences between every Pueblo, but in general the art of the entire region is very similar. All groups formerly made their own baskets and textiles, and they still make their own pottery. In recent years the Pueblos of Hopi and Zuñi have produced the bulk of the woven textiles such as kilts, belts, sashes, and dresses. Pottery varies from village to village, but as would be expected, neighboring villages often show a blending of styles. Frequently the origin of any piece of painted pottery is determined by a combination of the type of clay used, the thickness of the ware, and the character and color of the design. In general, the style areas for pottery coincide with the geographical proximity of the villages. The Hopi, being somewhat isolated in northeastern Arizona and surrounded by the Navaho reservation, produced a distinctive ceramic ware usually identifiable by the character of the clay. The unslipped ware fires from an orange to a cream in an uneven mottling which is caused by oxidation in firing. Sometimes the pottery is slipped in red, but the orange cream is more common. Designs are painted in red, black, and sometimes white. The forms are usually conventionalizations of natural and human forms (plates 66–68).

Prehistoric Hopi pottery was much like modern forms, but underwent a slow deterioration until the late nineteenth century. A Tewa potter named Nampeyó from Hano (First Mesa) studied the old pottery and sparked a revival of fine quality ware which has continued to the present. The bulk of what present-day production exists comes from the First Mesa, although it is lacking in both quality and quantity.

The groups to the east of the Hopi—Zuñi, Acoma, Laguna, Santa Ana, Zia, and Isleta—all make a related type of pottery with a white slip and painted designs in red and black. At Zuñi the base part of the pottery is slipped with black or brown in contrast to red or orange at the other villages. In addition, Zuñi pottery is usually decorated with a design laid out in equally

divided sections, ranging from two to four. Designs include rosettes and animals with arrows drawn from their mouths to their hearts (plates 3, 69, 70). The thinnest pottery in the Southwest is produced at Acoma, which is usually enough to identify it regardless of its design (plate 71). This pottery, painted in black and various shades of red orange, tends toward allover patterns of geometric units, or a style, probably borrowed from Zia, of birds and flowers. Some recent floral examples show painting in bright commercial paints after firing. Lucy Lewis, a famous potter from Acoma, has developed a new style based on prehistoric wares in black-on-white. At least three other women at Acoma now produce similar black-on-white wares. It is probable that more pottery is being produced at Acoma today than at any other Pueblo.

At present, the small quantity of pottery produced at Isleta is of a strictly commercial variety.[14] Isleta pottery is often slipped in white all over, including the bottom. A black-on-cream style is common at Santo Domingo, Cochiti, Tesuque, and San Ildefonso. The Santo Domingo ware is very distinctive, with geometric designs being most common (plate 73). A considerable amount of pottery is still being made at Santo Domingo, but mainly for tourist sale. Some of this is in the traditional style, but the bulk of modern production is in black-on-red, red and black-on-cream, or a polished red ware with polychrome painting after firing. Much of this recent pottery is decorated with floral designs. Cochiti, San Felipe, and Tesuque tend toward small designs on a basically cream background. Some potters at Cochiti used to make a quantity of realistic human and animal forms for tourist sale, but these are uncommon today. Very little old style Tesuque pottery is available. The most common forms from this Pueblo now are the small so-called "rain gods" produced for tourist sale, and poorly fired red ware painted with bright poster paints after firing.

Although the black-on-cream ware was common at San Ildefonso during the last century, this Pueblo is most noted for the polished black-on-black invented by Maria and Julian Martinez about 1919. These pots are painted after polishing, so that the painted area appears as dull black on a polished black surface. The painting is done by men after the women have made the basic ware, an unusual departure from the common practice where women make the pots from start to finish. About 1931, still another type of ware in the form of designs carved into the pot in low relief was introduced at San Ildefonso by Rosalie Aguilar. The Pueblo of Santa Clara, being situated

right next to San Ildefonso, makes a very similar pottery type. Santa Clara produces the standard polished red or polished black (plate 74) as well as the black-on-black and carved forms. Some of the pottery made at San Juan is also of the polished red or black variety; however, San Juan's specialty is pottery which is partially slipped and polished on the top rim only. San Juan also has a revival of a prehistoric form which consists of a light brown ware with fine scratched lines, usually in geometric designs (plate 75).

Still another distinct pottery type is produced at Taos and Picuris Pueblos in the northern part of the Southwest area. Here the clay has a high mica content. The pottery is unslipped to produce a brownish ware which has a glistening surface owing to reflections from the mica.

In addition to work in all these basic traditional forms, there has been a considerable amount of experimentation with new clays, new shapes, and new decorative techniques at various Pueblos. The incentive usually stems from an effort to produce more salable wares to non-Indians. Both San Ildefonso and Santa Clara have developed a finely painted polychrome ware that has had mild commercial success. But in general, pottery is a dying art. At any one Pueblo only a few women still make it, and of course, in some Pueblos no pottery is made at all.

Basketry is practiced in many of the Pueblos, but is usually very simple, undecorated work. Plaited yucca leaves were used for mats and winnowing trays at several villages, but these items are only made at Jemez and in the Hopi towns today. The finest baskets are made by the Hopi in two different techniques. On the Third Mesa the women specialize in wicker baskets made on frameworks of sumac. These take the form of round trays with colorful designs worked into them (plate 76). The patterns, done in native dyes, usually represent *kachinas*, while birds and whirlwind patterns are also common. On the Second Mesa the specialty is a type of coiled basket made of yucca leaves around a grass core (plate 77). While the technique is completely different, the designs and colors are very similar to those used on the Third Mesa.

Weaving is an old Pueblo craft. In early times the principal material, a type of native cotton, was grown to be spun. Of course, after the introduction of sheep by the Spanish, wool was commonly used for decoration, often as embroidery on a cotton garment (plate 78; colorplates 20, 21). Throughout the Pueblo area, weaving was man's work. Kilts, belts, and sashes had to

be woven for use in ceremonial dances. Among the Hopi, men also made the wedding costume for their brides. The woven designs, mainly consisting of transverse stripes, are usually quite simple; however, the construction itself is often rather elaborate. Although a plain basket-weave was common, Pueblo weavers were able to produce complex twills in diamond and herringbone patterns. Men's sashes were made in a type of brocade called "false embroidery," and women's belts were ornamented by a system of floating the warps to produce a design. A special type of white belt, known as a "rain sash" is done by braiding, the strands becoming alternately both warp and weft. The most elaborate garments are those with true embroidery which is often in complex, colorful designs. Except in the Hopi villages, the women do all the embroidery.

The Hopi are the principal producers of woven materials, the center being the villages of Hotevila and Shimopovi, and while other Pueblo groups occasionally make floated-warp belts, embroider commercial cotton cloth, or knit or crochet stockings and leggings, most of their ceremonial clothing is obtained in trade from Hopi weavers.

The items made in connection with the religious ritual are often some of the most impressive products of the Pueblo craftsman. The *kachinas*, or godlike spirits, always make their appearance in the dances wearing characteristic masks, some of which are elaborate in form (plate 6). Masked ritual was most highly developed in the western Pueblos, and especially at Hopi and Zuñi. Little is known about *kachina* ritual at some of the northern Rio Grande Pueblos, and it is believed to be absent altogether from Taos and Picuris. The Hopi and Zuñi often allow non-Indians to witness masked dances. The other Pueblos prohibit spectators altogether.

The masks are usually made of heavy leather or rawhide in a variety of basic shapes (plates 79–81). Some cover only the face, while others, inverted cylinders in form, cover the entire head. These masks are repainted with appropriate designs before each dance, and appendages such as ears, mouth, and nose are made from feathers and fur (or evergreen) ruffs. Often the same basic mask can be used to represent several different *kachinas* by a change of ornaments and painted designs. In former years these masks, along with other ceremonial equipment, were jealously guarded in the *kivas*, and only a few were collected before the turn of the century. Now a few which have never been ceremonially used are being made strictly for sale. This breakdown in

155

religious restrictions is a result of several factors. Some of the material is being offered for sale by Indians living off the reservations, but a good deal of it becomes available due to marriages between tribes. For example, a Zuñi man married to a Laguna woman and living at Zuñi might still observe the taboos against selling religious equipment, but his wife would not be under the same obligations.

At Hopi, Zuñi, Acoma, Jemez, and Laguna, the people make small wooden dolls carved to represent the *kachinas* (plates 82–86). These are given to the young girls to play with, and also so that the children can learn about their religion. The Hopi are the principal producers of *kachina* dolls, which are a fairly recent innovation in that the oldest example known dates from about 1879. Old dolls are quite flat with little detail of hands or feet. This style has continued to the present in a type of doll given to infants. However, there has been a tendency toward realism and natural bodily proportions, with even muscles depicted. The material most often used today is the soft root wood of the cottonwood tree.

Zuñi dolls can often be distinguished from Hopi ones by two signs: the Zuñi dolls' arms are frequently movable at the shoulders, and they are dressed in actual cloth apparel rather than painted clothing. The limited number of dolls known from Jemez, Acoma, and Laguna resemble the older Hopi forms without any indications of legs or arms. Hopi dolls are fairly common in collections; in fact, the Hopi have developed a considerable market for dolls. Until recently, dolls from Zuñi were quite scarce and Acoma and Laguna dolls were almost unknown. Now these three groups are also following the Hopi pattern of making dolls for sale.

Stone or wood fetishes are carved for a variety of religious usages by most Pueblo groups. Often they are used as shrine figures or offerings in the *kivas* (sacred underground chambers; plate 87), or in holy places situated away from the village proper. The wooden war gods made at Zuñi are well known (plate 88); new ones are still made each year. Equally impressive are the war god images of Acoma and Laguna, and the wooden shrine figures carved for altars in Hopi and Zuñi *kivas*. The animal fetishes made of hard stone probably represent the highest development of stone carving among Indians in historic times (plate 89; colorplate 2). They are excelled only by some of the stone carvings produced in the Northwest Coast area. Unfortunately, because of the tremendous demand for these stone fetishes among

collectors, they have been faked in large numbers. It is often difficult to distinguish the authentic from the spurious.

Stone and shell were commonly used for jewelry. Turquoise was locally mined, and prized for its decorative value everywhere among the Pueblo people. Shells, on the other hand, had to be imported from Mexico or California. Because they were rare and were associated with water, they also were valued ornaments. Some silver jewelry was probably made by Pueblo smiths from the latter part of the nineteenth century onward, but it so much resembles Navaho work that it is not usually recognized as being of Pueblo manufacture. Within the last thirty years, however, the Hopi have developed a rather distinctive style utilizing cutout silver soldered over sheet silver (plate 90); the recessed portion of the design is blackened with "liver of sulphur" (impure potassium sulfide). These Hopi designs are derived from pottery decoration, and have a very contemporary appearance. The silver industry at Zuñi has flourished in recent years, with as many women smiths as men. The work is often characterized by the use of many small turquoise sets, or by elaborate inlays of blue turquoise, black jet, and red spiny oyster shell. The smiths at Santo Domingo produce a wide variety of ornaments, most of which are very like the Navahos' work; only a few special Santo Domingo types have been developed, such as animal form brooches (plate 91). In general, Santo Domingo work is produced for sale, and is made of thin silver and set with turquoise of poor quality; however, some designs made for local use are as good as the best made anywhere in the area.

Painting has always been a Pueblo art, since prehistoric times when artists worked on pottery and *kiva* walls. In addition, some groups such as the Hopi, made dry sand paintings for some *kiva* ceremonies, simple naive designs on pottery tiles, and elaborate designs on Butterfly Dance *tablitas*. Shortly after 1900, the American anthropologist Jesse Walter Fewkes encouraged two Hopi artists to produce a series of watercolor sketches of *kachina* figures for a study he was making on Hopi religion. They were followed by other Indian artists who produced paintings on paper for sale to tourists. By 1917 this tendency was fully developed at San Ildefonso where several artists were devoting much of their time to painting. Art classes were taught in the Indian schools in Santa Fé and also in Oklahoma, and art was generally encouraged. Today there are well over one hundred artists from the Plains, Navaho, and Apache, who are as good as the Pueblo artists (plate 93;

157

colorplates 22–24). Everywhere the style is characterized by the use of water-colors or caseins in a flat outline painting. Bright colors are the rule and no effort is made at shading, but minute detail is shown in very fine lines. Today this art is very much alive, and several annual competitive exhibits are held at the Philbrook Art Center in Tulsa, the Gallup Intertribal Indian Ceremonial, at the Museum of New Mexico, at Scottsdale, Arizona, and elsewhere. Most present-day artists continue to paint in the fine-line flat style; however, a few are experimenting with new techniques and styles and are producing some exciting work.

The Pueblo peoples have, in general, resisted change with vigor. It sometimes seems that they firmly believe their way of living is the best possible, and that if their ceremonies were ever to stop, the world might come to an end. But in spite of the tenacity with which they cling to their old culture, many influences have affected them, and in a number of fields a good deal of change has occurred. Since these people have been in contact with Spanish settlers for some four hundred years, for instance, they have inevitably adopted some Spanish elements into their culture. All Pueblo villages have a Catholic church, and the people are devout Catholics although they maintain their own religions as well. If having one religion is good, they feel, then having two is better. Many Pueblo men speak at least three languages, their own tribal language, English, and Spanish. Sometimes they can add a little Navaho, or the language of a neighboring village as well. It has been said that by watching a Pueblo man change his clothing you can see the influences of three cultures. His undergarment is often still the native breechclout, but now made of commercial cotton cloth. Over this he will wear a pair of trousers cut in the Spanish style with flaring bottoms and a slit up the outside. And over this goes a pair of commercially manufactured pants.

The northern Rio Grande groups have also received considerable influence from the Plains tribes (colorplates 25, 26). At Taos, the men and women formerly wore leather shirts and dresses, and the men still wear a Plains type hard-sole moccasin. However, perhaps the most obvious cultural exchange has been in Hopi influences on the Navaho.

62. Taos Pueblo. This shows the typical →
adobe architecture of the Southwest.

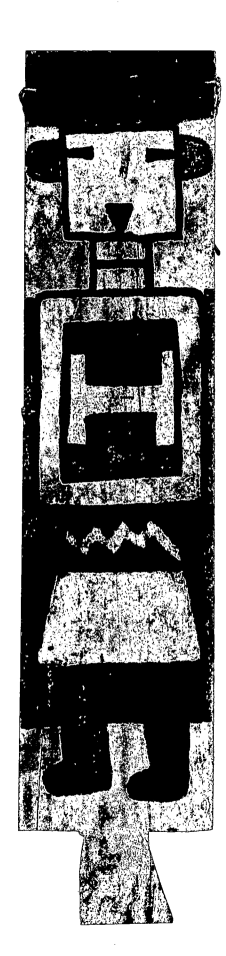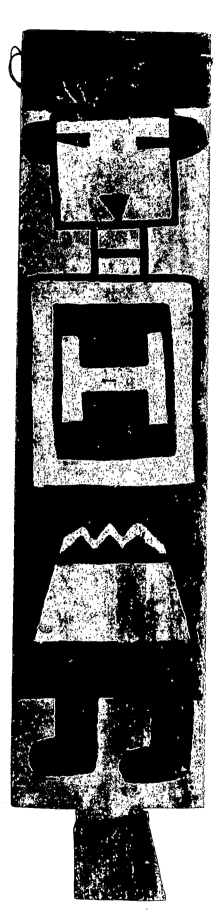

← 63. Corn dancers emerging from the *kiva* at San Ildefonso Pueblo. Note the simple *tablitas* on the heads of the women.

64. Pair of batons for Marau ceremony. Hopi. 20 7/8 x 4 3/4″. Denver Art Museum (Cat. Nos. QH–55 and 56)

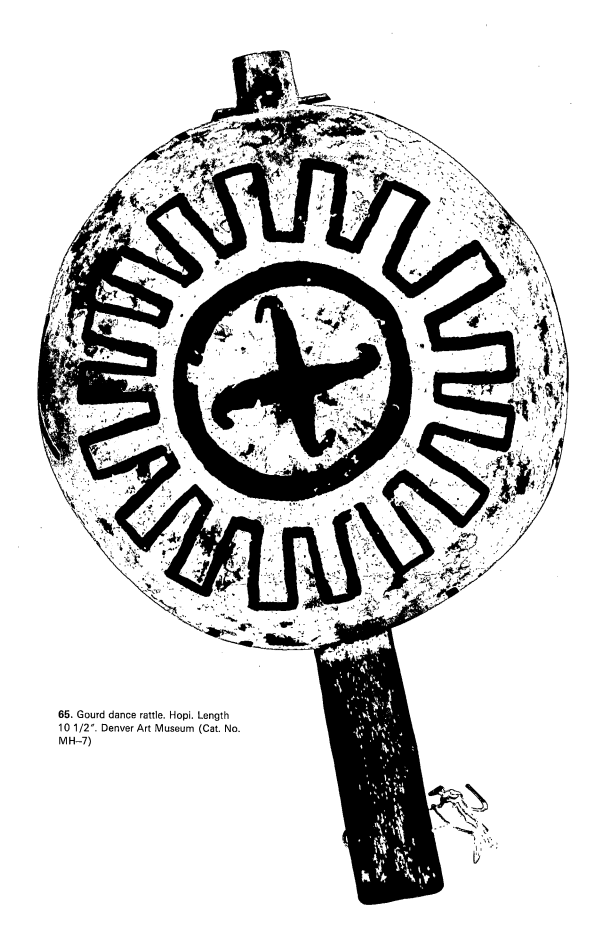

65. Gourd dance rattle. Hopi. Length 10 1/2″. Denver Art Museum (Cat. No. MH–7)

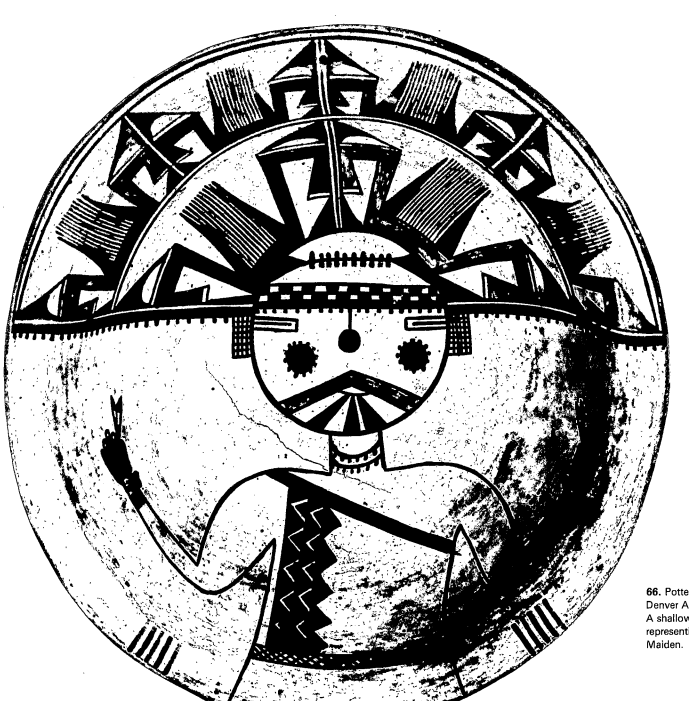

66. Pottery bowl. Hopi. Diameter 9 3/4″. Denver Art Museum (Cat. No. XH–5). A shallow bowl with a painting representing the Polik Mana or Butterfly Maiden.

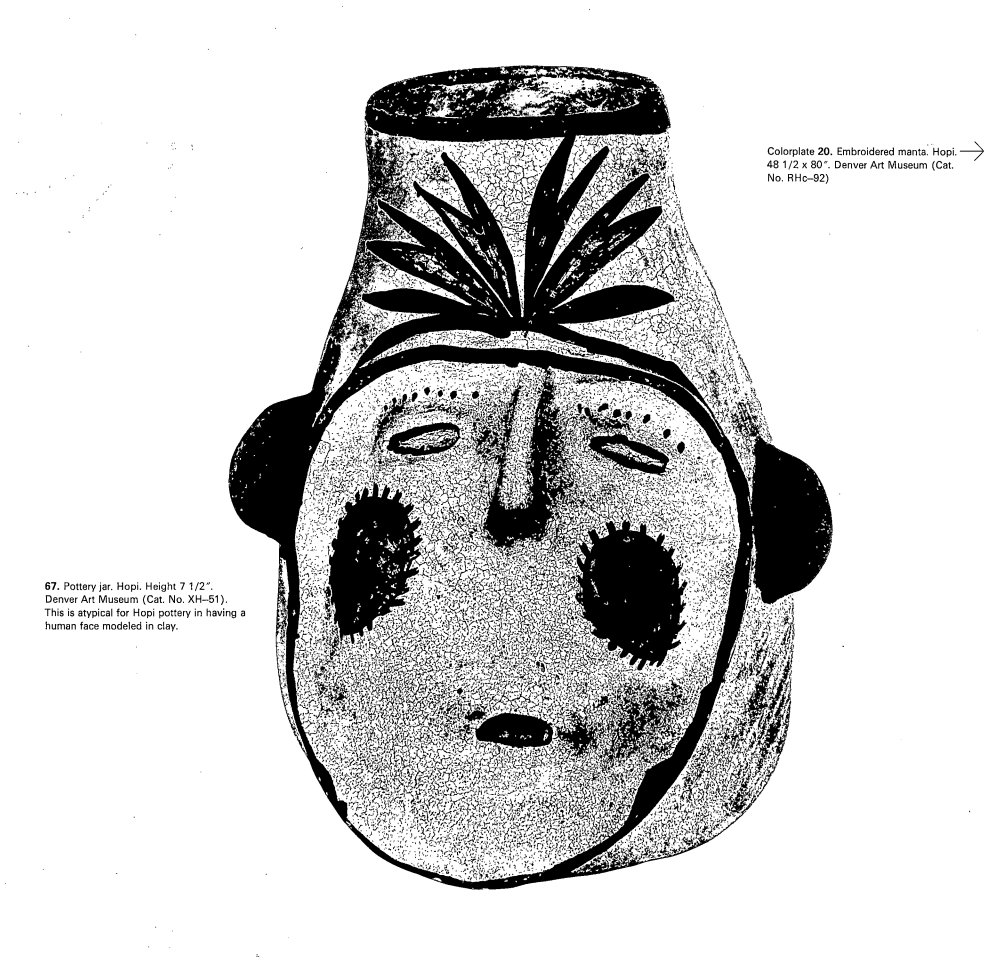

Colorplate **20.** Embroidered manta. Hopi. →
48 1/2 x 80″. Denver Art Museum (Cat.
No. RHc–92)

67. Pottery jar. Hopi. Height 7 1/2″.
Denver Art Museum (Cat. No. XH–51).
This is atypical for Hopi pottery in having a
human face modeled in clay.

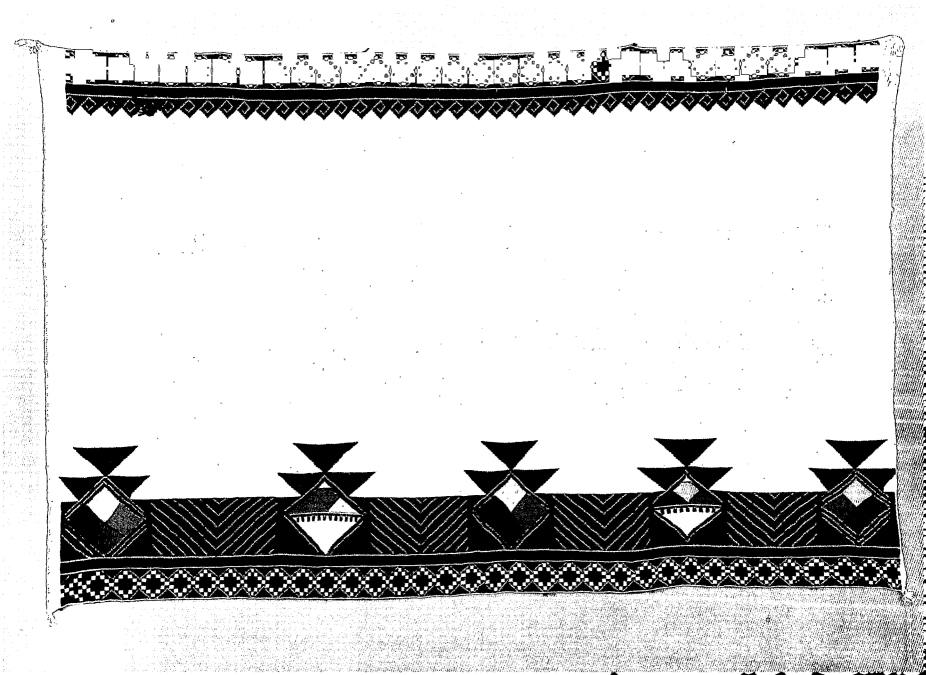

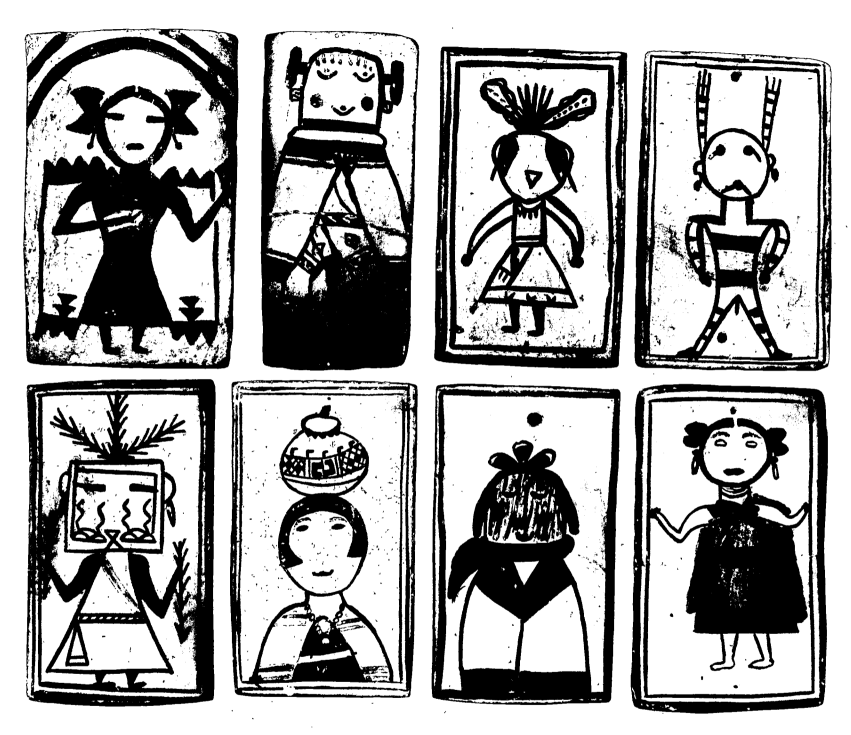

68. Painted pottery tiles. Hopi. Maximum size 6 1/2 x 4 1/4". Denver Art Museum. These show the simple childlike painting style common in the Pueblo area during the later part of the nineteenth century.

69. Pottery owl. Zuñi. 1930. Height
12 1/2". Denver Art Museum (Cat. No.
XZu–39). Made for sale to tourists.
A Zuñi specialty in the 1930s, but now
more commonly made at Acoma.

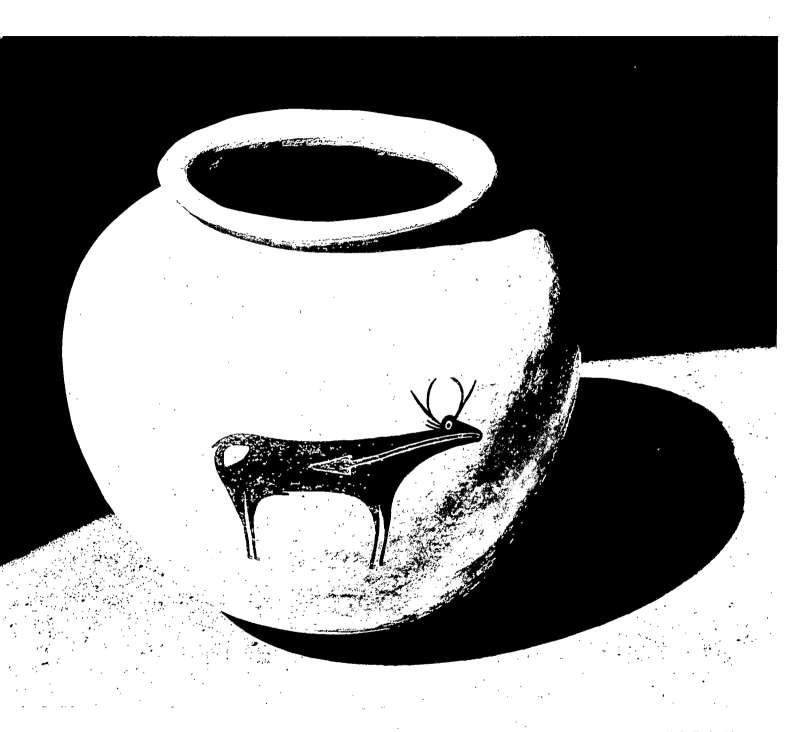

70. Pottery drum jar. Zuñi. Taylor Museum, Colorado Springs, Colorado.

Colorplate **21**. Woman's dress. Acoma Pueblo. ⟶
c. 1875. 46 x 56″. American Museum of
Natural History, New York City.
Embroidered on wool.

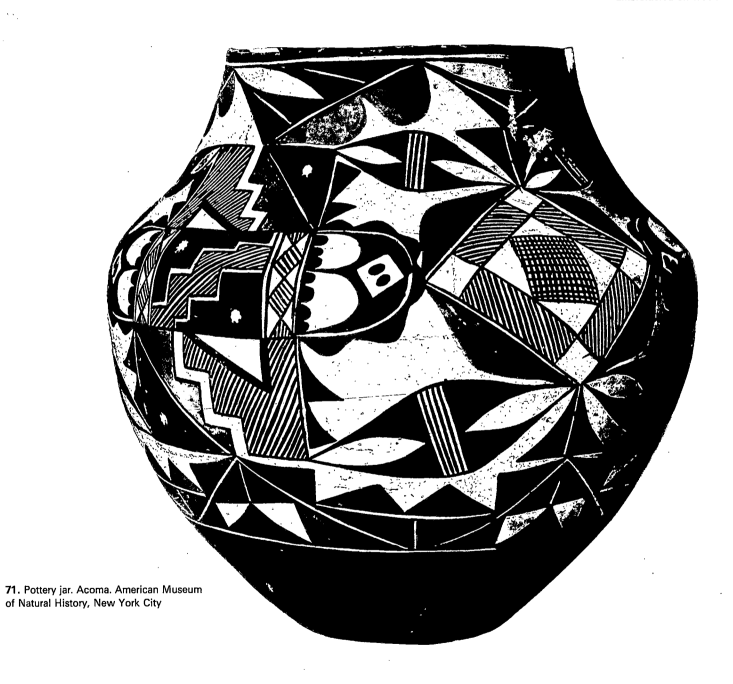

71. Pottery jar. Acoma. American Museum
of Natural History, New York City

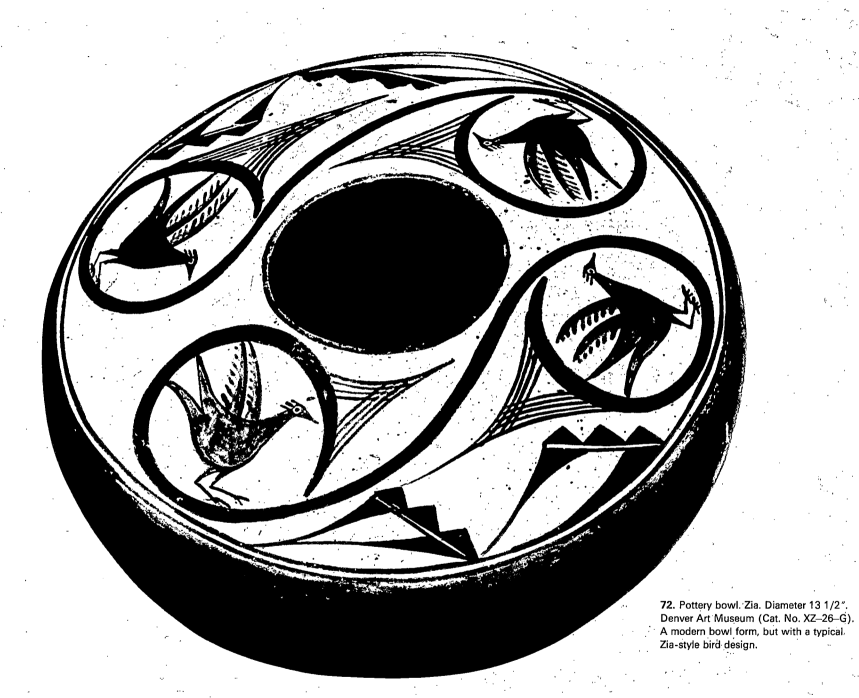

72. Pottery bowl. Zia. Diameter 13 1/2″.
Denver Art Museum (Cat. No. XZ–26–G).
A modern bowl form, but with a typical
Zia-style bird design.

73. Pottery jar. Santo Domingo Pueblo. Height 9 3/4″. Denver Art Museum (Cat. No. XSD–90)

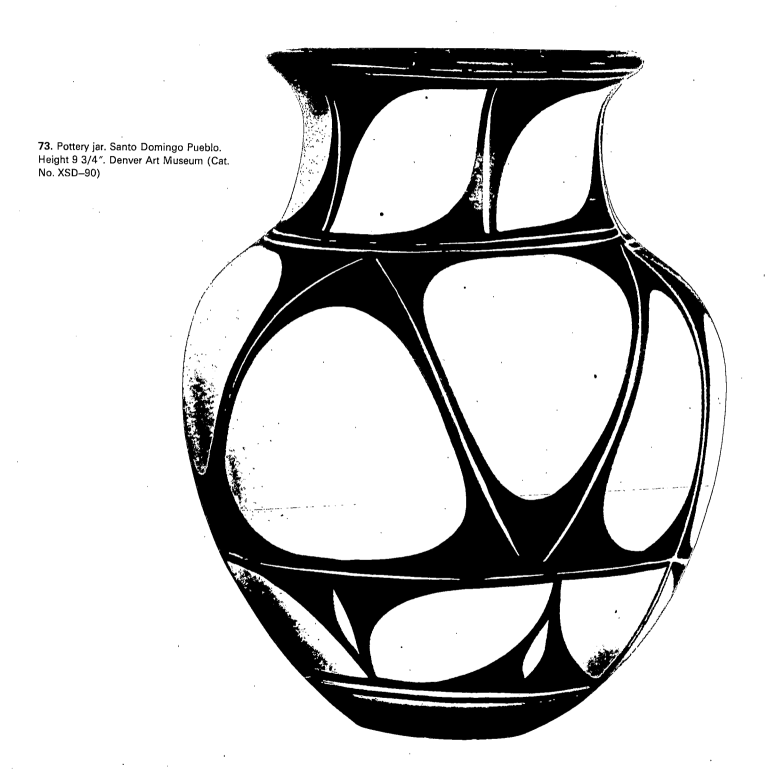

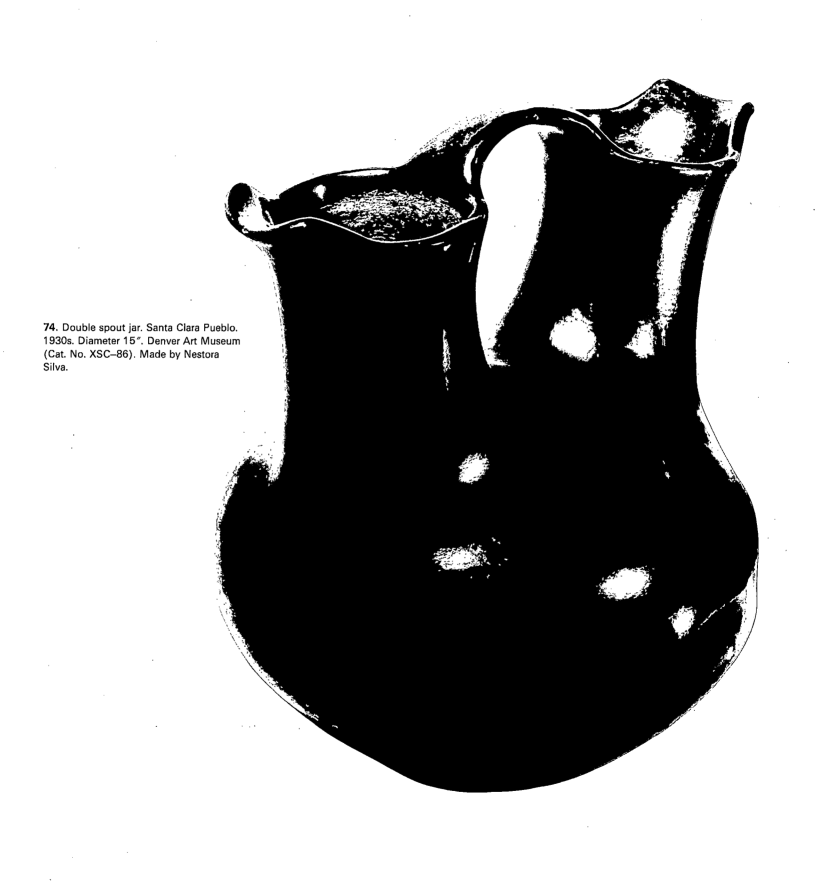

74. Double spout jar. Santa Clara Pueblo. 1930s. Diameter 15″. Denver Art Museum (Cat. No. XSC–86). Made by Nestora Silva.

Colorplate **22.** *Sioux Dancer*. Watercolor. ⟶
Denver Art Museum (Cat. No. PS–26).
Painted by Oscar Howe, a Sioux artist.

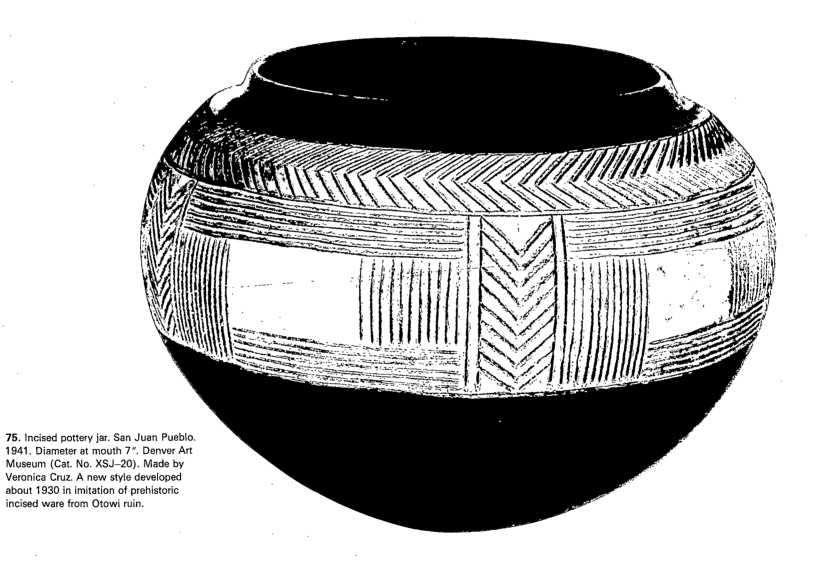

75. Incised pottery jar. San Juan Pueblo.
1941. Diameter at mouth 7″. Denver Art
Museum (Cat. No. XSJ–20). Made by
Veronica Cruz. A new style developed
about 1930 in imitation of prehistoric
incised ware from Otowi ruin.

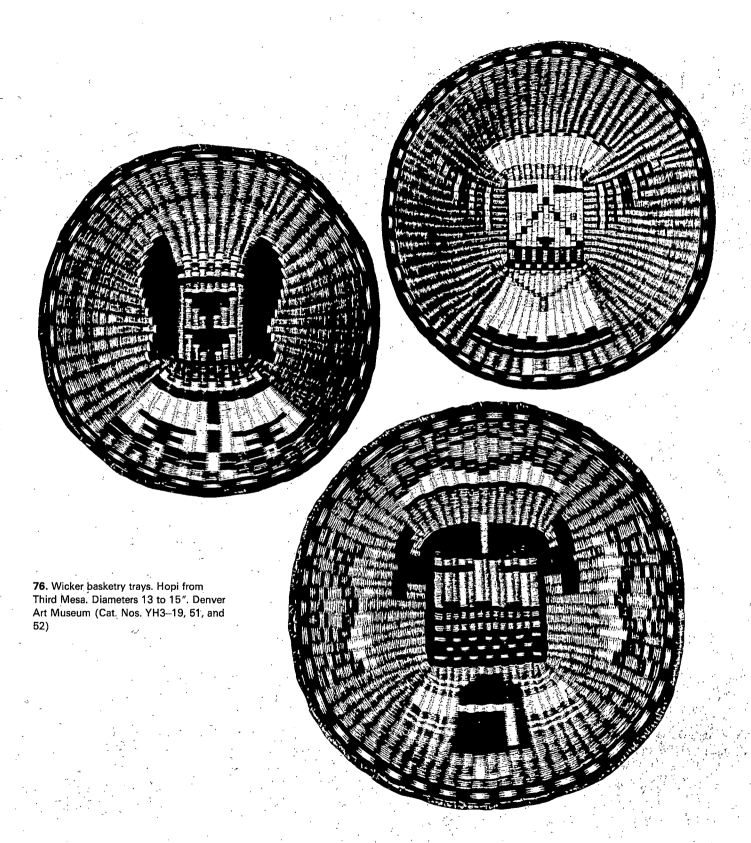

76. Wicker basketry trays. Hopi from Third Mesa. Diameters 13 to 15″. Denver Art Museum (Cat. Nos. YH3–19, 51, and 52)

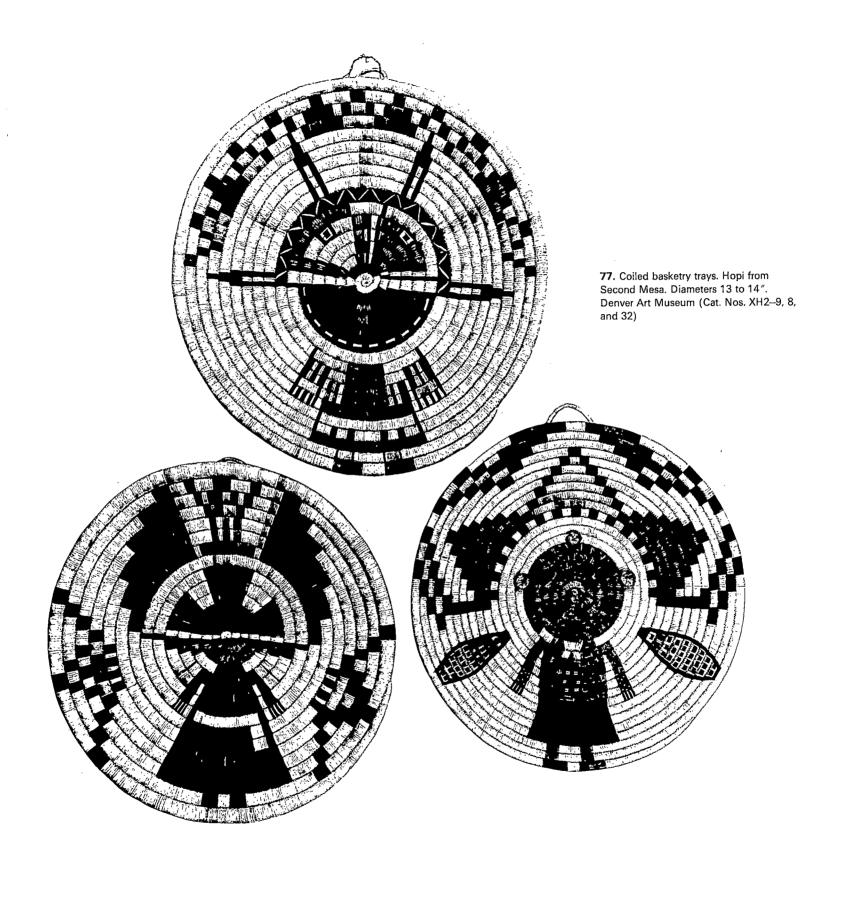

77. Coiled basketry trays. Hopi from Second Mesa. Diameters 13 to 14″. Denver Art Museum (Cat. Nos. XH2–9, 8, and 32)

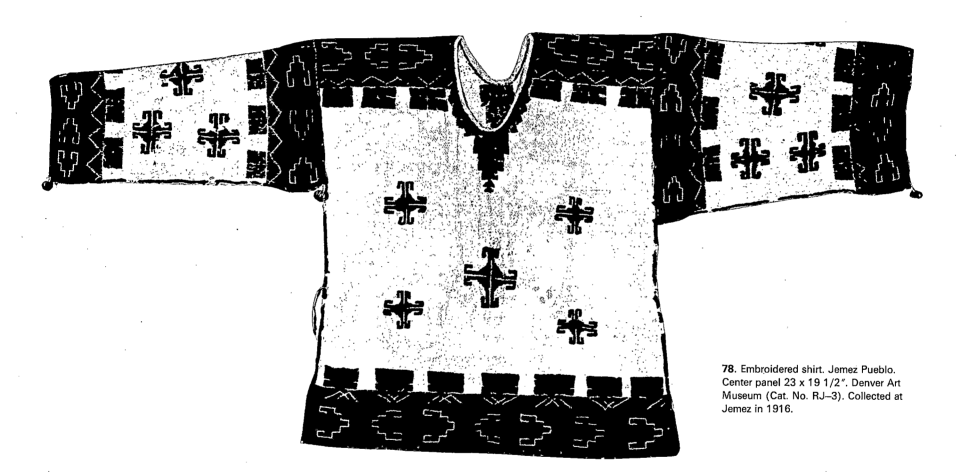

78. Embroidered shirt. Jemez Pueblo. Center panel 23 x 19 1/2″. Denver Art Museum (Cat. No. RJ–3). Collected at Jemez in 1916.

Colorplate **23.** *Navaho Shepherds at Waterhole.* Casein. Denver Art Museum (Cat. No. PN–16). Painted by Harrison Begay, a Navaho artist. →

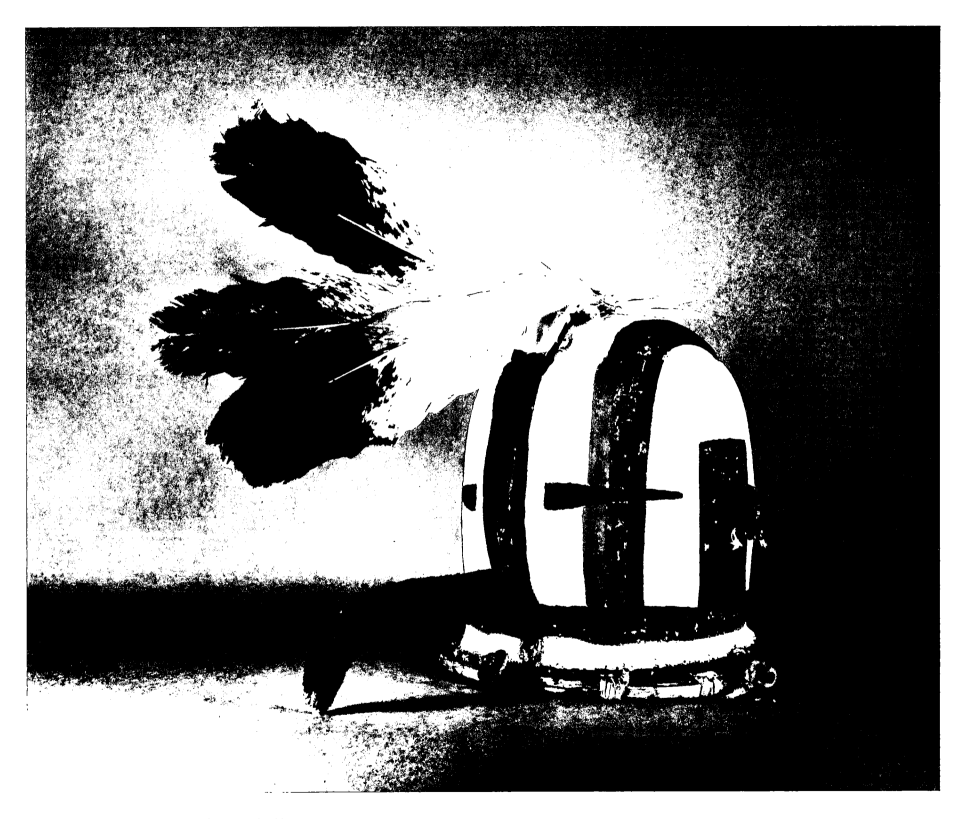

79. *Kachina* mask. Laguna Pueblo. Height 8 3/4″. Denver Art Museum (Cat. No. NL–2)

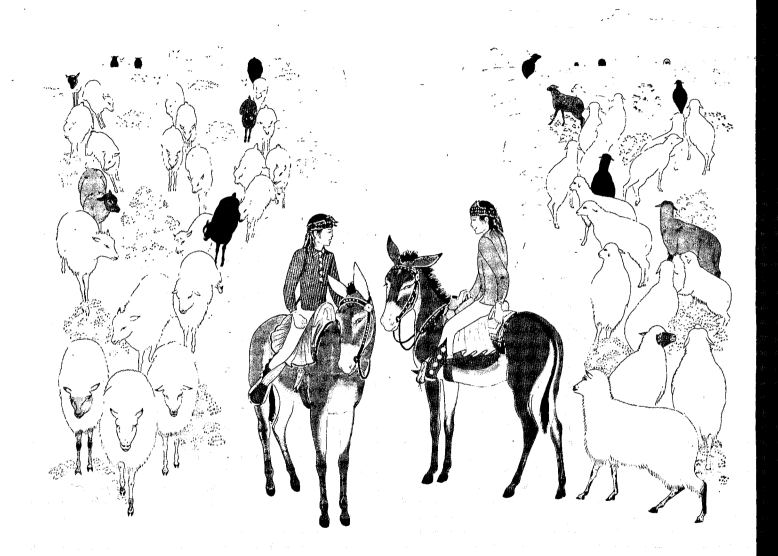

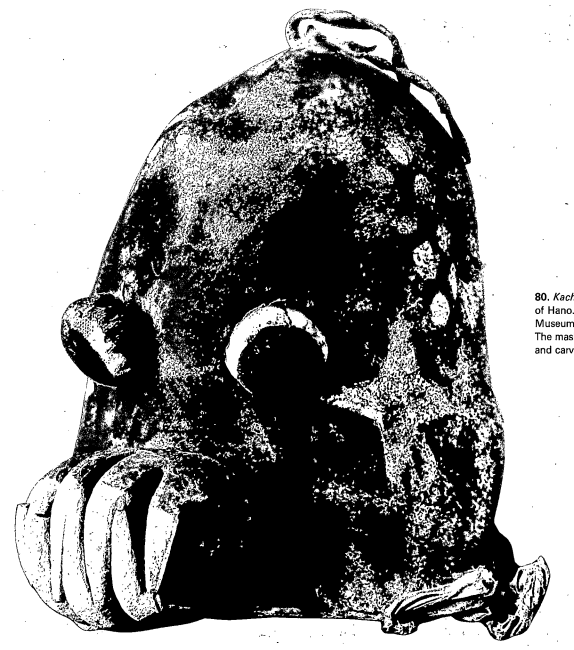

80. *Kachina* mask. From the Tewa village of Hano. Height 8 3/4″. University Museum, Philadelphia (Cat. No. 38720). The mask is of leather with cloth ball eyes and carved wooden protruding teeth.

81. *Kachina* mask. Zuñi Pueblo. Height 9″.
Brooklyn Museum, New York (Cat. No. 04,187).
Represents Anahoho, one of the gods of the
Salimopia.

82. *Kachina* doll. Hopi. Height 6 5/8″. Denver Art Museum (Cat. No. QH–153). Collected by James Stevenson on First Mesa in the winter of 1885–86. Represents Pawik *kachina*.

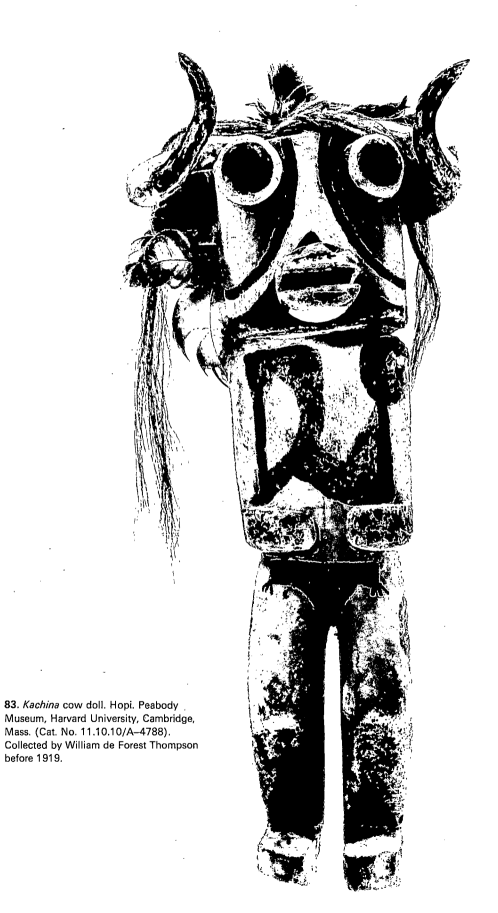

Colorplate **24.** *Herding Sheep.* Watercolor. →
Denver Art Museum (Cat. No. PAC–3).
Painted by Allan Houser, an Apache
artist.

83. *Kachina* cow doll. Hopi. Peabody
Museum, Harvard University, Cambridge,
Mass. (Cat. No. 11.10.10/A–4788).
Collected by William de Forest Thompson
before 1919.

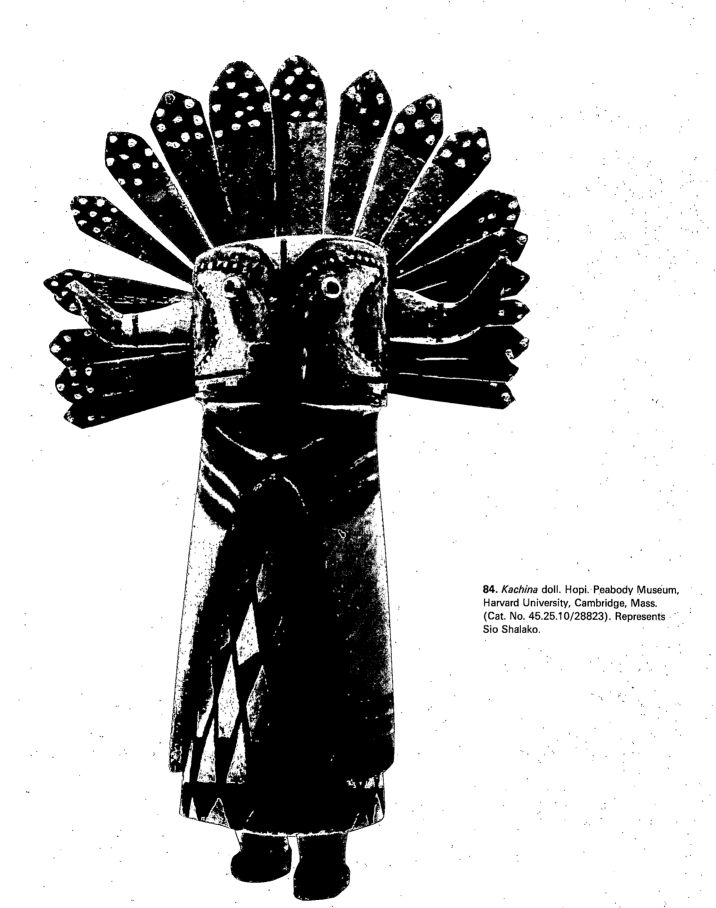

84. *Kachina* doll. Hopi. Peabody Museum, Harvard University, Cambridge, Mass. (Cat. No. 45.25.10/28823). Represents Sio Shalako.

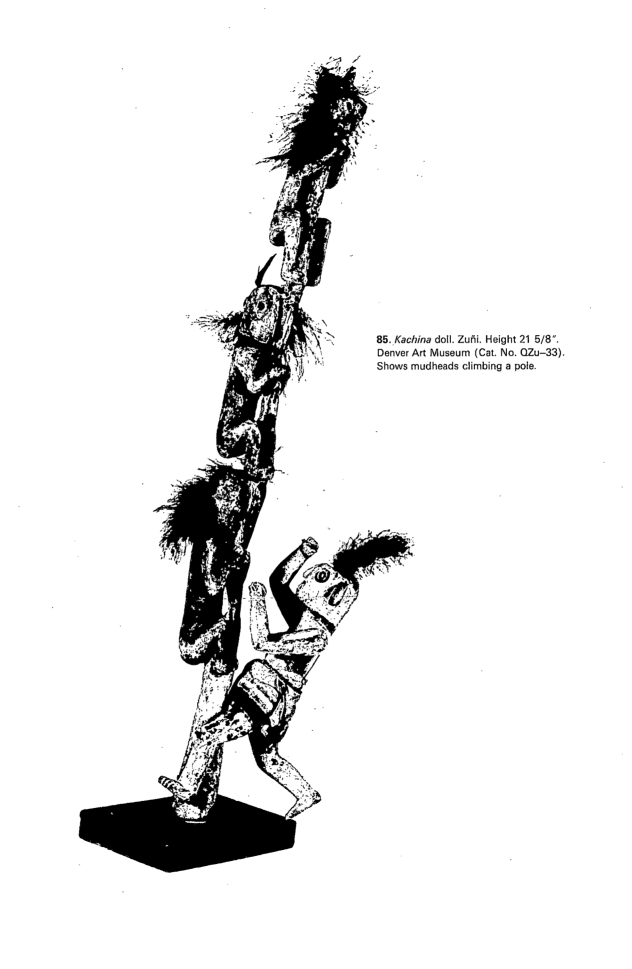

85. *Kachina* doll. Zuñi. Height 21 5/8″.
Denver Art Museum (Cat. No. QZu–33).
Shows mudheads climbing a pole.

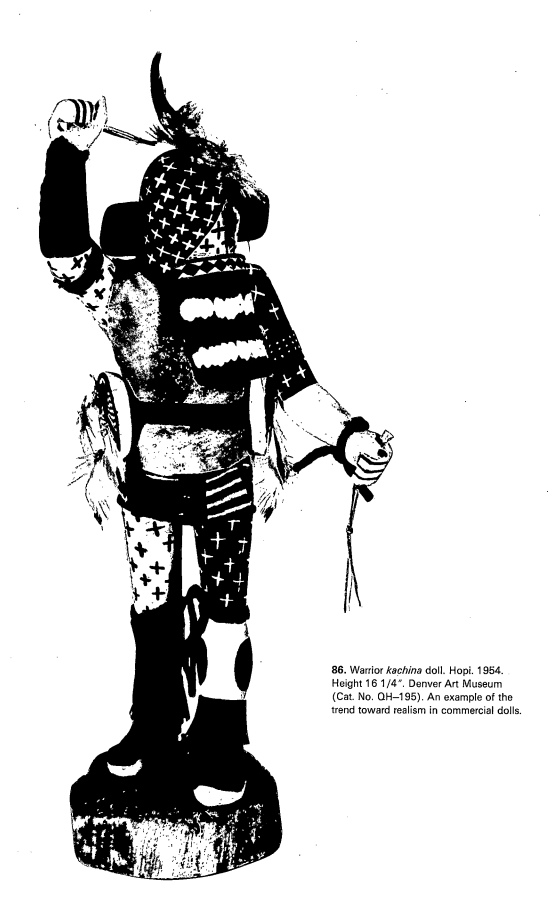

86. Warrior *kachina* doll. Hopi. 1954.
Height 16 1/4". Denver Art Museum
(Cat. No. QH–195). An example of the
trend toward realism in commercial dolls.

87. Altar of the Knife Society. Zia Pueblo.
Note the sand painting and the fetish
figures, including a pair of Chinese dogs.

88. War god figure. Zuñi Pueblo. Height
27 1/2″. Denver Art Museum (Cat.
No. QZu–44). Collected by Arthur G.
Clark about 1900.

CONCORD HIGH SCHOOL MEDIA CENTER
59117 SCHOOL DRIVE
ELKHART, INDIANA 46514

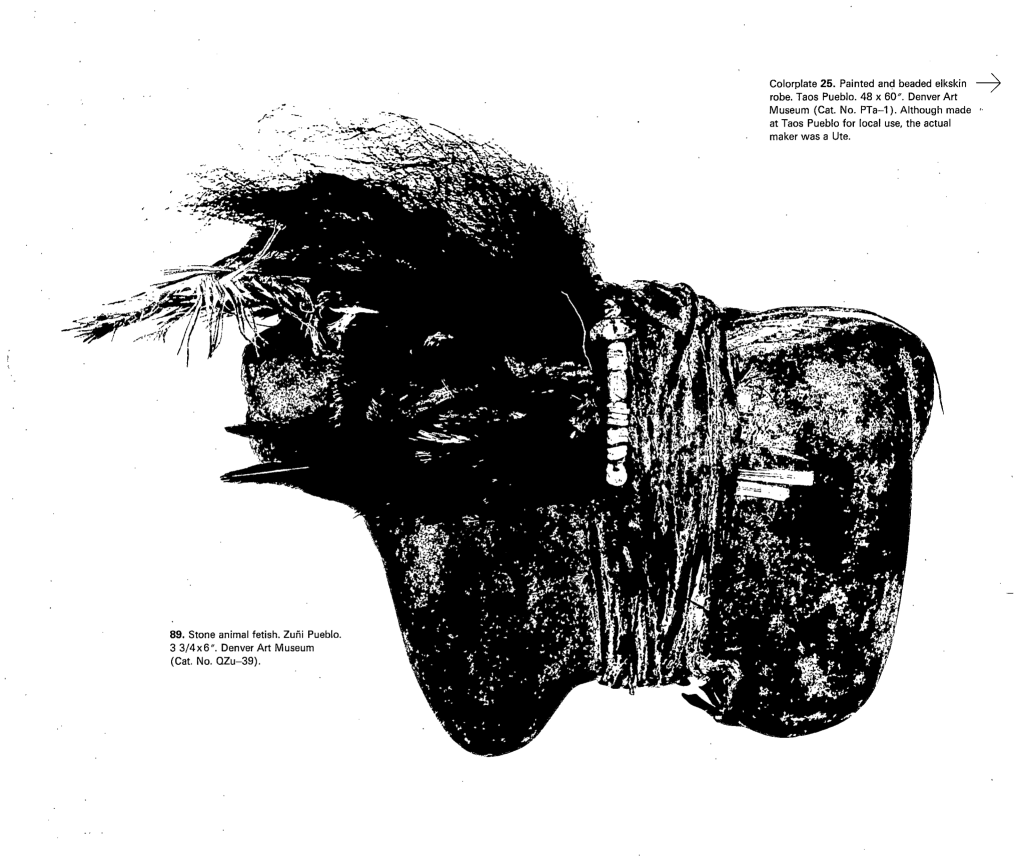

Colorplate **25.** Painted and beaded elkskin ⟶ robe. Taos Pueblo. 48 x 60″. Denver Art Museum (Cat. No. PTa–1). Although made at Taos Pueblo for local use, the actual maker was a Ute.

89. Stone animal fetish. Zuñi Pueblo. 3 3/4 x 6″. Denver Art Museum (Cat. No. QZu–39).

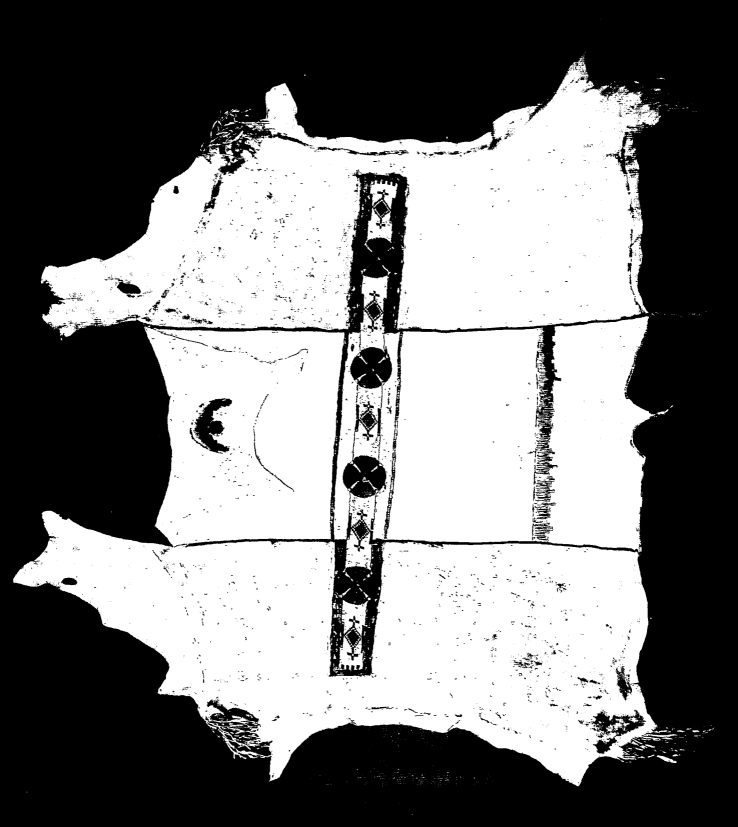

90. Silver bracelet and brooch. Hopi.
Denver Art Museum (Cat. Nos. JH 9 and
10). Hopi silversmiths specialize in a
cutout overlay technique with the cutout
sections oxidized black for contrast
against the silver.

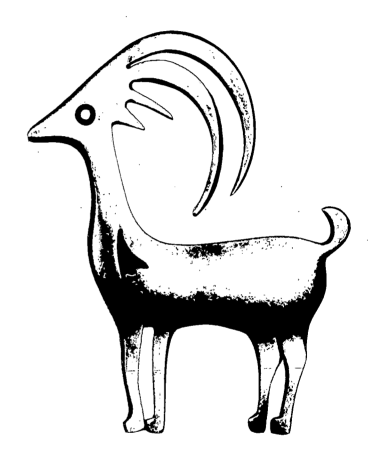

91. Silver animal pins. Santo Domingo
Pueblo. Bird, 2 x 2 3/4"; Animal, 2 1/8 x
1 7/8". Denver Art Museum (Cat. Nos. JSD 2
and 10). Bird made by Tony Aguliar in 1941;
animal made by J. C. Garcia in 1942.

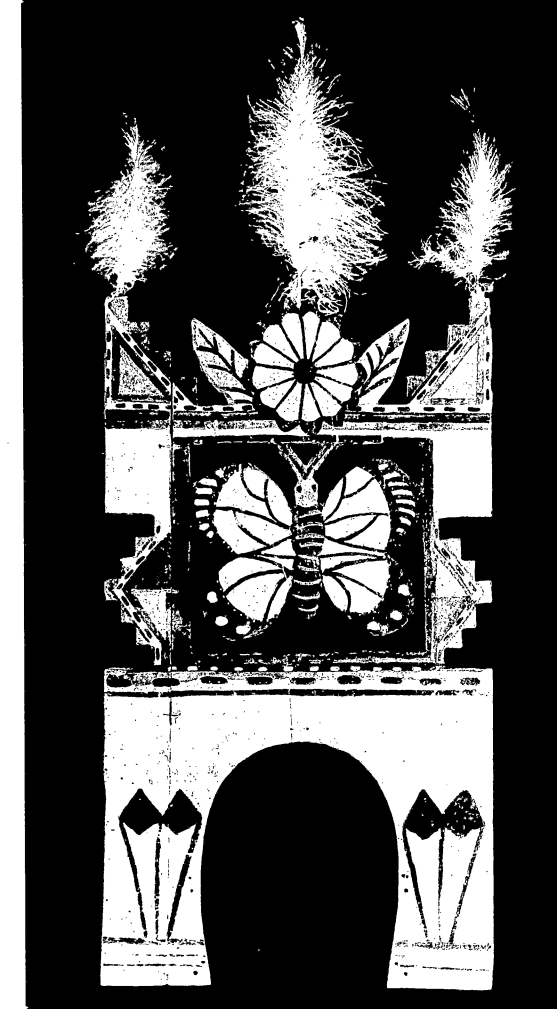

92. Butterfly Dance *tablita*. Hopi Pueblo.
19 1/2 x 11 1/2". Denver Art Museum
(Cat. No. QH–7)

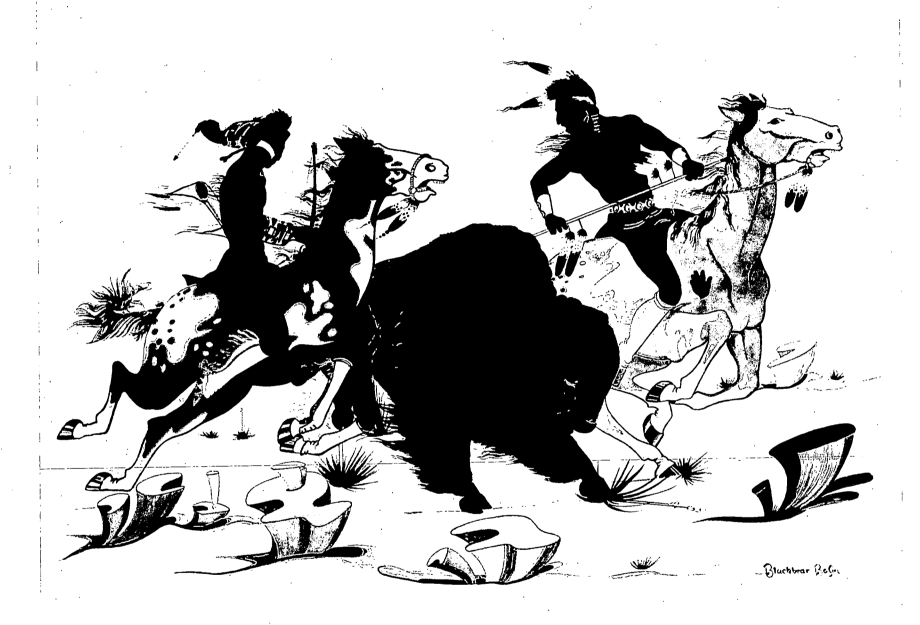

93. *Buffalo Runners.* Watercolor. Denver
Art Museum (Cat. No. PKi–3). Painted by
Blackbear Bosin, a Kiowa artist.

Colorplate **26.** Shield. Tesuque Pueblo. ⟶
c. 1850. Diameter 20″. Southwest
Museum, Los Angeles (Cat. No. 491 G
1058)

94. Sand painting. Navaho. 1962.
88 1/2 x 88 1/2″. Denver Art Museum
(Cat. No. SN–12). Made at the Denver
Art Museum by Billy Norton, a Navaho
medicine man.

95. Group of Navaho weavers. The woman
on the left is spinning yarn, the small girl
is carding. The loom on the right is for
weaving a floated warp belt.

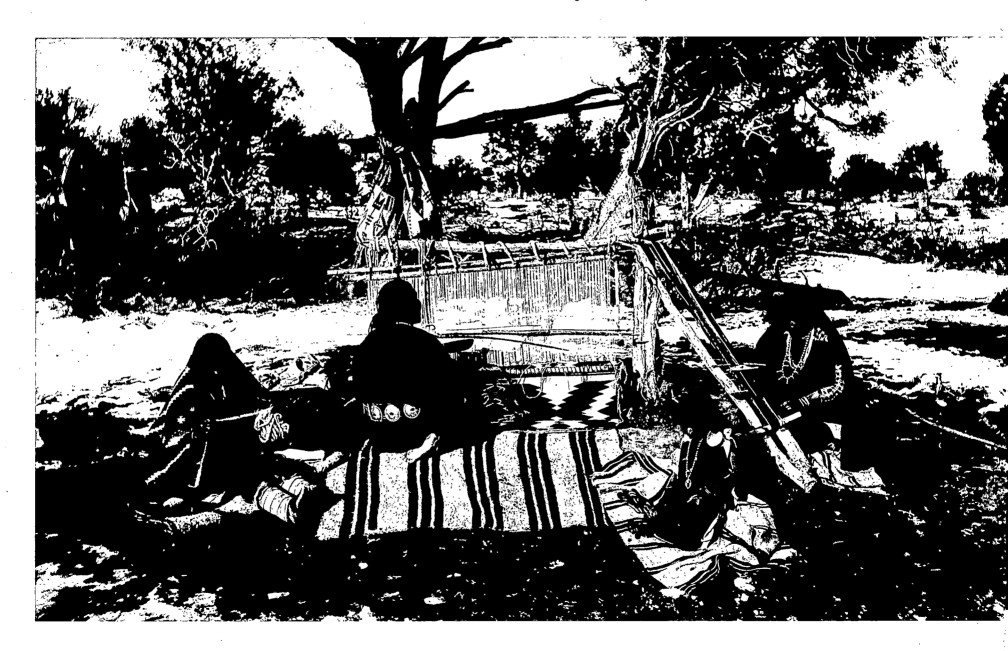

96. Sand painting type rug. Navaho. 66 x 64″. Denver Art Museum (Cat. No. RN–96). A copy in weaving of a design used in the Male Shooting Chant ceremony.

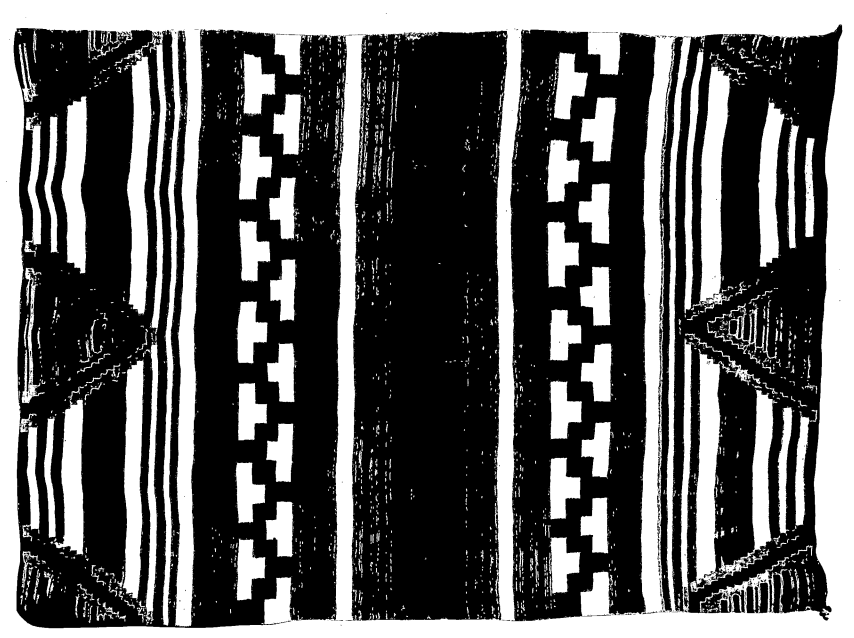

97. Classic blanket. Navaho. c. 1855–65.
Newark Museum, New Jersey
(Cat. No. 13785W). Made with bayeta and
Saxony yarns.

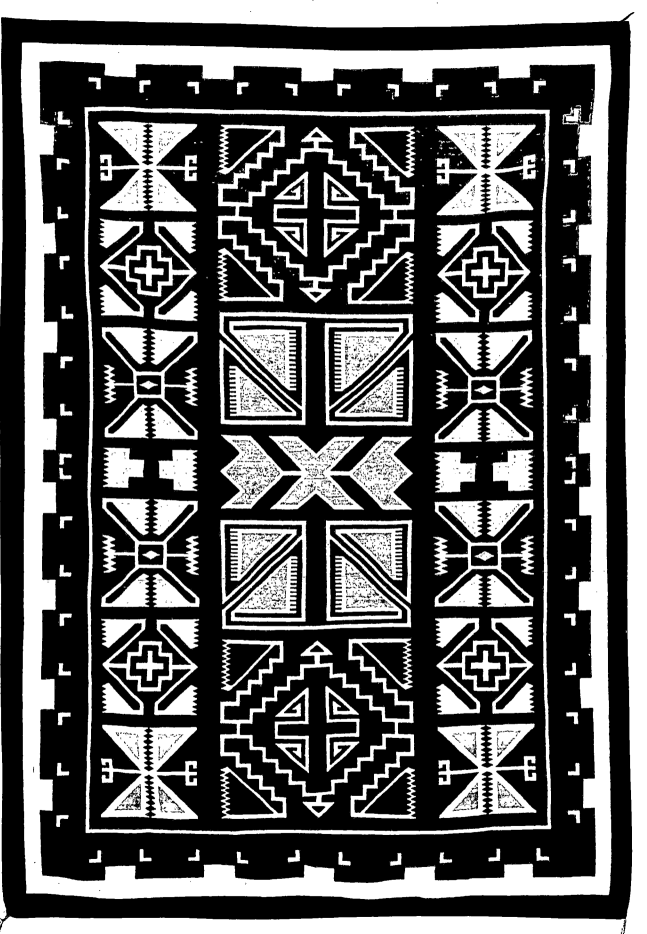

98. Two Grey Hills rug. Navaho. 1948.
70 1/2 x 49 3/4″. Denver Art Museum
(Cat. No. RN–86). Woven by Daisy
Touglechee near Toadlena, New Mexico.
This is an extremely fine piece of weaving
with ninety wefts to the inch and made
with handspun yarn.

Colorplate **27.** Germantown yarn rug.
Navaho. c. 1885–90. 29 1/2 x 54 1/2″.
Denver Art Museum (Cat. No. RNsd–36)

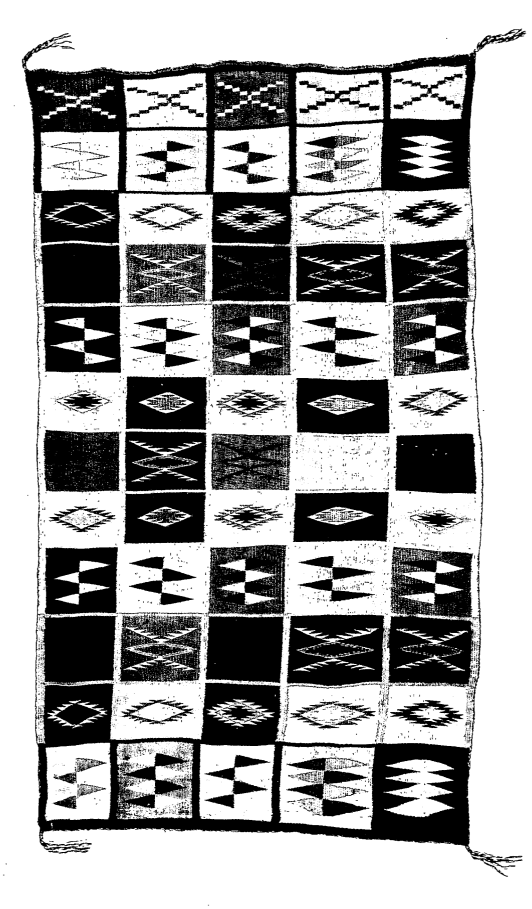

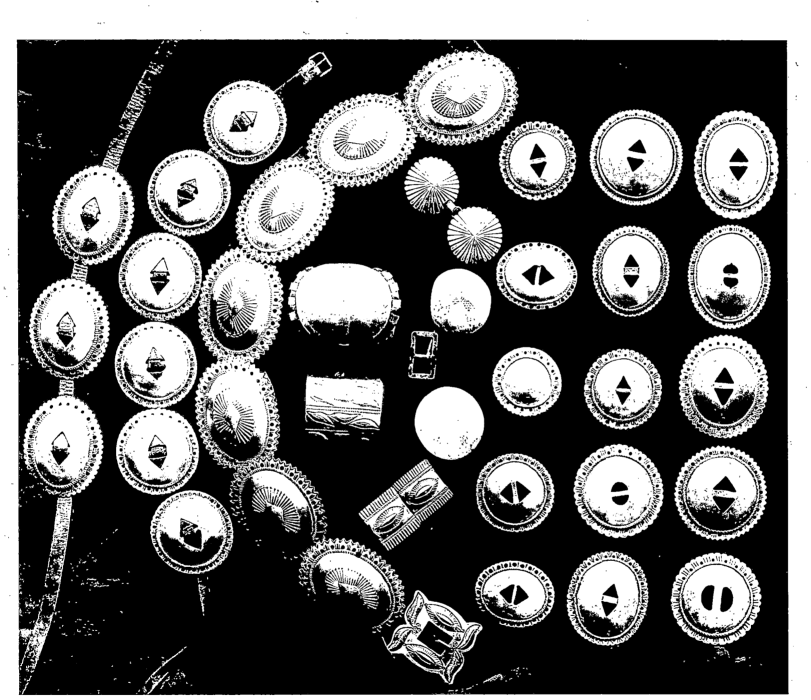

99. Silverwork. Navaho.
Smithsonian Institution,
Museum of Natural History,
Washington, D.C.
Early examples of conchas
and buckles.

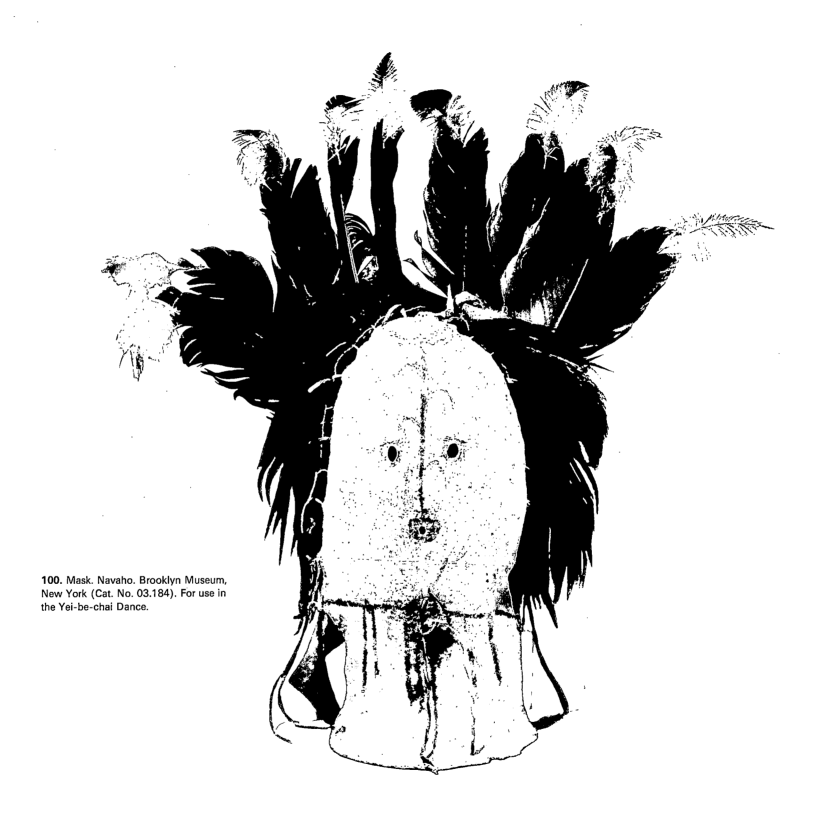

100. Mask. Navaho. Brooklyn Museum, New York (Cat. No. 03.184). For use in the Yei-be-chai Dance.

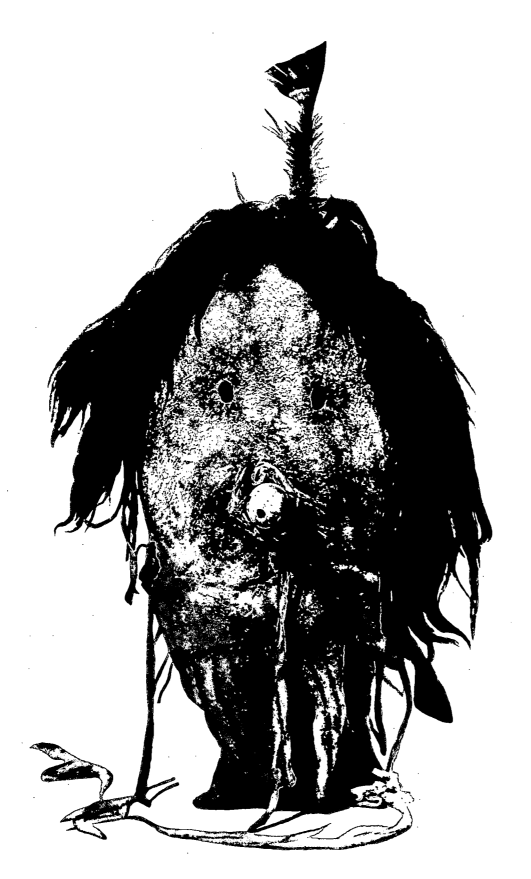

101. Mask. Navaho. Brooklyn Museum,
New York (Cat. No. 03.183)

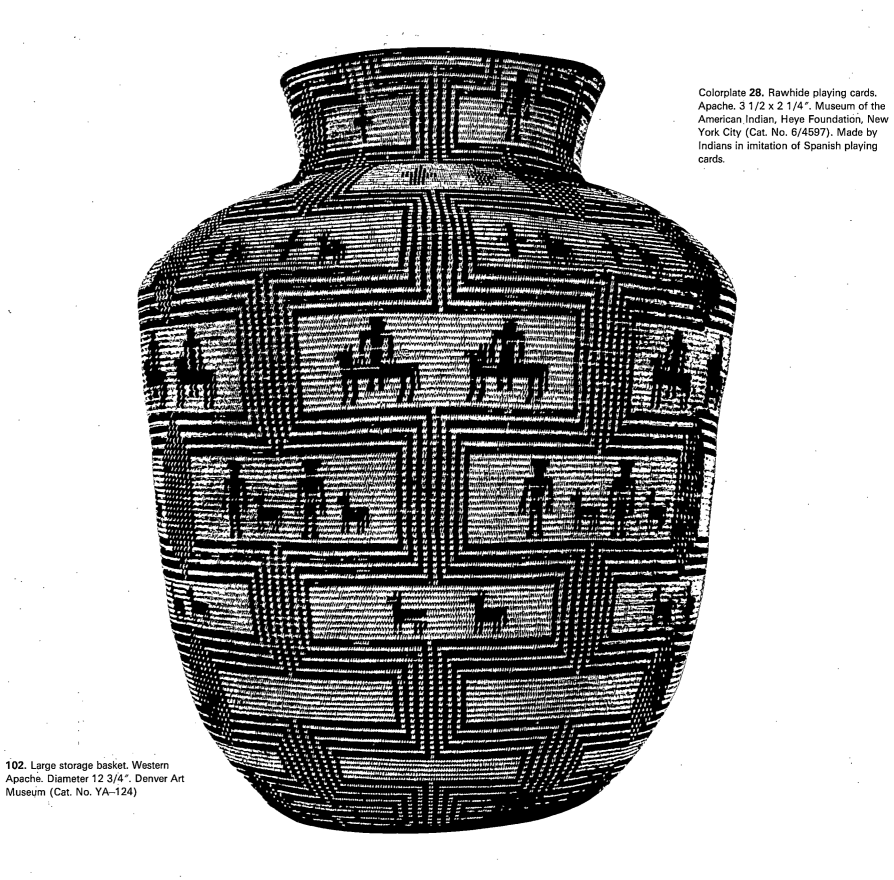

Colorplate **28.** Rawhide playing cards. →
Apache. 3 1/2 x 2 1/4″. Museum of the
American Indian, Heye Foundation, New
York City (Cat. No. 6/4597). Made by
Indians in imitation of Spanish playing
cards.

102. Large storage basket. Western
Apache. Diameter 12 3/4″. Denver Art
Museum (Cat. No. YA–124)

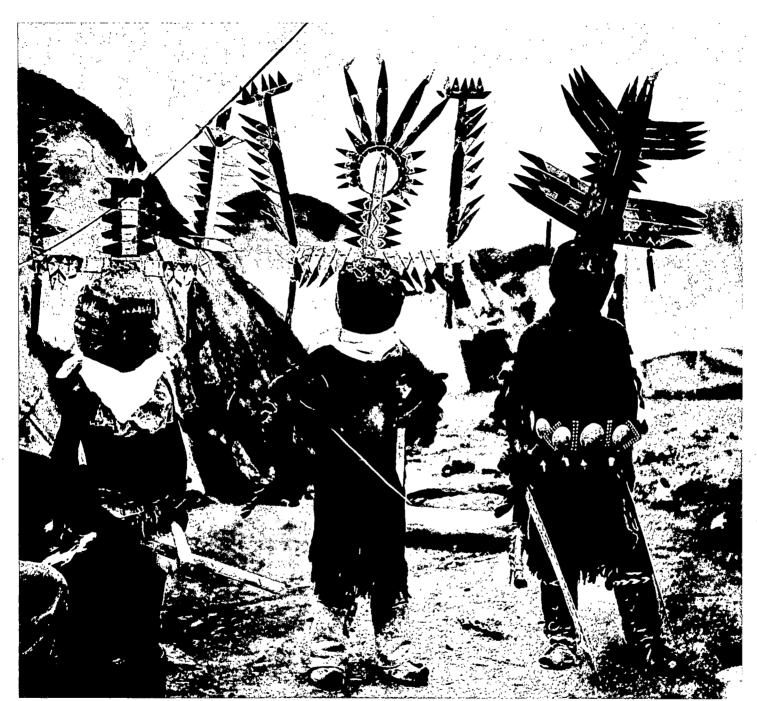

103. Apache Crown or Mountain Spirit Dancers. From a photo taken before 1900.

CONCORD HIGH SCHOOL MEDIA CENTER
59117 SCHOOL DRIVE
ELKHART, INDIANA 46514

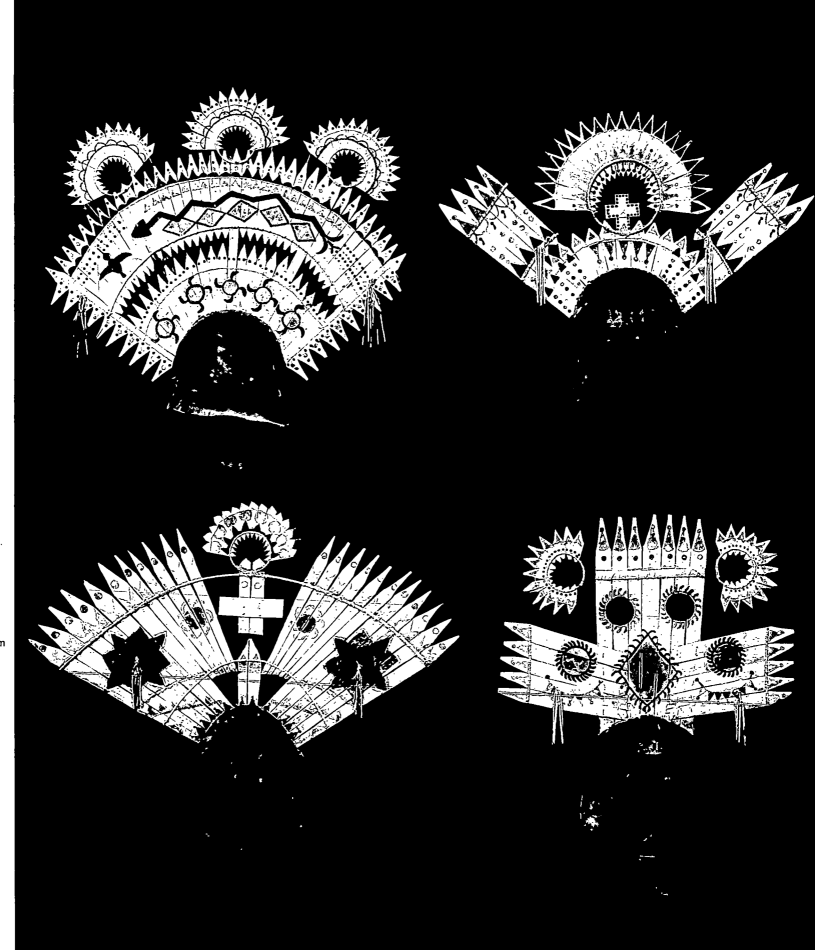

104. Crown Dance headdresses. White River Apache. American Museum of Natural History, New York City

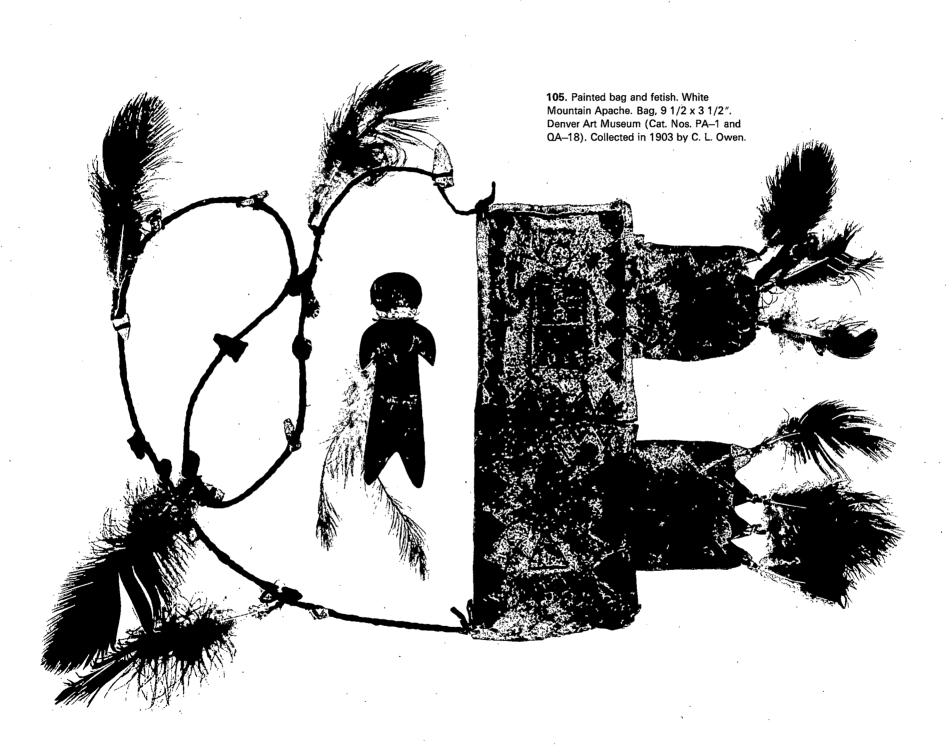

105. Painted bag and fetish. White Mountain Apache. Bag, 9 1/2 x 3 1/2″. Denver Art Museum (Cat. Nos. PA–1 and QA–18). Collected in 1903 by C. L. Owen.

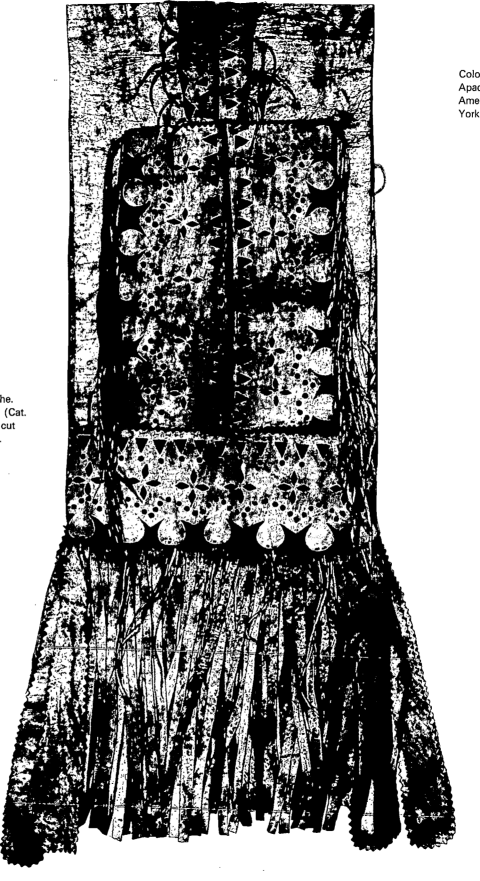

Colorplate **29.** Painted deerskin. Chiricahua ⟶
Apache. 33 x 51 ". Museum of the
American Indian, Heye Foundation, New
York City (Cat. No. 20/3519)

106. Saddle bag. San Carlos Apache.
89 x 16 3/4". Denver Art Museum (Cat.
No. LA–5). The design is made of cut
leather against a red cloth backing.

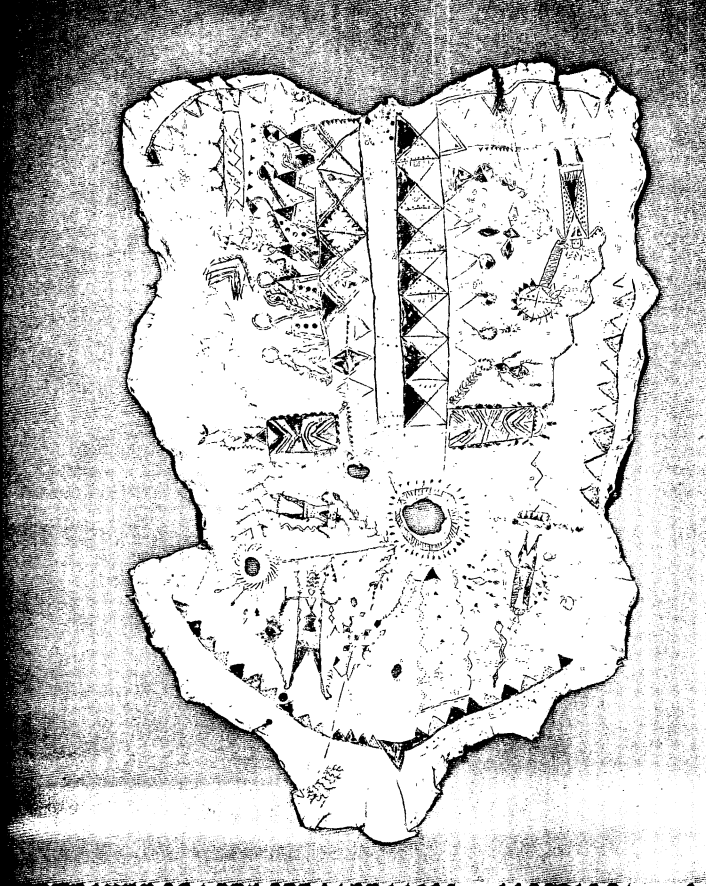

The Rancheria Tribes

The Pima, Papago, and Yuman—collectively the Rancheria tribes—form
still a third major subdivision of the Southwest area, in southwestern Arizona,
and along the Colorado and Gila rivers. It is generally believed that the
Pima and Papago, two closely related tribes, are the descendants of the pre-
historic Hohokam of the region. These people practiced some agriculture,
but depended to a considerable extent upon mesquite, cactus, and fish for
food. These tribes show a limited amount of Pueblo influences, and probably
served as a link between the Pueblo and southern California tribes. It is sur-
prising, however, that the Pueblo groups did not influence a wider area. A
few groups practiced simple weaving of cotton textiles, but this craft has
been extinct for at least one hundred years. Pima and Papago had traces
of Pueblo ritual practices in their ceremonies to bring rain and crop fertility,
including some masked dances. Pima also had developed a form of crop
irrigation, and the southwestern Arizona area is one of the few parts of the
country where fermented beverages were produced.

Pima and Papago groups excelled in basketry, using a coiled technique
(plates 5, 107). They traded baskets to their Yuman neighbors. Some pottery
was produced throughout this area as far as southern California, but it was
generally quite crude and poorly fired. The Mohave and their neighbors
along the Colorado River, the Yuma, Maricopa, and Cocopa produced
painted pottery dolls and vessels with pottery heads. Some of these, while
crude, have a certain strength of effect (plates 108–10; colorplate 30).

With the exception of basketry, the arts were generally poorly developed
in the entire Rancheria region. The Yuman groups practiced some beadwork
in a netted technique; certain examples done in only blue and white beads
resemble elaborate basketry designs (plate 111). The Yuman Havasupai and
Walapai living in the Grand Canyon area of northwestern Arizona produced
a limited amount of basketry, but little else. The Papago still produce baskets
in quantity and, surprisingly, their quality has improved in recent years.

The Pima and Maricopa still make a limited amount of pottery of a
polished red or cream decorated with black paint (plates 112–14). The
Mohave and Colorado River tribes still occasionally produce pottery in an
unpolished buff and brown. Pottery is certainly a dying art in the area, but
Papago basketry will probably survive for at least a couple of generations.

227

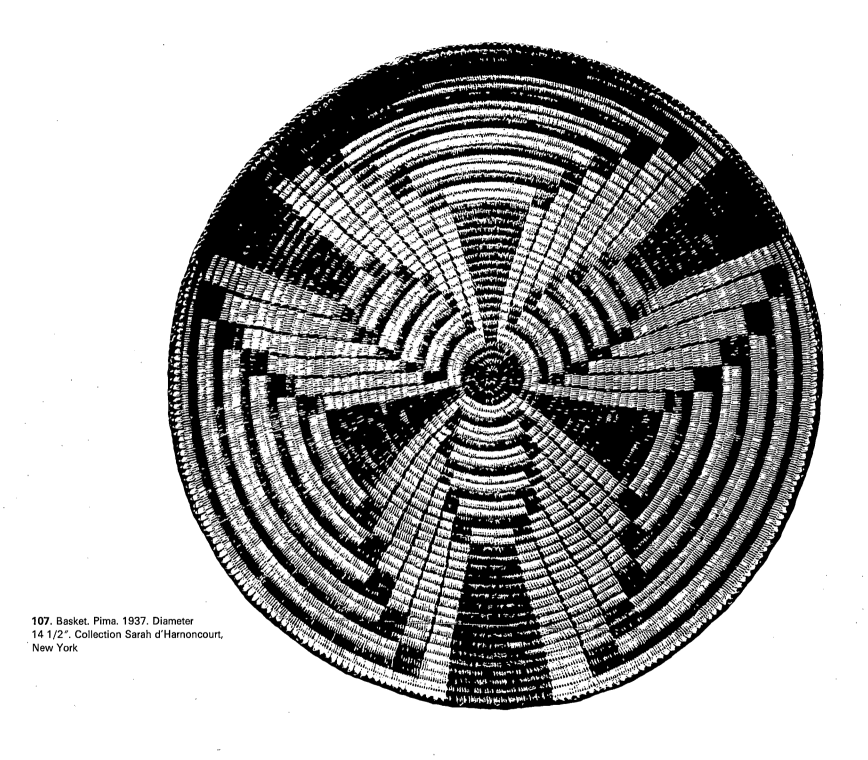

107. Basket. Pima. 1937. Diameter
14 1/2″. Collection Sarah d'Harnoncourt,
New York

108. Clay doll. Mohave. Peabody Museum,
Harvard University, Cambridge, Mass.
(Cat. No. 72.26.10/7062). Collected by
Jules Marcon in 1854.

109. Pottery figure. Cocopa. Peabody
Museum, Harvard University, Cambridge,
Mass. (Cat. No. 84105)

110. Pottery doll. Mohave. Height 8 7/8″.
Denver Art Museum (Cat. No. TMo–4)

111. Beaded collar. Mohave. Diameter 20″. Denver Art Museum (Cat. No. BMo–17). Made in a netted technique in blue and white beads only.

112. Pottery. Maricopa. c. 1895–1920. Bowl, diameter 4 3/4″; animal, 5 1/2 x 5 1/8″. Denver Art Museum (Cat. Nos. YMr–44 and 45). Both pieces were made when red was being added to the original black-on-cream traditional Maricopa ware.

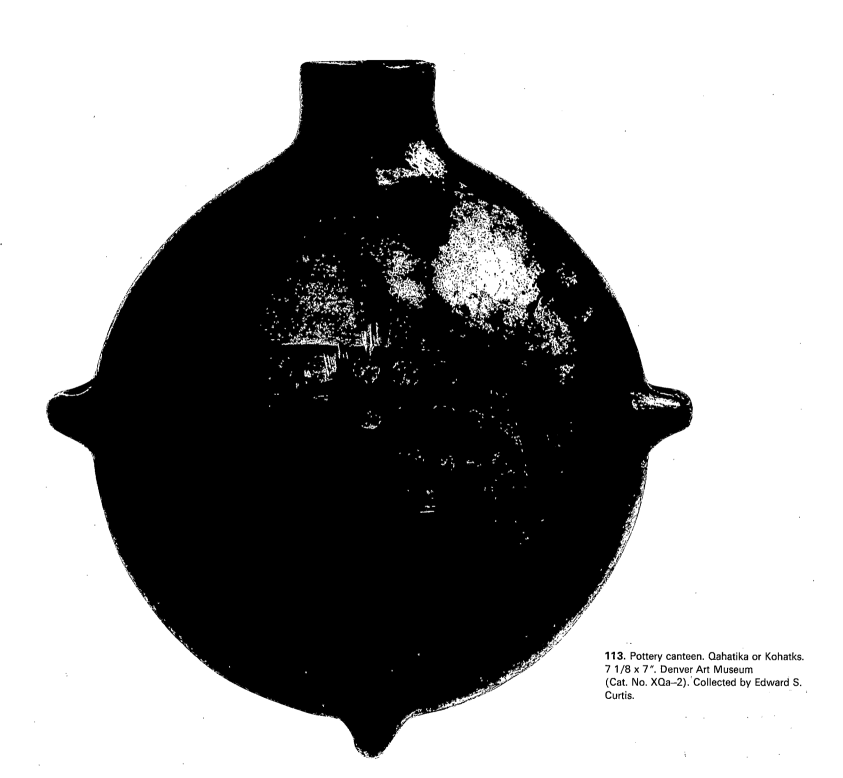

113. Pottery canteen. Qahatika or Kohatks.
7 1/8 x 7″. Denver Art Museum
(Cat. No. XQa–2). Collected by Edward S.
Curtis.

Colorplate **30.** Toy cradle with pottery ⟶
doll. Mohave. 17 3/4 x 4 3/4″. Denver
Art Museum (Cat. No. QMo–1)

114. Shallow pottery bowl. Pima.
Diameter 6″. Denver Art Museum (Cat.
No. XP–21). Collected in 1893. The view
shown here is the inside of the bowl.

California

CALIFORNIA

Almost all the state of California is generally considered an independent area. The Sierra Nevada and the desert to the east formed an effective barrier to east–west cultural exchanges, so that the California Indians were fairly isolated from the outside. The southern part of the state shows only some influence from the Southwest sand paintings and pottery, while the northern part reveals some from the Northwest Coast area in the use of wooden houses and carved spirit figures.

The entire area was densely populated in precontact times by many small and scattered tribes belonging to several linguistic families. Throughout the state, living was fairly easy, food abundant, and the climate mild. The people practiced no agriculture, but depended on food gathering. The acorn was the staff of life throughout most of California, supplemented by wild plants, seafood, and the catch from hunting. Clothing was scanty, even non-existent in some areas. Everywhere the level of technology was very primitive, with the major exception of basketry: California Indians produced some of the finest baskets in the world. Weaving was unknown, but a type of knot netting was produced with native fibers. Feathers were often used for decoration on baskets, hair pins, belts, headdresses, and even on capes.

The degree of white contact was, at first, inconsistent. Spanish missions and settlements were created quite early along the coast from San Diego to San Francisco, and many of the neighboring coastal groups became extinct at an early date. Other northern and interior tribes received almost no white contact until the 1849 Gold Rush, and were able to maintain their aboriginal way of life to a late date. As recently as 1911 an Indian was found who had had no contact with whites, and who was still making stone arrowpoints.[15]

From the standpoint of technology and style, the state is often divided into three areas, from south to north. The small groups who used to live in southern California are collectively known as Mission Indians (they early settled around the Spanish missions) or by the derogatory name "diggers,"

after their use of wild plant roots for food. Many of these groups are now extinct owing to white pressures and to diseases; those still existing retain very few vestiges of their former culture. Previously, however, they manufactured a finely made type of coiled basket in rich red brown tones and, often, naturalistic rattlesnake designs (plate 115). They produced some poorly made pottery in an unslipped, usually unpainted, red ware. Stone carvings—sandstone bowls and soapstone figures—were common; some soapstone animal effigies with inset shell beads are beautifully proportioned and naturalistic. Most were probably made before white contact.

Influences from the Southwest can be seen in the pottery (scanty as it is), the use of boomerang-like rabbit sticks, sandals, and especially the sand paintings made for the puberty ceremonies of boys. These paintings are usually quite simple even in comparison to Hopi paintings. The ceremonies involve the use of the so-called "Jimson weed" (*Datura stramonium*), a dangerous narcotic.

In the central California area, which is considered typical for the state, no pottery is produced and little woodwork, although basketry is highly developed. Both the coiled technique of the southern area and the twined techniques of the north are utilized in a variety of basketry types. Here the baskets are not only technically excellent, but the designs and forms are elegant in their simplicity. The Pomo tribe is especially well known for baskets ranging in size from three feet in diameter to those smaller than a pea. The so-called "jewel" or "gift" baskets, covered with brightly colored natural feathers and shell pendants, are a specialty of this tribe (colorplate 31).

In the northern part of the state, some influences drifted down from the Northwest Coast area. Some northern California groups made plank houses (plate 119), dugout canoes, used rod-and-slat armor, and wore basketry hats. The baskets were as fine as those produced in the central area. Yurok and Karok, in particular, made beautifully shaped baskets with knobbed lids, often decorated with yellow porcupine quills and the natural rich brown of the maidenhair fern stem (plate 120).

A specifically Northern trait is the use of elk antler for spoons which, with carved designs on the delicate handles, must have been extremely difficult to manufacture with primitive tools. The actual techniques have long been forgotten (plate 121).

With the exception of the prehistoric soapstone carvings, a limited

amount of featherwork (plate 122), a few fine elk antler carvings, and a very few wood carvings from the northern area (plate 123), the entire California area is mainly notable for its basketry. In general the baskets are technically excellent. The colors are the natural plant browns and blacks; the design elements are often simple geometric units of squares, triangles, diamonds, and zigzags. Exceptions are the naturalistic designs on Mission baskets, the yellow porcupine quills on Karok baskets, and the feathers used by the Pomo. Anyone examining a large collection of baskets from the entire state cannot help but be impressed by the tremendous variety of sizes and shapes, as well as by the vast number of plants utilized.

At the turn of the century, several women were still producing baskets of high quality. Some achieved a limited degree of fame for the excellence of their work. The Pomo woman Mary Benson and Dat-so-la-lee, a Washo, produced baskets which were eagerly sought by collectors (plate 124). Today the art of basketry is almost extinct, except that occasionally a very few women weave a basket for sale. Religion survives to some extent. Ceremonies are still performed, with the participants wearing costumes which are heirlooms among the Hupa and Yurok of northern California (plate 125).

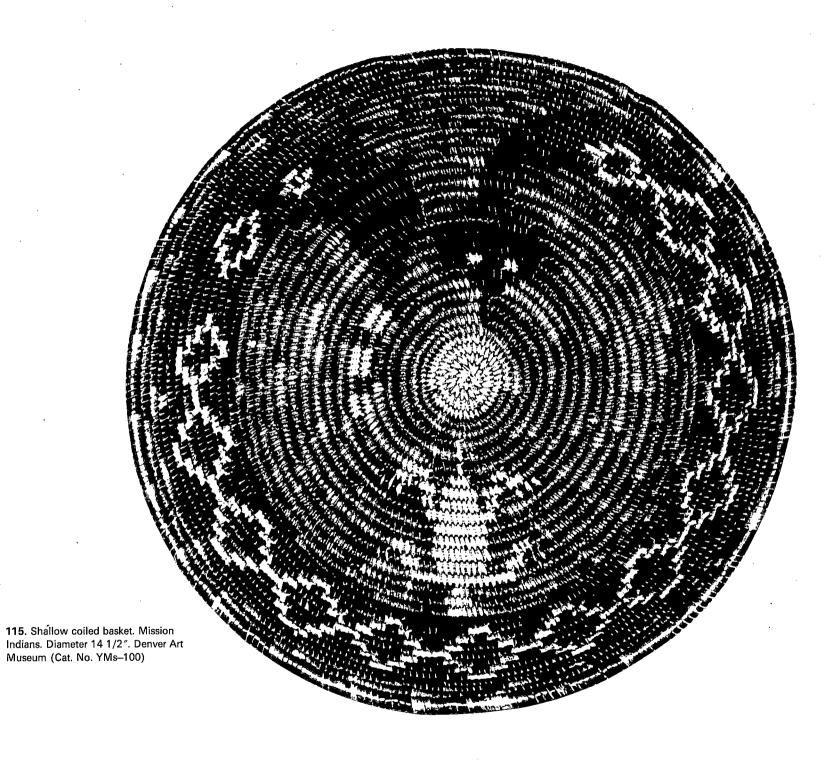

115. Shallow coiled basket. Mission
Indians. Diameter 14 1/2″. Denver Art
Museum (Cat. No. YMs–100)

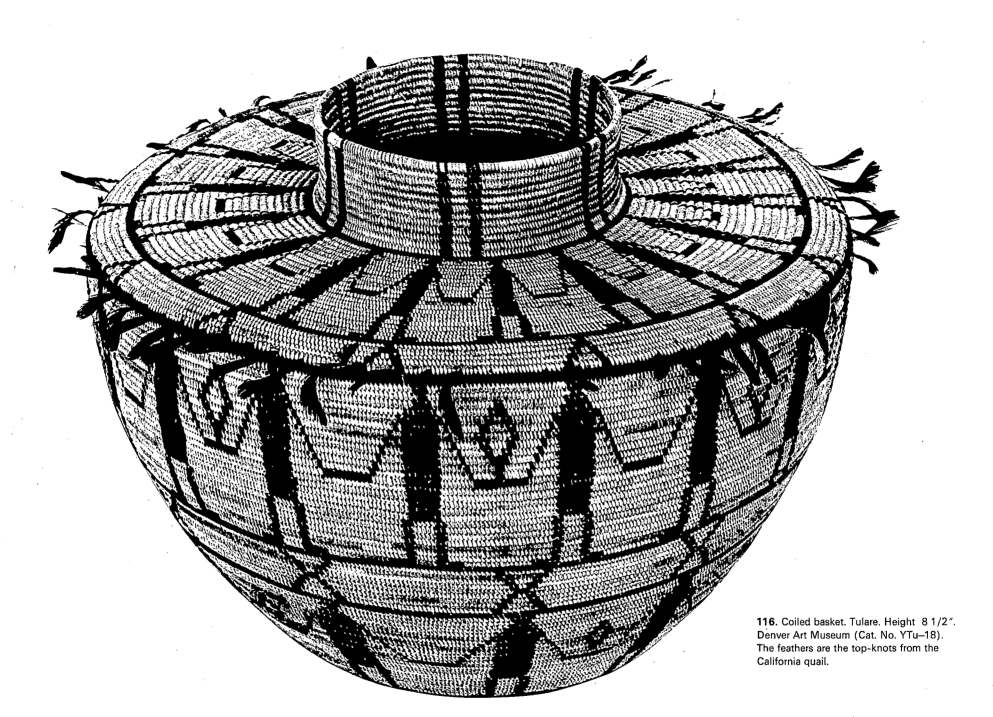

116. Coiled basket. Tulare. Height 8 1/2″.
Denver Art Museum (Cat. No. YTu–18).
The feathers are the top-knots from the
California quail.

118. Unfinished basket tray. Achomawi, \longrightarrow
Pitt River. American Museum of Natural
History, New York City (Cat. No. 58580)

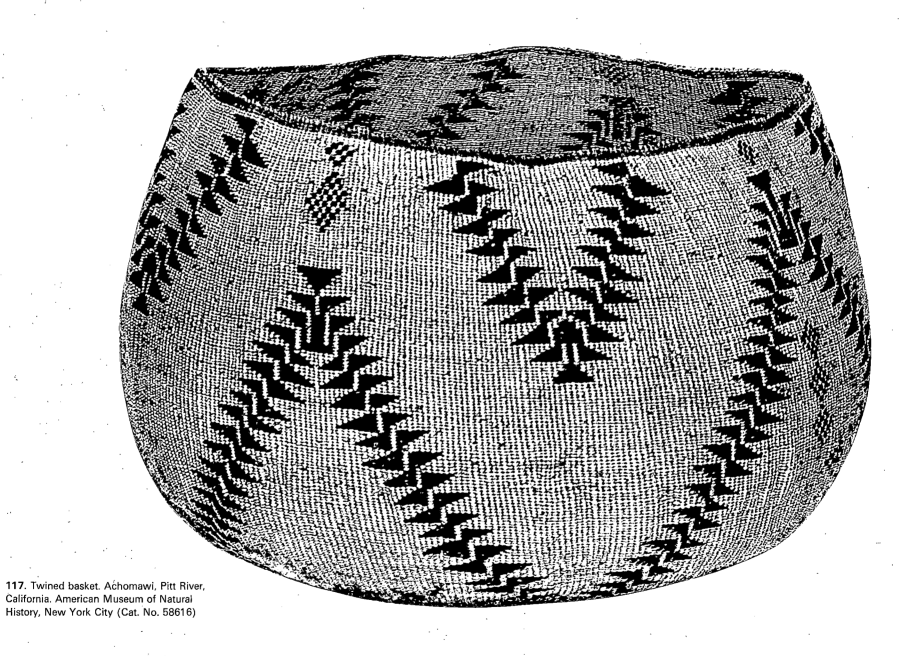

117. Twined basket. Achomawi, Pitt River,
California. American Museum of Natural
History, New York City (Cat. No. 58616)

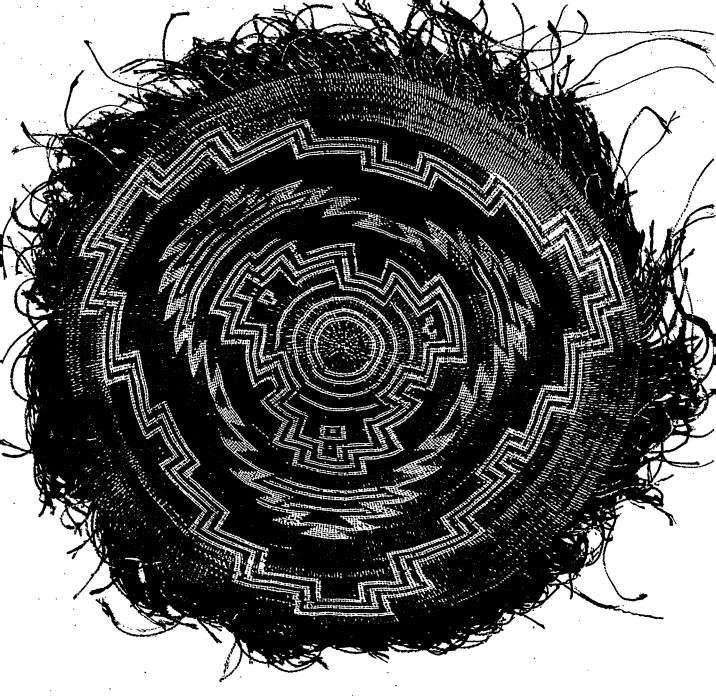

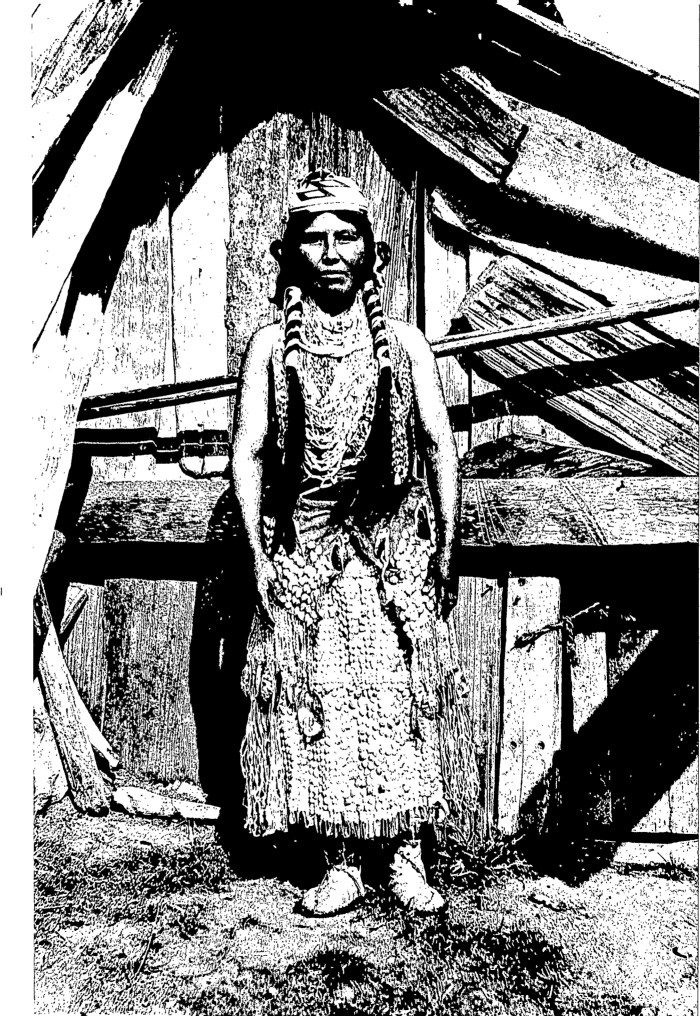

119. Alice Spot, a Hupa woman, in typical native dress. She is standing in front of an old style Hupa plank house.

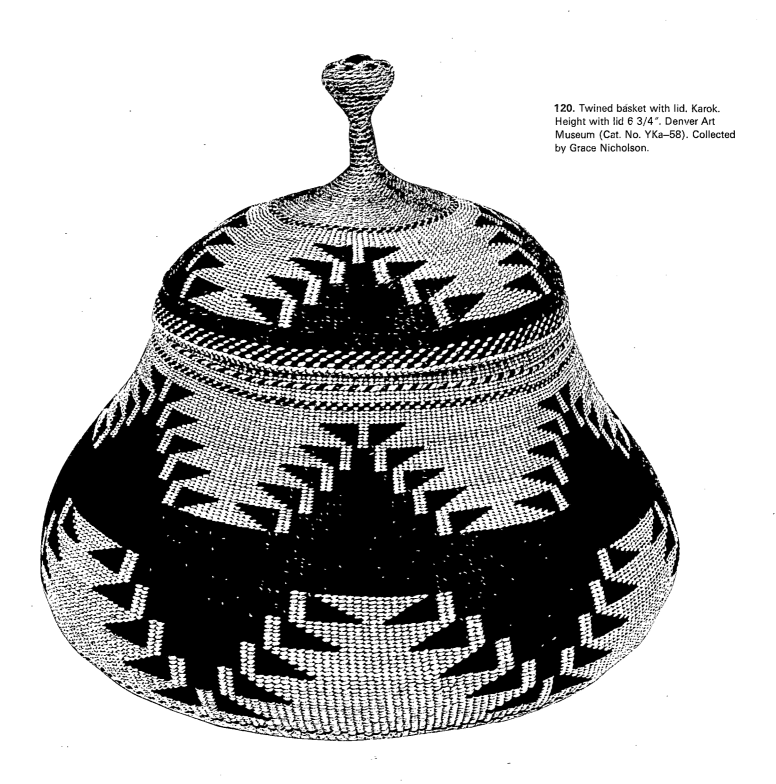

120. Twined basket with lid. Karok. Height with lid 6 3/4″. Denver Art Museum (Cat. No. YKa–58). Collected by Grace Nicholson.

121. Elk antler spoons. Karok, Yurok, and Hupa. Longest spoon 6 3/4″. Denver Art Museum (Cat. Nos. QKa–19; QKa–17; QYu–21; QKa–18; QHu–7)

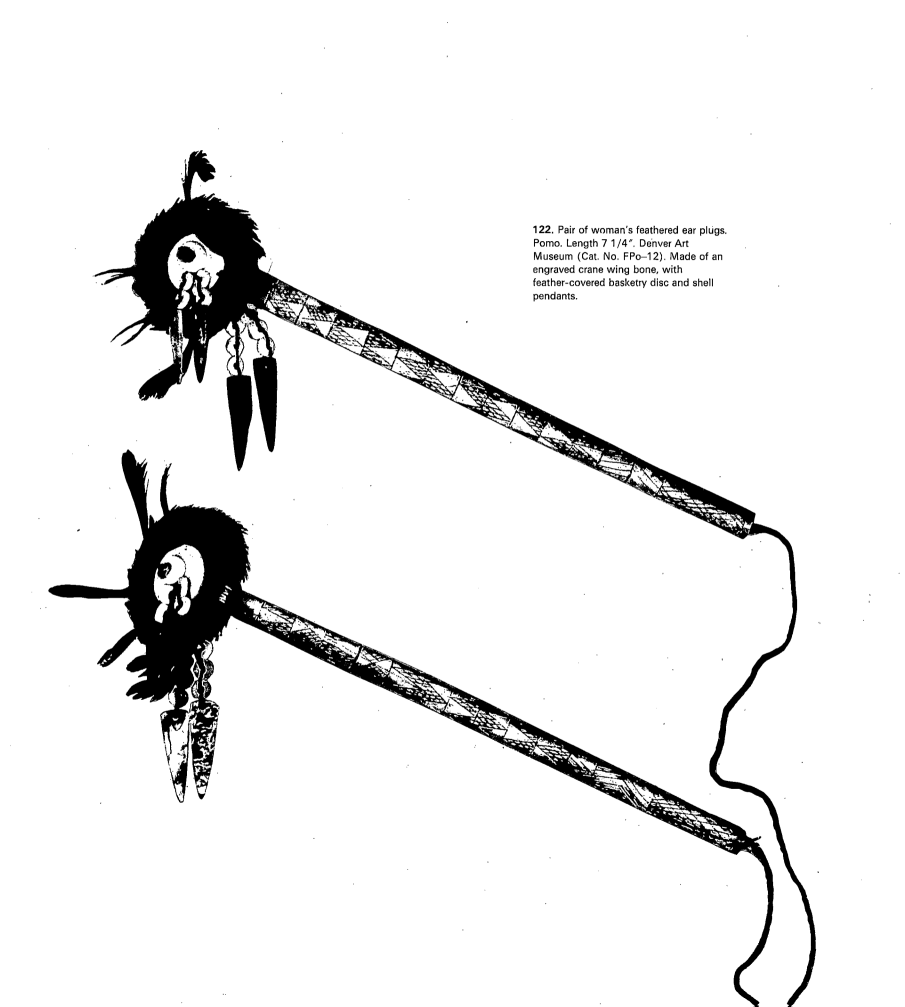

122. Pair of woman's feathered ear plugs. Pomo. Length 7 1/4". Denver Art Museum (Cat. No. FPo–12). Made of an engraved crane wing bone, with feather-covered basketry disc and shell pendants.

123. Wooden effigy of Pock-San-e
(place in meadow) Chuck-e-yok (big
boy). Klamath. Peabody Museum,
Harvard University, Cambridge, Mass.
Gift of Lewis H. Farlow (Cat.
No. 10.21.10/76535). Collected by Grace
Nicholson and Mr. Hartman in 1910.
The placement of the arms coming out
from the chest is an unusual treatment.

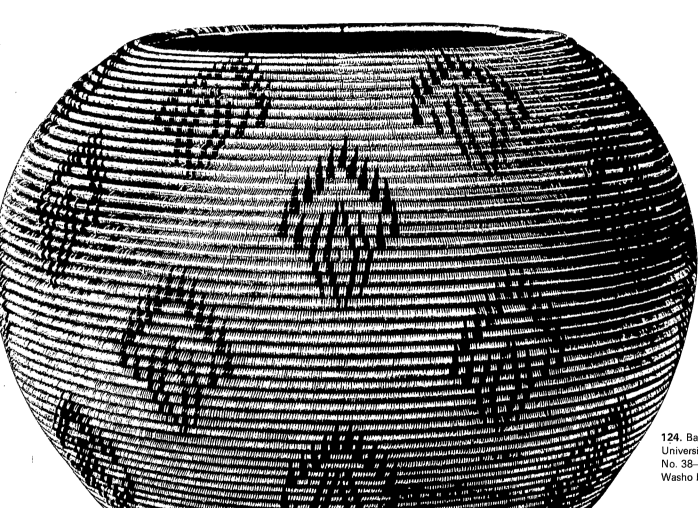

124. Basket bowl. Washo. Diameter 10″.
University Museum, Philadelphia (Cat.
No. 38–26–1). Made by the famous
Washo basket maker, Dat-so-la-lee.

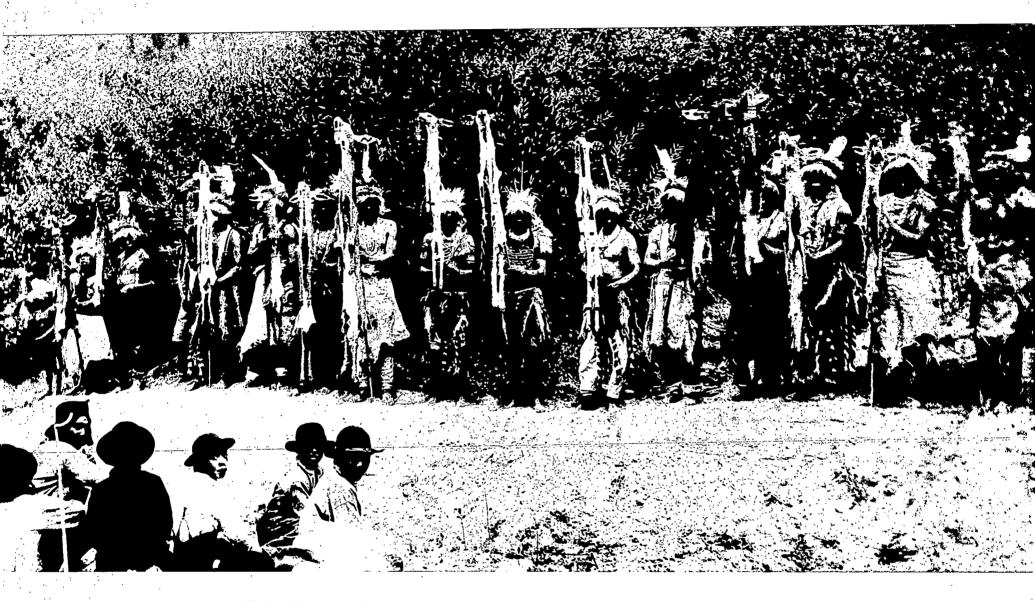

125. The White Deerskin Dance of the
Hupa. Photographed at Fort Gaston,
California between 1887–91. This dance
is still being performed in alternate years.

Colorplate **31.** Three feather baskets.
Pomo. Diameter of largest basket 13 1/2″.
Denver Art Museum (Cat. Nos. YPo–145,
154, and 157)

The
Great Basin
and the
Pacific Plateau

THE GREAT BASIN AND THE PACIFIC PLATEAU

The Great Basin and Pacific Plateau groups are often included with those of California in a single great "intermountain" culture area; but although there are many similarities between all of these areas, on a stylistic basis it is preferable to discuss the Basin and Plateau arts as distinct entities. The Great Basin comprises the area between the Rocky Mountains on the east and the Sierra Nevada on the west, the largely barren deserts of Utah, Nevada, and southern Oregon. The scattered bands of Paiute and Shoshone Indians living in this region are the most primitive of any in the United States. They, like their California neighbors, were often called diggers. Theirs is a bare subsistence economy based on seed gathering, supplemented by a little hunting of small game. They utilize almost all the potential food products of their environment, including even insects and grubs. Food gathering consumes almost all their waking hours, allowing little time for artistic production. Basin groups live in very simple brush shelters (plate 126), produce little pottery, and only a limited amount of crude basketry. Some Washo groups, along the California–Nevada border, produced finely made basketry, but the usual baskets were the pitch-covered water jars, or the coiled plaques, often traded to the Navaho in the south. Their only form of weaving was a type of blanket woven from strips of rabbit fur.

Some Basin groups still produce a limited number of tanned hides, beaded novelties, and some basketry. Baskets or commercial glass bottles completely covered with beadwork were latterly a Paiute specialty (plate 127), and a few are still made. The Washo, Paiute, and Shoshone on the Pyramid Lake reservation at Dixon, Nevada, have formed an arts and crafts cooperative known as Wa-Pai-Shone Craftsmen. The Ghost Dance religion, launched about 1889 by Wovoka, a Paiute prophet from the Pyramid Lake reservation, had little effect on the arts of the Basin area; on the other hand, it introduced a new art form to many Plains tribes. The prophet foretold that if the Indians performed the new dance, refrained from fighting, and did no

.. iA ᴜᴇⁿ ᵢᴇR
CONCUʀᴜ ... SCHOOL DRIVE
59117
ELKHART, INDIANA 46514

harm to anyone but always did what was right, then the buffalo would return, the white man would disappear, and all the dead would return to life. The Sioux, Cheyenne, Kiowa, and Arapaho all developed specially painted shirts, to be worn during the dances, which the faithful thought possessed the magical property of invulnerability to bullets (plates 128, 129).

The Plateau area is composed of portions of Idaho and Washington to the east of the coast range, inland British Columbia, and northern Oregon. The area is somewhat less isolated than the Great Basin because travel is feasible on the Columbia and Fraser rivers. The people here subsisted largely on roots and berries, but also depended heavily upon the salmon and other fish from the rivers. There are many tribes in this area belonging mainly to the Salishan and Sahaptian linguistic families. They formerly lived in semi-subterranean houses or in mat covered lodges, but in later years adopted the Plains type of tepee covered either with skin or bulrush mats (plate 130).

Throughout all this area basketry was developed to a fine art in both coiled and twined techniques. Twining was used mainly for soft bags and hats, and coiling for large storage containers. Coiled baskets from this area often have a distinctive form of decoration known as "imbrication" which consists of sewing decorative elements on the outer surface of the baskets made with the regular coiled stitches (plate 131). Imbricated baskets are often assigned to the Klickitat tribe, but were also made by Yakima, Lillooet, Shuswap, Chilcotin, Thompson, and Fraser Indians. The Nez Percé produced a distinctive type of flat twined wallet with polychrome designs worked in with a false embroidery (plate 132). Here again, however, although the Nez Percé were the principal makers of such basket wallets, they were also made by their neighbors, the Umatilla, and Walla Walla. These people made no pottery, but did have dugout canoes for river travel.

The Plateau peoples show a considerable number of Plains traits, although when and how these influences made themselves felt is not clear. They developed a horse culture to a high degree, and the Cayuse and Nez Percé tribes were noted for their breeding of the appaloosa. Horse trappings in the form of saddles, martingales, and cruppers were very similar in style to those made by the Crow in the Plains themselves (plate 133). Likewise, the costumes of both men and women were made of skin in Crow style, although some recent examples seem to show more influence from the Blackfeet. Since the turn of the century, the beadwork of the Plateau groups, as with

254

those of the Northern Plains, seems to have changed from the use of geometric to floral motifs. In the inland area of British Columbia, several influences from the Northwest Coast area can be traced. The Lillooet and Thompson peoples made carved figures used as grave monuments representing totems, simple carved stone bowls, and crude blankets of dog hair and mountain goat wool (colorplate 32). Some groups, like the Shuswap, produced birchbark baskets resembling those from the Great Lakes area.

The upper Chinook groups, Wishram and Wasco, living along the Columbia River near The Dalles, Oregon, developed a quite distinct style usually referred to as "X-ray" owing to the fact that ribs, for instance, are shown as if exposed. Baskets in flat or pail-like form are twined, with human and animal figures showing this X-ray character (plate 135). Figures of the same type are carved on bowls and spoons of sheep horn as well as of wood; they can sometimes also be found on wooden mortars and antler adze handles (plates 136–45). These Wishram and Wasco groups are now scattered and intermingled with other Indians on the Yakima reservation in Washington and the Warm Springs reservation in Oregon. Early reports indicate that these people at one time had a rich decorative art, but few examples are known today.[16] The sketch of a canoe prow carving made by George Gibbs in 1850 indicates the caliber of this art, which is now lost (plate 146).

Some parts of the Plateau area have remained fairly conservative, and in almost every reservation a few women can be found who practice traditional crafts. Nez Percé and their neighbors still produce a limited number of twined baskets and wallets, but the material has changed from grass and corn husk to modern commercial yarns and jute string. Yarns with metallic fibers seem to be preferred in recent years. Typical imbricated baskets of good quality are made in several places, and they command high prices. A limited quantity of beadwork is still being made in the form of horse trappings, personal costumes, and especially rectangular women's bags with solidly beaded front panels, called "friendship bags." Twined wallets or beaded bags filled with roots are still standard gift items at intertribal gatherings. Much of this contemporary work, although made with new materials, is very much in traditional style. On the basis of style alone, it is often difficult to distinguish a new piece from one produced fifty years ago. Perhaps one of the reasons for this conservatism of design is that Plateau people have retained a fair number of old objects, and continually have them on hand as models.

126. A simple type of home in the Paiute
Indian village near St. George, Utah.

127. Beaded baskets. Paiute, Nevada.
Diameters approximately 3 1/2″. Denver
Art Museum (Cat. Nos. YPu—35, 33, and
36)

128. Painted muslin Ghost Dance shirt. Sioux. 36 1/2 x 24″. Denver Art Museum (Cat. No. PS–12). Used by the Sioux before 1890 in a religious revival known as the Ghost Dance.

129. Ghost Dance dress. Arapaho. Field Museum of Natural History, Chicago (Cat. No. 71950). Several dresses and men's shirts with very similar painted designs are known from the Arapaho. Note the use of the turtle as compared to Colorplate 16.

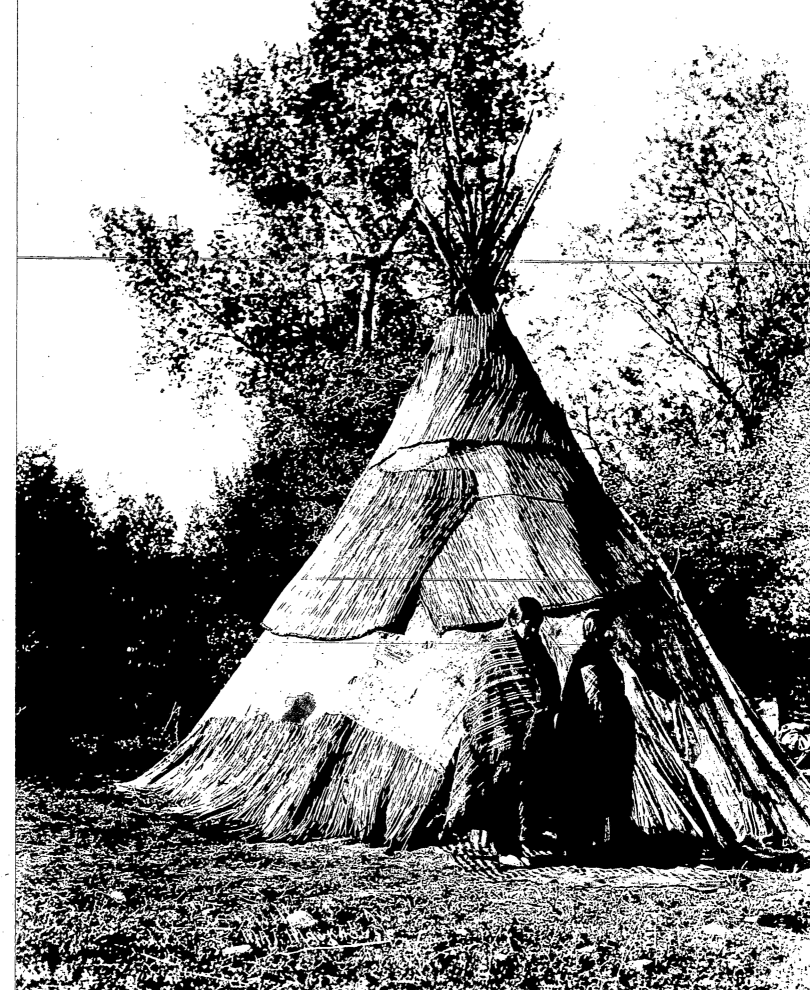

130. An Umatilla lodge in the form of a conical Plains tepee, but covered with cattail mats.
Photo by Major Moorhouse about 1890–92.

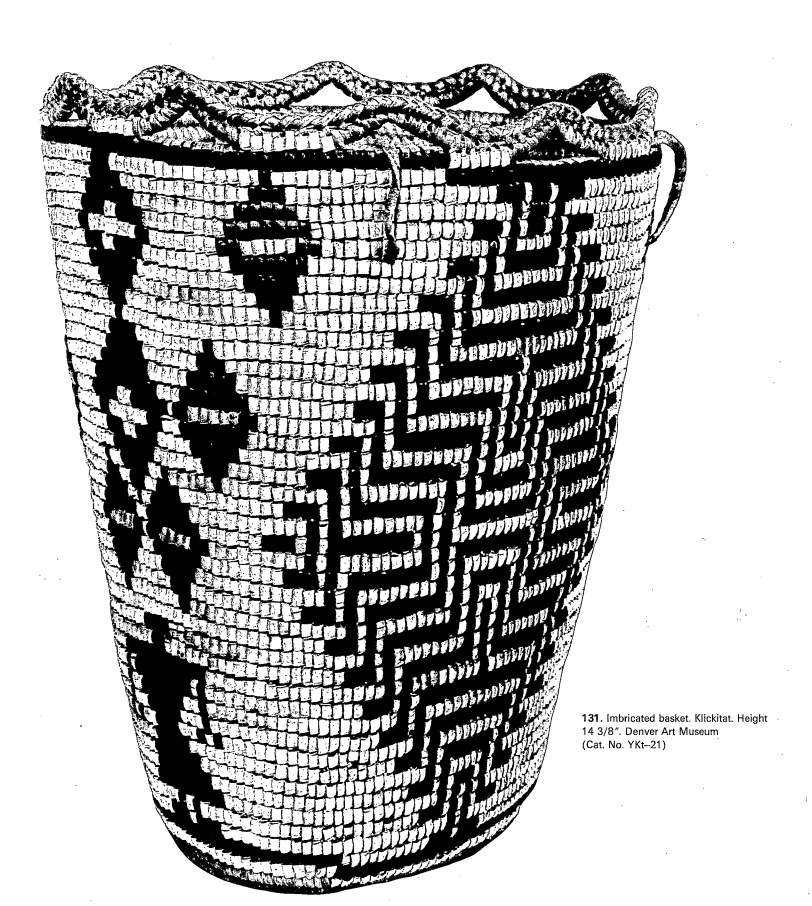

131. Imbricated basket. Klickitat. Height 14 3/8". Denver Art Museum (Cat. No. YKt–21)

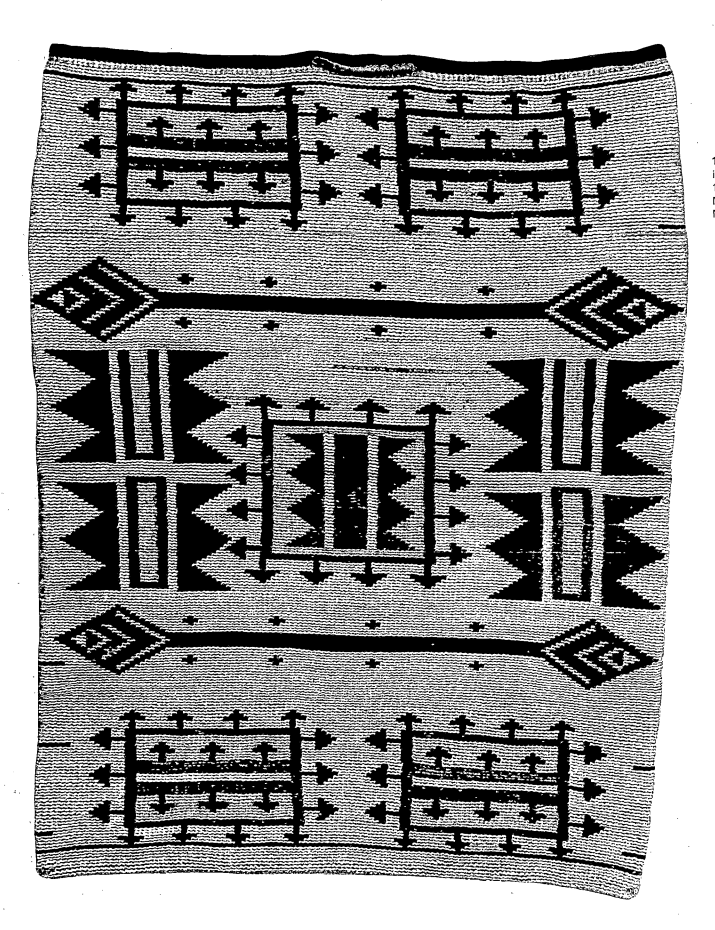

132. Twined bag with false embroidery in corn husk and wool yarn. Nez Percé. 17 1/2 x 14″. Denver Art Museum (Cat. No. YNP–16). Collected by Grace Nicholson.

133. Elaborate horse gear at a modern \longrightarrow powwow, showing a Yakima Indian woman of Satus Creek, Washington, at the Toppenish powwow, July, 1959.

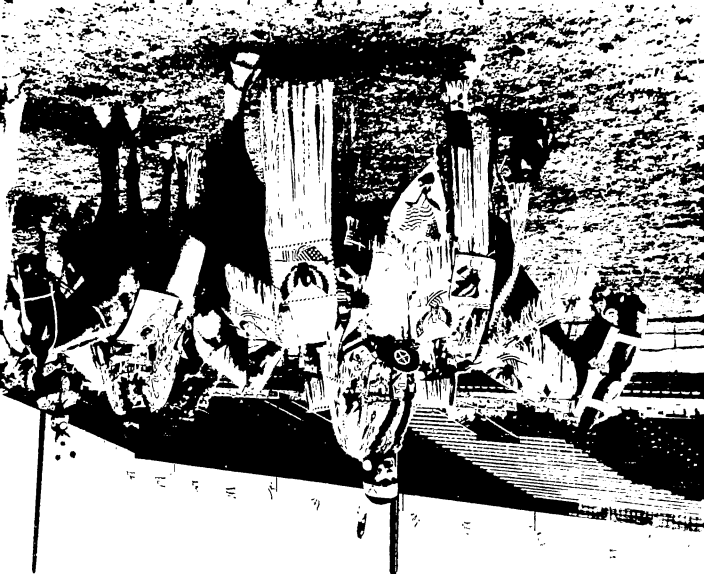

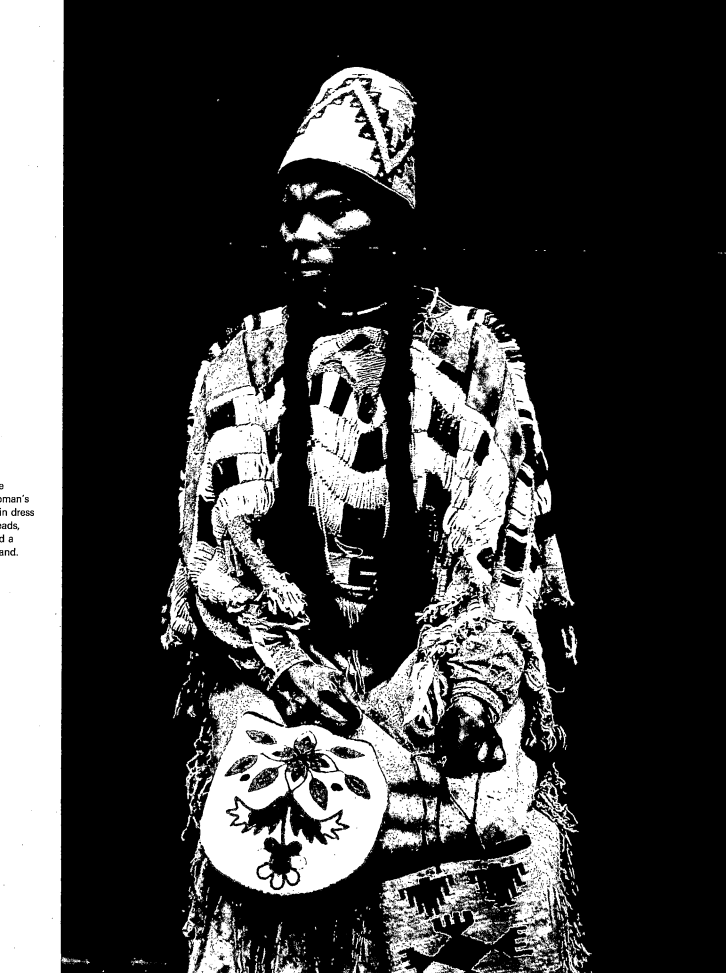

134. Kupt, a woman of the Cayuse tribe. Shown in typical Plateau woman's costume of a basketry hat, buckskin dress with bold design in pony trader beads, a beaded bag in her right hand and a twined corn husk bag in her left hand.

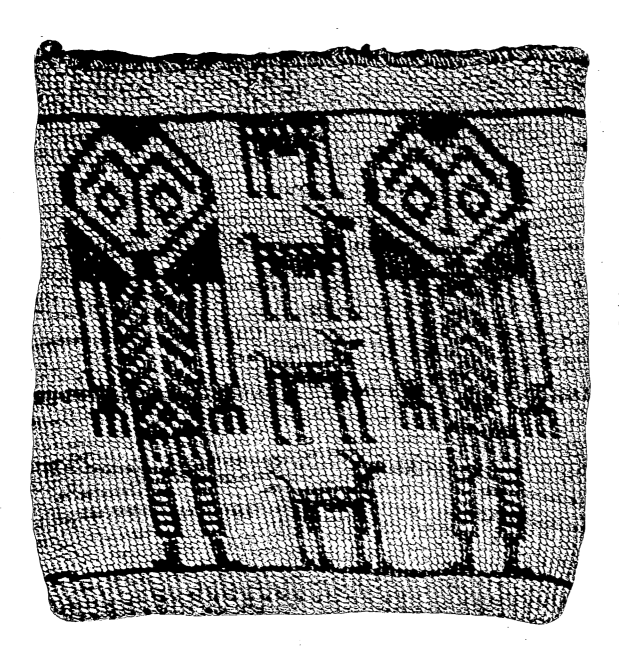

135. Twined basket wallet. Wasco. 7 3/4 x 7 1/2". Denver Art Museum (Cat. No. YWas–1)

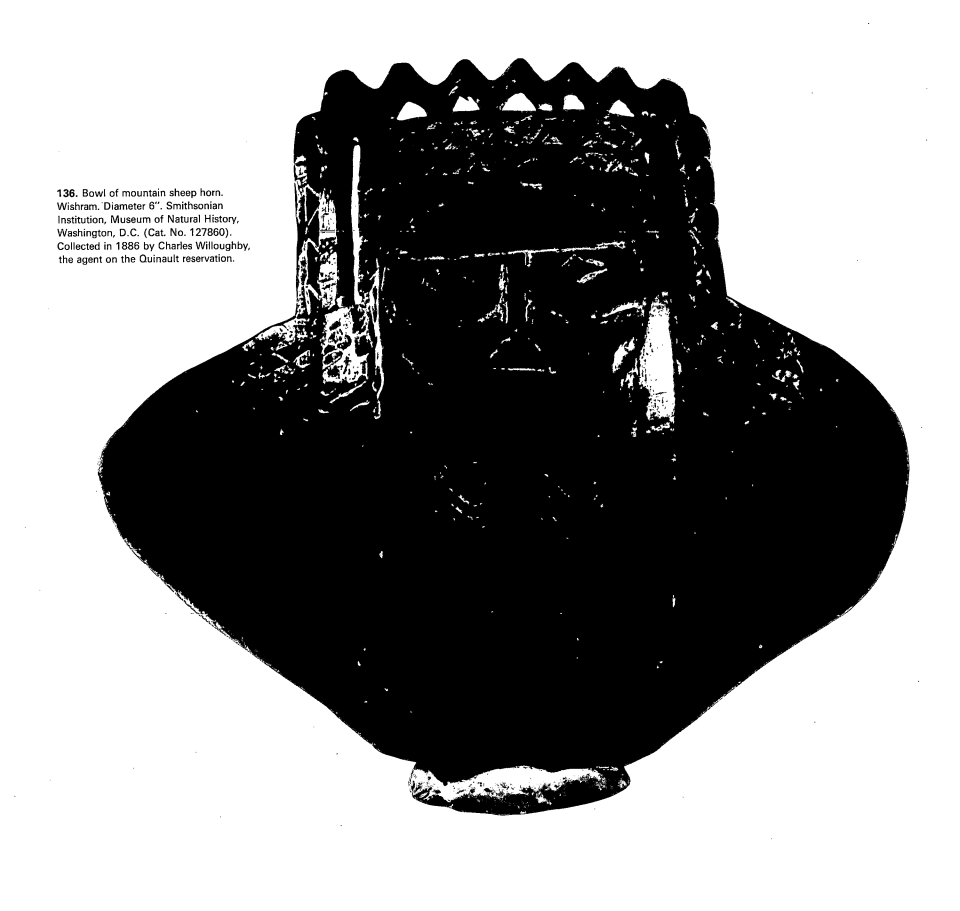

136. Bowl of mountain sheep horn. Wishram. Diameter 6". Smithsonian Institution, Museum of Natural History, Washington, D.C. (Cat. No. 127860). Collected in 1886 by Charles Willoughby, the agent on the Quinault reservation.

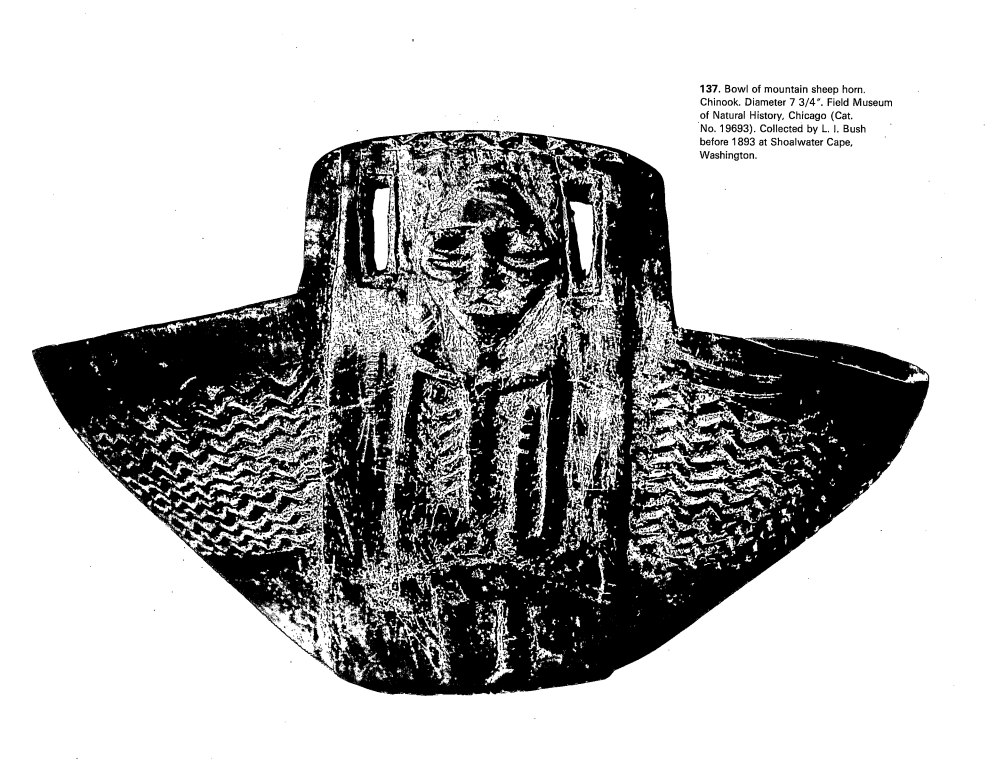

137. Bowl of mountain sheep horn. Chinook. Diameter 7 3/4″. Field Museum of Natural History, Chicago (Cat. No. 19693). Collected by L. I. Bush before 1893 at Shoalwater Cape, Washington.

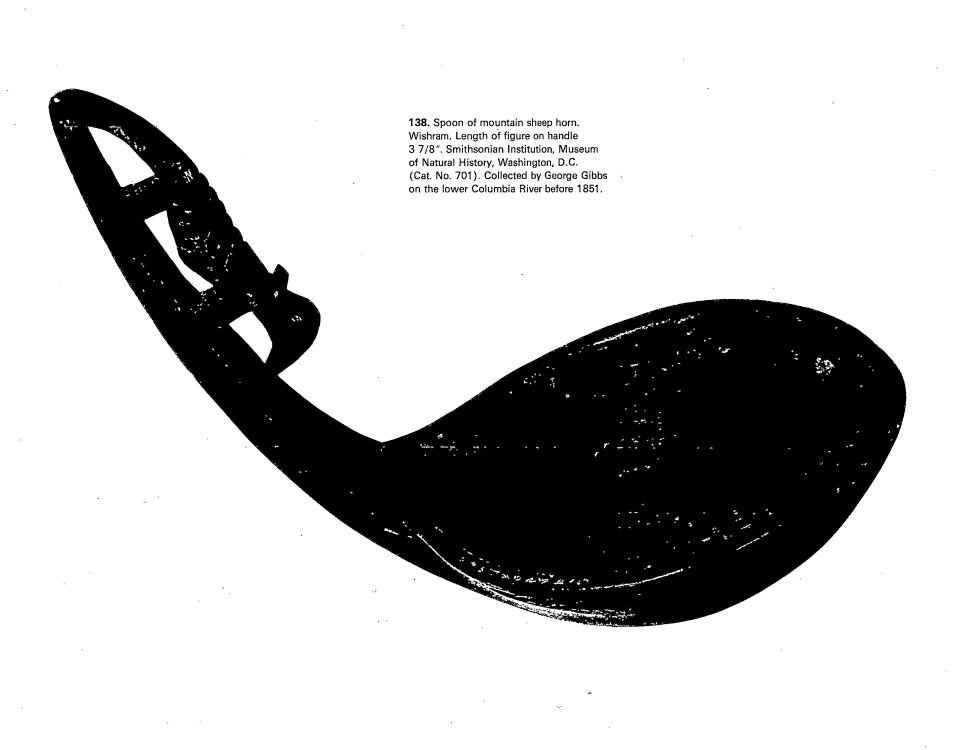

138. Spoon of mountain sheep horn.
Wishram. Length of figure on handle
3 7/8″. Smithsonian Institution, Museum
of Natural History, Washington, D.C.
(Cat. No. 701). Collected by George Gibbs
on the lower Columbia River before 1851.

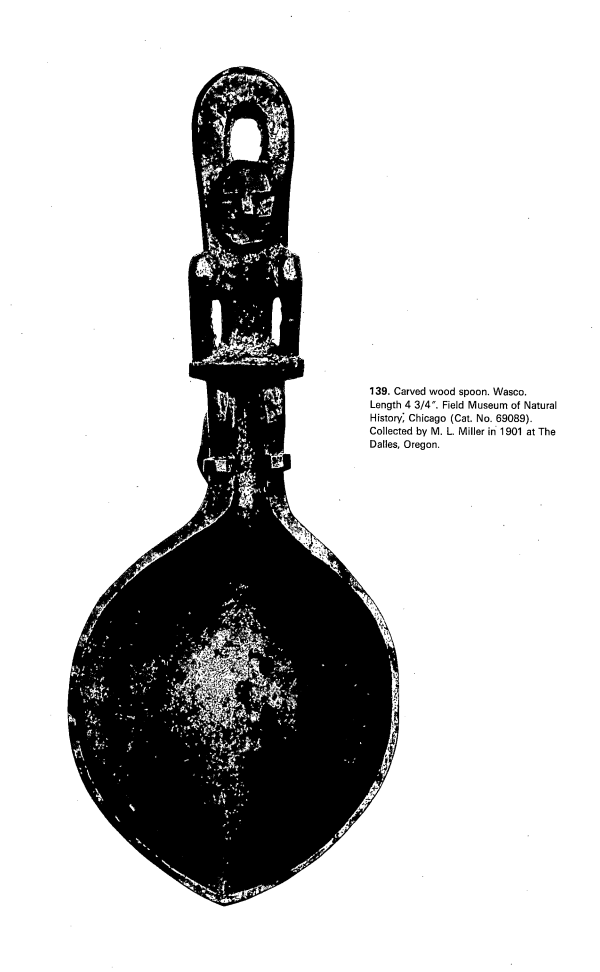

139. Carved wood spoon. Wasco. Length 4 3/4″. Field Museum of Natural History, Chicago (Cat. No. 69089). Collected by M. L. Miller in 1901 at The Dalles, Oregon.

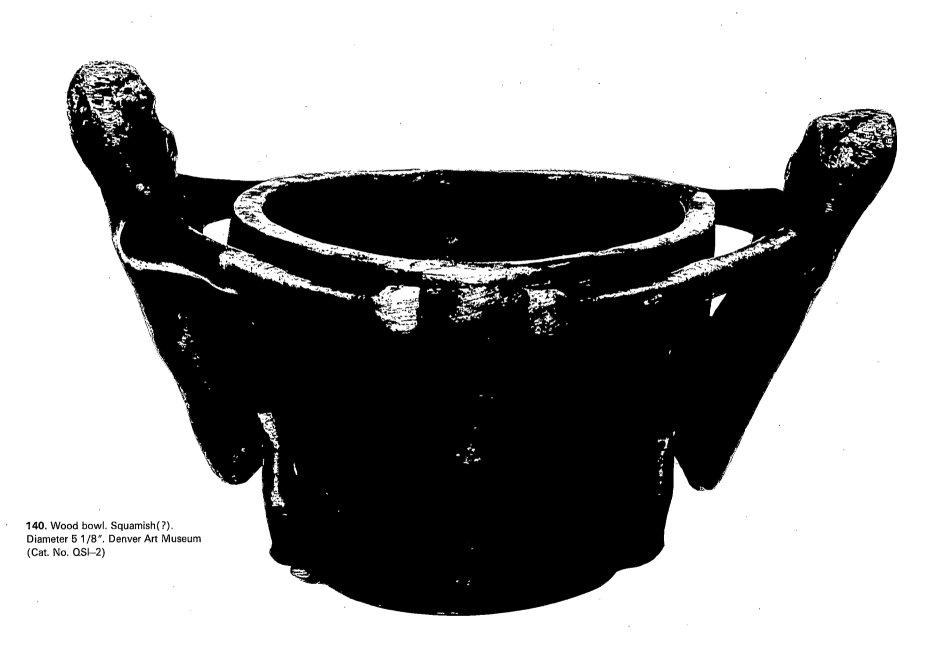

140. Wood bowl. Squamish(?).
Diameter 5 1/8″. Denver Art Museum
(Cat. No. QSI–2)

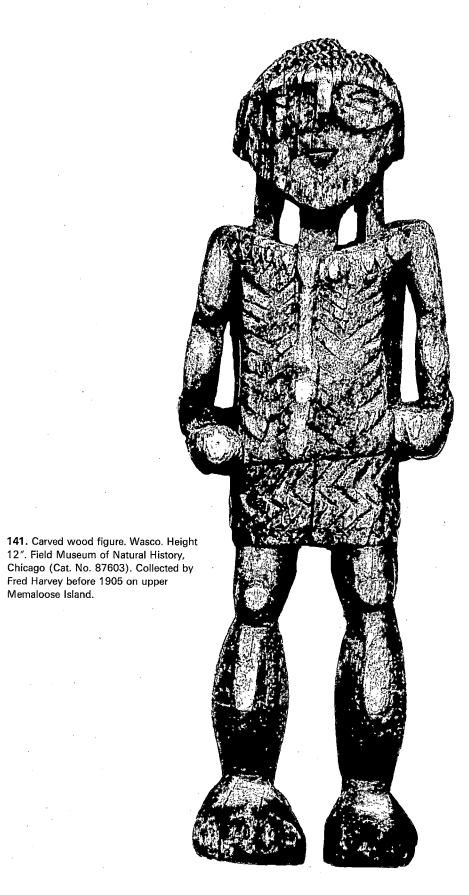

141. Carved wood figure. Wasco. Height 12″. Field Museum of Natural History, Chicago (Cat. No. 87603). Collected by Fred Harvey before 1905 on upper Memaloose Island.

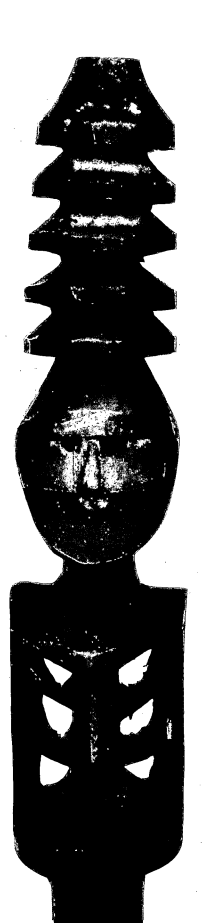

142. *Shaman's* stick. Wasco. Height of carved section 9″. Field Museum of Natural History, Chicago (Cat. No. 87630.4). Collected by Fred Harvey before 1905 at The Dalles, Oregon.

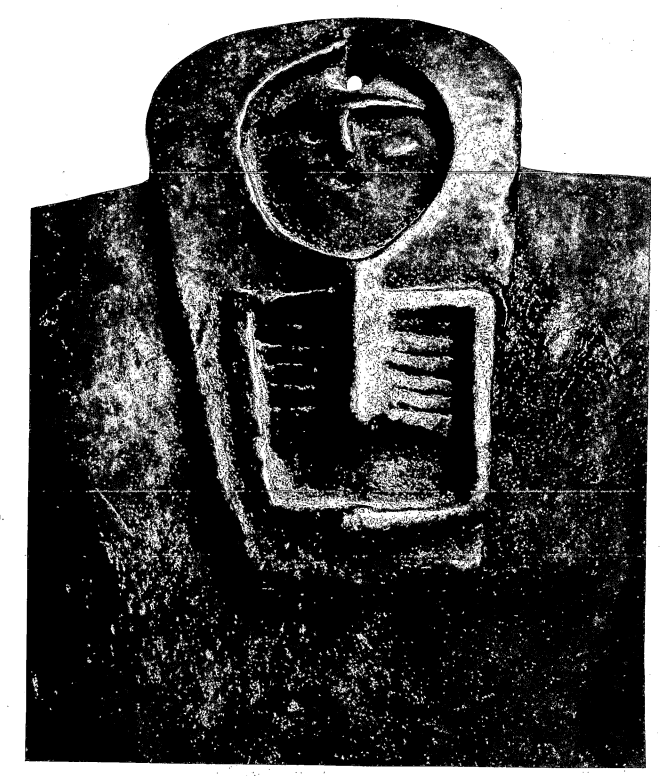

143. Carved wood mortar. Wasco.
Diameter 11 1/2″. Field Museum of
Natural History, Chicago (Cat. No. 87705).
Collected by Fred Harvey before 1905
at The Dalles, Oregon.

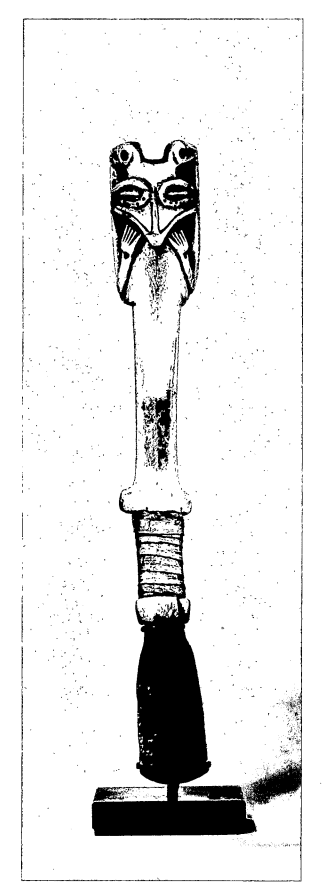 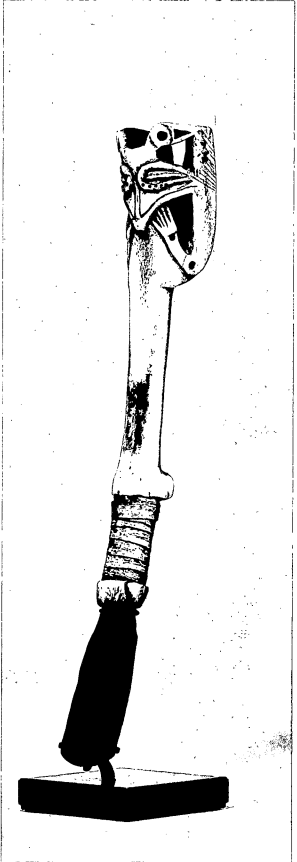

144. Adze (front and side).
Wishram–Wasco style. Length 11 3/4″.
Art Institute of Chicago (Cat. No.
Rw 65–262). The handle is of elk antler
with a metal blade.

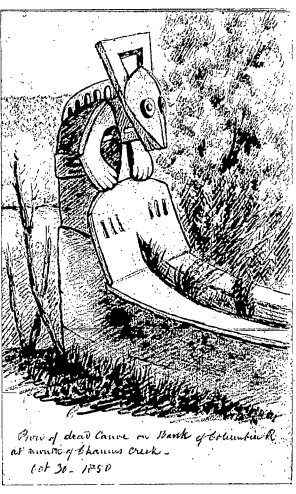

Colorplate **32.** Blanket. Salish. Peabody
Museum, Harvard University, Cambridge,
Mass. (Cat. i. . 97917). An example of a
rare type of nobility blanket made by
several Salish tribes. Early blankets of this
type were supposedly made of dog hair.

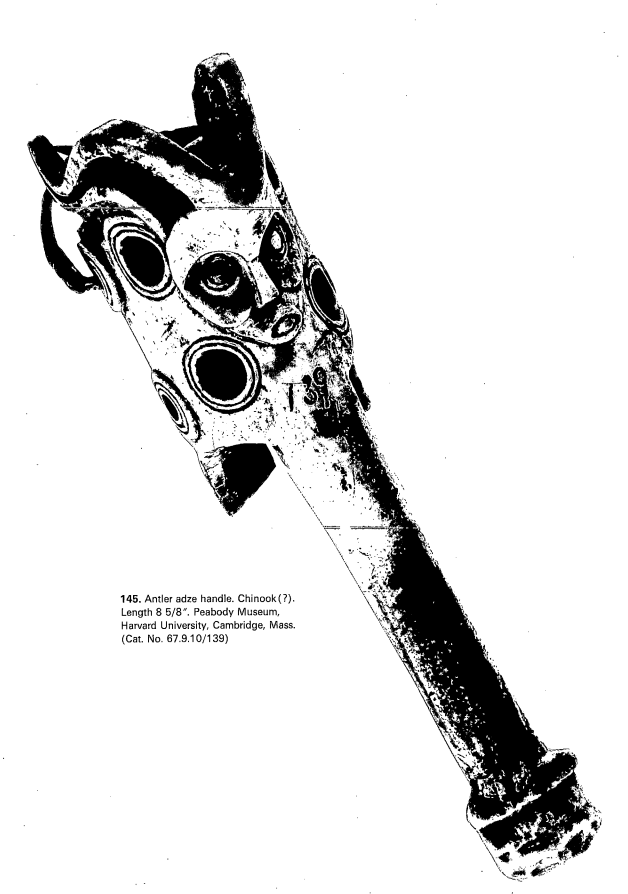

145. Antler adze handle. Chinook (?).
Length 8 5/8″. Peabody Museum,
Harvard University, Cambridge, Mass.
(Cat. No. 67.9.10/139)

*Prow of dead Canoe on Bank of Columbia R.
at mouth of Chamus Creek -
Oct 30 - 1850*

146. Prow of a Burial Canoe on the bank
of the Columbia River at the mouth of
Chamus Creek, Oct. 30, 1850. Sketch by
George Gibbs. Smithsonian Institution,
Museum of Natural History, Washington,
D.C. This is an example of a rich art form
which has not survived in our museum
collections.

The Pacific Northwest Coast

THE PACIFIC NORTHWEST COAST

The Pacific coastline from Yakutat Bay in southeastern Alaska down to about the Columbia River is a clearly defined area with a distinct culture and art style, the influence of which extended as far as northern California. The area is fairly isolated by the abruptly rising Coast Range on the east. The waterways were the chief avenues of travel, with some access to the interior possible by way of the inland rivers to the south. In addition, the Tlingit and Tsimshian people had well-developed trails across the mountains for trade with the interior Athabascan groups.

In general, the area is characterized by a mild climate, thanks to the Japan current which warms much of the coastline, and by abundant rainfall. This combination has resulted in a dense vegetation with cedar, fir, and hemlock as common trees. The people lived along the rivers, or on the sheltered ocean inlets in the few places where a natural beach could be found. Although a little hunting was practiced in the forests, the people much preferred to stay close to the water. The sea became their main—and abundant—source of food. Fish of several varieties were regularly caught during spawning times, shell fish were gathered, and water mammals hunted. Wild plants and berries also contributed to a plentiful food supply. A very limited amount of agriculture in the form of tobacco farming was practiced in some areas, but no other crops were raised.

Because of the wealth of food, a good deal of leisure was available for a non-essential art industry, often a rare situation in a hunting–gathering economy. Wood and wood products were the main raw materials. Not only were the houses made of wood, but also storage boxes, food bowls, some spoons, and canoes. So also was ritual equipment, such as masks and rattles (plates 147–49; colorplates 3, 33, 34). Cedar bark was used for mats and clothing, and spruce roots for sewing and baskets. Other raw materials included animal products in the form of wool, skins, horn, bone, teeth, and ivory. There were also some stones, and seashells. Almost everything used

277

by the Indians of this area was elaborately decorated, from the paint brushes and sewing awls, to the house posts and canoes. Artistically it was perhaps the most productive area in North America north of Mexico.

Rank was primarily based on ancestry and family connections in that the latter carried with them certain privileges, titles, names, and exclusive rights to certain dances, songs, rituals, and animal crests. However, each inherited privilege had to be validated at a *potlatch* in which guests were given gifts (actually payments for witnesses) which varied according to the importance of the privilege being validated and the rank of the recipient. Wealth in the form of material possessions was therefore an important prerequisite for achieving a high standing within the society. Efforts to raise one's social position consisted of acquiring wealth, and then holding a *potlatch* to validate an inherited privilege. To be an important individual on the Northwest Coast, it was first necessary to be "born right," that is, to have a defensible hereditary claim to high ranking privileges; and second, to have the necessary wealth to validate these privileges.

A certain degree of prestige could be achieved by well-known and skilled craftsmen who were continually called upon to create important carvings. *Shamans* who cured disease or predicted the future were also important personages, and they usually produced a specialized type of carving which was often particularly forceful (plates 153–56; colorplates 36, 37). Among the Kwakiutl and their neighbors, membership in secret societies assured prestige in that the right to membership was an inherited prerogative which was validated by lavish feasts and gift-giving.

Warfare was an important, if sporadic, activity in the Northern area. Sneak raids on neighboring tribes were common in order to acquire slaves or to avenge some supposed insult. Body armor was often elaborate, consisting of rod-and-slat jackets or heavy hides to protect the body, and wooden helmets and neck protectors in carved designs. A unique knife form was developed which was often pointed at both ends with a handle in the middle (plate 158). Daggers (plate 159), bows, and arrows were among the chief weapons, along with spears. Some Northern groups had the *atlatl* or spear-thrower, apparently borrowed from the Eskimo.

Ancestry was based on mythology about animals, and the art was therefore basically an expression of totemism. The people felt a direct and close relationship to mythological animals and used them as decoration on all of their clothing, houses, utensils, and of course the famous totem poles

(plates 160, 161). The only non-totemic art was in the geometric treatment of designs on basketry and, occasionally, on woven garments. Some carving was quite realistic and actual portraiture was sometimes intended; but generally the art took the form of a series of conventionalizations. These included a type of symbolic presentation in which a whole animal, a beaver for example, was represented by the large incisor teeth and a large, usually cross-hatched tail; birds can be identified by the shape of their beaks, and other animals by the presence (or absence) of teeth, tongues, and tails. Some mythological animals are difficult to identify because land and sea animal characteristics are combined; thus, a "sea wolf" is shown as a typical conventionalized wolf, but with the addition of flippers. Important elements were sometimes enlarged for emphasis. Several conventions were developed specifically to permit the natural animal shape to conform to the form being decorated, especially among the Northern groups where there seemed to be a horror of blank spaces. The representation of an animal figure might be split down the middle, both halves being shown attached to a common head. In addition, internal organs were sometimes shown in order to fill a space which would otherwise appear vacant. An eyelike element was often used at all joints, and occasionally faces or even complete animals were inserted within parts of a larger animal form.

It is fairly well demonstrable that the Northwest Coast art style had a flourishing tradition before Europeans arrived; however, early white contact produced a florescence of production. Not only were metal tools introduced in quantity, but also new materials—cloth, buttons, and copper (plates 163–65). Most important, however, was the new opportunity for acquiring wealth opened up by the trade of furs and other services. Families of merely middle-class status were able to acquire sufficient possessions to compete in the *potlatches* with important chiefs. This new wealth accelerated the entire economy and vast quantities of carvings, totem poles, blankets, boxes, and other works of art were made from the late eighteenth century down to about the beginning of the twentieth century. About this time, the *potlatch* was outlawed by Canadian law, missionaries discouraged any Indian practices as being heathen, and whole villages became economically dependent upon commercial fishing—all factors which contributed to a decline in the arts.

Owing to the basically similar geographic terrain along the entire stretch of the coast, and the frequency of traveling and raiding, a basically similar cultural pattern subsisted throughout the area. There are, of course,

many local differences even within tribal groups; each village was an independent unit and tribal unity was poorly developed. The art styles were determined rather by geographic proximity than by linguistic affiliation. For example, the northern Kwakiutl (Haisla) were more closely related to their Tsimshian neighbors than to the southern Kwakiutl. Likewise the northern Haida (Kaigani) showed many Tlingit characteristics, and the Salish-speaking Bella Coola resembled the central Kwakiutl more than any group of related Salishan Indians.

The Northwest Coast area can be roughly divided into three artistic areas, from north to south. The northern group, consisting of Tlingit, Haida, and Tsimshian, although showing many differences, are still closely related. Their sculpture is more refined than that of other areas, and more limited by the basic form of the material being decorated. Their totem poles, carved from a basically cylindrical tree form, have the figures wrapped around the curved surface so that the finished carving retains its cylindrical form. This contrasts with the southern style, in which added arms project from the carving and the space between the legs is sometimes completely cut through. Northern carving is usually finely finished and sometimes naturalistic, but always conforms rigidly to set conventions. The general feeling is of dignified restraint rather than freedom or boldness of form.

The Tsimshian, and especially the Tlingit, borrowed many elements of culture from the interior Athabascan tribes. They practiced such crafts as porcupine quillworking (plate 170) and beadwork in floral designs, used leather garments, and made skin moccasins. These two tribes were also famous for their woven goat hair and cedar bark blankets of the type known as "Chilkat." The name is derived from the Chilkat division of the Tlingit, which principally produced them in the historic period (plates 173, 174). All the Northern groups produced very fine twined baskets in a basic pail shape, usually using spruce roots (plate 175). Basketry hats and mats were also manufactured. A specialty of the Haida was the carving of miniature stone totem poles and novelties for the tourist trade; argillite, the material used, was only found in the Haida country near the town of Skidegate on the Queen Charlotte Islands (plate 176). The Aleuts, living to the north of the Tlingit, also had some influences on Tlingit culture but little influence on their art, with the possible exception of the concept of adding extra faces and projections on some masks.

The Central Northwest Coast area is populated by the Kwakiutl and

Bella Coola tribes, whose sculpture is bolder and less refined than that of the northern region. A clever carver could produce a fine texture, with rows of parallel adze marks running in different directions on different parts of the carving (colorplate 41). Masks from this area frequently have mechanical contrivances, or interchangeable parts, which enabled the wearers to completely change the character of the mask during a dramatic dance presentation. An identifying characteristic of carvings from this area is a rounded and projecting eye with a flattened pupil. Both the Bella Coola and Kwakiutl tended toward a bold use of paint, but in general Kwakiutl painting follows the lines of the carving, while the Bella Coola tended to paint across carved lines. Bella Coola also seem to prefer the use of a bright blue paint which became characteristic of the tribe's art (plates 178–80; colorplate 42; see also frontispiece).

Less basketry was produced in this area than in the other two, and little use was made of skin clothing. In the Kwakiutl area, there occurred the greatest development of secret societies, involving elaborate ritual and carvings connected with the ceremonies. Some, such as the Hamatsa or Cannibal Society, have received much notoriety because human flesh was evidently eaten during a portion of the ritual (colorplate 43). The Kwakiutl, though conscious of clan ancestry, placed somewhat less emphasis on clan crests than did the northern tribes.

The southern portion of the Northwest Coast area is comprised of the Coast Salish tribes, the Nootka, and lower Chinook. The people here had a greater dependence upon vegetable food, but also utilized sea products. The Nootka actually hunted whales on the open sea in their dugout canoes, and developed elaborate rituals around whale hunting. The sculpture in this area seems an indigenous development, but was considerably influenced from the north in comparatively recent times; in general, it is crude and simple, with a use of bright paint. A notable type made by the Nootka was a common form of mask, consisting of flat painted boards, and used in their Wolf ritual (plate 185).

Fine basketry in the twined technique is produced in this area by the Nootka (plate 186), while the Salishan groups used the imbricated coiled technique. Some Salish tribes produced a crude woven blanket of dog's hair; early examples had elaborate geometric designs in polychrome twining, but later examples were simply white with a one-line red border.

The importance of the *potlatch* and the secret societies was replaced

among the Coast Salish by an emphasis on personal guardian spirits, which spread as far south as the Columbia River. The most important carvings from this area took the form of guardian spirit figures, which were carried by some tribes in their spirit dances (plates 187–89).

Today there are no longer any wood-carvers among the northern tribes who have been trained in the traditional manner, that is, by serving an apprenticeship to a known craftsman. However, this is not true among the Kwakiutl who have maintained an unbroken tradition of fine craftsmanship along with a continuation of the *potlatch* system. The work of artists such as Charlie James, Willie Seaweed, and Mungo Martin are now eagerly sought after by both collectors and museums. There are also quite a few contemporary practicing artists who do excellent work. Some of the better-known artists are Henry Hunt, Tony Hunt, Charlie George, Jr., Charlie G. Walkus, Ed Walkus, and Doug Cranmer, to mention just a few. Bill Reid, a Haida artist, was not brought up in a wood-carving tradition but trained himself; he produces excellent work, including a reconstruction of a house and totem poles on the campus of the University of British Columbia at Vancouver. Bob Davidson, a young Haida, does fine work in wood, argillite, and silver under Bill Reid's tutelage.

The Indian Arts and Crafts Board is encouraging a few select carvers in Alaska by emphasizing creative effort rather than copying. Lincoln Wallace of Sitka, and Amos Wallace of Juneau are both doing fine Tlingit work. A project at Port Chilkoot, Alaska is helping to revive quality carvings among the Chilkat and in Nathan Jackson has produced a top rate artist. The Northwest Coast is indeed perhaps the only area where it is economically feasible to continue fine quality arts and crafts production in the old traditions.

Today there is a very limited production of Chilkat blankets. Baskets are still made at several places and the Nootkas still produce basketry of high quality. Carvings in bone, shell, and ivory, however, are no longer made, and there are only a very few Indians capable of engraving silver bracelets.

There are several non-Indians and Indians of tribes other than those from the Northwest Coast who produce Northwest Coast type carvings. It is a sign of the popularity of the style that carvings are produced by Seminole Indians in Florida in the form of totem poles—though these are not intended to fool anyone. Moreover, in recent years many obvious fakes have been placed on the market in an effort to meet the demands of collectors clamoring for examples of Northwest Coast art.

Colorplate **33.** Clan hat. Tsimshian. ⟶
National Museum of Canada, Ottawa
(Cat. No. VII–C–1764)

147. Face mask with movable eyes. Tsimshian. National Museum of Canada, Ottawa (Cat. No. VII–C–1768)

CONCORD HIGH SCHOOL MEDIA CENTER
59117 SCHOOL DRIVE
ELKHART, INDIANA 46514

148. Mask. Haida(?).
Peabody Museum,
Harvard University,
Cambridge, Mass.

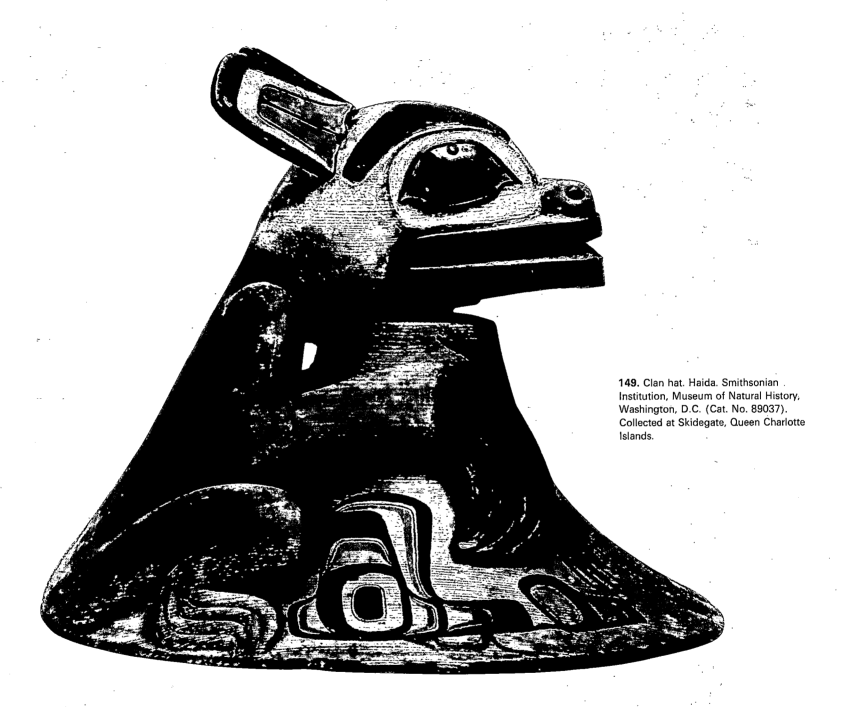

149. Clan hat. Haida. Smithsonian
Institution, Museum of Natural History,
Washington, D.C. (Cat. No. 89037).
Collected at Skidegate, Queen Charlotte
Islands.

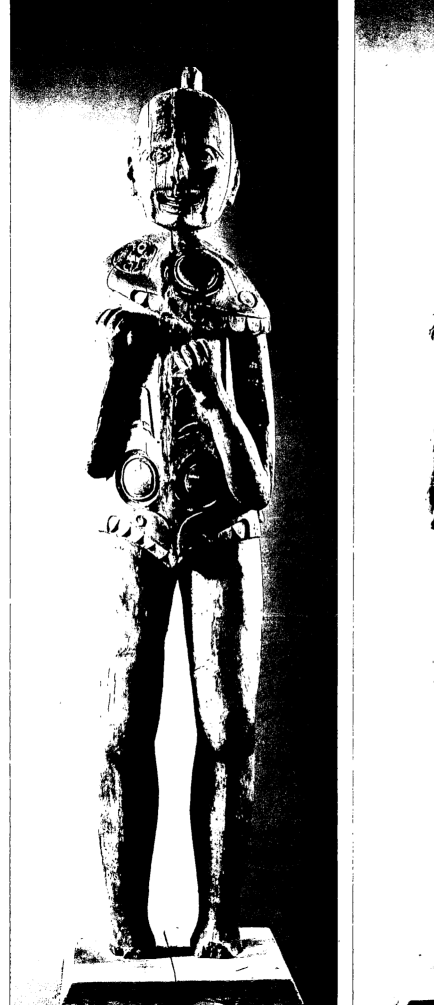

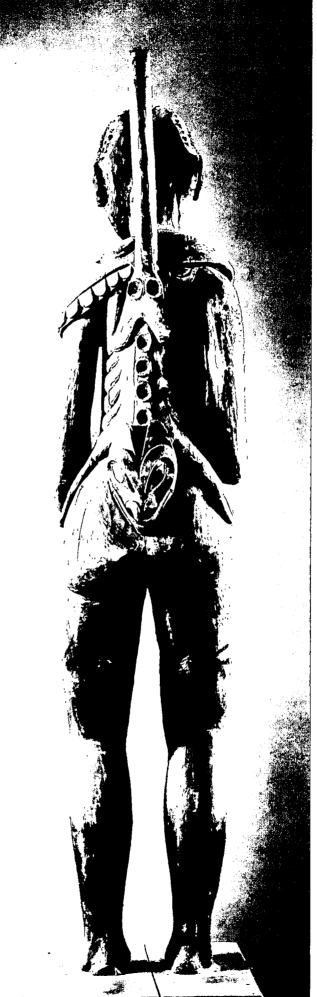

150. Carved standing figure (front). Tlingit. Height 61˝. American Museum of Natural History, New York City (Cat. No. E 1915). From a *shaman's* grave house.

151. Back view of figure in Plate 150

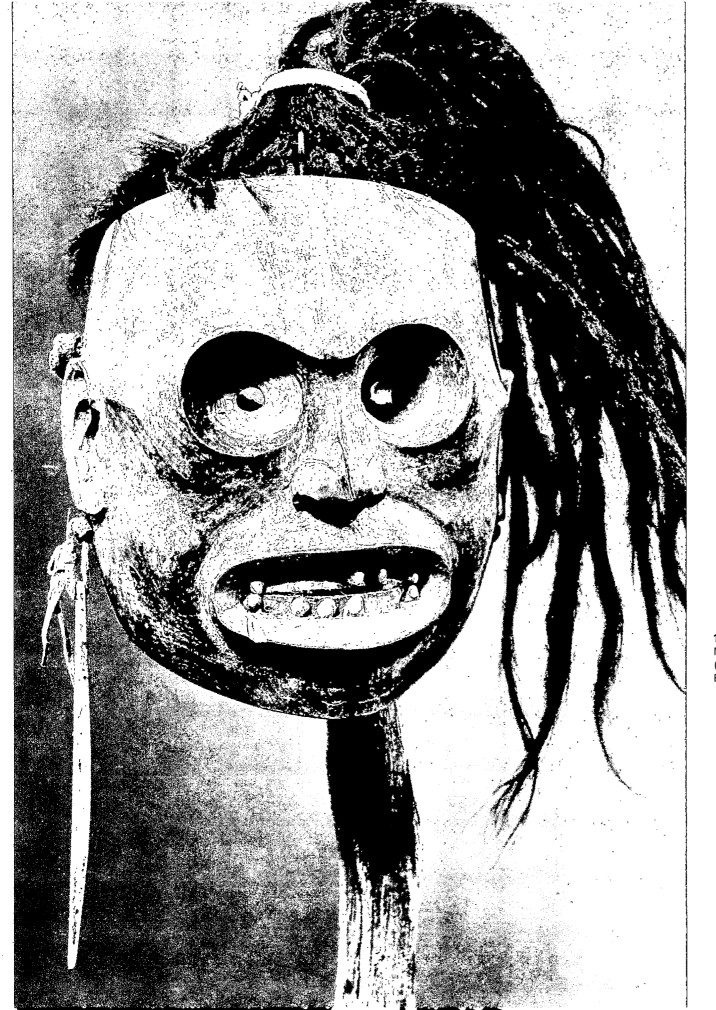

152. Face mask. Chilkat Tlingit. American Museum of Natural History, New York City (Cat. No. 19/854). Collected by George Emmons before 1890.

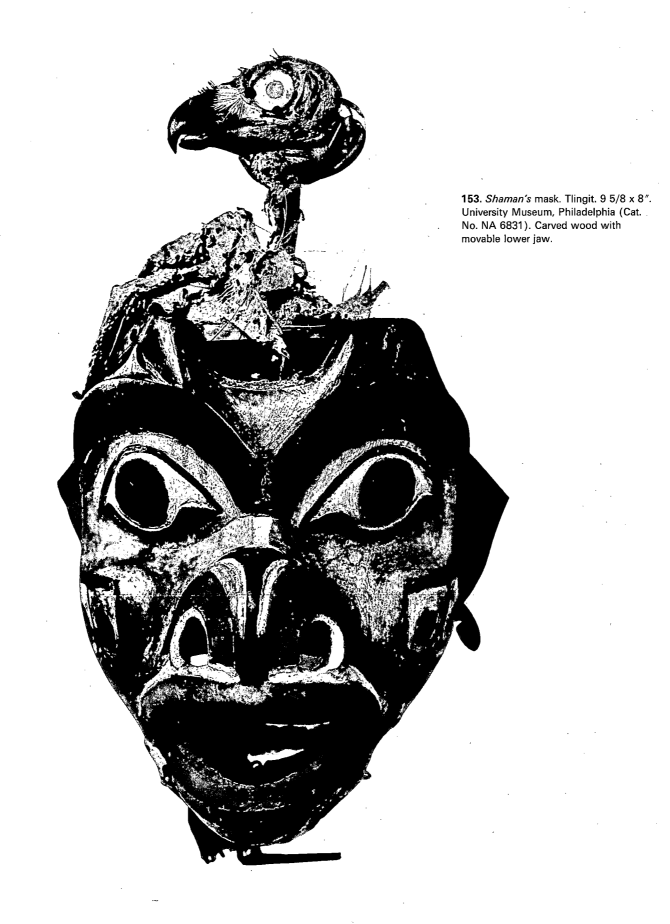

153. *Shaman's* mask. Tlingit. 9 5/8 x 8".
University Museum, Philadelphia (Cat.
No. NA 6831). Carved wood with
movable lower jaw.

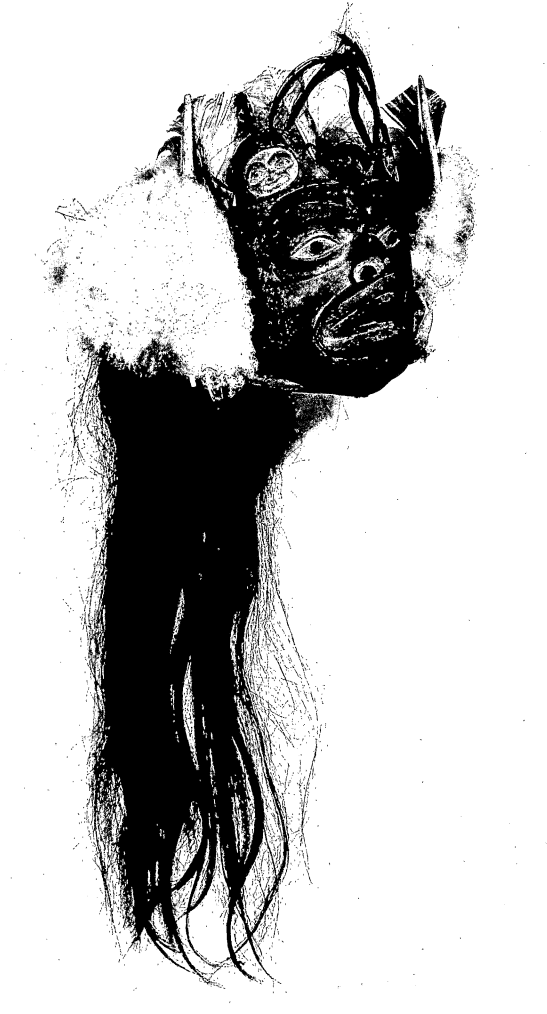

154. *Shaman's* headdress. Tlingit. Height
6 1/4". Museum of the American Indian,
Heye Foundation, New York City (Cat.
No. 11/1747)

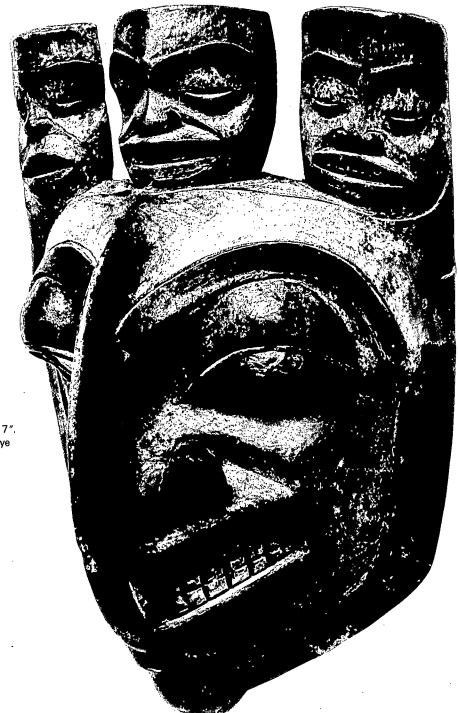

155. *Shaman's* mask. Tlingit. Height 7".
Museum of the American Indian, Heye
Foundation, New York City (Cat.
No. 9/7888)

Colorplate **34.** Bird mask with movable
beak. Probably Haida. Carnegie Museum,
Pittsburgh. Fred Harvey Collection
(Cat. No. 31.78/30)

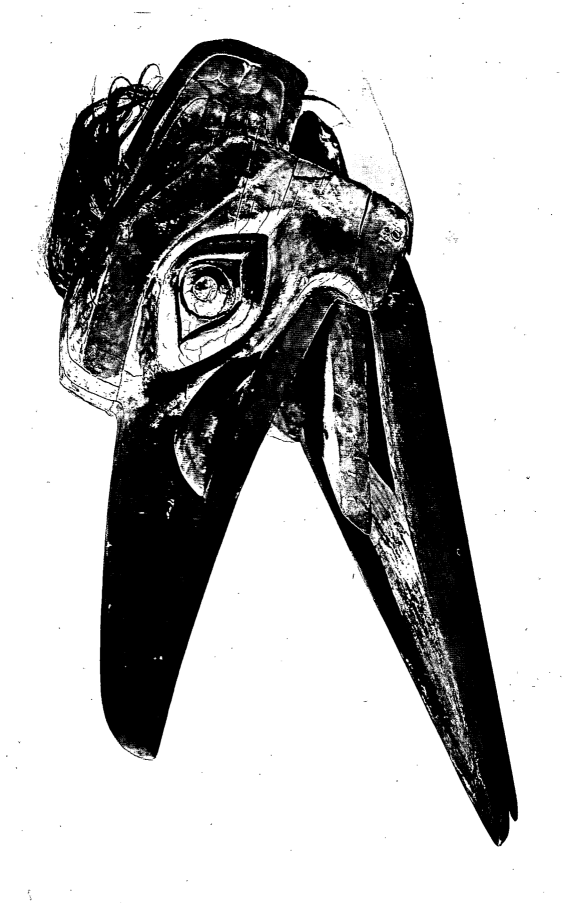

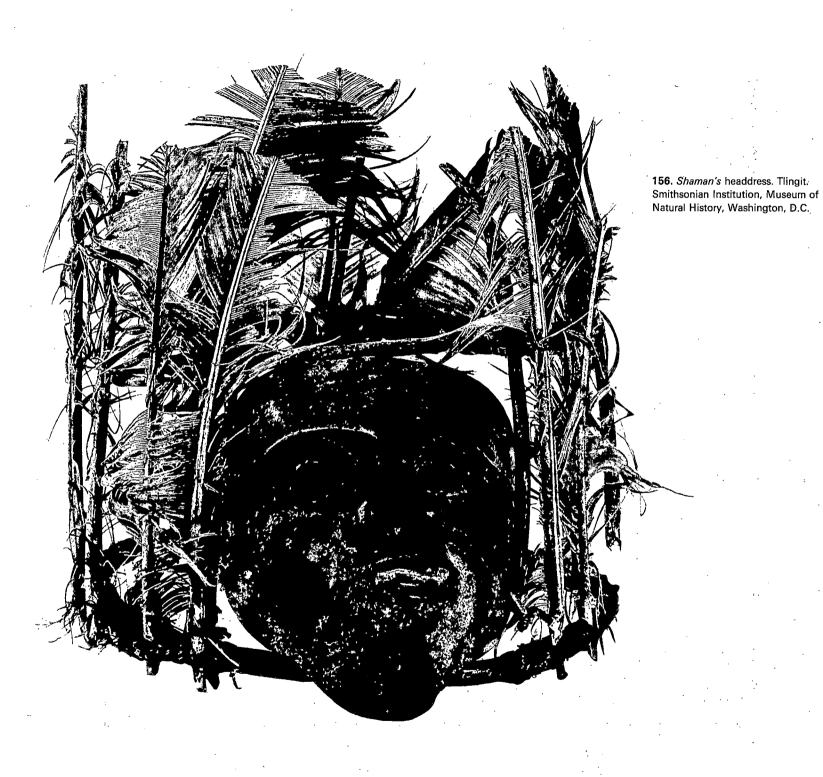

156. *Shaman's* headdress. Tlingit. Smithsonian Institution, Museum of Natural History, Washington, D.C.

Colorplate **35.** Face mask. Chilkat Tlingit. ⟶
Height 9 3/8″. Smithsonian Institution,
Museum of Natural History, Washington,
D.C. (Cat. No. 76855). Collected by T.
Dix Bolles before 1885. Chinese temple
coins for eyes and opercula for teeth.

157. Raven rattle. Tribe unknown.
Length 17″. Smithsonian Institution,
Museum of Natural History, Washington,
D.C. (Cat. No. 2668). Collected on the
Lieutenant Charles Wilkes expedition of
1838–42.

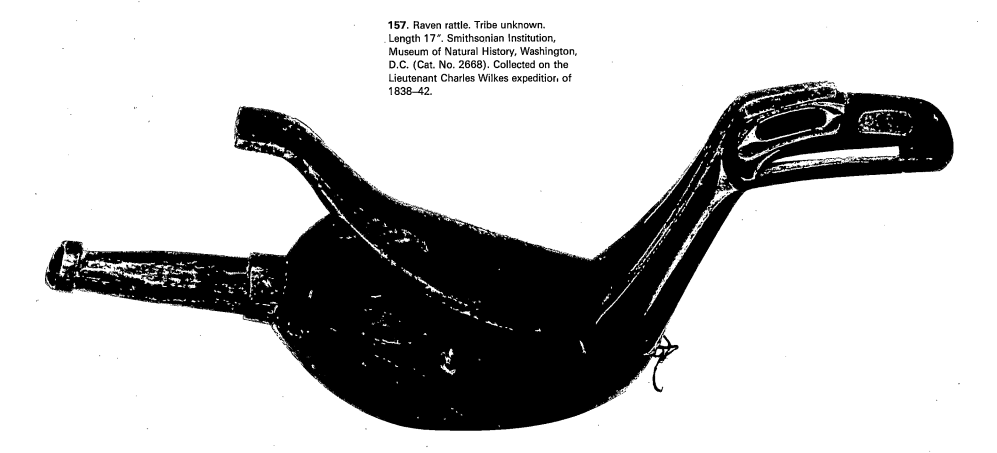

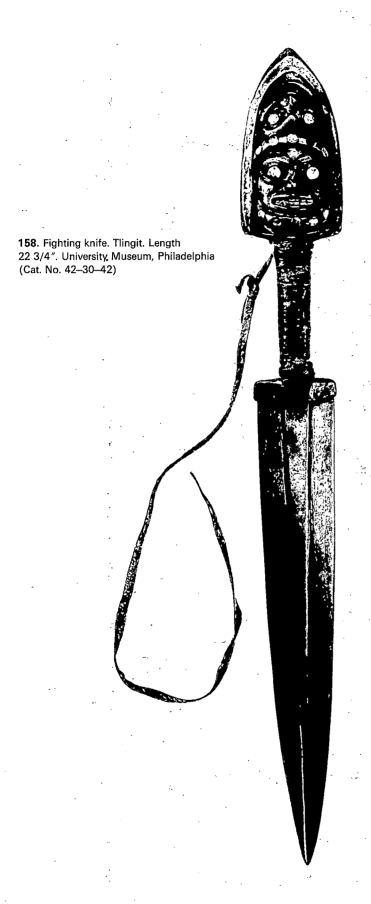

158. Fighting knife. Tlingit. Length
22 3/4″. University Museum, Philadelphia
(Cat. No. 42–30–42)

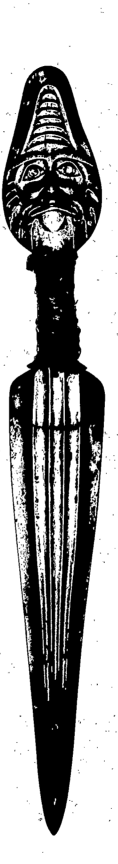

159. Iron dagger. Tlingit. Length 21 1/4″.
Denver Art Museum (Cat. No. QTI–3)

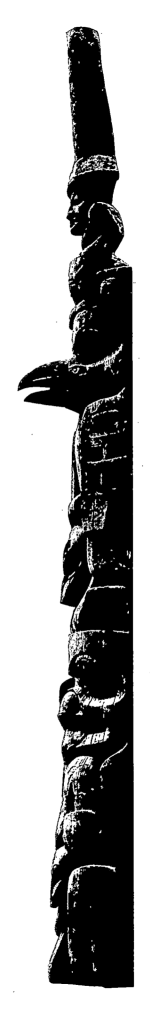

160. Totem pole (front). Haida. Height
20′ 10″. University Museum, Philadelphia
(Cat. No. 37728 and 29–47–201).
Collected by C. F. Newcombe at Masset,
Queen Charlotte Islands in 1900.

161. Side view of pole in Plate 160

162. Button blanket. Tsimshian.
50 3/4 x 74 3/8". University Museum,
Philadelphia (Cat. No. NA 8516).
Collected by Louis Shotridge on the Nass
River in British Columbia, 1918.

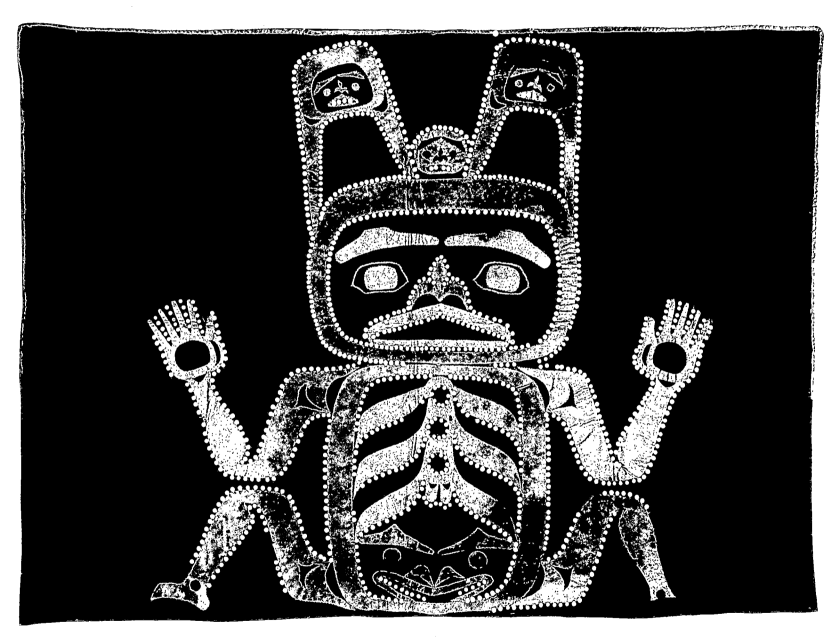

163. Engraved silver blanket pin. Haida. American Museum of Natural History, New York City (Cat. No. 16.1/2538). Represents a beaver.

Colorplate 36. *Shaman's* mask of a wolf \longrightarrow
according to George Emmons. Tlingit. Height 10″. American Museum of Natural History, New York City (Cat. No. 19/853). Collected by George Emmons from a Chilkat grave. Opercula teeth and metal eye.

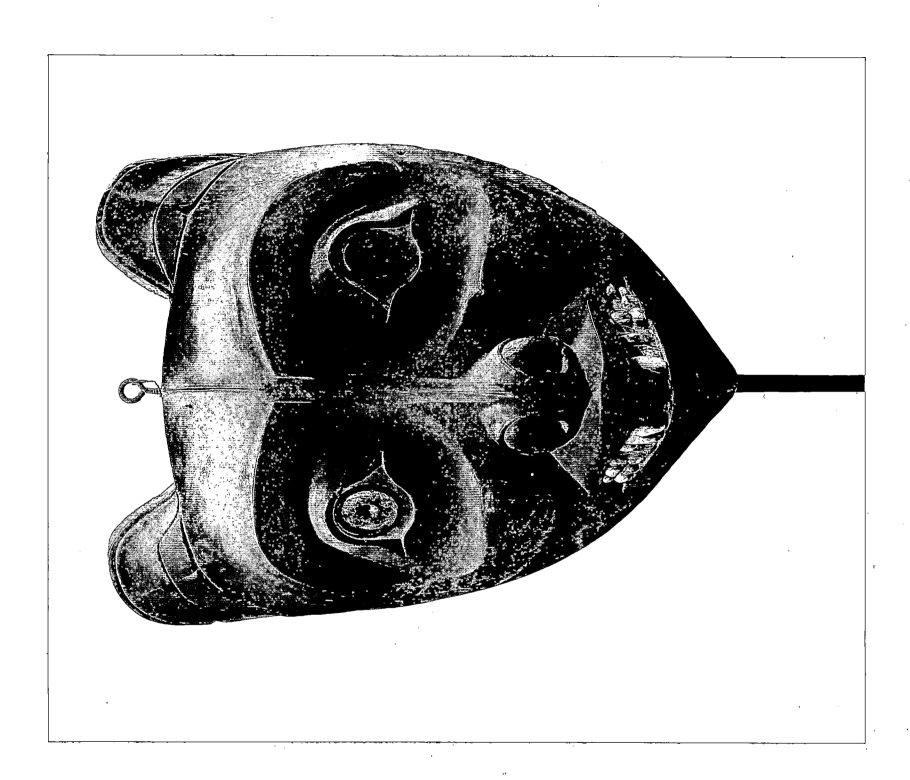

164. Cloth appliqué shirt (front).
Haida(?). Royal Ontario Museum,
University of Toronto, Canada (Cat. No.
HN 894). A double-headed wolf is shown
on the front.

165. Back view of shirt in Plate 164
showing a shark

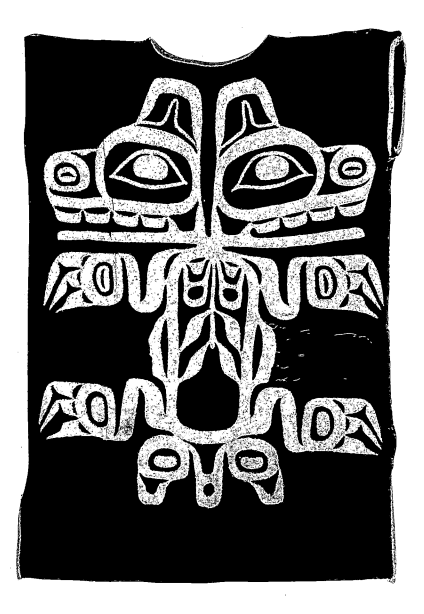

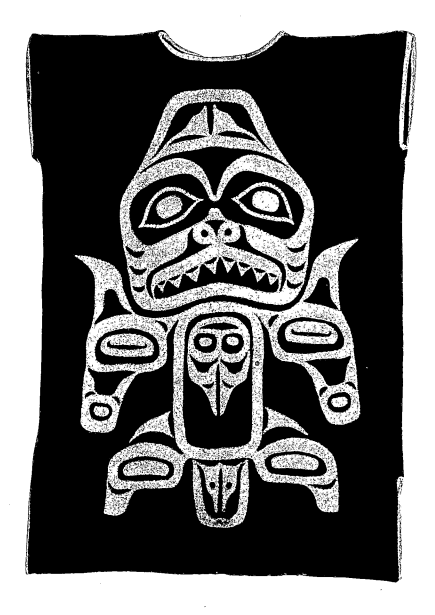

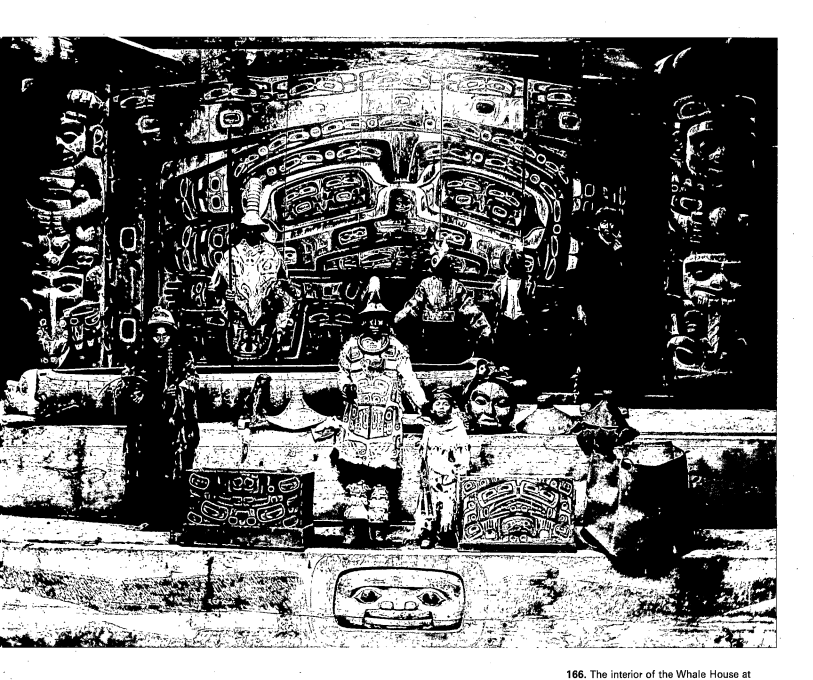

Colorplate **37.** *Shaman's* crown. Tlingit. Height 6 3/4″. American Museum of Natural History, New York City (Cat. No. E 2350). Collected by George Emmons at Klukwan, Alaska. Human hair, feathers, bird skin, blue jay feathers, and bearskin.

166. The interior of the Whale House at Klukwan, Alaska. Chilkat Tlingit. Note the beautifully carved and painted wall screen and the house posts. The old Whale House is no longer standing, but the screen and house posts are still preserved by the Chilkat at Klukwan.

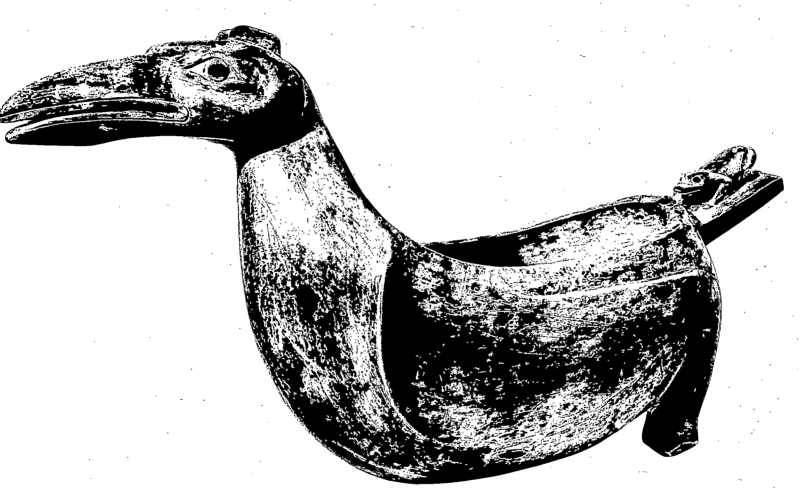

167. Wood dish in bird form. Tlingit(?). Royal Ontario Museum, University of Toronto, Canada (Cat. No. HN–895)

→

Colorplate **38**. Panel from a house platform. Tlingit. American Museum of Natural History, New York City (Cat. No. E 1385). Collected by George Emmons from an old Kar-gwan-ton House at Sitka, Alaska. Represents a bear with opercula for teeth.

168. Carved antler charm (front). Tribe unknown. Royal Ontario Museum, University of Toronto, Canada (Cat. No. HN–1408). Collected by Paul Kane.

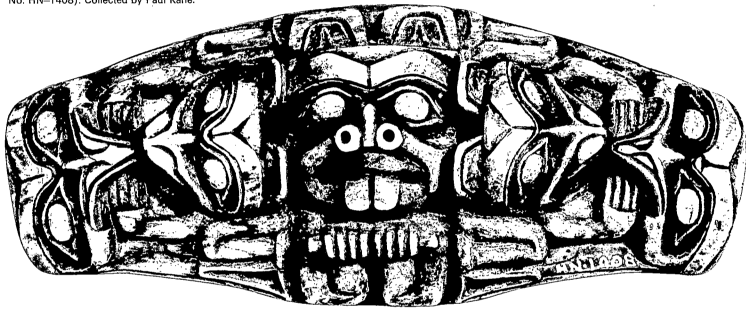

169. Back view of charm in Plate 168.

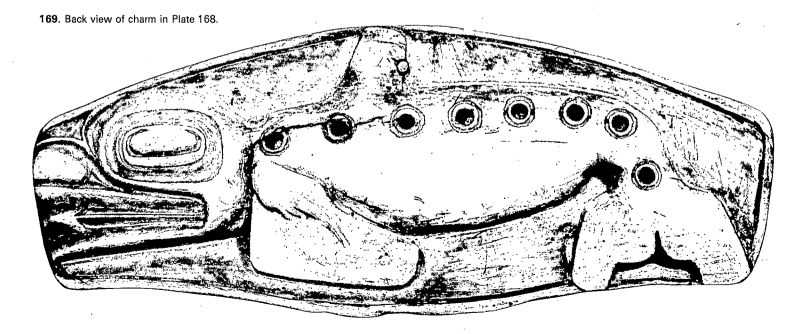

170. Skin leggings with porcupine quill embroidery. Tsimshian(?). Field Museum of Natural History, Chicago (Cat. 155568). The quillwork is done over a painted design.

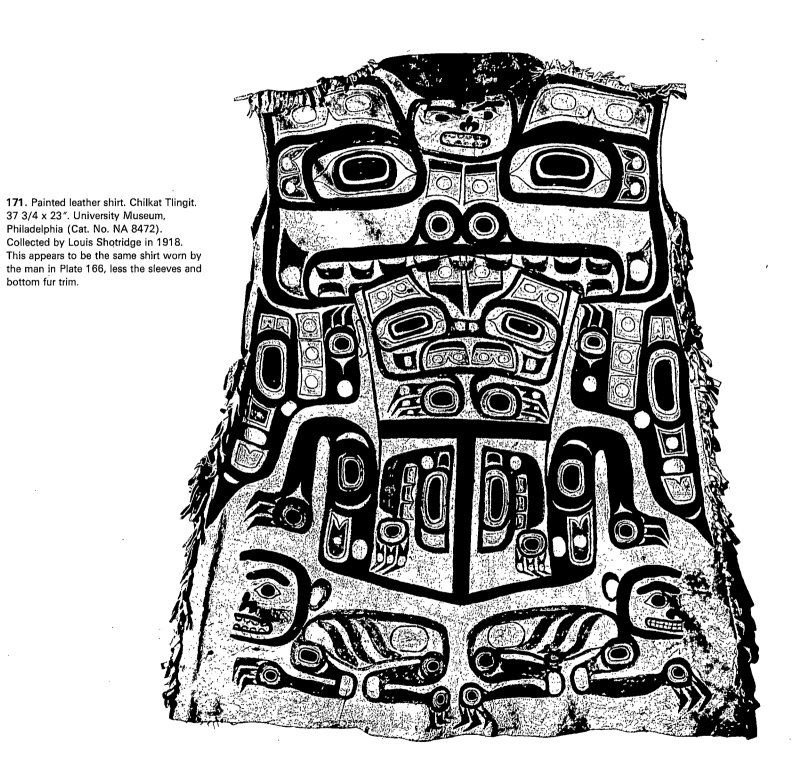

171. Painted leather shirt. Chilkat Tlingit. 37 3/4 x 23″. University Museum, Philadelphia (Cat. No. NA 8472). Collected by Louis Shotridge in 1918. This appears to be the same shirt worn by the man in Plate 166, less the sleeves and bottom fur trim.

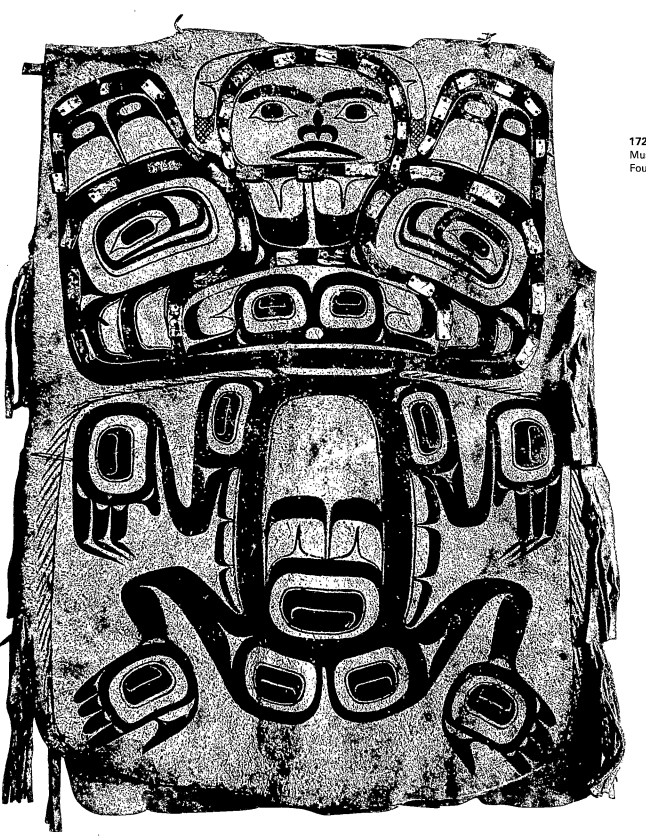

172. Painted skin shirt. Tsimshian. Museum of the American Indian, Heye Foundation, New York City

Colorplate **39.** Face mask. Heiltsuk (Bella ⟶
Bella). American Museum of Natural
History, New York City (Cat. No. 16/594).
Abalone shell inlay. From the Bishop
Collection and purchased in 1888.

173. Chilkat blanket. Tlingit. Museum of
Primitive Art, New York City (Cat. No. 61.568)

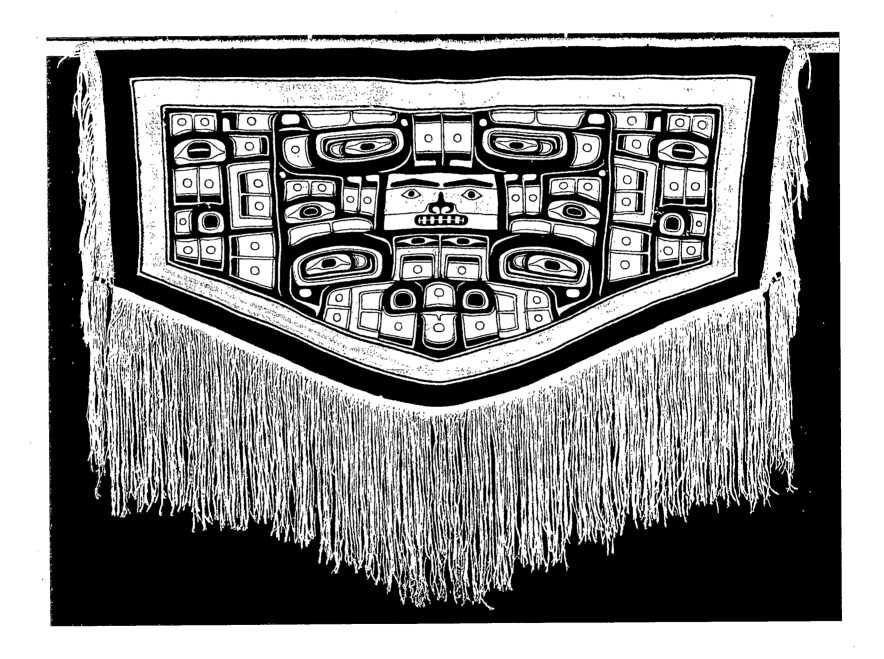

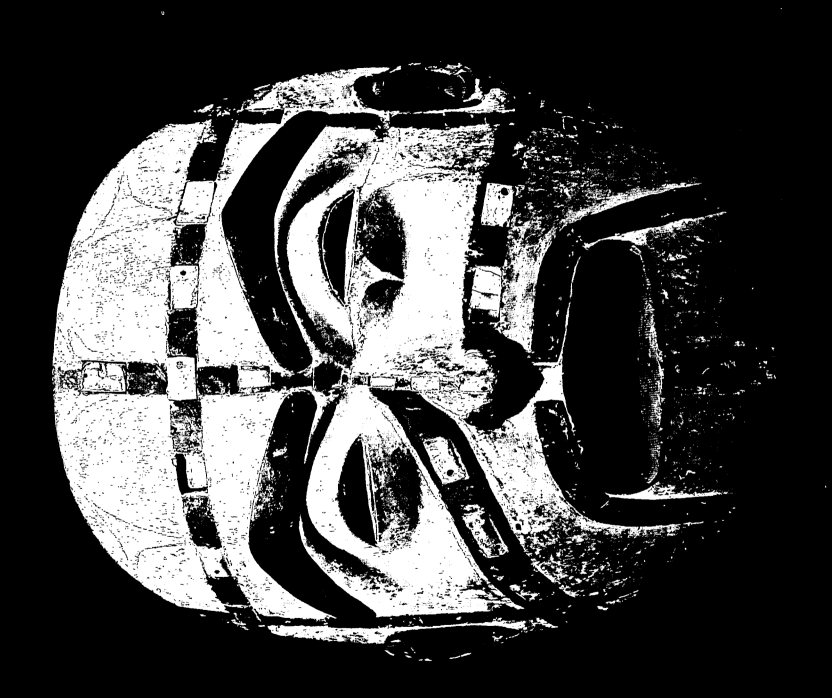

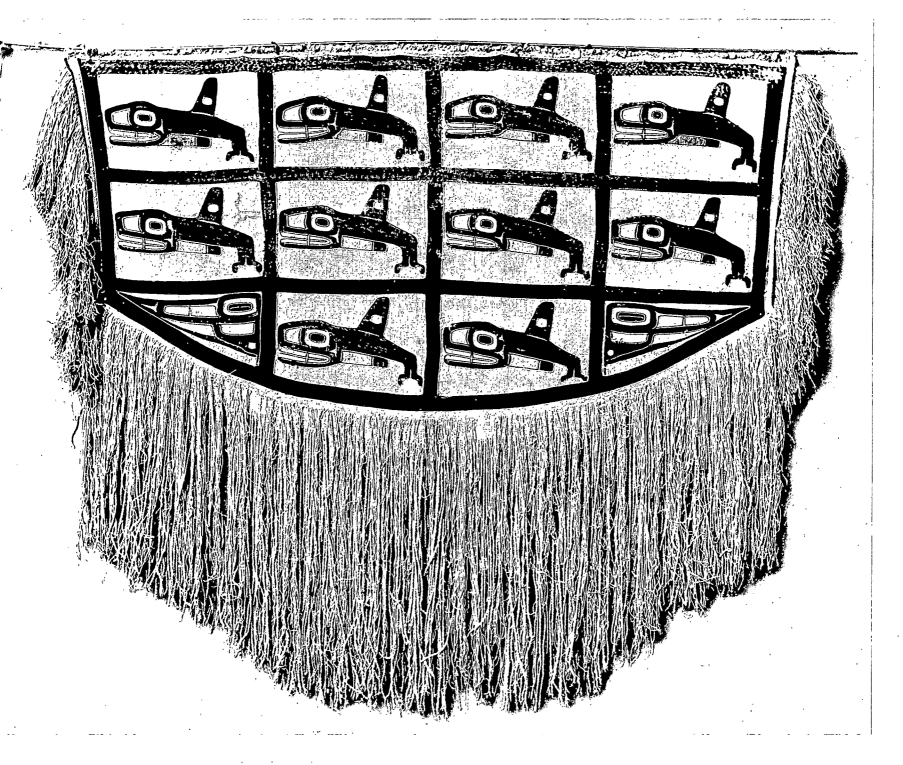

174. Chilkat blanket. Tlingit. Field Museum of Natural History, Chicago (Cat. No. 19571)

Colorplate **40**. Face mask. Bella Coola. ⟶
Height 14 1/2″. American Museum of
Natural History, New York City (Cat.
No. 16/596)

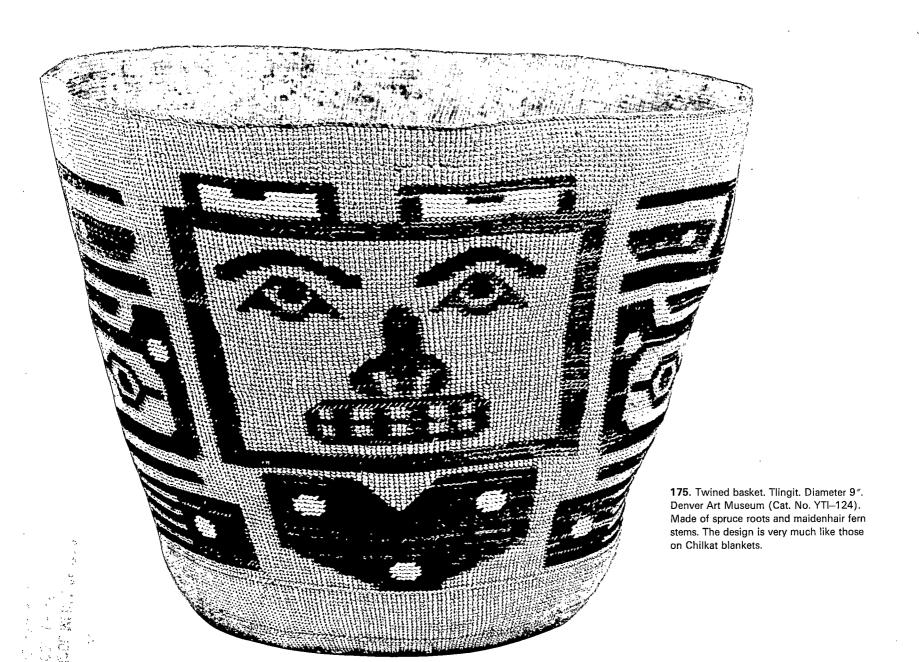

175. Twined basket. Tlingit. Diameter 9″.
Denver Art Museum (Cat. No. YTl–124).
Made of spruce roots and maidenhair fern
stems. The design is very much like those
on Chilkat blankets.

CONCORD HIGH SCHOOL MEDIA CENTER
59117 SCHOOL DRIVE
ELKHART, INDIANA 46514

176. Carving in argillite and ivory. Haida. Height 15 5/8″. Denver Art Museum (Cat. No. QHi–114)

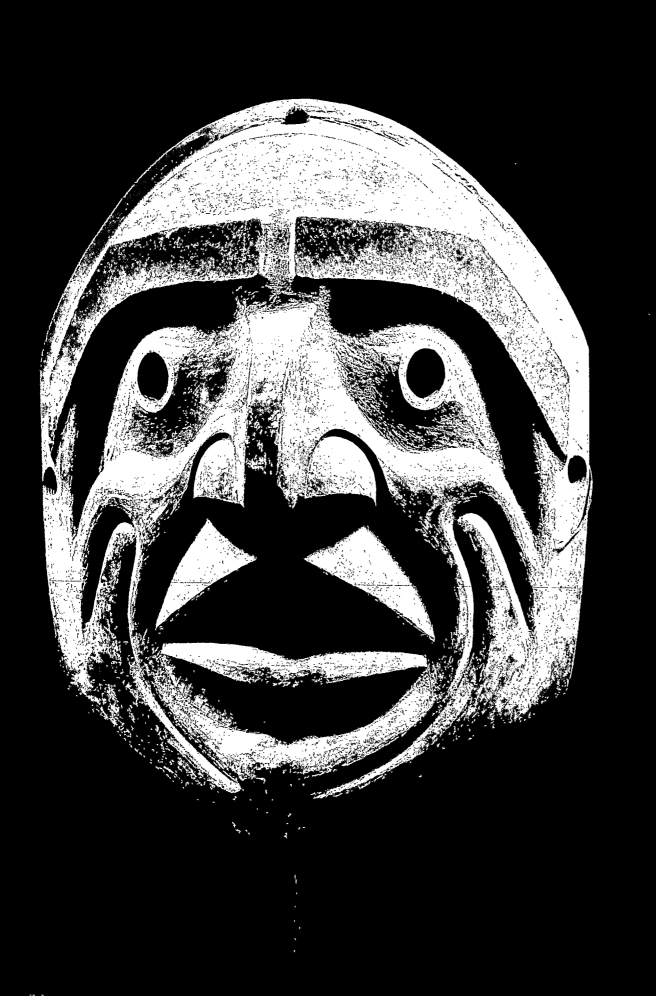

Colorplate **41**. Wolf mask. Kwakiutl(?). →
7 1/4 x 20 1/4″. Denver Art Museum
(Cat. No. NNu–7). A very old and very
finely carved mask. Note the detailed
adzing.

177. Face mask. Bella Coola. American
Museum of Natural History, New York City
(Cat. No. 16/1503)

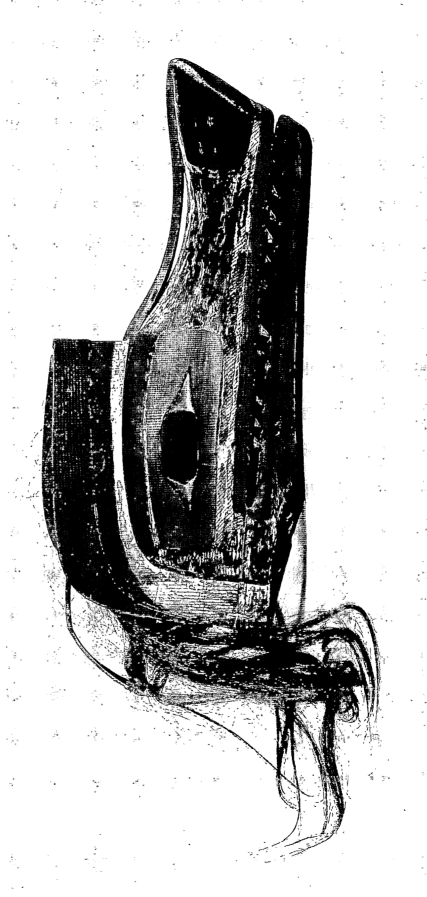

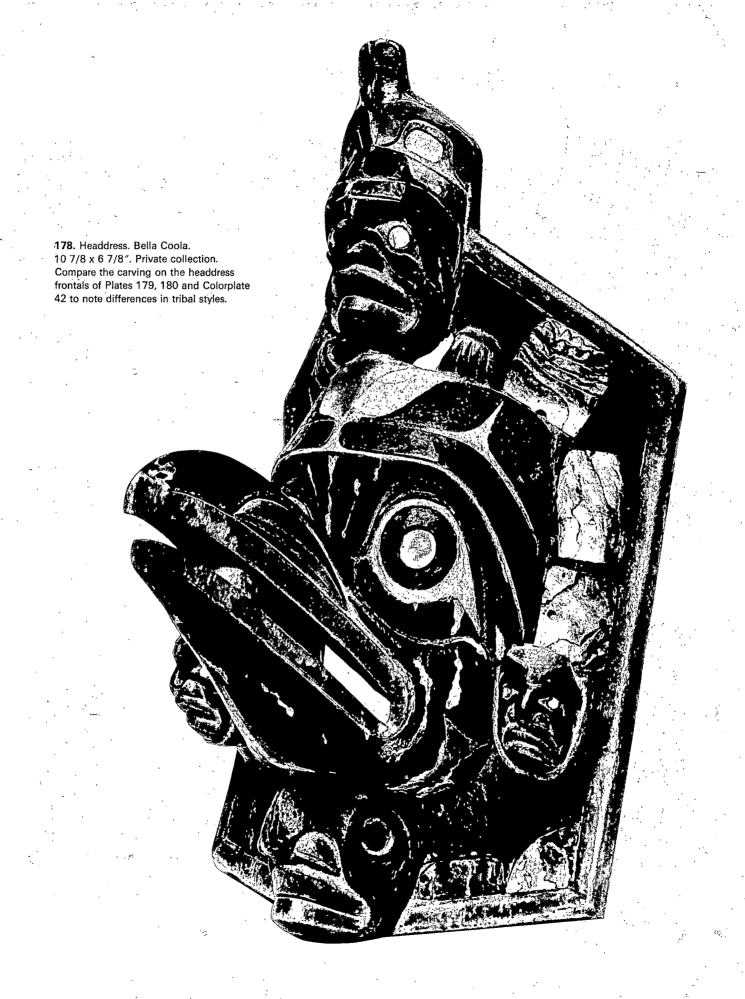

178. Headdress. Bella Coola.
10 7/8 x 6 7/8". Private collection.
Compare the carving on the headdress
frontals of Plates 179, 180 and Colorplate
42 to note differences in tribal styles.

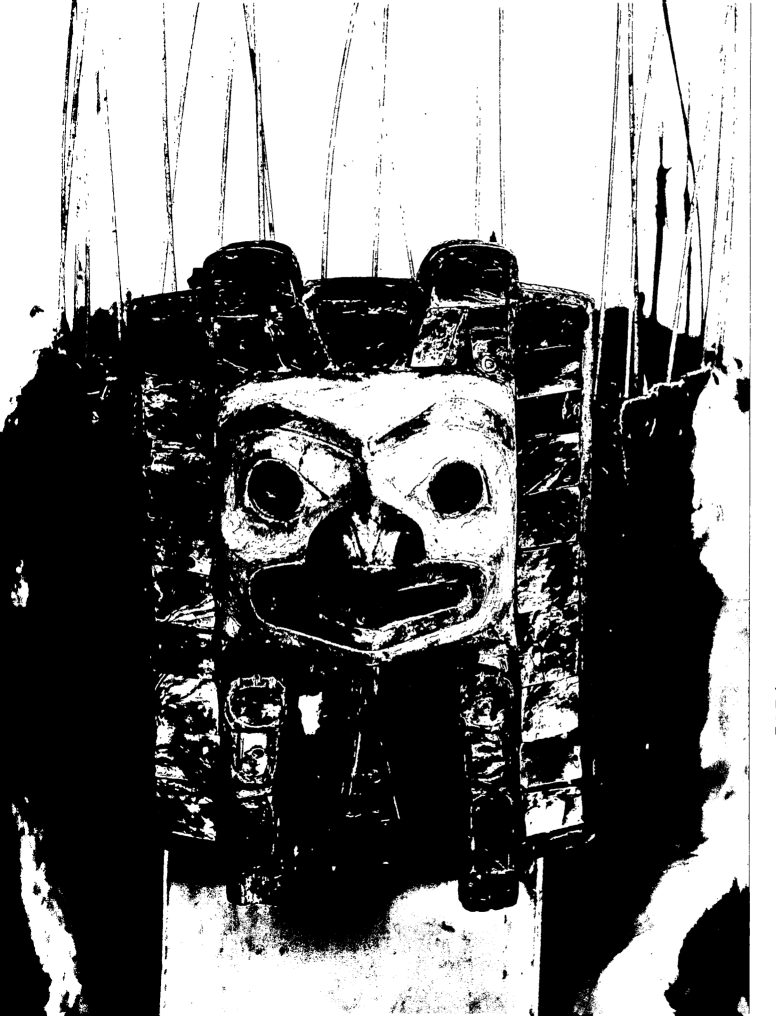

179. Headdress. Tsimshian. Royal Ontario Museum, University of Toronto, Canada (Cat. No. HN 910). Collected on the Nass River by Charles Marius Barbeau.

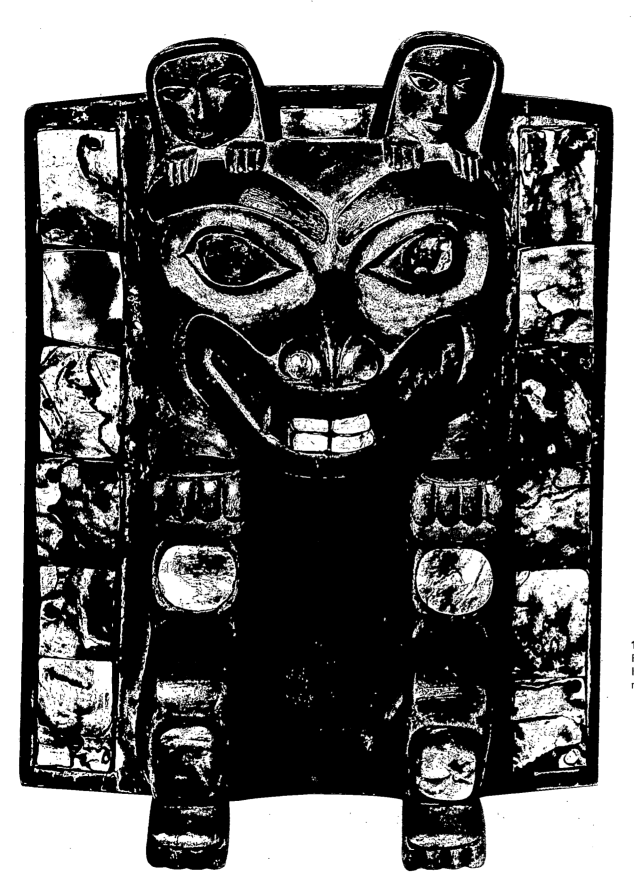

180. Headdress. Haida(?). 7 1/4 x 5 1/2″.
Private collection. Collected from the
Kwakiutl at Alert Bay, but not of Kwakiutl
manufacture.

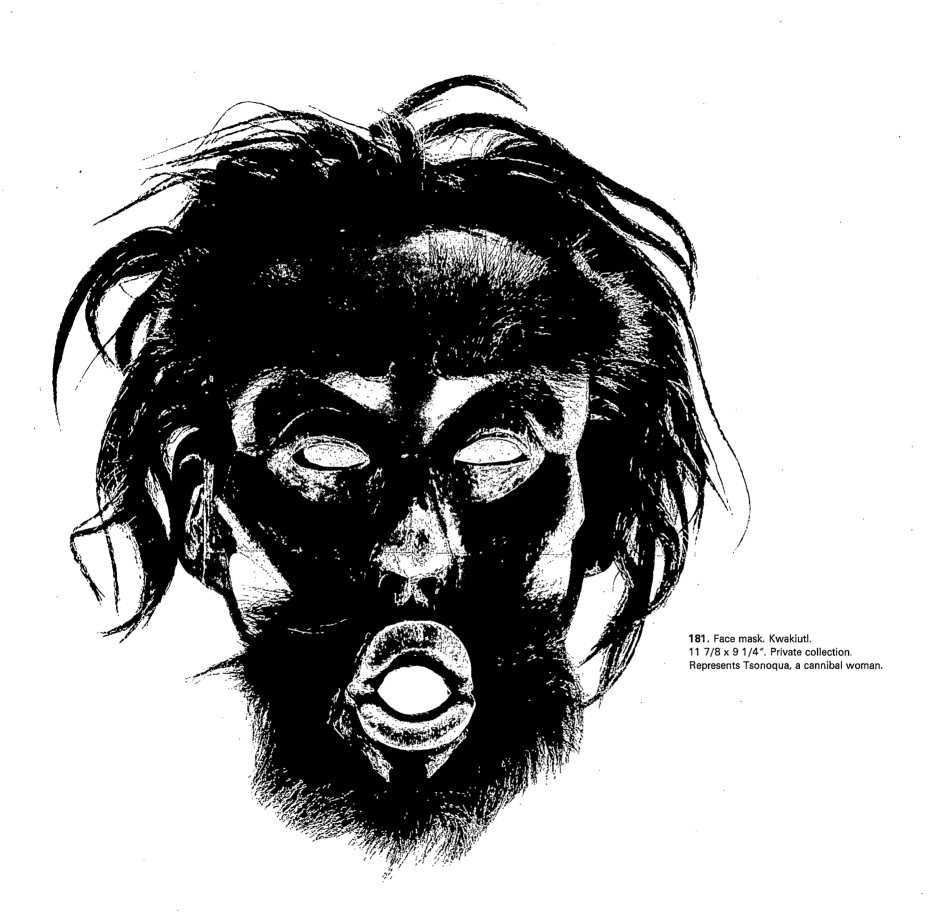

181. Face mask. Kwakiutl.
11 7/8 x 9 1/4". Private collection.
Represents Tsonoqua, a cannibal woman.

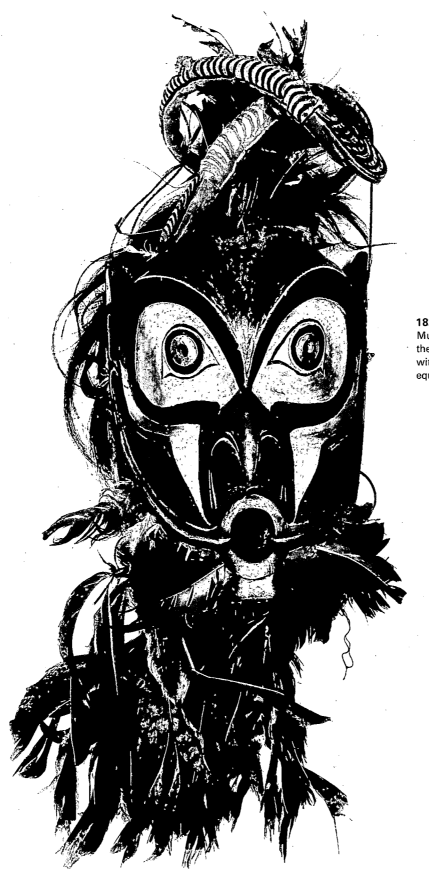

182. Face mask. Kwakiutl. National Museum of Canada, Ottawa. Represents the Wild Man of the Woods. Compare with Plate 7 which is a Bella Bella equivalent of the same mask.

183. Face mask. Kwakiutl. Height 12 1/4".
Milwaukee Public Museum, Wisconsin.
Anthropology Collection (Cat. No. 17357).
Another version of the Wild Man mask,
collected by S. A. Barrett in 1915.

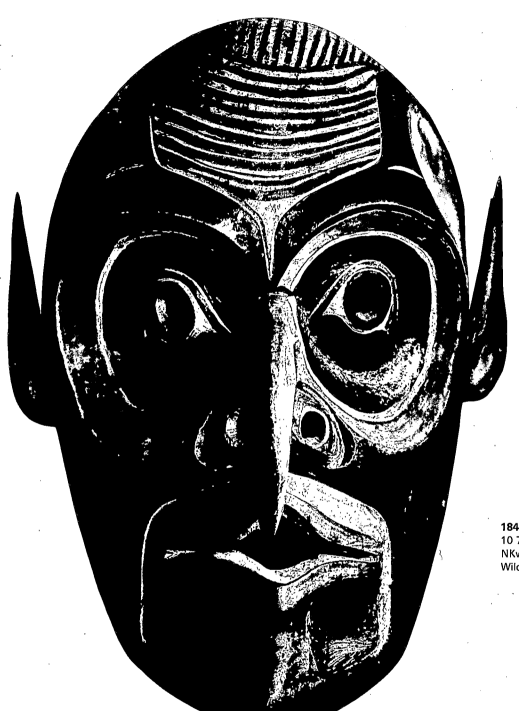

184. Face mask. Kwakiutl. Height
10 7/8″. Denver Art Museum (Cat. No.
NKw–39–P). Still another variation on the
Wild Man theme.

Colorplate **42**. Headaddress. Bella Bella. →
8 1/4 x 7 3/4″. Collection John Hauberg,
Seattle, Wash. An extremely fine and old
example with copper inlay in place of the
usual abalone shell inlay.

185. Head mask. Nootka, Neah Bay,
Washington. Field Museum of Natural
History, Chicago (Cat. No. 19852)

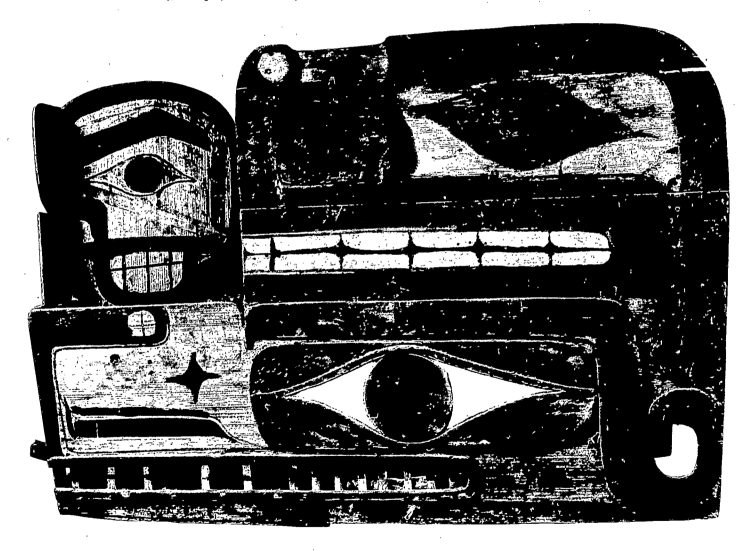

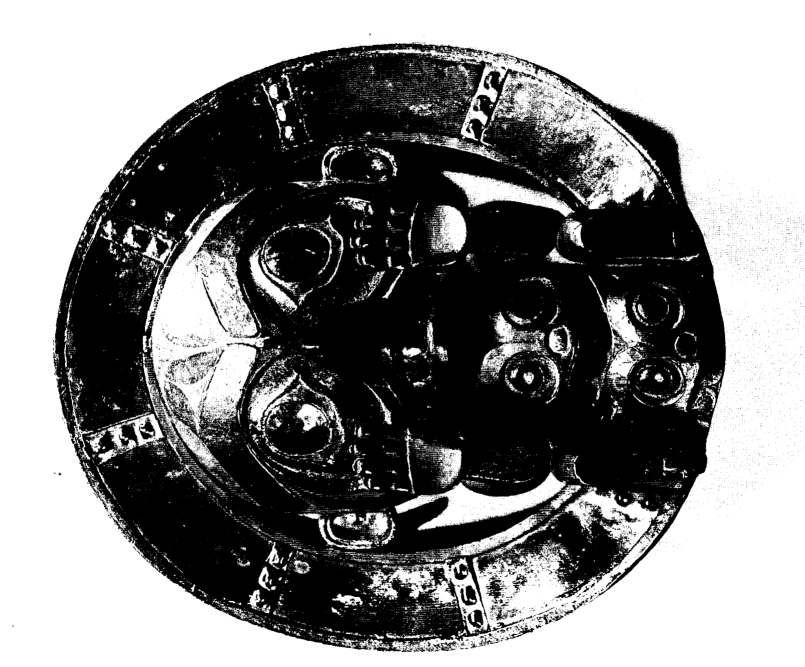

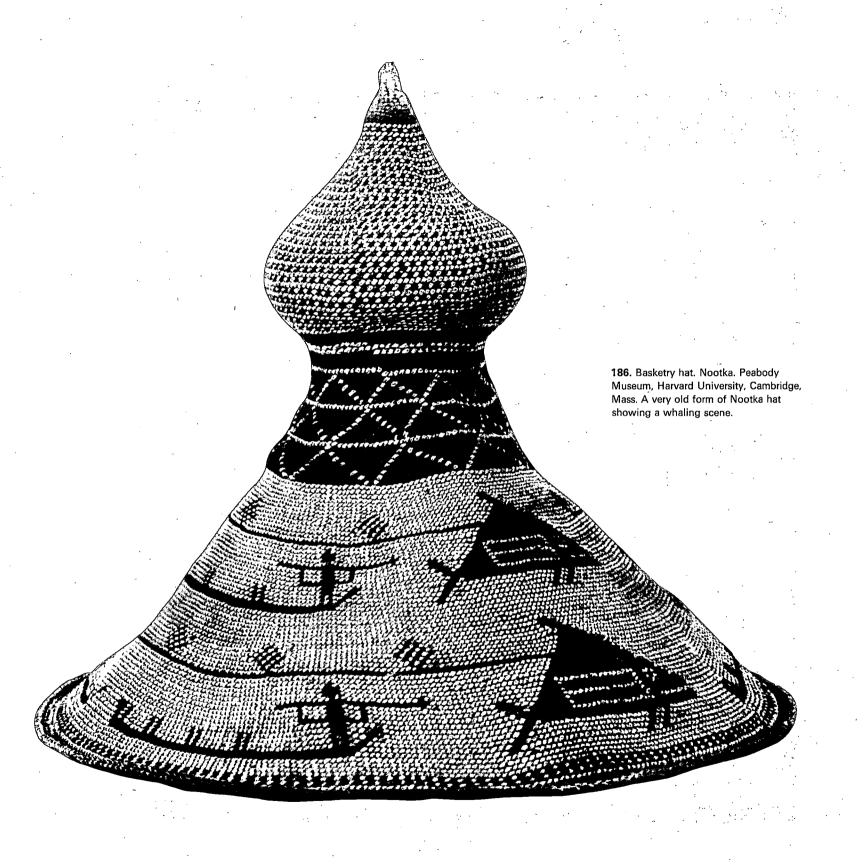

186. Basketry hat. Nootka. Peabody Museum, Harvard University, Cambridge, Mass. A very old form of Nootka hat showing a whaling scene.

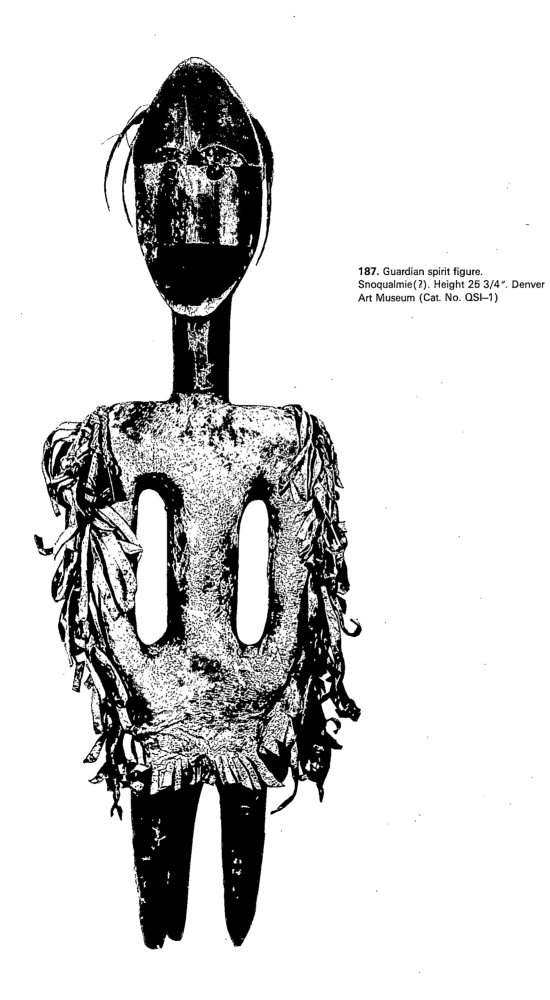

187. Guardian spirit figure.
Snoqualmie(?). Height 25 3/4″. Denver
Art Museum (Cat. No. QSI–1)

188. Face mask. Cowichan. Denver Art Museum (Cat. No. NCow–1). Collected by George Emmons in 1935 at Duncan, British Columbia. The mask, called Swaixwe, represents a guardian spirit.

Colorplate **43.** Dance mask. Kwakiutl. \longrightarrow
21 x 51 ″. Denver Art Museum (Cat.
No. NKw–25). A four-headed mask for
use in the Hamatsa (Cannibal) Society
Dances. Carved by George Walkus of
Blunden Harbor, British Columbia in 1938

189. Spindle whorls. Cowichan.
Smithsonian Institution, Museum of
Natural History, Washington, D.C. (Cat.
Nos. 221, 179b, and c). Collected
on Vancouver Island.

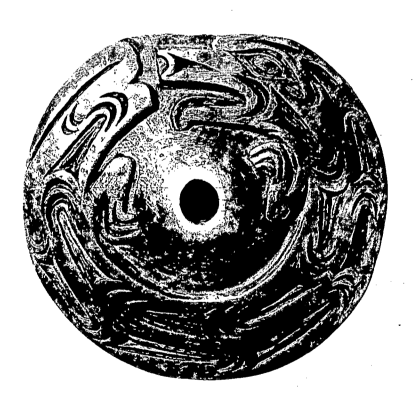

THE ARCTIC COAST

The Arctic Coast from the Aleutian Islands to eastern Greenland is the home of a group of people racially quite distinct from American Indians to the south. Although the Eskimo have inhabited the area for at least two thousand years, they are comparative newcomers to the North American continent, and still bear close cultural affinities to parts of eastern Siberia. The Arctic Coast is a vast area; nevertheless, the Eskimo living on Greenland are not very different culturally from those in western Alaska, and they are also related linguistically.

The normal economic pattern for Eskimo groups consists of seasonal migrations on land in the summer to hunt caribou, musk ox, and polar bear, in addition to doing some fishing; and on or near the sea during the winter when seal and walrus are hunted through their breathing holes in the ice. Some Eskimo groups, such as those around Point Hope, Alaska, are also proficient whalers.

Geographically and climatically the area is inhospitable, with long, cold, dark winters and short summers. The Eskimo made an amazing adaptation to this difficult environment. House types varied. They include the familiar dome-shaped igloo built of snow blocks, simple skin-covered tents, and fairly permanent, earth-covered semi-subterranean structures. Clothing, made of a variety of skins with or without fur, was more tailored than anywhere else north of Mexico. Transportation was accomplished by dog sled in winter, and in summer by skin-covered canoes, these being the smaller enclosed boat known as a kayak, and the larger open vessel known as an umiak.

The harsh conditions in which these people lived was eased by social attitudes in which food and shelter became in effect communal property. Each individual was willing to share whatever resources he had, in the realization that at some future time his own survival might depend upon someone else's sharing with him. It was also the custom, in difficult times, to practice

343

CONCORD HIGH SCHOOL MEDIA CENTER
59117 SCHOOL DRIVE
ELKHART, INDIANA 46514

infanticide and abandonment of the lame or aged which, however barbaric to our society, was necessary in the Arctic.

Religious practices were somewhat rudimentary, but a rich mythology concerning the animals hunted was evolved, and a host of taboos and restrictions were followed. *Shamans* had the important responsibilities of curing disease, controlling the weather, and insuring an adequate food supply. In some areas the people gathered once a year for ceremonies in which masked dancers impersonated gods and spirits. The masks worn on these occasions are perhaps the most striking form of art produced in this area; they occur in a great variety (plates 190–95; colorplate 44). In their most characteristic shape, they have small appendages attached around the perimeter, in the form of hands, feet, fish, clams, and seals. Real feathers are also attached. The older masks are made of pieces of driftwood and are painted in dull polychrome. A type of plain face mask without appendages was also common.

Since the area is so poor in natural resources, it is surprising to find the Eskimo artistically productive. Wood is not available in some regions; walrus ivory, horn, bone, and stone took its place (plates 196–97). Even native copper was used where it was available. Some of the Eskimo inventions included the bow drill, snow goggles, harpoons, dog sleds, stone oil lamps, and a moon-shaped type of woman's knife. They produced no weaving, but made a type of coiled basket in some areas—perhaps a recent introduction due to external influence. A crude form of pottery was formerly produced, but generally more stable materials than clay were preferred.

The earliest prehistoric Eskimo remains show a fully developed artistic tradition of carving in ivory and slate. In the historic period, the Eskimo have continued to excel in ivory carving, but now produce mostly objects for resale: small carvings of animals and birds are common, as are ivory pipes, cribbage boards, jewelry, buttons, buckles, and needle cases. Some of these larger ivory carvings have naive, scratched engravings showing hunting or boating scenes, or simple geometric designs which have survived from prehistoric periods. Early efforts at encouraging Eskimo artistic production have developed new crafts, including painting on parchment in imitation of engraving on ivory. Wooden bowls were also produced with imaginative paintings of mythological animals (plate 198) and, of course, reproductions of wood masks were made for sale. Masks of whalebone are being made for resale in an old tradition, as well as masks of fur made in Alaska but copied

344

from those of an old Labrador Eskimo tradition. Recent years have seen the considerable commercial success of brand new arts which have little or no basis in tradition, but which are nevertheless very much in the Eskimo character: carvings in soapstone, and prints made from soapstone blocks or skin stencils. Sale of both prints and soapstone carvings has met with phenomenal success, and experiments with new techniques will probably follow.

The Aleut groups who inhabited the Aleutian Islands were linguistically related to the Eskimo, but their culture was somewhat different, owing to a different environment. They lived in an area where there was little snow and ice, and so could remain on land in permanent villages all winter. They shared many traits with their Eskimo kinsmen, such as the harpoon hunting of seals from kayaks. They also borrowed many elements of social culture from the Northwest Coast groups. Having class distinctions and slaves, they were notable for making flexible baskets which are among the very finest in the world. Aleut men wore a distinctive type of visor hat—bent wood, painted in polychrome, with attachments in the form of sea lion whiskers, beads, and carved ivory ornaments (colorplates 45, 46).

Aleut culture was early destroyed by Russian fur traders who employed the men on their voyages, and no distinctive Aleut crafts are being manufactured today.

190. Masks. Eskimo. University Museum, Philadelphia (Cat. Nos. 35.22.43 and 42). From Hologachaket, Innoko River, Alaska.

Colorplate **44.** Mask. Eskimo. 14 1/2 x 12 1/2″. Denver Art Museum (Cat. No. P–105–25–E)

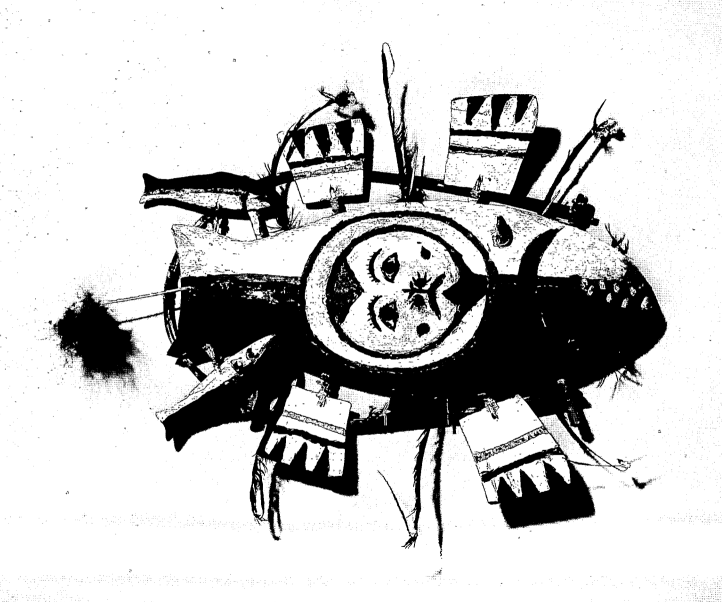

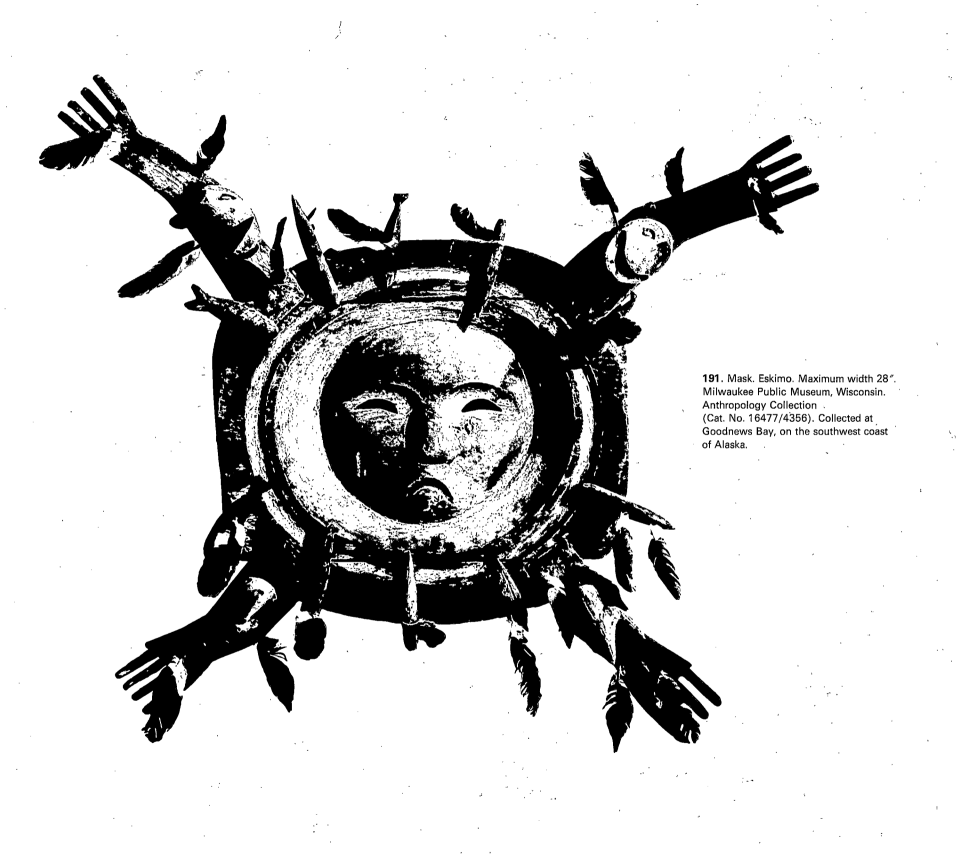

191. Mask. Eskimo. Maximum width 28″.
Milwaukee Public Museum, Wisconsin.
Anthropology Collection
(Cat. No. 16477/4356). Collected at
Goodnews Bay, on the southwest coast
of Alaska.

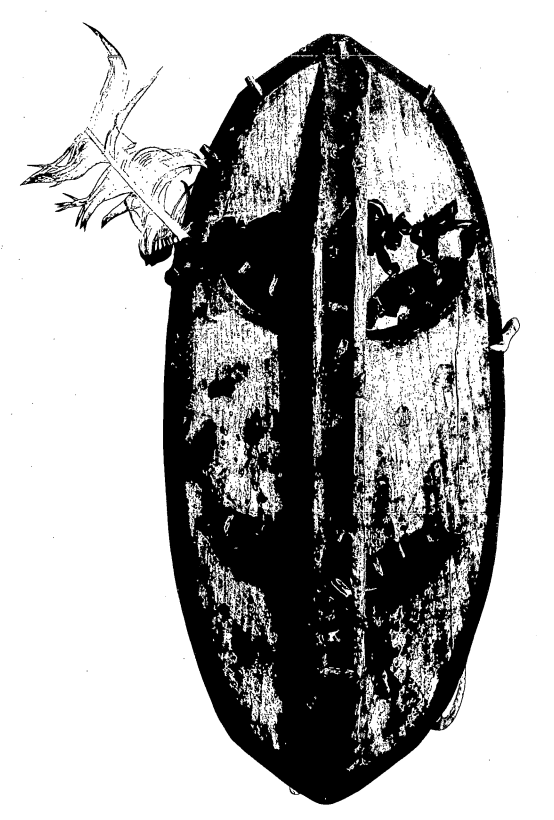

192. Mask. Eskimo. Peabody Museum, Salem, Mass. (Cat. No. 17703)

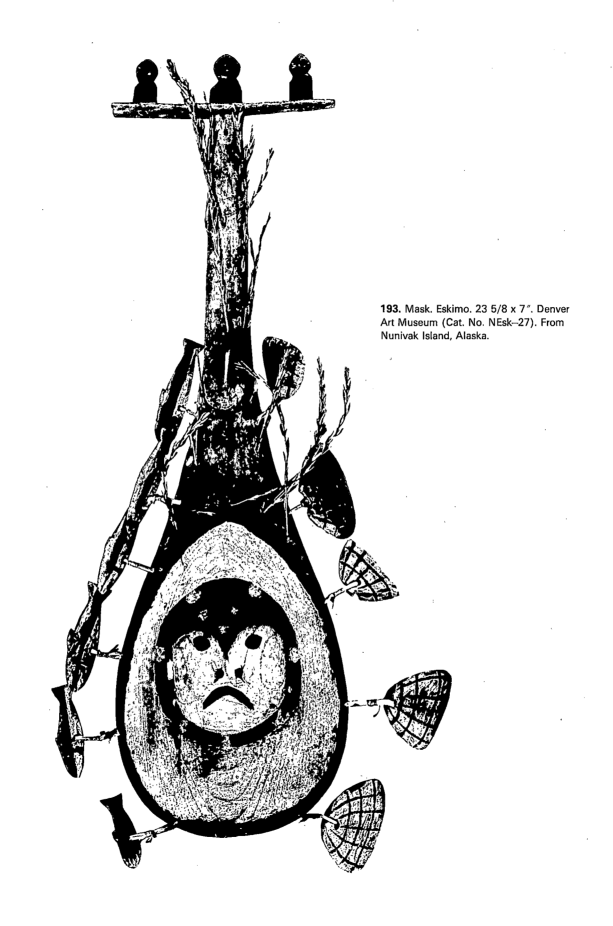

193. Mask. Eskimo. 23 5/8 x 7″. Denver Art Museum (Cat. No. NEsk–27). From Nunivak Island, Alaska.

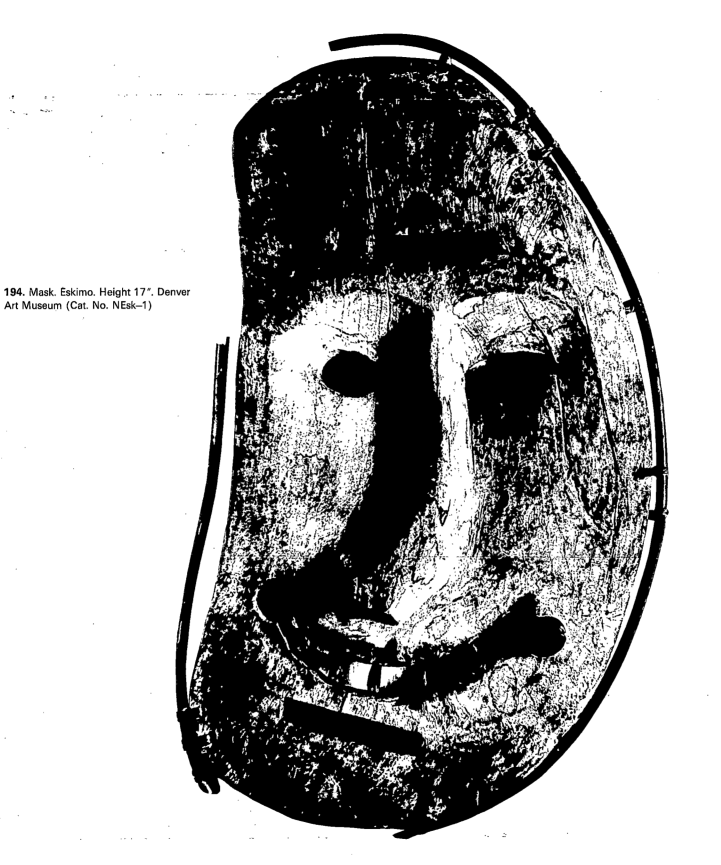

194. Mask. Eskimo. Height 17″. Denver
Art Museum (Cat. No. NEsk–1)

Colorplate **45.** Hat. Aleut. Peabody
Museum, Salem, Mass. (Cat. No. E3486).
Collected by Captain William Osgood in
1829. →

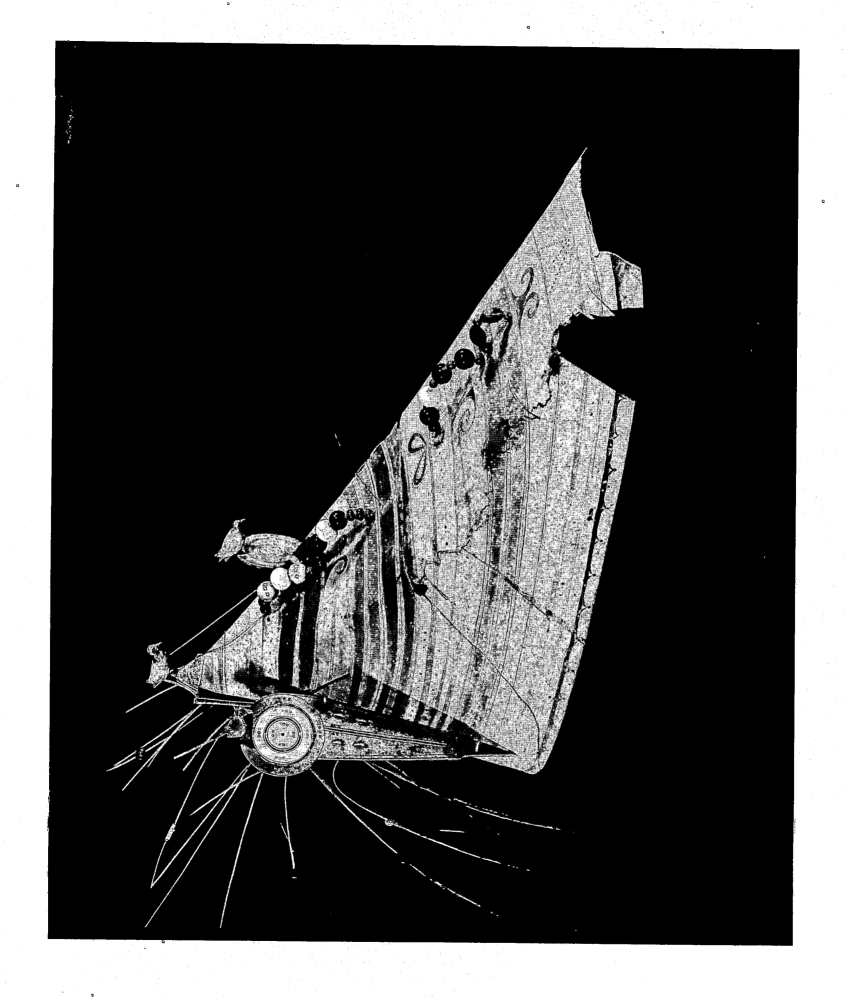

195. Two small masks. Eskimo. Peabody
Museum, Salem, Mass. (Cat. Nos. 13091
and 13082)

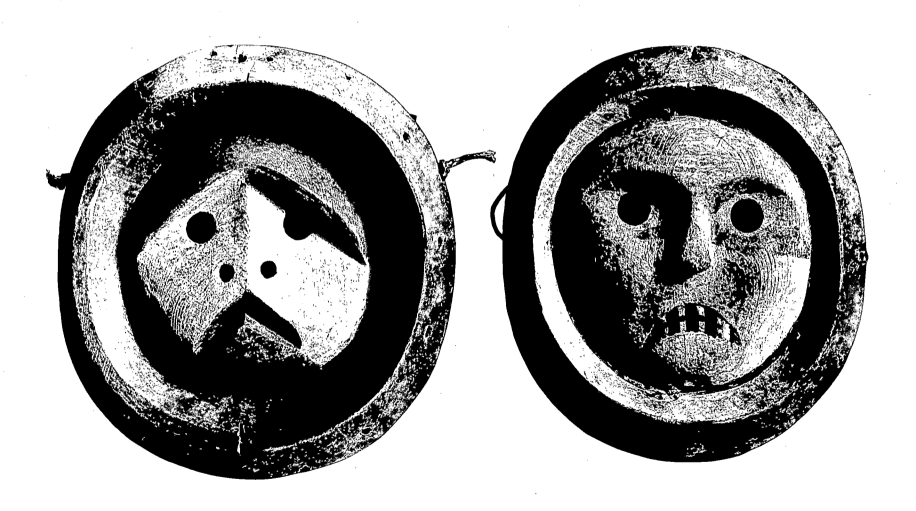

196. Ivory carvings. Eskimo. c. 1930.
Lengths 2 to 4″. Denver Art Museum
(Cat. Nos. QEsk–90 and 100). These were
carved for sale to tourists.

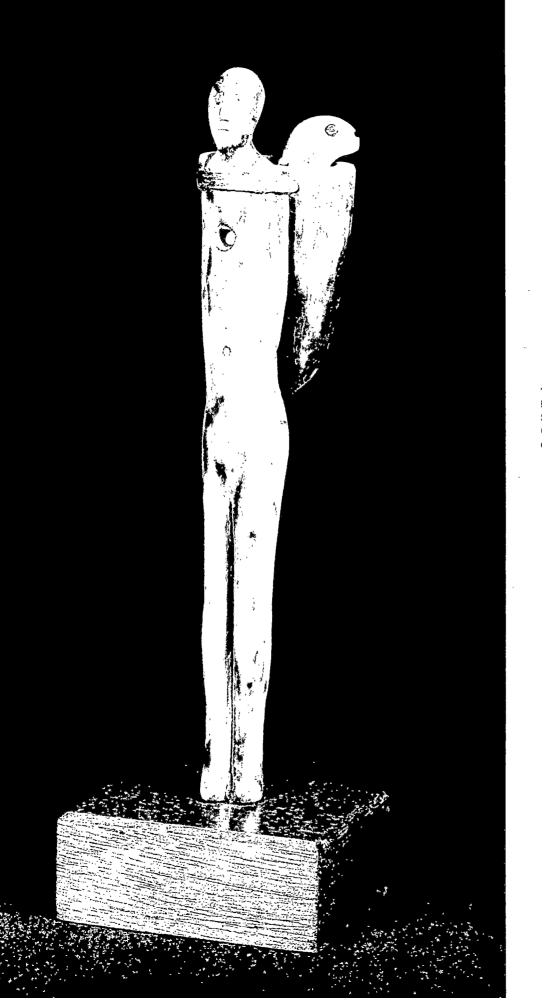

197. Carved ivory figure. Eskimo. Height
5 1/4″. Buffalo Society of Natural
Sciences, New York (Cat. No. 4313/
C14138). Carved of ivory with blue glass
eyes.

Colorplate **46.** Wooden hat. Aleut. Length ⟶
16 1/2″. Museum of the American Indian,
Heye Foundation, New York City (Cat.
No. 14/4869). Painted wood with glass
trade beads, carved ivory, and walrus
whiskers.

198. Painted wood bowl. Eskimo.
7 1/2 x 12 1/4″. Denver Art Museum
(Cat. No. QEsk–58). Collected by Edward
S. Curtis.

The Woodlands

THE WOODLANDS

The entire area from the interior of Canada and Alaska to the Atlantic Coast, and all of the United States east of the Mississippi River is, for convenience, discussed here as one area; except in the far north, the area is characterized by deciduous forests. In general, the Indian inhabitants derived at least a portion of their food supply from corn farming, but the cultures of this vast area, although they showed superficial similarities, were certainly not homogeneous. As a culture area, the Woodlands therefore is considered as divisible into four distinct subareas: the Northern Woodlands, the Great Lakes area, the Northeast, and the Southeast.

The Northern Woodlands run just south of the Eskimo area through Alaska and Canada, and form a sparsely settled region covered with evergreen forests. The people may be divided into two major divisions: Athabascans to the west, and Algonkian-speaking people to the east. Farming was not practiced here; the economy was based on seasonal hunting and gathering, and almost everywhere famine alternated with plenty. The arts were poorly developed. The lives of these people were affected almost immediately upon first contact with Europeans. They soon became dependent upon the fur trade and trade goods. Rifles and steel traps took the place of their bows and arrows, flour and bacon replaced wild game. They adopted Christianity, and much of their old material culture completely disappeared.

Influences from neighboring tribes had previously caused variations in their culture. In the west, the Carrier and Tahltan were influenced by Northwest Coast peoples; the Naskapi, Kutchin, Ingalik, and Chipewyan showed many traits borrowed from the Eskimo; Plains Cree and Bungi showed Plains characteristics; and Ojibwa living north of the Great Lakes showed influences from that area. Almost everywhere in this vast region the Indians made bark vessels of birch, elm, or spruce (plate 199). Bark was also used for sheathing canoes, and some groups even covered their houses with it. Thin laces of rawhide known as *babiche* were used to construct bags and to lace

snowshoes. Other crafts included the making of some splint and wicker baskets, wood carving of spoons and bowls, and simple weaving of rabbit skin blankets, as well as twined bags and burden straps. Pottery was unknown.

Garments were often fitted in a style perhaps borrowed from the Eskimo and decorated with porcupine quill or moose-hair embroidery. The Naskapi used elaborate painted decoration on their garments as late as the beginning of the twentieth century (plate 200). This type of painting must have been more widespread in the precontact period, but was generally replaced by decoration in brightly colored quills and glass beads. The quill and moose-hair embroidery produced in this area was some of the finest made anywhere, and was remarkable for delicacy of line, fine stitching, and technical excellence (plate 201). A small amount is still being produced, but most of the workers prefer to use silk embroidery thread rather than porcupine quills.

Lake Michigan is the center of the Great Lakes area. Here the abundance of water, game, and hard wood forests helped to shape the pattern of living: the people lived very much like those of the Northern Woodlands but, in addition to seasonal hunting and gathering, practiced corn farming, gathered wild rice as a staple food, and made a greater use of fish and small game than the northerners. Relatively sedentary, they not only build fairly large villages around their corn fields, but often maintained separate villages for the winter season (plate 202).

Owing to their abundant and easily obtainable food supply, and the sedentary pattern of life, they were able to develop a more complex religious system and more refined arts than those of the Northern Woodlands, which, in general, they resemble. Again, bark was commonly used for containers, canoes, and for covering the conical or dome-shaped wigwams. The Great Lakes people also used snowshoes and toboggans, made plaited baskets, twined bags, and decorated clothing with porcupine quillwork. However, there are of course many differences between the cultures. Folded rawhide boxes took the place of *babiche* bags, quills completely replaced moose hair for embroidery, and work in wool and yarn was more highly developed (plate 203; colorplates 50, 51). Above all, they used wood, making a great variety of finely carved wooden bowls, spoons, war clubs, and dolls for use in medicine bundles (plates 210, 211, 213). Indeed, although they carved no masks, the Great Lakes people ranked second in wood carving only to the Northwest Coast Indians.

Some of the more distinctive features of Great Lakes art are to be found in their ribbon appliqué (colorplate 53). Silk ribbons in assorted widths and colors were traded or given as gifts as early as were glass beads. The former were sewn to bags and garments as edge trim, or cut and folded into designs applied to the object being decorated. Sometimes dozens of narrow ribbons would be overlapped to produce wide bands of design which were then applied to women's skirts or blankets. The use of ribbon for decoration was widespread, but was brought to its highest development in this area.

Great Lakes people also excelled in embroidery with porcupine quills (plates 216, 217; colorplate 54). They developed native dyes which produced bright, long-lasting colors, and sewed the dyed quills onto leather often smoked a rich brown, or dyed a brown black color, the better to accentuate the richly colored quills. Early quillwork often took the form of designs worked in triangles, but floral designs are also known.

When commercial woolen cloths were introduced, the Indians seemed to favor dark blue or black for decoration with colored glass beads. The Ojibwa developed a distinctive style, using naturalistic floral designs on black velvet; other Great Lakes tribes used more abstract floral designs on black wool cloth. Although Great Lakes Indians seemed to prefer floral designs for appliquéd beadwork, their loomed beadwork was usually in geometric patterns. Ribbon appliqué could be in either floral or geometric designs, but a widespread style was very much like some early triangular quillwork patterns.

Metal ornaments were produced by all Great Lakes tribes, and as elsewhere, were made in imitation of earlier trade pieces. A certain amount was produced from hammered coins, but the great bulk of it was made after 1860 from flat sheets of nickel silver. The most common ornament was a perforated brooch used on women's garments; there were also finger rings, earrings, bracelets, hat bands, head bands, and women's combs.

The Midéwiwin or Grand Medicine Society, a secret curing society which supposedly endowed members with supernatural powers, was the dominant religion. Membership was gained by purchasing initiation into the different degrees by gifts and feasts. The ritual and paraphernalia were elaborate, and a form of picture writing was developed as a memory aid to recall the songs and ritual sequence (plate 218). The medicine bags associated with this society were passed down from generation to generation; they are

some of the oldest examples of Indian objects still retained by living Indians. All Great Lakes tribes kept a variety of sacred medicine bundles, which often contained ancient treasures. Bundles were kept for warding off disease, for luck in love, or for success in war. Some were clan property, others belonged to individuals; some were made up following a dream-vision which directed how the bundle should be made and what it should contain, but others simply contained relics of important chiefs. Bundles are still owned by many Indians in this area and the Grand Medicine Society is active in a few places. In some tribes the Drum religion has replaced the Midéwiwin (plate 220), and in others, Peyote (Native American Church) or Christianity is the dominant religion.

Much cross-cultural influence affected the Great Lakes and neighboring areas. The Ojibwa influenced groups to the north, especially the related Plains Ojibwa and Cree, in the production of naturalistic floral designs. Many Great Lakes groups were pushed out into the prairies, assuming Plains characteristics in their new environments. Groups such as the Nebraska Winnebago, Iowa, Prairie Potawatomi, and Santee Sioux all shared both Woodland and Plains traits. In addition, the displacements and migrations which sent some Great Lakes tribes to resettle in the Prairies also caused some Northeastern Woodland groups to move west into the Great Lakes area. Wisconsin became the new home for scattered Oneida, Stockbridge, Brotherton, and Munsee groups, which certainly brought Eastern influences with them.

A few craft workers remain. Although their production is limited, some is in the old, fine tradition. Metalwork, wood carving, quill embroidery, and skin tanning are no longer viable crafts; but a few women still make yarn sashes and twined bags, good ribbon appliqué, and bead decoration.

The Northeastern Woodlands area runs from the eastern Great Lakes through New York and New England. At the time of first contact by Europeans, it was occupied with a great many tribes of the Algonkian stock, and the powerful Iroquois confederacy. Little is known about most of the Atlantic Coast groups because of their early extinction by disease and by warfare with Indians and whites alike. They seem to have had a culture much resembling that of the Great Lakes area, although lacking wild rice and the Midéwiwin religion. The Coast tribes depended upon seafoods to a great extent, but were also corn farmers and hunters.

The Iroquois are a conservative group still occupying much the same territory as they did on first contact. They live today on scattered reservations in New York State and Canada, and have maintained a surprising amount of their culture in spite of their having been so early exposed to white contact. Many Iroquois still speak their own language, follow the religious teachings of their prophet "Handsome Lake," participate in masked dances, and maintain some old arts. The political organization of the Iroquois—a confederation of six tribes, with the women having a strong voice in major policy making—is well known, and the model which held the Oneida, Seneca, Mohawk, Onondaga, Cayuga, and Tuscarora together in the League of the Iroquois was supposedly followed in framing the Constitution of the United States. Always an important military power, the Iroquois also expertly controlled trade over a wide area, and forced the removal of some of the Eastern Algonkian groups. Their alliance was eagerly sought by the Dutch, the English, and later by the United States.

Northeastern tribes, and especially the Iroquois, were similar in material culture to Great Lakes people (plates 221–27; colorplate 55). Splint basketry received its greatest development in this area; wood carving was highly developed; yarn sashes, twined bags, and metal ornaments were made. Bark containers differed from those of the Great Lakes in that elm bark was used more commonly than birch. The typical Iroquois home was a long rectangular structure covered with sheets of elm bark. The Iroquois received a larger quantity of trade silver ornaments than Great Lakes groups because of their proximity to early settlers, and thus developed more advanced techniques of metalworking. Iroquois worked with real silver, rather than with nickel silver, and learned to run it into molds as well as pound out coins into flat shapes. In early historic times, the Iroquois were potters, but their ware was soon replaced by traded metal utensils. Leather garments were replaced at an early date by imported cloth, as happened everywhere in the eastern United States. The Iroquois developed a distinctive beadwork style consisting of light, lacy designs worked mostly in white beads on a dark cloth background.

Perhaps the most spectacular works produced by the Iroquois are their wooden masks, worn in curing ceremonies (plates 230–33; colorplate 56). These false face masks are carved from living trees, and those actually used in ceremonies are believed to possess animate spirits. Small packets of tobacco

are tied to their hair, they are fed regularly, and when not in use are carefully wrapped in clean white cloths and put away face down. These masks take a great variety of shapes[17] depending in part upon what role they are intended to play in the ceremonies. They are painted in black, red, or sometimes a combination of both. More recent examples often have white paint in addition to the black and red. Other trim includes circular metal eyes, horsehair, and corn husks on a few examples.

The Delaware tribe, neighbors of the Iroquois to the south, also made masks but, owing to early displacement and acculturation, few examples have survived (plates 234, 235; colorplate 57).

Some traditional Iroquois crafts are still very much alive. Although no metalwork, woven sashes, or twined bags are being produced, wood carving is actively carried on: spoons, bowls, stirring paddles (plate 236), and canes are made, in addition to masks. Several women still make corn husk masks (plate 237) and dress corn husk dolls, while others produce splint baskets.

The entire southern part of the United States, from Texas to the Atlantic Ocean, comprises the Southeastern area (plate 238). This part of the country, in prehistoric times, could boast the highest development of native American civilization north of Mexico. Huge earth mounds, elaborate artistic production, sun worship, royal families, and large cities were features of it, which probably owed their forms to influences from Mexico. Some groups, like the Natchez, still showed evidences of this higher civilization when first encountered by Europeans, but a decline had begun long before. The entire Southeast was subsequently strongly affected by European settlement in their area; entire tribes became extinct owing to war and new diseases, while others adopted the white man's ways. The so-called Five Civilized Tribes—Cherokee, Choctaw, Creek, Chickasaw, and Seminole—very early adopted European clothing, and went on to organize their own universities and newspapers. The invention of a Cherokee alphabet by Sequoya in 1821 facilitated this process of acculturation. Most of the Five Civilized Tribes moved to the Oklahoma area by 1830, leaving only a few scattered groups in the Southeast.

Early Southeastern products included finely made pottery with designs in a scroll pattern either painted or incised. A special type of beaded belt or shoulder sash was made with a very similar scroll design. Baskets were commonly made in split and plaited cane, and formerly feather capes were produced. Southeastern Indians made some of the most complex yarn sashes to

CONCORD HIGH SCHOOL MEDIA CENTER
5511 COWAN DRIVE
ELKHART, INDIANA 46514

be found anywhere; some, with beads worked into the design, are technically more accomplished than anything produced in the Great Lakes or Northeastern areas. There are also a few early examples of shoulder bags with beaded straps and triangular flap pouches (plate 240; colorplate 58). These are often done in very fine beads, but the designs usually look like random wandering lines.

Simple silverwork was produced by most groups, but the ornaments were quite crude in comparison to those made by the Iroquois. The Seminole developed a distinctive type in the form of flat plaques, with cutout designs, to decorate women's capes. In general, however, little is known about early Southeastern crafts because so little has survived from the preacculturation period.

Recent Southeastern crafts include a continuation, among several groups, of the fine basketry tradition. Most notable are the Chitimacha who produced fine cane baskets, sometimes in a double weave (plate 241). The Seminole in Florida now specialize in a type of patchwork decoration on skirts and jackets for sale to tourists (colorplate 59). It is made by sewing, cutting, and resewing small scraps of differently colored cloth into geometric patterns. The work is done on a sewing machine, often hand-cranked in remote parts of the Florida Everglades!

A few groups, such as the Cherokee and Catawba, still produce a little pottery for sale; the Cherokee in North Carolina have generally maintained a considerable production, for the tourist trade, of split baskets, blow guns, and wooden masks, as well as such non-traditional items as wooden figures and handspun woolen cloths (plate 242).

CONCORD HIGH SCHOOL MEDIA CENTER
59117 SCHOOL DRIVE
ELKHART, INDIANA 46514

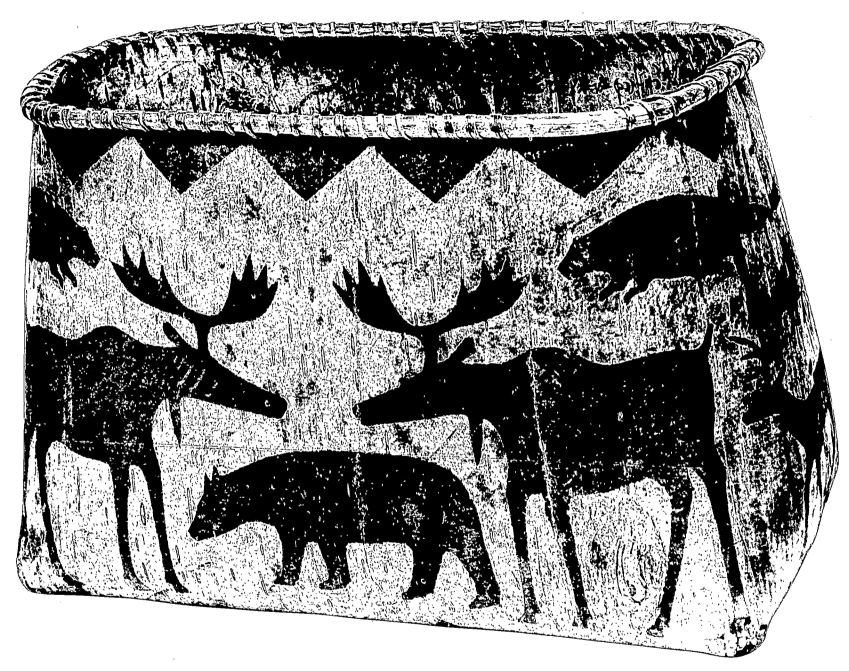

199. Birchbark container. Cree.
7 1/2 x 11 1/2". Denver Art Museum
(Cat. No. CWC–1). The design is produced
by scraping away the brown layer of bark.

200. Painted skin masks. Naskapi. Each approximately 9 1/4 x 8 1/8″. Denver Art Museum (Cat. Nos. NNE–3 and 5). Both collected by Dr. Frank G. Speck.

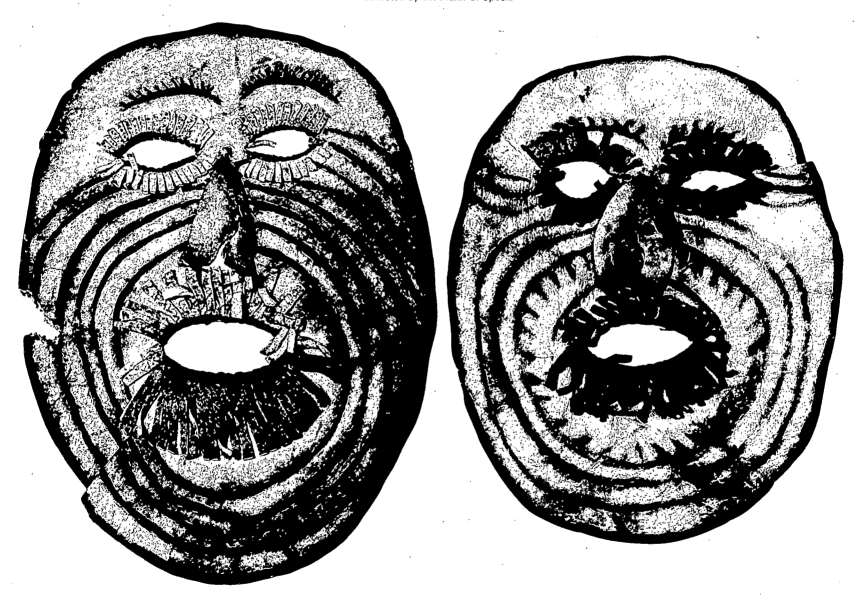

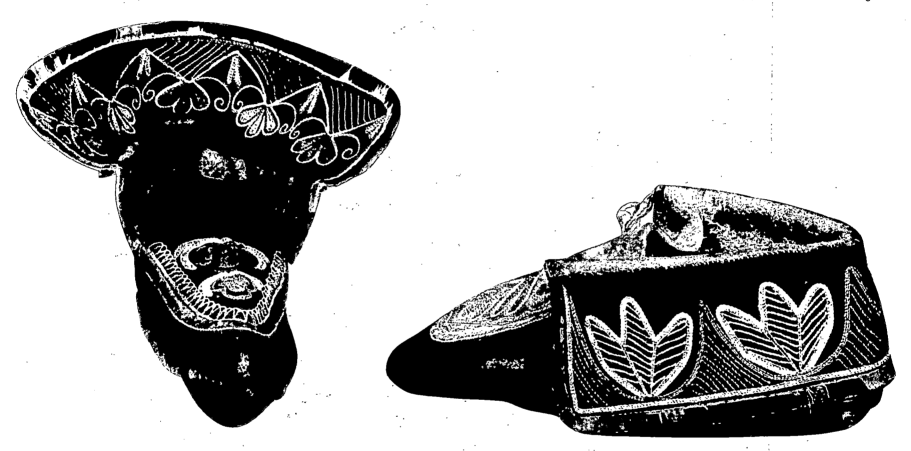

Colorplate **47.** Snowshoes. Chippewa.
Cranbrook Institute of Science, Bloomfield
Hills, Michigan. This shows a painted
thunderbird on the webbing of the toe. →

201. Moccasins. Huron(?). National
Museum of Ethnology, Leiden, Holland
(Cat. No. 330.6). Black dyed buckskin
decorated with moose-hair embroidery.

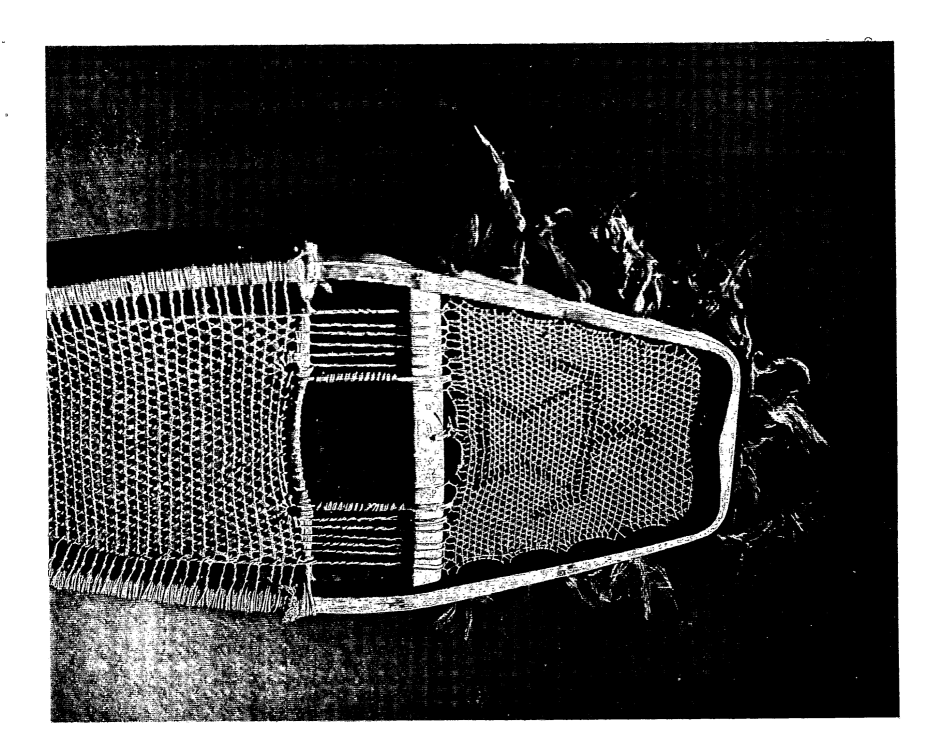

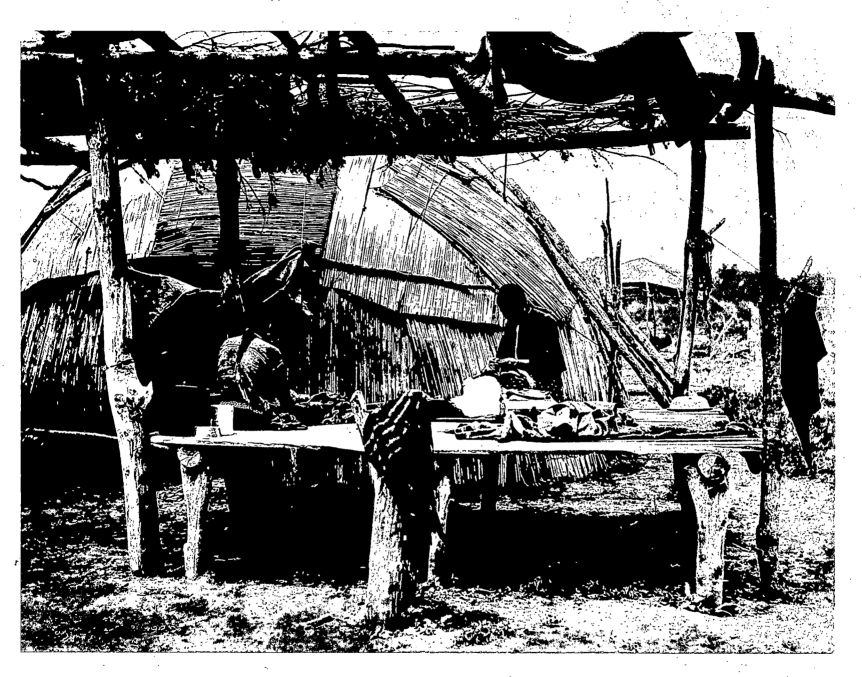

202. Structures at Tama, Iowa. Mesquakie (Fox) Indians performing domestic chores on a work platform. Note the sunshade, and the home covered with cattail mats.

Colorplate **48.** Crupper for horse. Cree. →
Length 30″. Museum of the American
Indian, Heye Foundation, New York City
(Cat. No. 18/5498). Made of porcupine
quills.

203. Twined bag. Stockbridge(?).
11 1/2 x 15″. State Historical Society of
Wisconsin, Madison (Cat. No. 1954.2048)

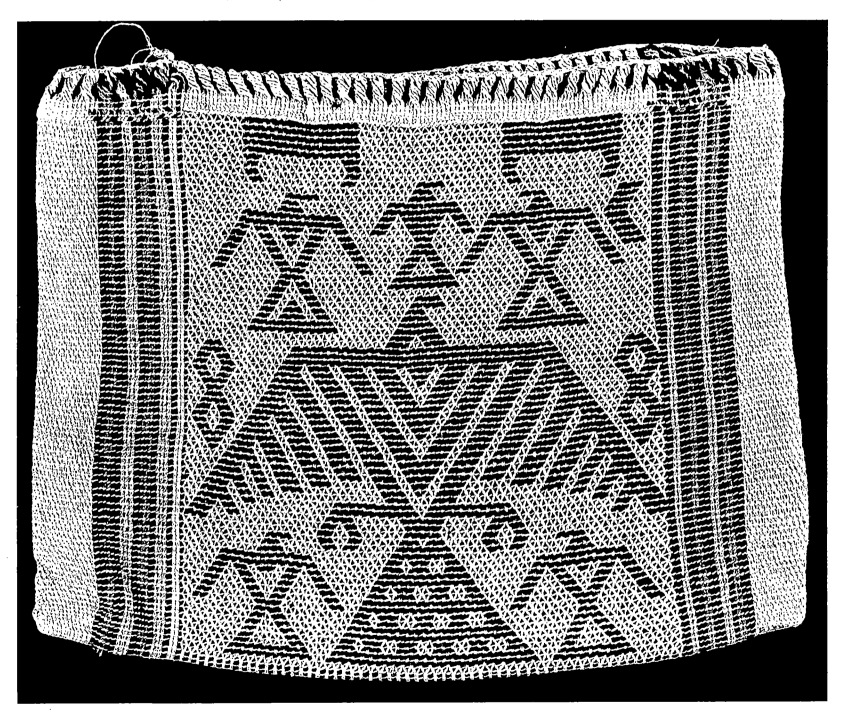

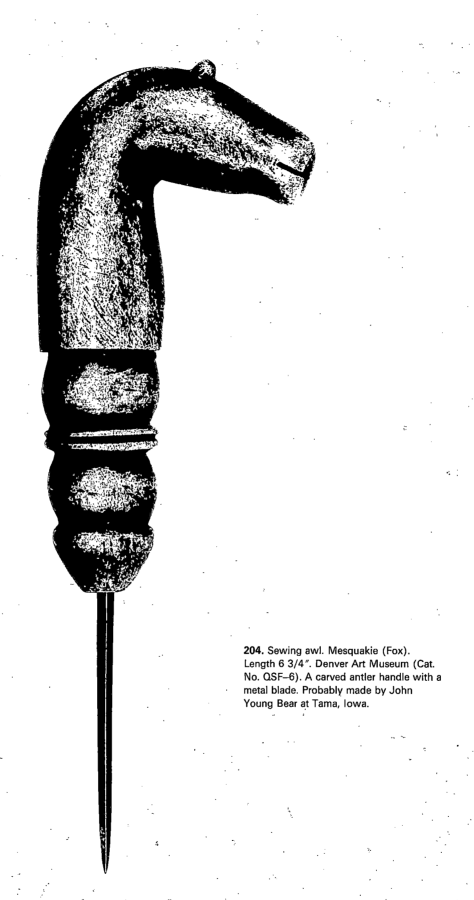

204. Sewing awl. Mesquakie (Fox).
Length 6 3/4″. Denver Art Museum (Cat.
No. QSF–6). A carved antler handle with a
metal blade. Probably made by John
Young Bear at Tama, Iowa.

Colorplate **49**. Man's hood. Tribe →
unknown. Royal Ontario Museum,
University of Toronto, Canada (Cat.
No. 916.22.1)

205. Tobacco cutting board. Winnebago.
7 1/4 x 7 1/2″. Denver Art Museum
(Cat. No. QBI–118). The incised design is
of two otters.

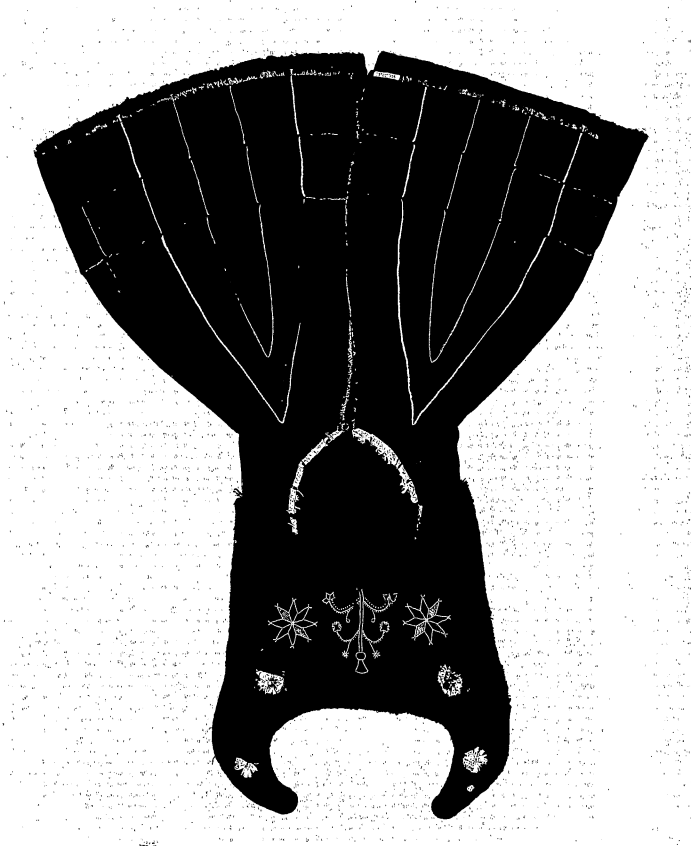

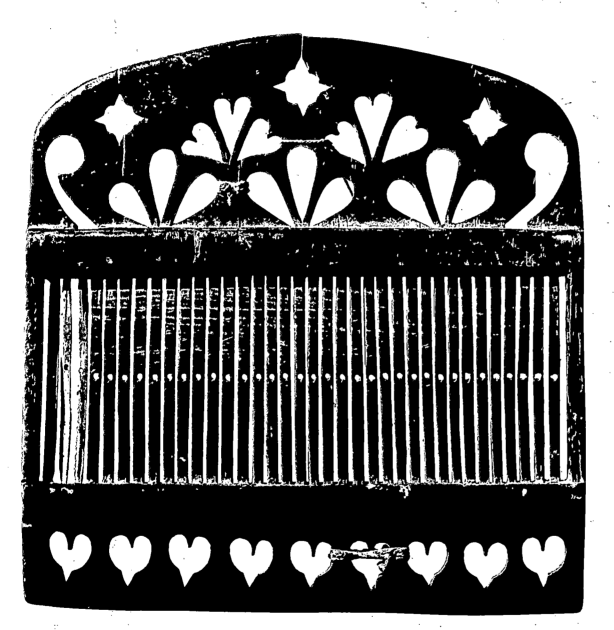

206. Carved wood heddle for loom beadwork. Menominee. Milwaukee Public Museum, Wisconsin. Anthropology Collection (Cat. No. 4532). Collected by S. A. Barrett in 1910.

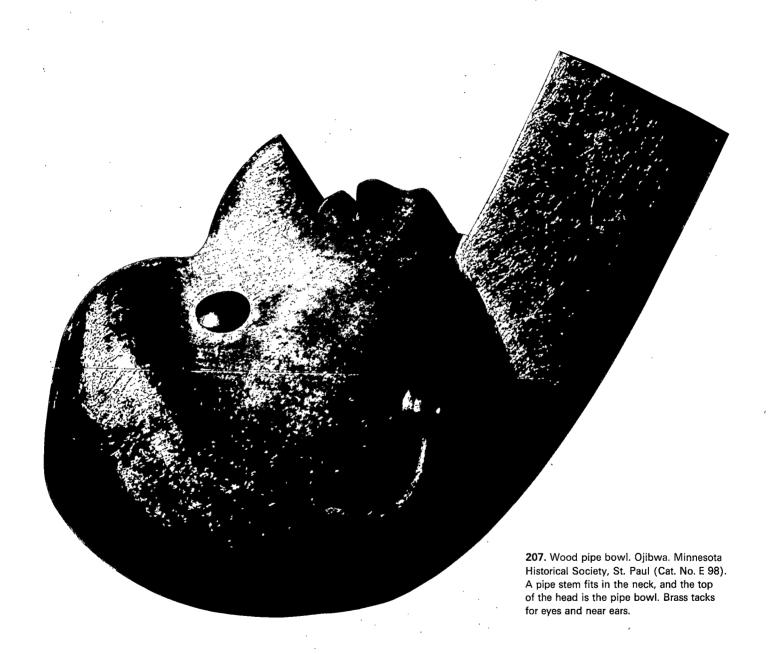

207. Wood pipe bowl. Ojibwa. Minnesota Historical Society, St. Paul (Cat. No. E 98). A pipe stem fits in the neck, and the top of the head is the pipe bowl. Brass tacks for eyes and near ears.

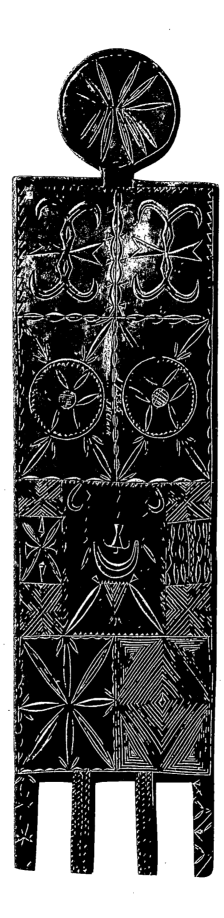

208. Lid for feather box. Ojibwa.
24 5/8 x 6 1/4″. Smithsonian Institution,
Museum of Natural History, Washington,
D.C. (Cat. No. 17535). Collected before
1875.

Colorplate **50.** Yarn belt. Menominee. →
100 x 15″. American Museum of Natural
History, New York City (Cat. No. 50/9797).
Made of commercial yarn in a
finger-braiding technique.

209. Carved saddle. Menominee. American
Museum of Natural History, New York City
(Cat. No. 50/4848). Collected in 1910 by
Alanson Skinner. Carved of wood and
covered with rawhide. The carved horse
head on the pommel was a specialty of the
Menominee and some of their neighbors.

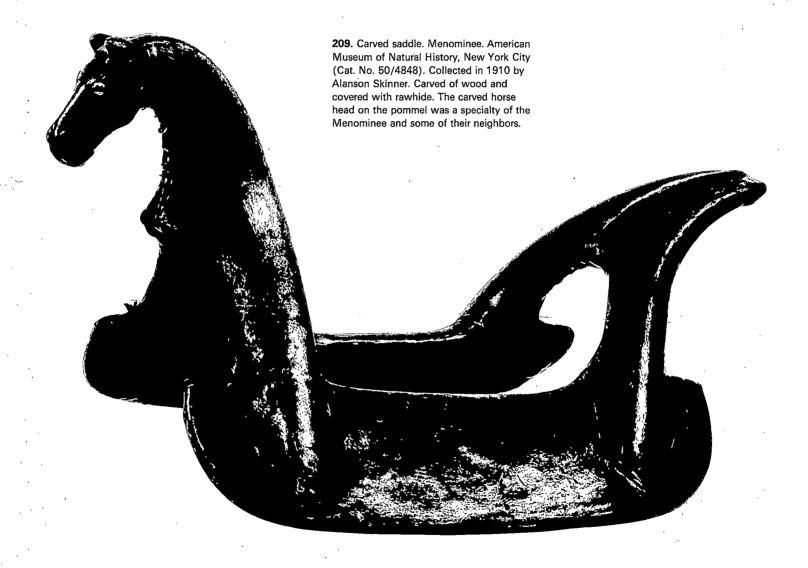

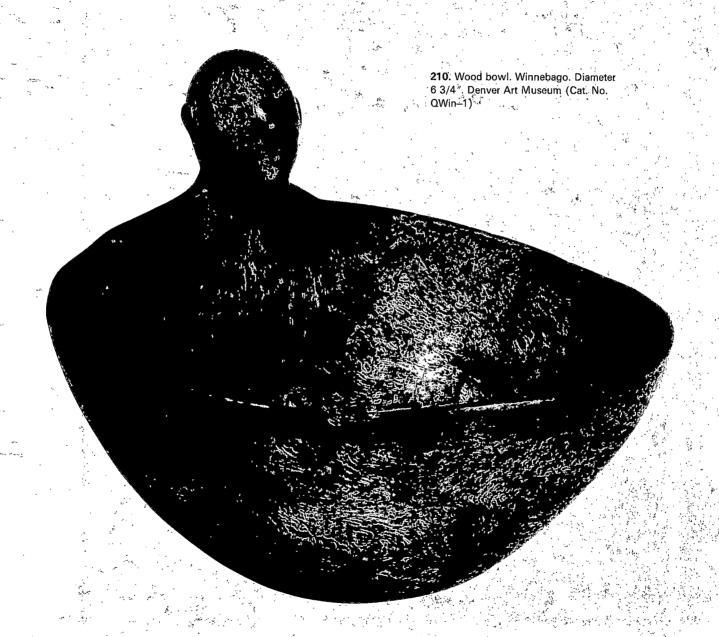

210. Wood bowl. Winnebago. Diameter
6 3/4″. Denver Art Museum (Cat. No.
QWin–1)

Colorplate **51**. Twined bag. Sauk, Oklahoma. 20 1/2 x 30″. Denver Art Museum (Cat. No. RSF–10) →

211. Wood bowl. Kaskaskia(?). Peabody Museum, Harvard University, Cambridge, Mass. (Cat. No. 52998)

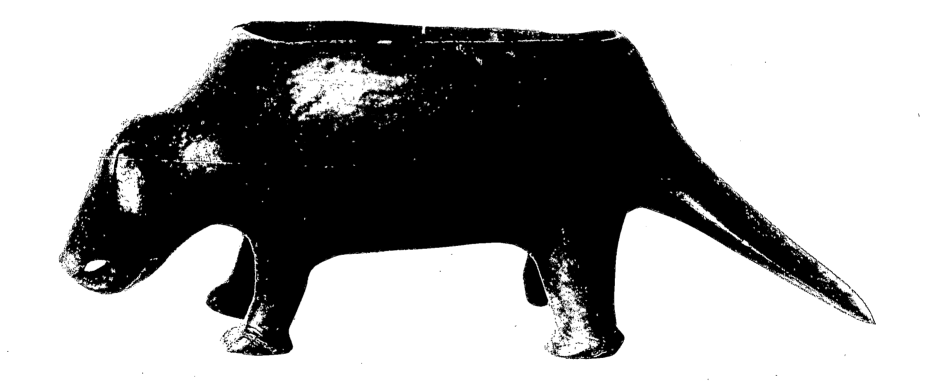

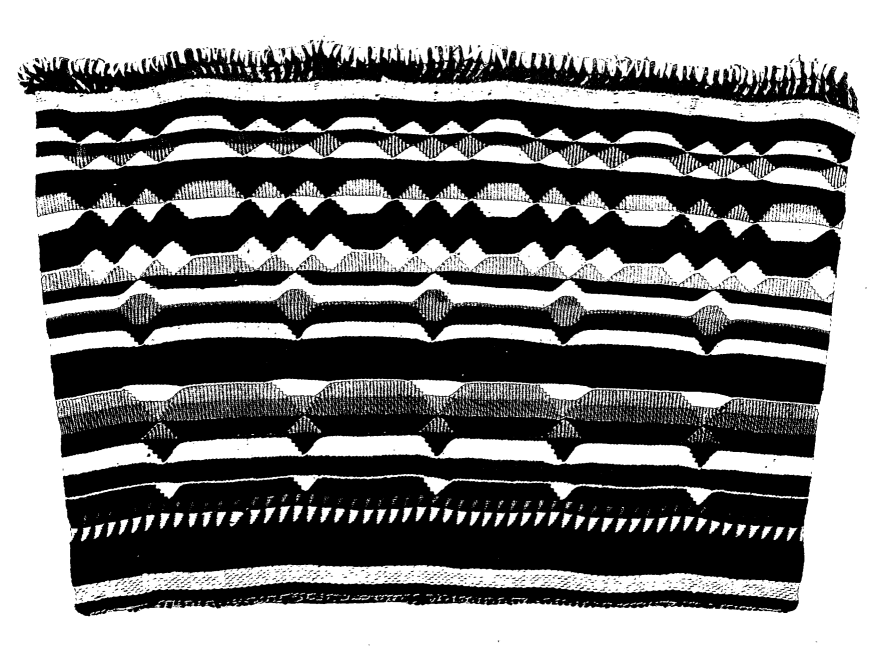

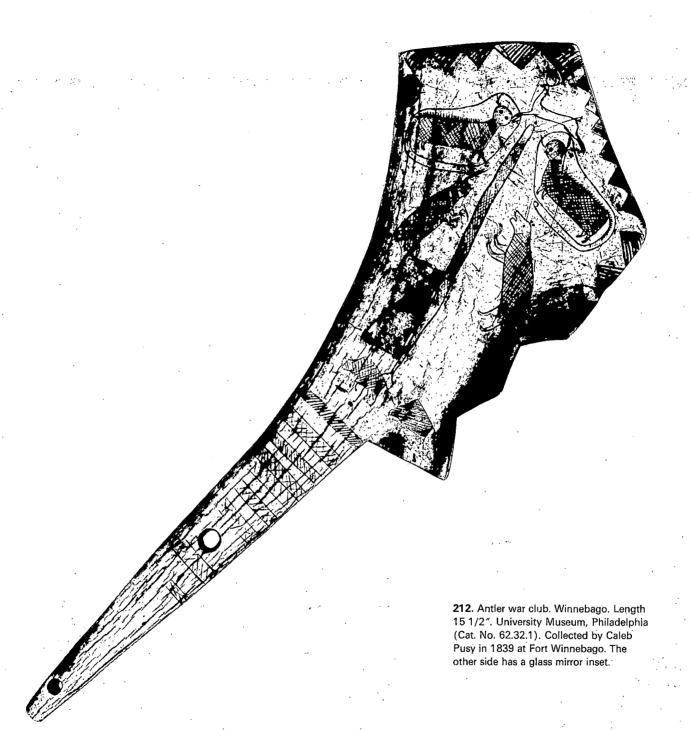

212. Antler war club. Winnebago. Length
15 1/2". University Museum, Philadelphia
(Cat. No. 62.32.1). Collected by Caleb
Pusy in 1839 at Fort Winnebago. The
other side has a glass mirror inset.

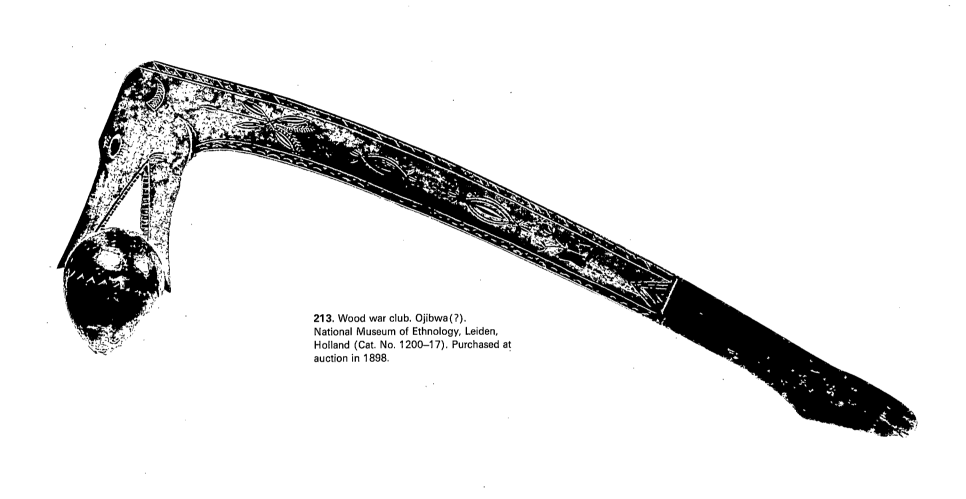

213. Wood war club. Ojibwa(?).
National Museum of Ethnology, Leiden,
Holland (Cat. No. 1200–17). Purchased at
auction in 1898.

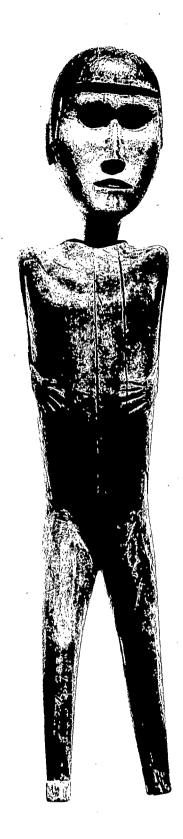

214. Juggler's doll. Ojibwa. Height 17″.
Milwaukee Public Museum, Wisconsin.
Anthropology Collection (Cat. No. 55324)

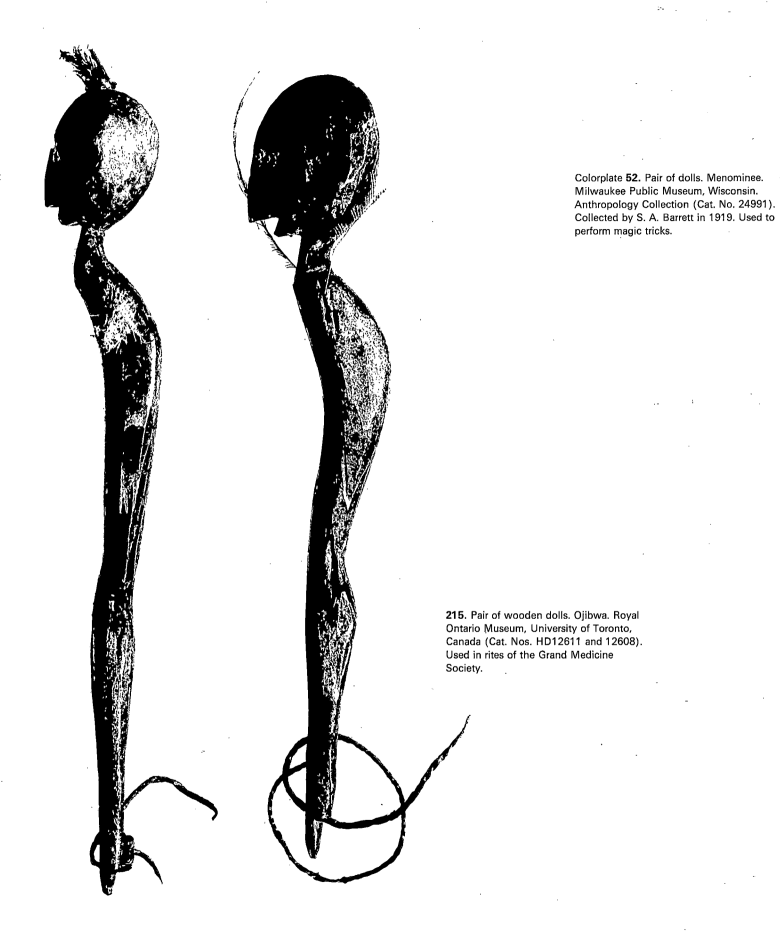

Colorplate **52.** Pair of dolls. Menominee. Milwaukee Public Museum, Wisconsin. Anthropology Collection (Cat. No. 24991). Collected by S. A. Barrett in 1919. Used to perform magic tricks.

215. Pair of wooden dolls. Ojibwa. Royal Ontario Museum, University of Toronto, Canada (Cat. Nos. HD12611 and 12608). Used in rites of the Grand Medicine Society.

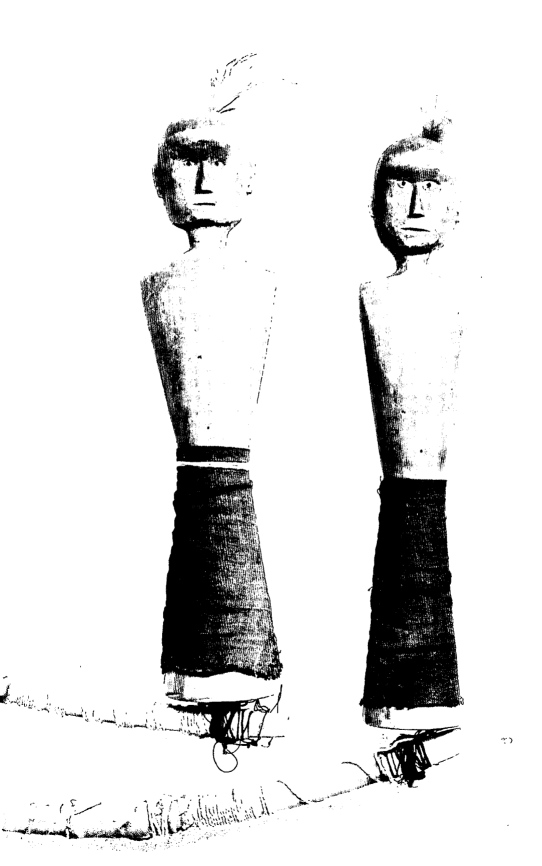

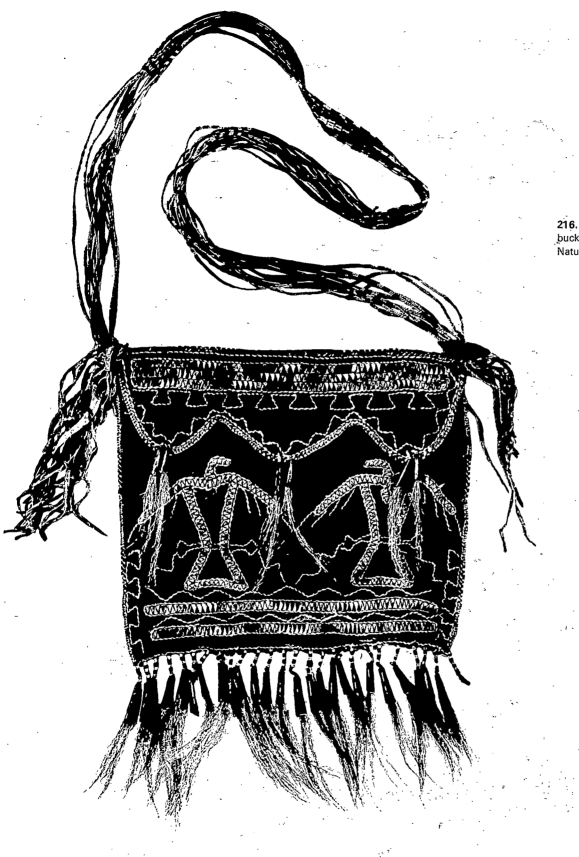

216. Quilled pouch on black dyed buckskin. Tribe unknown. Field Museum of Natural History, Chicago. (Cat. No. 15563)

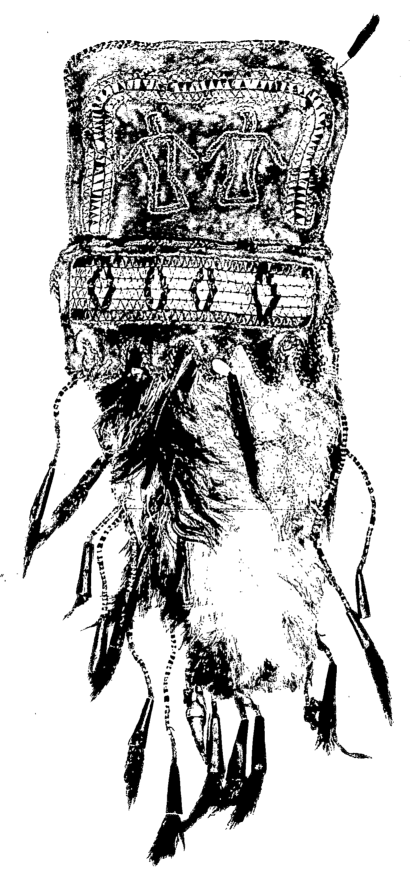

218. Incised birchbark scroll (detail). Ojibwa. Size of entire scroll 71 3/4 x 15 3/4″. Denver Art Museum (Cat. No. COj–36). Collected by A. G. Heath in 1915 from Chief Jim Greenhill at Cass Lake, Minnesota. These scrolls are used as memory aids in the performance of the ceremonies of the Grand Medicine Society.

217. Quilled pouch. Menominee. 5 x 11″. American Museum of Natural History, New York City (Cat. No. 50.1/5916). The bottom portion of the pouch is of eagle skin.

Colorplate **53.** Man's moccasins. Miami. →
c. 1850–75. Length 9 1/2″. Cranbrook
Institute of Science, Bloomfield Hills,
Michigan (Cat. No. 3053). Silk ribbon
appliqué on flaps.

219. Beaded charms. Ojibwa. Larger
charm, 9 1/4 x 7 3/8″; smaller charm,
7 3/4 x 6″. Denver Art Museum (Cat.
Nos. BOj–24 and 23). These are worn as
health charms by members of the Grand
Medicine Society. Small shells are sewn in
pockets behind the hands, feet, and head.

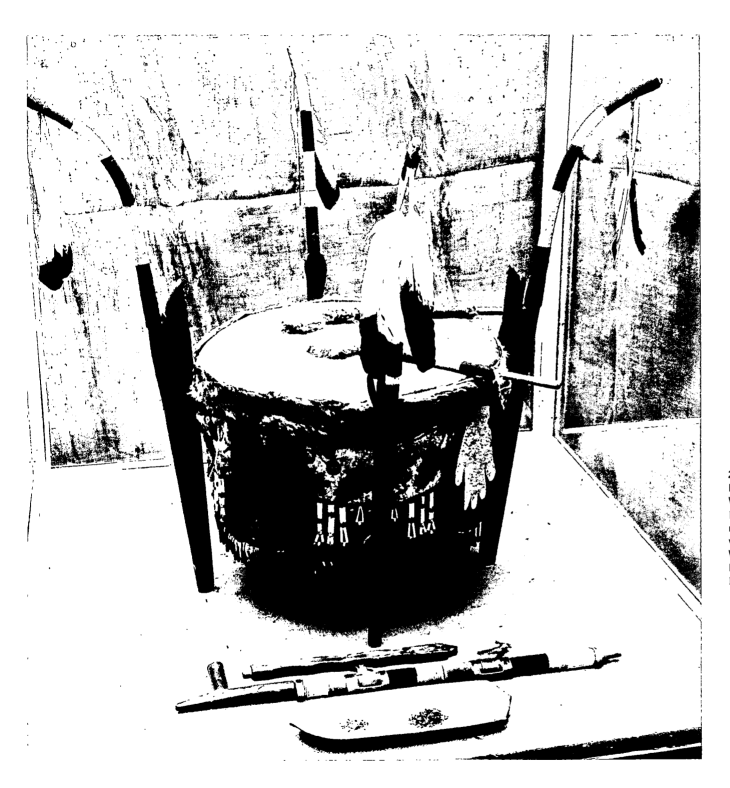

220. Dream Dance drum. Forest
Potawatomi. State Historical Society of
Wisconsin, Madison (Cat. No. 1954.1359–c).
Drums of this type are the major
religious focus for a religion
which is still active among several
Woodland tribes. It is variously called the
Drum religion, the Dream Dance, or the
Powwow.

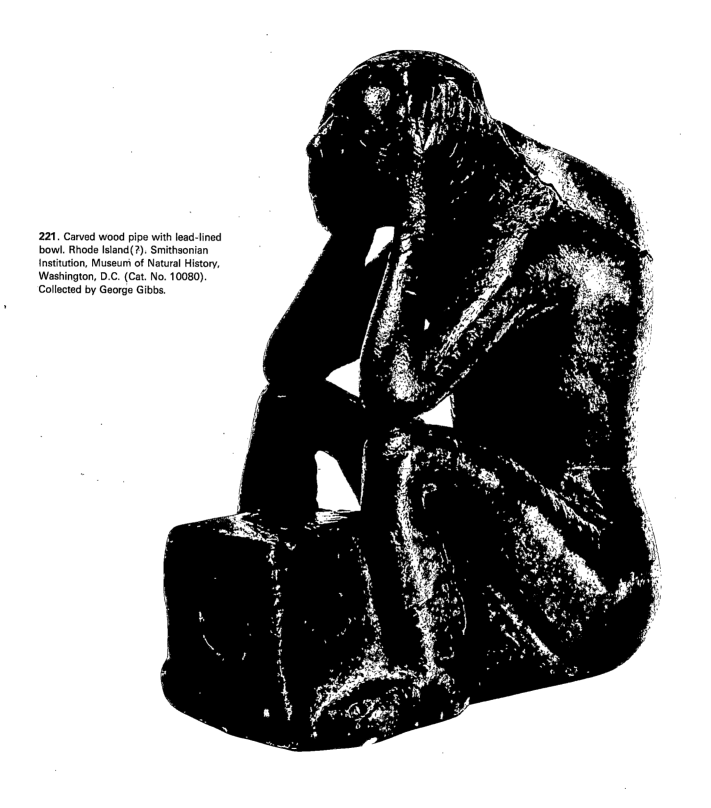

221. Carved wood pipe with lead-lined bowl. Rhode Island(?). Smithsonian Institution, Museum of Natural History, Washington, D.C. (Cat. No. 10080). Collected by George Gibbs.

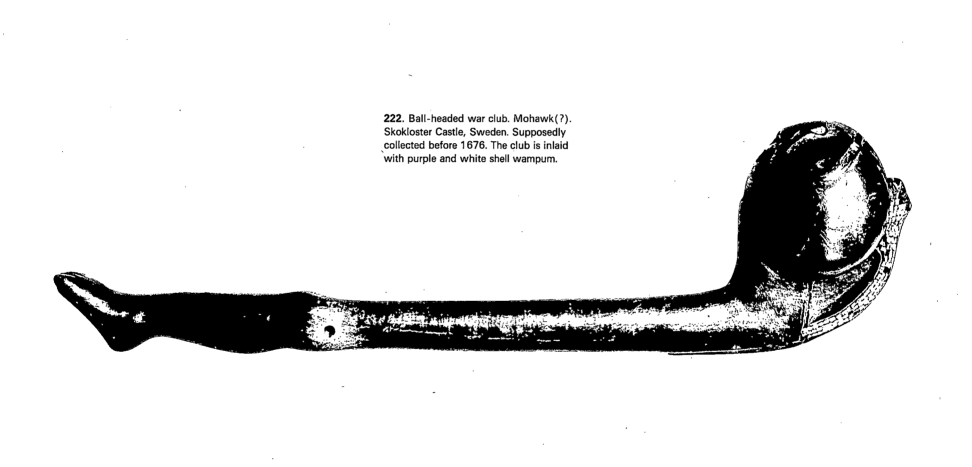

222. Ball-headed war club. Mohawk(?). Skokloster Castle, Sweden. Supposedly collected before 1676. The club is inlaid with purple and white shell wampum.

Colorplate **54**. Quilled pouch. Mesquakie →
(Fox). Collection Milford G. Chandler,
Detroit. The bottom portion is the skin of a
mallard duck.

223. Incised birchbark box. Penobscot.
Diameter 5″. Denver Art Museum (Cat.
No. CPt–5). Collected by Dr. Frank G.
Speck.

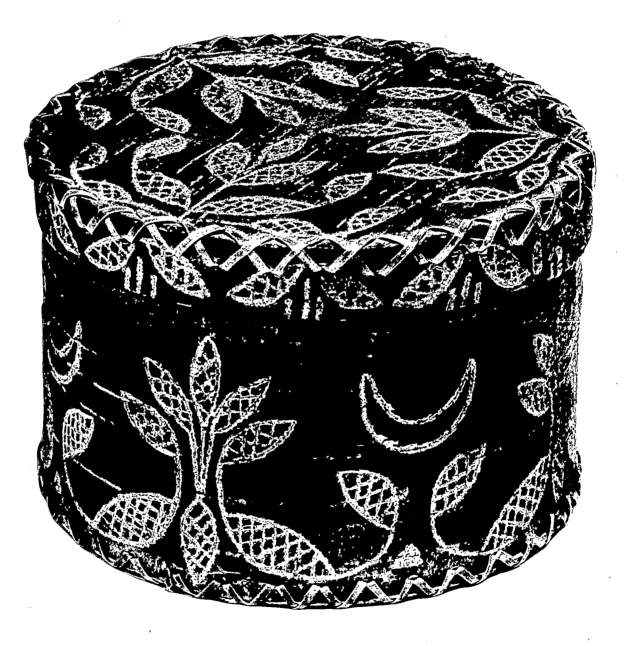

224. Engraved powder horn. Penobscot.
Length 11 1/4". Denver Art Museum
(Cat. No. FPt–1)

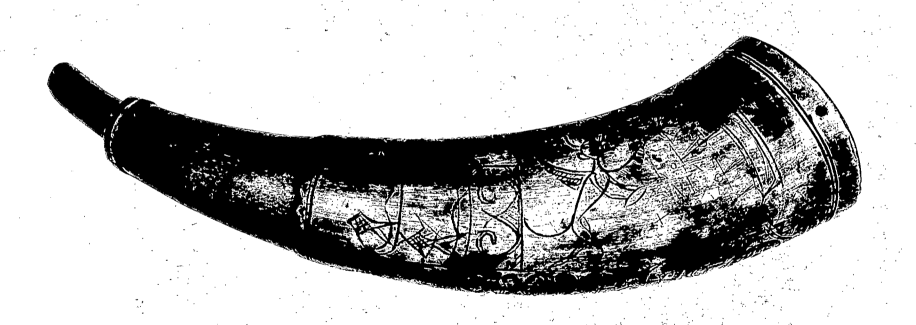

CONCORD HIGH SCHOOL MEDIA CENTER
59117 SCHOOL DRIVE
ELKHART, INDIANA 46514

225. Quilled black buckskin bag.
Delaware(?). c. 1775. 20 1/2 x 5 3/4″.
Denver Art Museum (Cat. No. VAI–2).
An old bag with no collection history.

226. Wampum belt. Huron. 4 x 22″.
Smithsonian Institution, Museum of
Natural History, Washington, D.C. (Cat.
No. 165, 103). Collected by William
Welles Thompson in 1892. The so-called
Confederation belt.

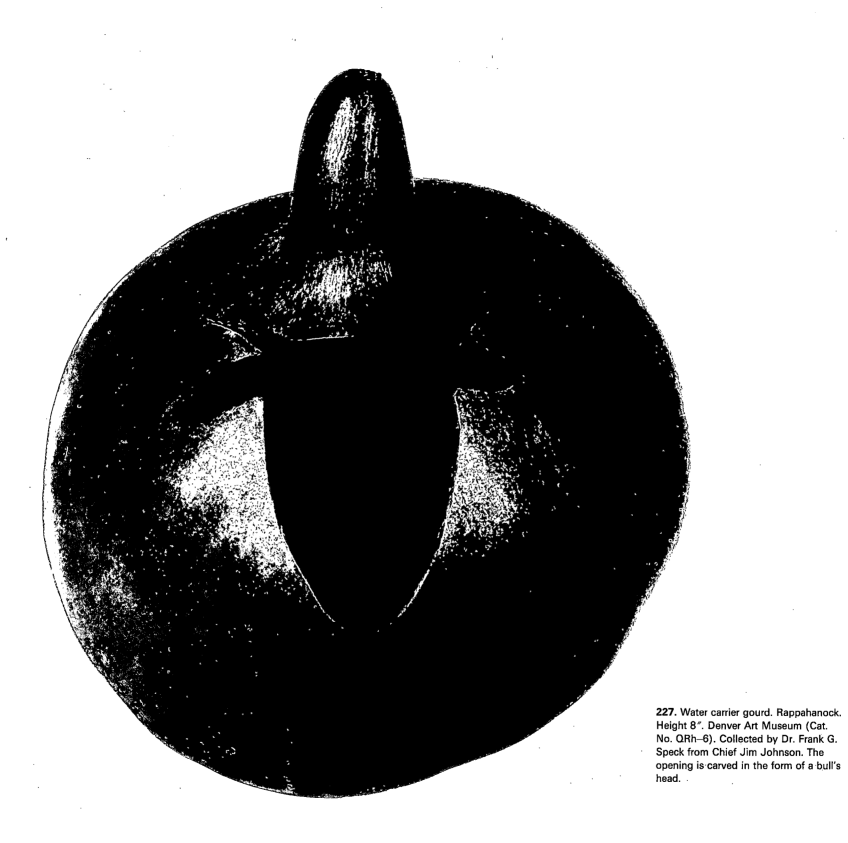

227. Water carrier gourd. Rappahanock. Height 8″. Denver Art Museum (Cat. No. QRh–6). Collected by Dr. Frank G. Speck from Chief Jim Johnson. The opening is carved in the form of a bull's head.

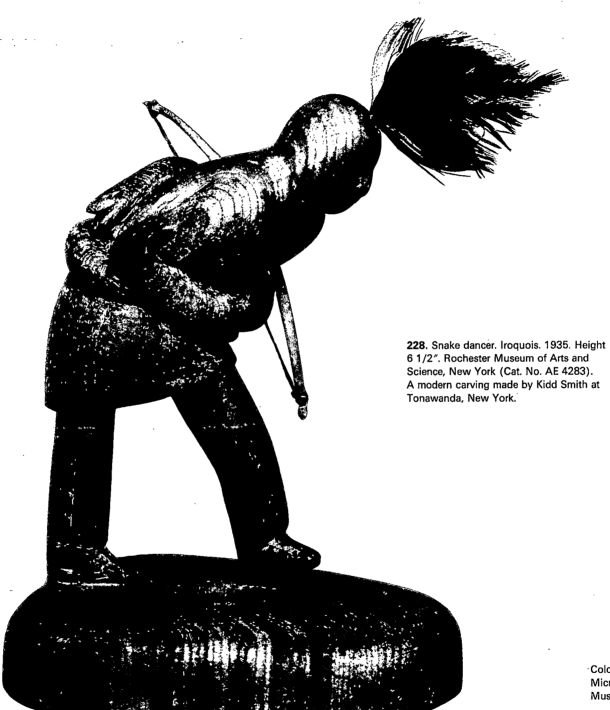

228. Snake dancer. Iroquois. 1935. Height
6 1/2″. Rochester Museum of Arts and
Science, New York (Cat. No. AE 4283).
A modern carving made by Kidd Smith at
Tonawanda, New York.

Colorplate **55**. Quilled birchbark box. ⟶
Micmac. 10 1/2 x 8 1/2″. Denver Art
Museum (Cat. No. VMi–12)

229. Carved wood cradle board. Mohawk.
Length 26 1/2". Museum of the American
Indian, Heye Foundation, New York City
(Cat. No. 18/7092)

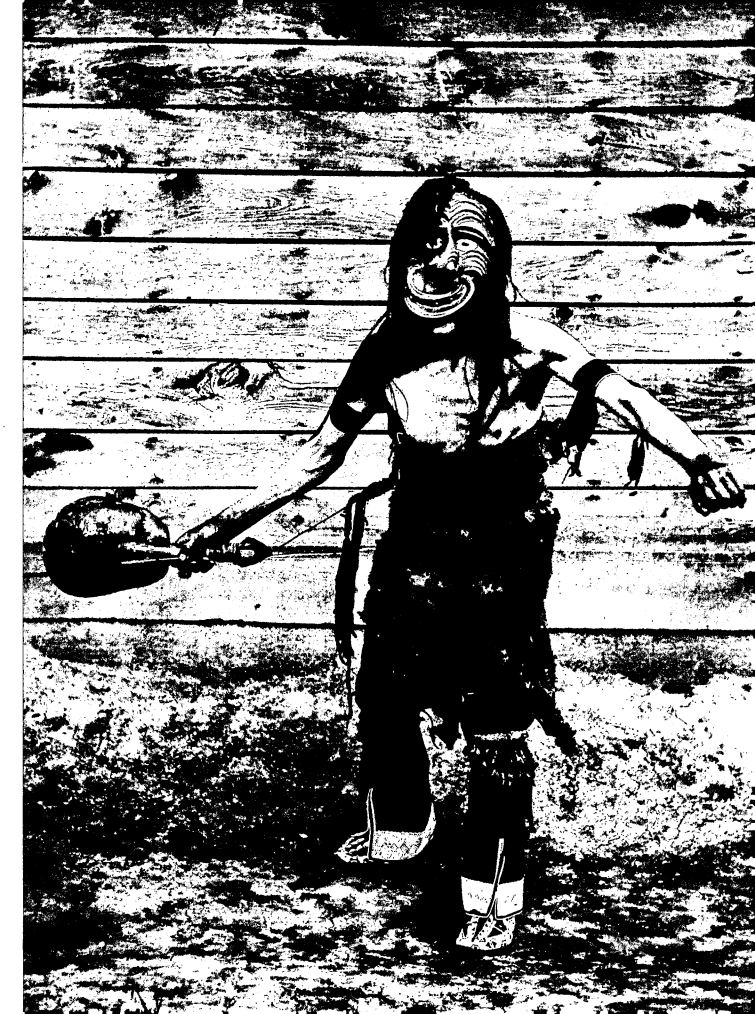

230. Cayuga man wearing a false face mask and carrying a turtle shell rattle. Photo by M. R. Harrington on the Grand River reservation, Canada, 1907.

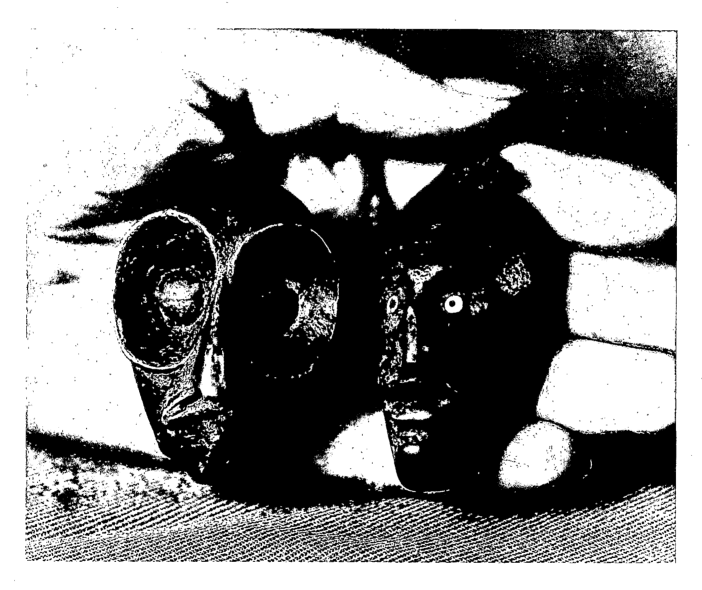

231. Two miniature masks. Iroquois or Delaware. University Museum, Philadelphia (Cat. Nos. NA 3881 and 3882)

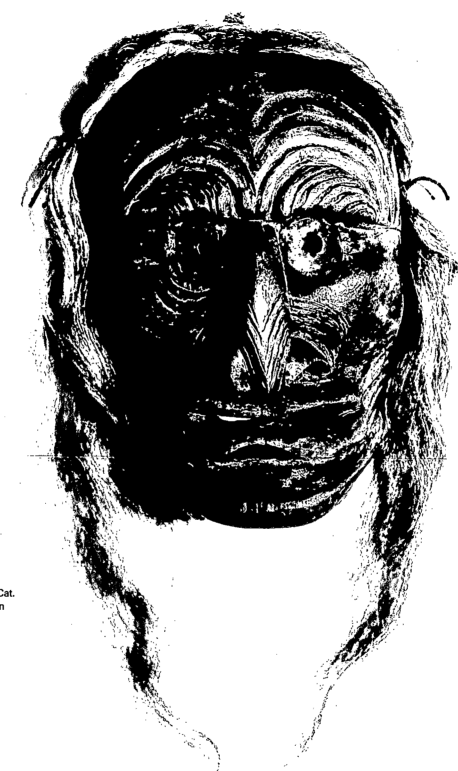

Colorplate **56**. False face mask. Cayuga. ⟶
1860. Height 11 1/2″. Museum of the
American Indian, Heye Foundation,
New York City (Cat. No. 21/8246)

232. False face mask. Oneida. Height
10 1/4″. Milwaukee Public Museum,
Wisconsin. Anthropology Collection (Cat.
No. 3242). Collected by T. R. Roddy in
1906 in Canada.

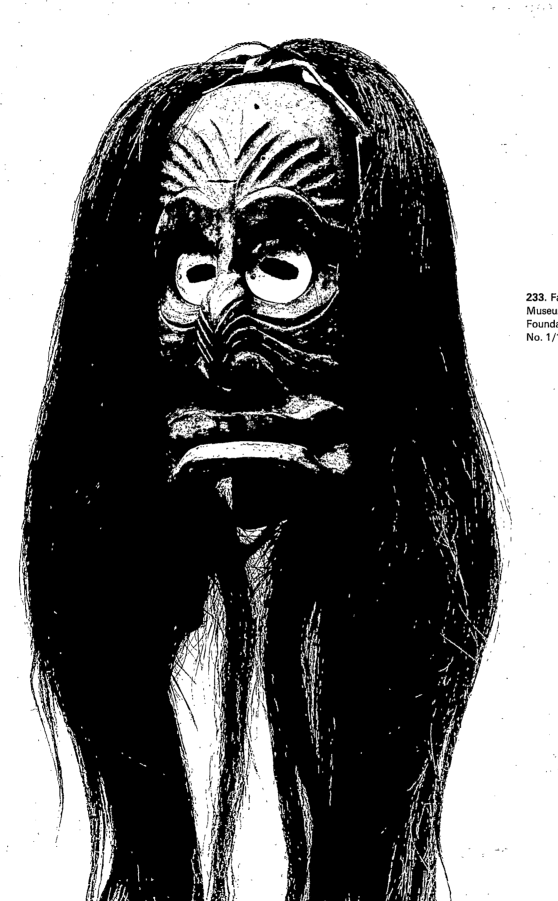

233. False face mask. Iroquois. Height 10″.
Museum of the American Indian, Heye
Foundation, New York City (Cat.
No. 1/1878B)

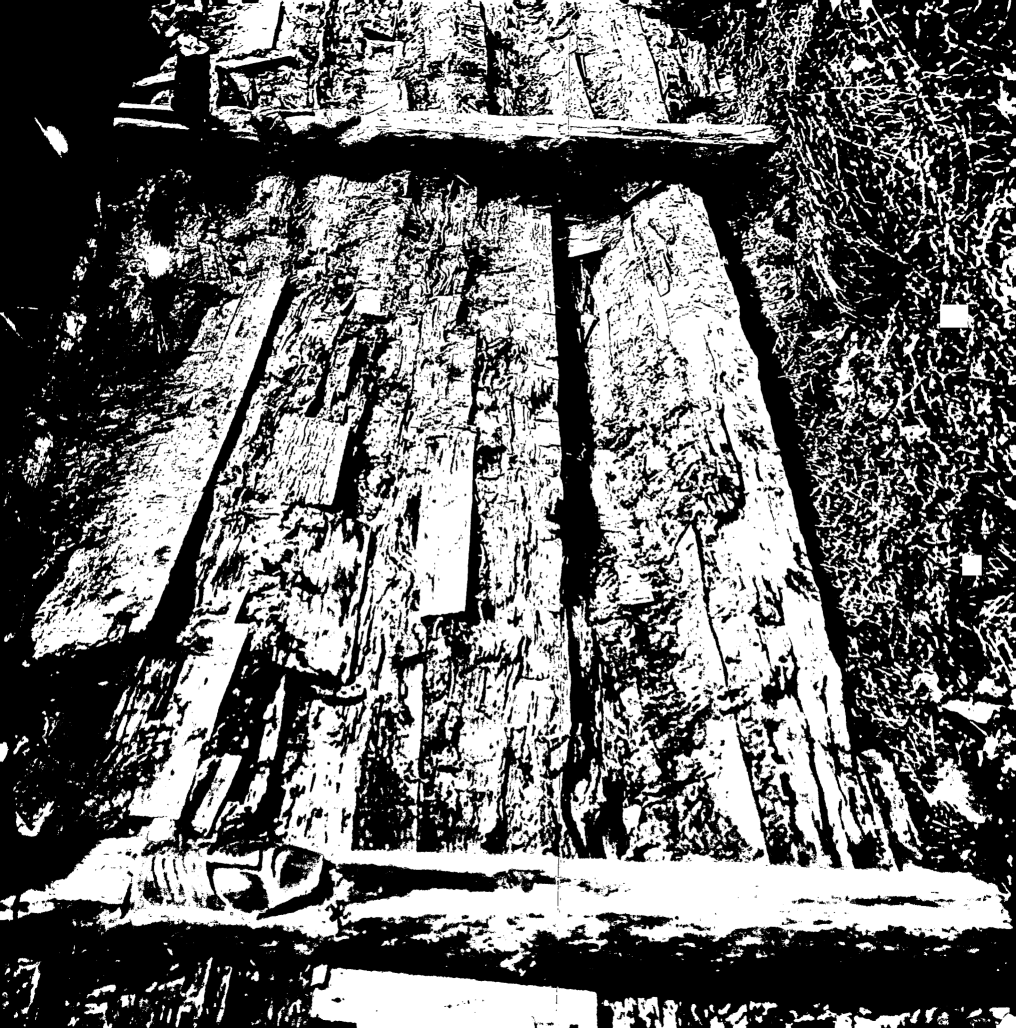

234. North wall of the Delaware Big House near Dewey, Oklahoma. Photo by M. R. Harrington in 1909. Note the faces carved on the supporting poles.

235. Wood carved drum sticks. Delaware. 19 x 3 1/4″. Denver Art Museum (Cat. No. QD–1). Used in the Big House Ceremonies to beat on a folded rawhide drum.

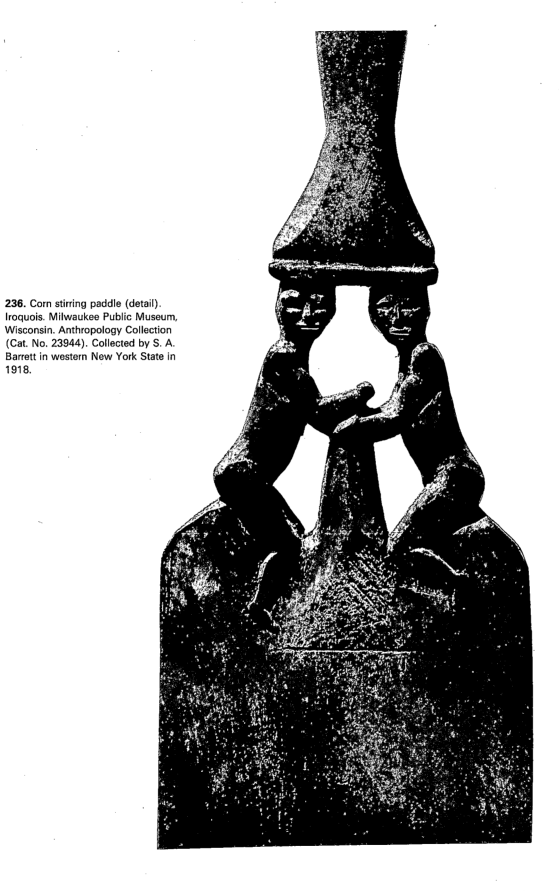

236. Corn stirring paddle (detail). Iroquois. Milwaukee Public Museum, Wisconsin. Anthropology Collection (Cat. No. 23944). Collected by S. A. Barrett in western New York State in 1918.

Colorplate **57.** Wood face mask. Delaware. ——▷ Length with fur drop 28″. Museum of the American Indian, Heye Foundation, New York City (Cat. No. 2/814)

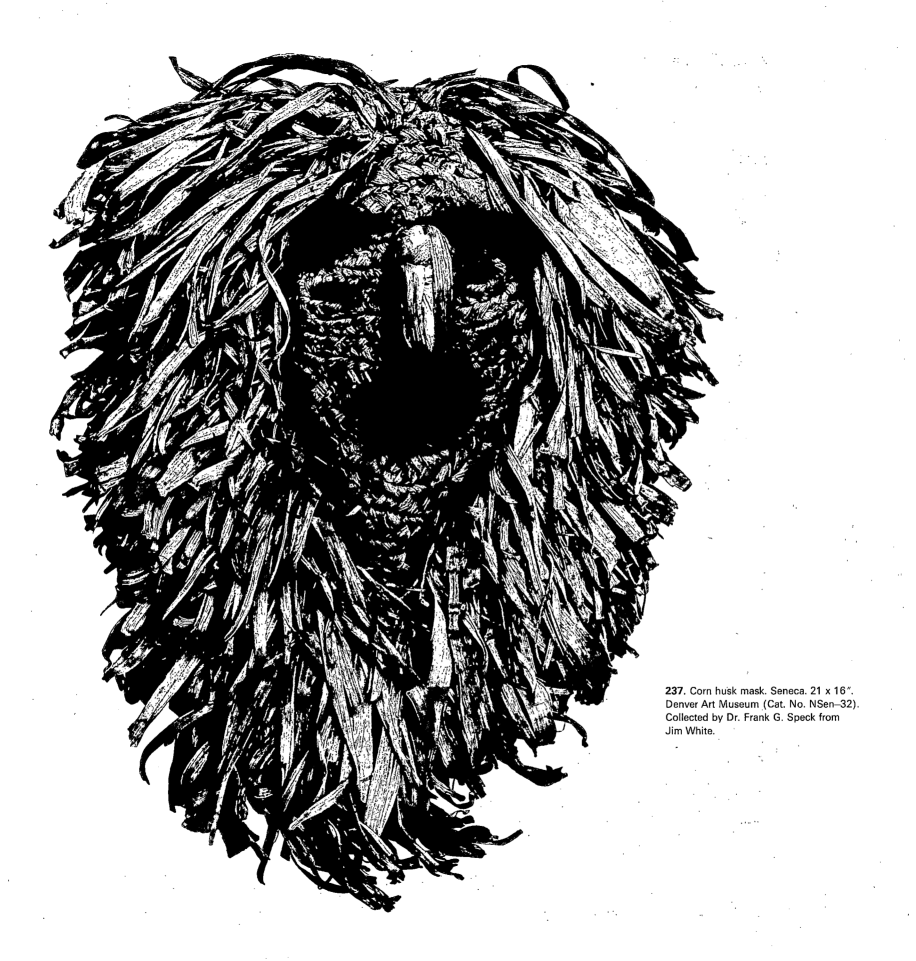

237. Corn husk mask. Seneca. 21 x 16″.
Denver Art Museum (Cat. No. NSen–32).
Collected by Dr. Frank G. Speck from
Jim White.

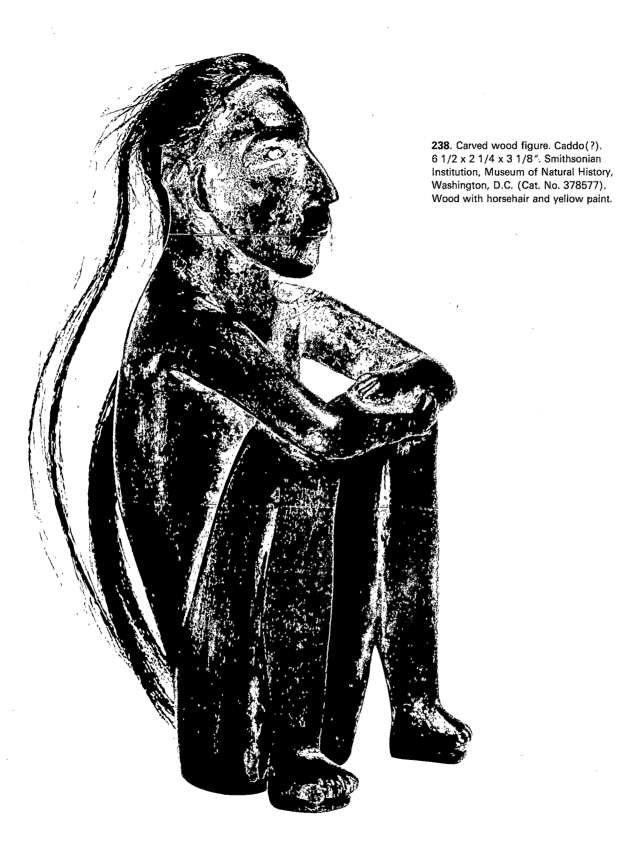

238. Carved wood figure. Caddo(?).
6 1/2 x 2 1/4 x 3 1/8″. Smithsonian
Institution, Museum of Natural History,
Washington, D.C. (Cat. No. 378577).
Wood with horsehair and yellow paint.

Colorplate **58.** Beaded shoulder pouch.
Seminole(?). Pouch 8 3/8 x 7 1/2″.
Field Museum of Natural History, Chicago
(Cat. No. 258646). The design of a man
on the pouch flap is unusual.

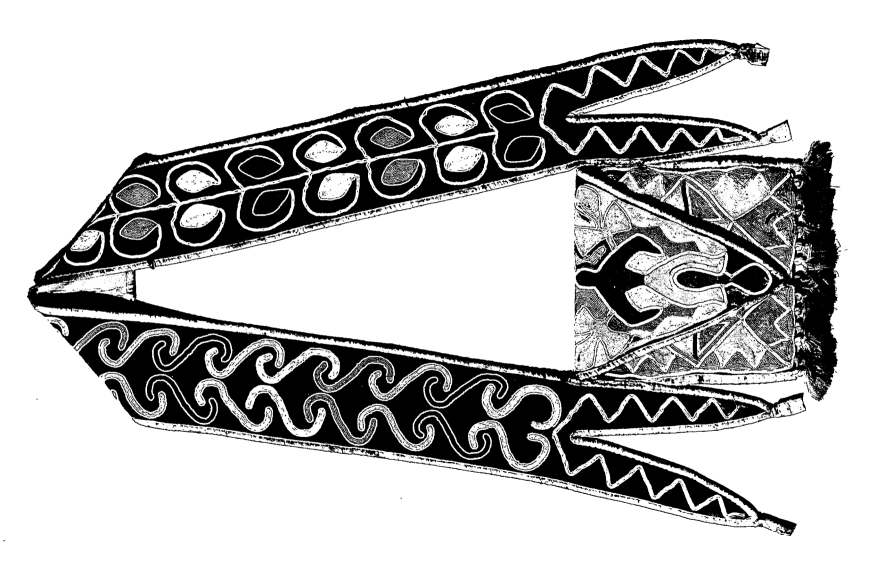

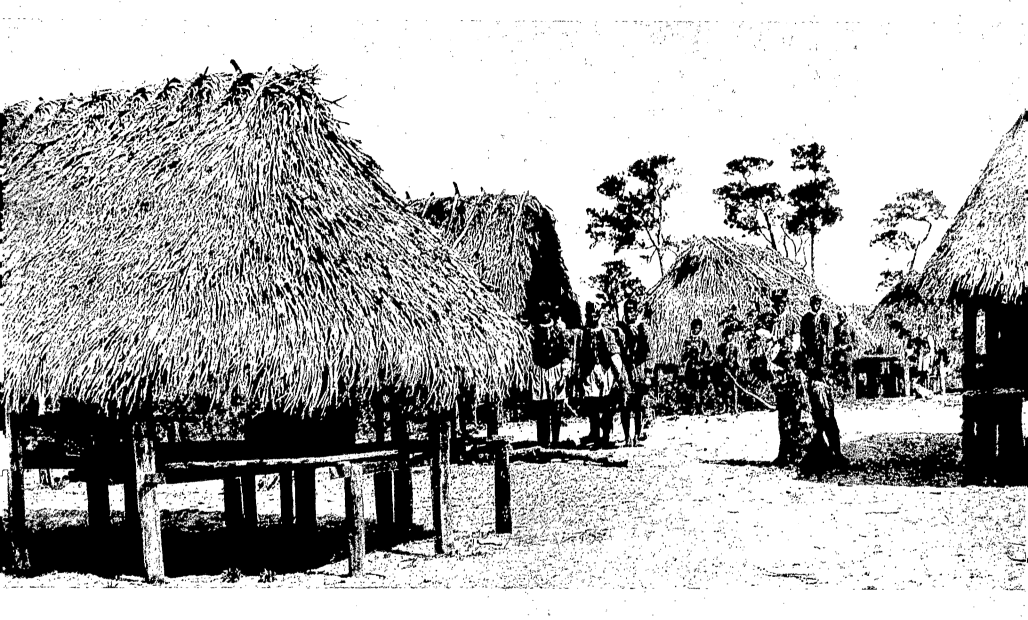

239. A Seminole city at Pine Island, Florida. Photo by H. A. Ernest in 1897. Shows the typical Seminole home of a raised platform with a thatched palm roof and open sides.

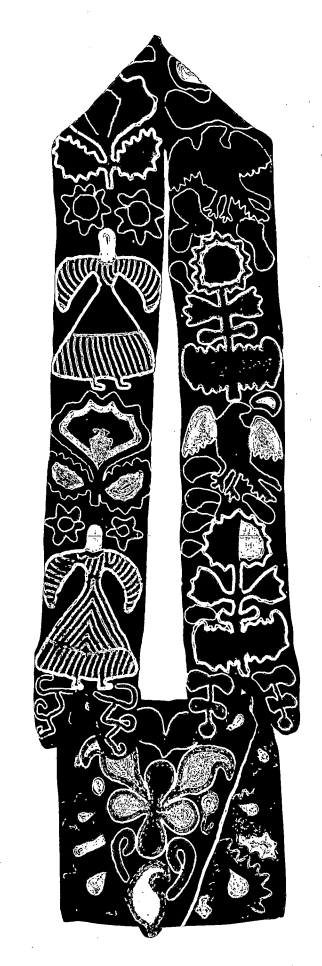

240. Beaded shoulder pouch.
Seminole(?). c. 1840. 29 5/8 x 7 7/8".
Denver Art Museum (Cat. No. Bse–5)

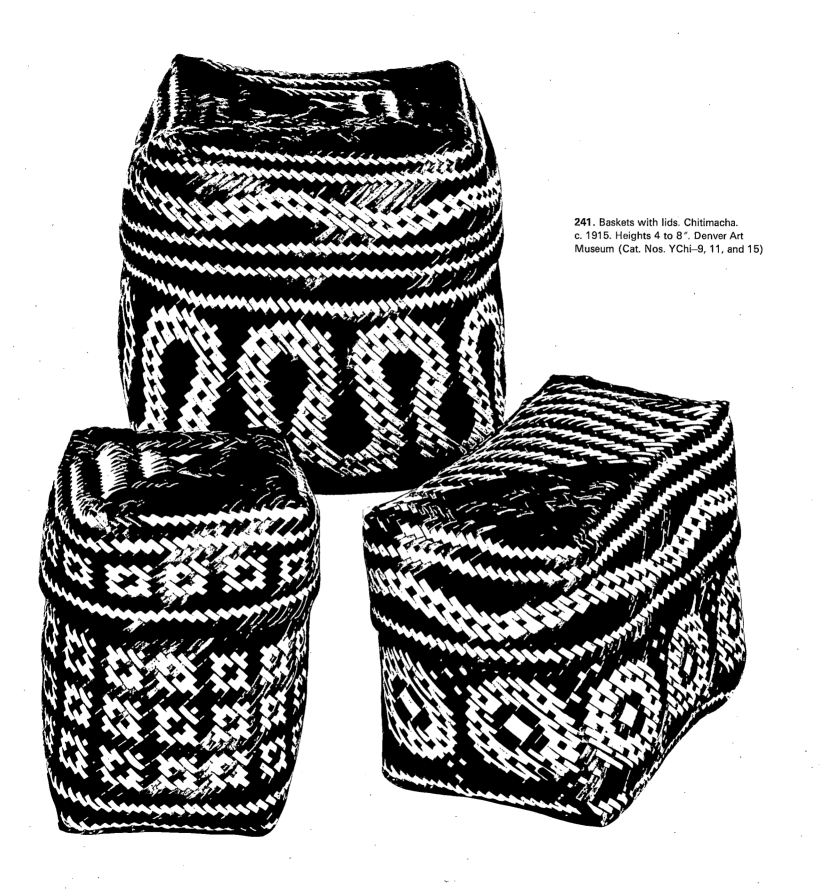

241. Baskets with lids. Chitimacha.
c. 1915. Heights 4 to 8″. Denver Art
Museum (Cat. Nos. YChi–9, 11, and 15)

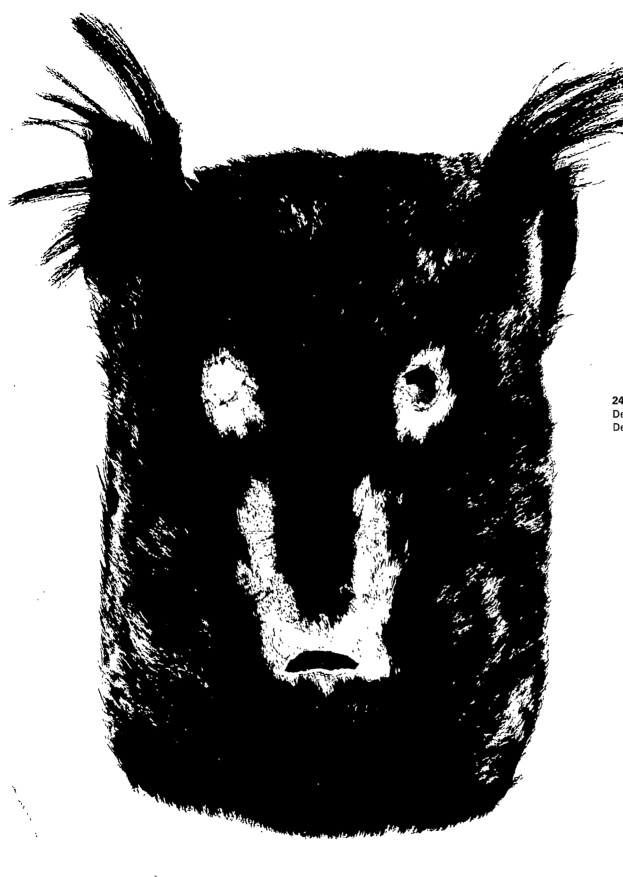

242. Fur mask. Cherokee. 12 1/2 x 9 1/2″.
Denver Art Museum (Cat. No. NCh–3).
Decoy mask of woodchuck skin.

Colorplate 59. Man's patchwork shirt and →
skirt. Seminole. Length 56″. Denver Art
Museum (Cat. No. RSe–1)

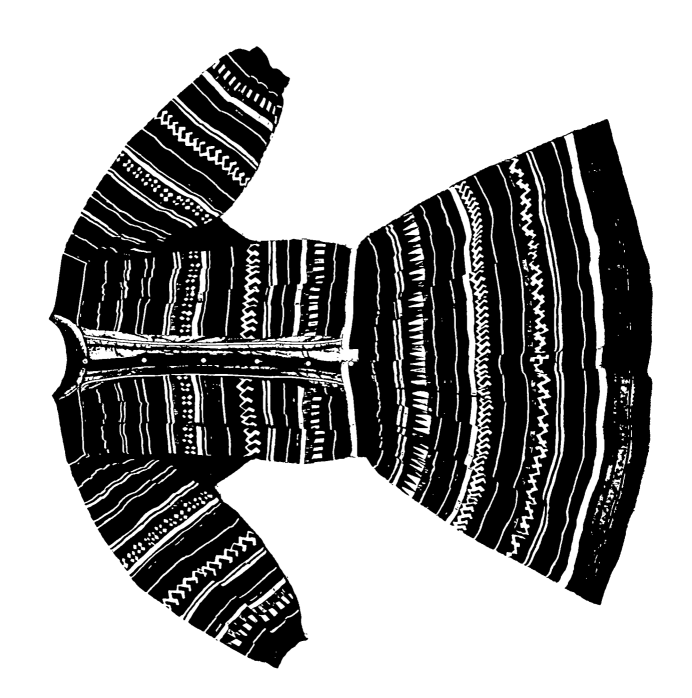

Notes

1 John Sloan and Oliver La Farge, *Introduction to American Indian Art*, New York, 1931.
2 Robert T. Davis, *Native Arts of the Pacific Northwest*, Stanford, 1949, and Robert B. Inverarity, *Art of the Northwest Coast Indians*, Berkeley, 1950.
3 Robert H. Lowie, *Crow Indian Art* (Anthropological Papers of the American Museum of Natural History, Vol. XXI, Part 4), 1922, pp. 271–322.
4 Thomas Donaldson, "The George Catlin Indian Gallery," *Annual Report of the United States National Museum*, 1885, pp. 450–51.
5 Frederick J. Dockstader, "The Kachina and the White Man," *Cranbrook Institute of Science Bulletin*, No. 35, 1954.
6 Alice Marriott, *Maria: The Potter of San Ildefonso*, Norman, 1948.
7 James Howard, "Pan-Indian Culture of Oklahoma," *The Scientific Monthly*, November, 1955, pp. 215–20.
8 Alice Marriott, "The Trade Guild of Southern Cheyenne Women," *Bulletin of the Oklahoma Anthropological Society*, Vol. IV, April, 1956, pp. 19–27.
9 For further details on culture areas, see Clark Wissler, *The American Indian*, New York, 1938, and Alfred L. Kroeber, *Cultural and Natural Areas of Native North American*, Berkeley, 1939.
10 John C. Ewers, *Plains Indian Painting*, Stanford, 1939.
11 John C. Ewers and William Wildschut, *Crow Indian Medicine Bundles* (Museum of the American Indian, Contributions from the Heye Museum, Vol. XVII), 1960.
12 Charles Marius Barbeau, "Indian Days of the Western Prairies," *Bulletin of the National Museum of Canada*, No. 163, 1960, figure 28; Frederic H. Douglas and René d'Harnoncourt, *Indian Art of the United States*, New York, 1941, color-plate p. 24. Other examples of this type of hide are in the Denver Art Museum, the Wyoming State Museum, the Brooklyn Museum, Noble Hotel, Lander, Wyoming, etc.
13 Miss Mabel Morrow of Sante Fé, New Mexico is putting the finishing touches on a manuscript which will answer most of the questions about tribal styles in *parfleche* decoration.

14 See Ruth Underhill, *Pueblo Crafts*, Lawrence, 1944 for a detailed discussion of pottery types, and Frederic H. Douglas, *Modern Pueblo Pottery Types* (Denver Art Museum Leaflet No. 53–54), 1933.
15 Theodora Kroeber, *Ishi in Two Worlds*, Berkeley, 1961.
16 Leslie Spier and Edward Sapir, *Wishram Ethnography* (Publications in Anthropology, Vol. III, No. 3), 1930.
17 William N. Fenton, "Masked Medicine Societies of the Iroquois," *Annual Report of the Smithsonian Institution*, 1940, pp. 397–430.

Bibliography

The following bibliography is a brief listing of the more important books dealing with the artistic aspects of American Indian culture. It is not intended as an exhaustive list, but it is a guide to additional reading on specific subjects. A few of the books are included only because they are mentioned in the text.

The literature on the American Indian is quite extensive, and fortunately there are excellent bibliographies available. For anyone interested in detailed information I can strongly recommend the first two works cited:

Harding, Anne D., and Bolling, Patricia. "Bibliography of North American Indian Art." Mimeographed, Washington, D.C., 1939. (Out of print; references listed by technique; a handy guide but outdated.)

Murdock, George P. *Ethnographic Bibliography of North America.* (Human Relations Area Files.) 3rd ed.; New Haven: Yale University Press, 1960. (A listing of references by tribe and area.)

Adair, John. *The Navaho and Pueblo Silversmiths.* Norman: University of Oklahoma Press, 1944.

Amsden, Charles A. *Navaho Weaving.* Santa Ana, Calif.: The Fine Arts Press, 1934. (Chicago: Rio Grande Press, 1964.)

Appleton, Le Roy. *Indian Art of the Americas.* New York: Charles Scribner's Sons, 1950.

Barbeau, Charles Marius. "Totem Poles," *Bulletin of the National Museum of Canada,* No. 119. (Anthropological Series, No. 30.) 2 vols. Ottawa, 1930.

———. "Haida Carvers in Argillite," *Bulletin of the National Museum of Canada,* No. 139. Ottawa, 1957.

———. "Indian Days of the Western Prairies," *Bulletin of the National Museum of Canada,* No. 163. Ottawa, 1960. (Good illustrations of pictographic painting, but text is a collection of myths.)

Birket-Smith, Kaj. *The Eskimos.* New York: E. P. Dutton & Co. Inc., 1936.

Bourke, John G. "Medicine-men of the Apache," *9th Annual Report of the Bureau of American Ethnology* (Washington, D.C., Smithsonian Institution), 1892.

Bushnell, David I., Jr. *Drawings by George Gibbs in the Far Northwest, 1849–1851.* (Smithsonian Miscellaneous Collections, Vol. XCVII, No. 8.) Washington, D.C.: Government Printing Office, 1938. (A sketch of a canoe prow is reproduced in the text.)

Colton, Harold S. *Hopi Kachina Dolls.* Albuquerque: University of New Mexico Press, 1959.

Covarrubias, Miguel. *The Eagle, the Jaguar, and the Serpent.* New York: Alfred A. Knopf, 1954.

Davis, Robert T. *Native Arts of the Pacific Northwest.* Stanford: Stanford University Press, 1949.

Dockstader, Frederick J. "The Kachina and the White Man," *Cranbrook Institute of Science Bulletin*, No. 35. Bloomfield Hills, Mich., 1954.

———. *Indian Art in America.* Greenwich, Conn.: New York Graphic Society, 1961.

Donaldson, Thomas C. "The George Catlin Indian Gallery," *Annual Report of the United States National Museum* (Washington, D.C., Smithsonian Institution), 1885.

Dorsey, George A. *The Ponca Sun Dance.* (Field Columbian Museum Anthropological Series, Vol. VII, No. 2.) Chicago, 1905. (Complete discussion of this important Plains ceremony for one tribe.)

Douglas, Frederic H. *Modern Pueblo Pottery Types.* (Denver Art Museum Leaflet No. 53–54), 1933.

———, and d'Harnoncourt, René. *Indian Art of the United States.* New York: The Museum of Modern Art, 1941.

Drucker, Philip. *Indians of the Northwest Coast.* New York: Natural History Press, 1963. (An excellent and complete discussion of the people and art.)

Dunn, Dorothy. "The Development of Modern American Indian Painting," *El Palacio* (Santa Fé, 1951), 331–53.

Ewers, John C. *Plains Indian Painting.* Stanford: Stanford University Press, 1939.

———. *Blackfeet Crafts.* Lawrence, Kans.: Haskell Institute, 1945.

———, and Wildschut, William. *Crow Indian Medicine Bundles.* (Museum of the American Indian, Contributions from the Heye Museum, Vol. XVII.) New York, 1960.

Feder, Norman, and Malin, Edward. *Indian Art of the Northwest Coast*. Denver Art Museum, 1962.

Fenton, William N. "Masked Medicine Societies of the Iroquois," *Annual Report of the Smithsonian Institution* (Washington, D.C.), 1940.

Fontana, Bernard L. *Papago Indian Pottery*. Seattle: University of Washington Press, 1962.

Goddard, Pliny E. *Indians of the Southwest*. 4th ed. New York: American Museum of Natural History, 1931.

Gunther, Erna. *Northwest Coast Indian Art*. Exhibition catalog. Seattle World's Fair, 1962.

————, and Haeberlin, Herman. *The Indians of Puget Sound*. (Publications in Anthropology, Vol. IV.) Seattle: University of Washington Press, 1930.

Hassrick, Royal B. *Indian Art of the Americas*. Denver Art Museum, 1960.

Hoffman, Walter J. "The Mide'wiwin or 'Grand Medicine Society' of the Ojibwa," *7th Annual Report of the Bureau of American Ethnology* (Washington, D.C., Smithsonian Institution), 1891.

————. "The Graphic Art of the Eskimo," *Annual Report of the Bureau of American Ethnology* (Washington, D.C., Smithsonian Institution), 1895.

Holm, Bill. *Northwest Coast Indian Art*. Seattle: University of Washington Press, 1965. (Detailed analysis of two-dimensional art.)

Howard, James. "Pan-Indian Culture of Oklahoma," *The Scientific Monthly* (November, 1955), 215–20.

Inverarity, Robert B. *Art of the Northwest Coast Indians*. Berkeley: University of California Press, 1950.

Jenness, Diamond. "The Indians of Canada," *Bulletin of the National Museum of Canada*. Ottawa, 1932.

Krickeberg, Walter. *Altere Ethnographica aus Nordamerika im Berliner Museum für Volkerkunde*. Berlin, 1954. (Good discussion of early material in German museums.)

Kroeber, Alfred L. "Handbook of the Indians of California," *Bulletin of the Bureau of American Ethnology*, No. 78. Washington, D.C., 1925.

————. *Cultural and Natural Areas of Native North America*. (Publications in American Archaeology and Ethnology.) Berkeley: University of California Press, 1939.

Kroeber, Theodora. *Ishi in Two Worlds*. Berkeley: University of California Press, 1961.

La Barre, Weston. *The Peyote Cult.* (Publications in Anthropology.) New Haven: Yale University Press, 1938.

Lowie, Robert H. *Crow Indian Art.* (Anthropological Papers of the American Museum of Natural History, Vol. XXI, Part 4.) New York, 1922.

———. *Indians of the Plains.* New York: McGraw-Hill, 1954.

Lyford, Carrie A. *Quill and Beadwork of the Western Sioux.* Lawrence, Kans.: Haskell Institute, 1940.

———. *Iroquois Crafts.* Lawrence, Kans.: Haskell Institute, 1945.

———. *Ojibwa Crafts.* Lawrence, Kans.: Haskell Institute, 1945.

Mallery, Garrick. "Picture Writing of American Indians," *Annual Report of the Bureau of American Ethnology,* No. 10 (Washington, D.C., Smithsonian Institution), 1893.

Marriott, Alice. *Maria: The Potter of San Ildefonso.* Norman: University of Oklahoma Press, 1948.

———. "The Trade Guild of Southern Cheyenne Women," *Bulletin of the Oklahoma Anthropological Society,* Vol. IV (April, 1956), 19–27.

Mason, Otis T. "Aboriginal American Basketry," *Annual Report of the United States National Museum* (Washington, D.C., Smithsonian Institution), 1902.

Matthews, Washington. *The Night Chant: A Navaho Ceremony.* (Memoirs of the American Museum of Natural History, Vol. VI.) New York, 1902. (The Navaho sand painting ceremony)

Mera, Harry P. *Pueblo Indian Embroidery.* (Memoirs of the Laboratory of Anthropology, Vol. IV.) Santa Fé: University of New Mexico Press, 1943.

Mills, George T. *Navaho Art and Culture.* Colorado Springs: Taylor Museum of the Colorado Springs Fine Arts Center, 1959. (An excellent treatment of the role of art in Navaho life.)

Mooney, James. "The Ghost Dance Religion," *Annual Report of the Bureau of American Ethnology,* No. 14 (Washington, D.C., Smithsonian Institution), 1896.

Morgan, Lewis H. *The League of the Ho-dé-no-sau-nee, or Iroquois.* Ed. H. M. Lloyd. 2 vols. New York, 1901. (New Haven: Yale University Press, 1954.)

Orchard, William C. *The Technique of Porcupine-Quill Decoration among the North American Indians.* (Contributions of the Museum of the American Indian, Vol. IV, No. 1.) New York, 1916.

————. *Beads and Beadwork of the American Indian.* (Contributions of the Museum of the American Indian, Vol. XI.) New York, 1929.

Skinner, Alanson. *Material Culture of the Menomini.* (Indian Notes and Monographs, Misc. Ser. No. 20.) New York: Museum of the American Indian, 1921.

Sloan, John, and La Farge, Oliver. *Introduction to American Indian Art.* Exposition of Indian Tribal Arts. New York, 1931.

Slotkin, James S. *The Menomini Powwow.* (Publications in Anthropology, Vol. IV.) Milwaukee Public Museum, 1957. (A complete report on the Dream Dance religion practiced by one typical tribe.)

Spier, Leslie, and Sapir, Edward. *Wishram Ethnography.* (Publications in Anthropology, Vol. III, No. 3.) Seattle: University of Washington Press, 1930.

Swanton, John R. "The Indians of the Southeastern United States," *Bulletin of the Bureau of American Ethnology,* No. 137. Washington, D.C., 1946.

Tschopik, Harry, Jr. *Indians of North America.* New York: American Museum of Natural History, 1952. (A very good popular guide to the Indians north of Mexico.)

Underhill, Ruth. *Pueblo Crafts.* Lawrence, Kans.: Haskell Institute, 1944.

Vaillant, George C. *Indian Arts in North America.* New York and London: Harper and Brothers, 1939.

Wardwell, Allen. *Yakutat South: Indian Art of the Northwest Coast.* Art Institute of Chicago, 1964.

West, George A. "Tobacco Pipes and Smoking Customs of the American Indians," *Bulletin of the Milwaukee Public Museum,* No. 17. 2 vols. Milwaukee, 1934.

Wingert, Paul S. *American Indian Sculpture.* New York: J. J. Augustin, 1949. (Features the sculpture of the southern part of the Northwest Coast, mainly Salish art.)

Wissler, Clark. *The American Indian.* New York: Oxford University Press, 1938.

————. *Indians of the United States.* Garden City: Doubleday Doran, 1940. (2nd ed. 1945; rev. ed. 1966 by Lucy W. Kluckhohn.)

Publications by the author (arranged chronologically):

"Laguna Scalp Dance," *American Indian Hobbyist* (Los Angeles), I (September, 1954), 3.

"Navaho Feather Dance," *ibid.* (October, 1954), 9.

"Yei-be-chi," *ibid.* (December, 1954), 22.

"Whistles," *ibid.*, 28.

"California Ethnobotany," Mimeographed. Prepared for United States Department of Justice in connection with California Indian Land Claims, 1955.

"Apache Crown Dance," *American Indian Hobbyist* (Los Angeles), I (January, 1955), 32.

"Porcupine Quillwork Technique," *ibid.*, II (September, 1955), 3–4.

"Porcupine Quillwork Technique," *ibid.* (October, 1955), 13–14.

"Hopi Lightning Frame Dance," *ibid.* (January, 1956), 41.

"Ribbon Appliqué," *ibid.*, III (October–November, 1956), 11–26.

"Fry Bread," *ibid.* (December, 1956), 34.

"Tlingit Face Stamps," *ibid.* (May–June, 1957), 82–83.

"Flutes," *ibid.*, 96–98.

Feder, Norman, White, Glenn, and Umscheid, Issy. "Costume of the Oklahoma Straight Dancer," *ibid.* (Reseda, Calif.), IV (September–October, 1957), 3–17.

"Old Time Sioux Costume," *ibid.* (November–December, 1957), 23–38.

"Details of a Sioux Cloth Dress," *ibid.* (January–February, 1958), 50–51.

"Oklahoma Fancy Dance Costume," *ibid.*, 52–57.

"Hopi Yarn Anklets," *ibid.* (March–April, 1958), 70–74.

"Embroidered Kilts," *ibid.*, 76–77.

"Cochiti Parrot Dance," *ibid.* (March–April, 1958), 78–79.

"Plains Hair and Roach Ornaments," *ibid.* (May–June, 1958), 83–88.

"Hopi Butterfly Dance and Costume," *ibid.*, 90–93.

"Oklahoma Women's Crowns," *ibid.*, 96.

"Modern Swing Bustles," *ibid.*, V (November–December, 1958), 28–32.

"Navaho Moccasins," *ibid.*, 36–38.

"Roach Spreaders," *ibid.*, 42–45.

"Modern Crow Costume," *ibid.* (March–April, 1959), 74–80.

"Women's Bow-type Hair Ornaments," *ibid.*, 86–90.

"The Kickapoo of Couhuila," *ibid.*, 91–94.

"Modern Oklahoma Buckskin Dress," *ibid.* (Denver, Colo.), V (May–June, 1959), 98–104.

"Sioux Pheasant Bustle," *ibid.*, 111–17.

"Seminole Patchwork," *ibid.*, VI (September–October, 1959), 1–18.

"Mirror Boards," *ibid.* (November–December, 1959), 26–32.

"Ute Bear Dance," *ibid.*, 39–42.

"Shoshone Split-horn Bonnet," *ibid.*, 35–38.

"Quill and Horsehair Feather Ornaments," *American Indian Tradition* (Alton, Ill.), VI, Nos. 9 & 10 (Summer, 1960), 109–10.

"Otter Fur Turbans," *ibid.*, VII, No. 3 (1961), 84–96.

Feder, Norman, and Chandler, Milford G., "Grizzly Claw Necklaces," *ibid.*, VIII, No. 1 (1961), 7–16.

"A Note on 'An Unusual Beadwork Technique'," *ibid.* (1961), 41–42.

"Plains Indian Metalworking," *ibid.*, VIII, No. 2 (1962), 55–76.

"Matachines," *ibid.*, 79–82.

"Plains Indian Metalworking, Part Two," *ibid.*, No. 3, 93–108.

"Front Seam Leggings," *ibid.*, 119–24.

"Bottom Tab Leggings," *ibid.*, No. 4, 148–59.

"Indian Art of the Northwest Coast," *Denver Art Museum Winter Quarterly* (1962).

"Book review of *Primitive Art*, by Paul S. Wingert," *Ethnohistory* (Winter, 1963), 97–98.

"Origin of the Oklahoma Forty-nine Dance," *Ethnomusicology* (Middletown, Conn.), VIII (September, 1964), 290–94.

Art of the Eastern Plains Indians. New York: The Brooklyn Museum, 1964.

"Art of the Eastern Plains Indians," *The Brooklyn Museum Annual* (New York), IV (1964), 6–41.

American Indian Art before 1850. Denver Art Museum, 1965.

Head and Tail Fans. (Indiancraft Pamphlet, No. 2.) Somerset, N.J.: Powwow Trails, 1965.

Crow Indian Art. Exhibit brochure. Denver Art Museum, 1966.

North American Indian Paintings. Exhibition catalog. New York: The Museum of Primitive Art, 1967.

Elk Antler Roach Spreaders. (Material Culture Monograph, No. 1.) Denver Art Museum, 1968.

PHOTOGRAPHIC SOURCES

The author and publisher wish to thank the museums and private collectors for permitting the reproduction in black and white of works of art in their collections. Photographs have been supplied by the owners except for the following, whose courtesy is gratefully acknowledged:

Denver Art Museum (22); Field Museum of Natural History, Chicago (32); Gannon, William L., Mabton, Wash. (133); Haitz, Fred, Sioux City, Iowa (39); Museum of the American Indian, New York City (230, 234); Smithsonian Institution, Bureau of American Ethnology, Washington, D.C. (1, 4, 6, 10, 15, 31, 87, 95, 103, 119, 125, 126, 130, 134, 202, 239).